Silk

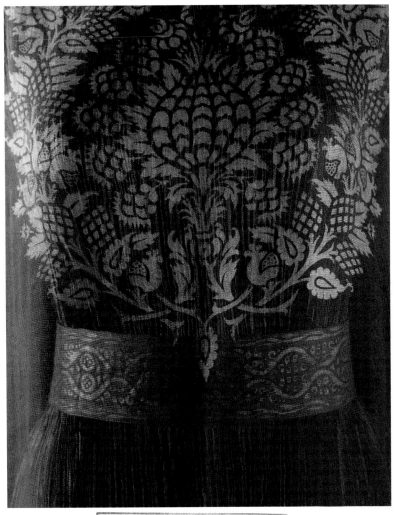

170185

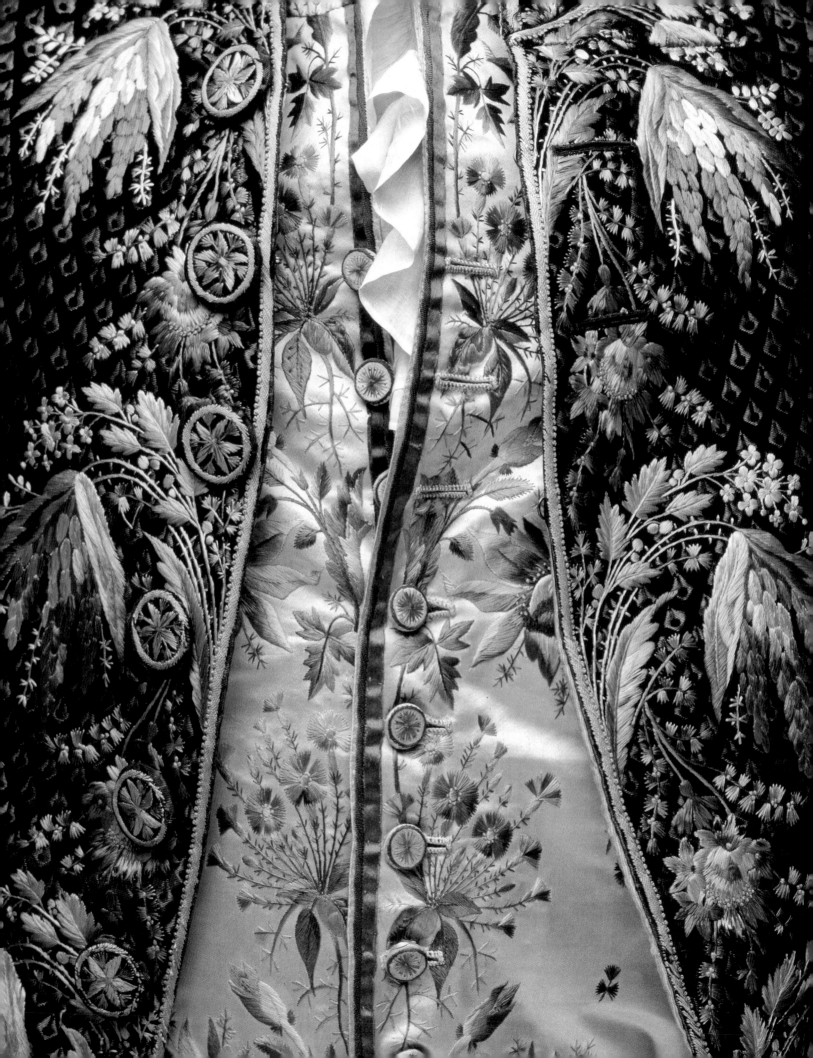

Silk

MARY SCHOESER

*With a foreword by Julien Macdonald
and contributions by Bruno Marcandalli*

YALE UNIVERSITY PRESS
NEW HAVEN AND LONDON

For Terry McLean with love
again, and always

First published in the United States of America in 2007 by
YALE UNIVERSITY PRESS
302 Temple Street, P.O. Box 209040, New Haven, CT 06520
www.yalebooks.com

Library of Congress Control Number: 2006937044

ISBN-13: 978-0-300-11741-7
ISBN-10: 0-300-11741-8

Created and produced for Yale University Press by
PALAZZO EDITIONS LTD
15 Gay Street, Bath, BA1 2PH, UK
www.palazzoeditions.com

From an original concept by
Mark Thomson/International Design UK,
and made possible through the support of CEPS
(Commission Européene Promotion Soie)

Book design: *Terry Jeavons*
Picture research: *Emily Hedges and David Penrose in association with Mary Schoeser*
Managing editor: *Catherine Hooper*
Copyeditor: *Eleanor van Zandt*

Printed and bound in Singapore

page 1 Fortuny Delphos and sleeved tunic, after 1909, courtesy of the Museo Fortuny.
Photography by Claudio Franzini.

page 2 Detail of a French gentleman's silk suit of the 1780s, lavishly embroidered
in silks and completed with narrow ribbon edgings and silk embroidered buttons.
Photography by Cary Wolinsky/National Geographic Image Collection.

Contents

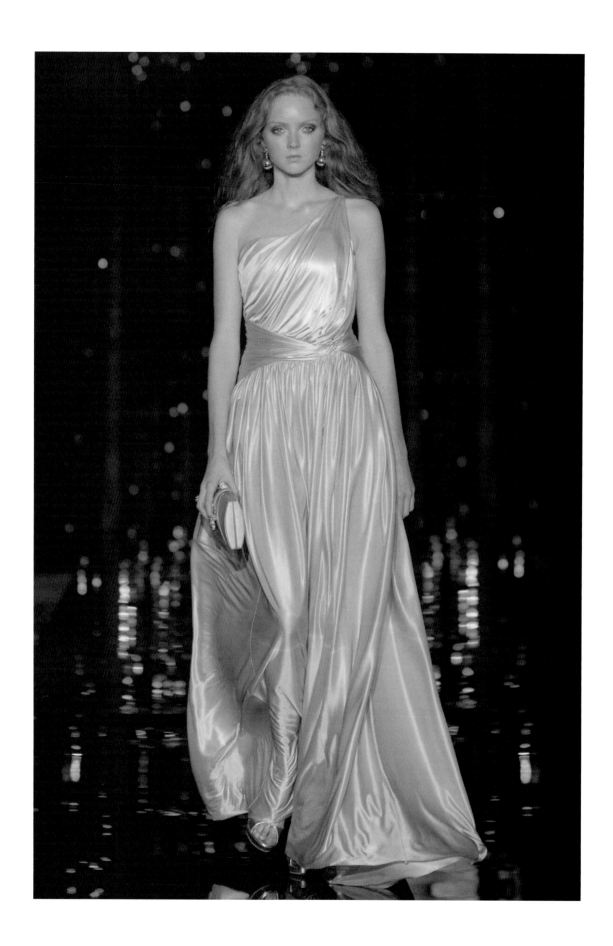

Foreword *by Julien Macdonald*

My mother was right: when you've got nothing left,

all you can do is get into silk underwear and start reading Proust.

JANE BIRKIN, ENGLISH ACTRESS, BORN 1946

To my mind, there's nothing more sensuous than silk underwear for women. For men, perhaps not (see the views of actor Matt LeBlanc at brainyquotes.com). Since 2005 I've been designing a range of lingerie for Debenhams, and this has reminded me of some of the qualities of silk that have always appealed to me, namely that it's so soft and fluid, gliding over and accentuating the body at just the right points. Then there's the "Hollywood boudoir" thing: the silk peignoir with marabou trim that makes everyone think of Marilyn Monroe or Greta Garbo. This is also part of what I like about silk. It's possible to mix this vintage sensibility with something very modern; it's a timeless fabric, yet it never goes out of fashion.

The vintage-modern mix is one that I really like to work with. Satin woven with silk and Lycra, for example, can mould the body to create a futuristic statement and yet still retain the luxurious surface and handle for which silk is renowned. To my eyes, even more modern in

its look is printing on silk, especially when it moderates the cloth's sheen or—better still—uses a textured silk to start with. But I've used all types of silk since I launched my own label in 1997; other favourites are georgette and jersey. The former is particularly interesting because, aside from its fluidity, it can be transparent, and it also allows me to design garments that can be for both day and evening.

Silk jersey is close to my heart because it's a knitted fabric, and knitting is where my career began. Karl Lagerfeld discovered me at the Royal College of Art and asked me to design knitwear for Chanel, in 1994, and so my first real involvement with silk was as a thread. I knitted lace dresses for Chanel: filigree lace dresses in which the silk was the key, its strength holding the structure of the lace so that you could really see it. Although sensual decadence and glitzy glamour have become associated with both my own collections and those I designed during my recent three-year contract as creative director at Givenchy, behind it all is a serious regard for silk and the remarkable range of things I can do with it.

As far as I'm concerned, nothing will ever replace silk. It can look tenderly feminine or high-tech, timeless or cutting edge. This book explains everything about why this can be so, as well as giving an insight into how each couturier's response to silk is very much a part of his or her signature style. I'm delighted to recommend it for its comprehensive coverage of the history, science, and art of silk.

page 6 and opposite Julien
Macdonald Spring/Summer 2007.

JULIEN MACDONALD, O.B.E.

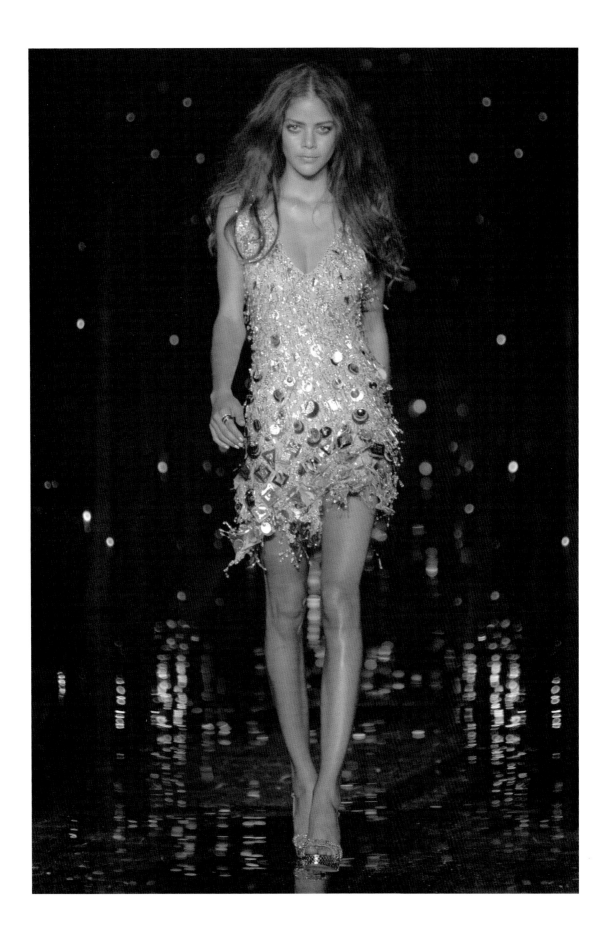

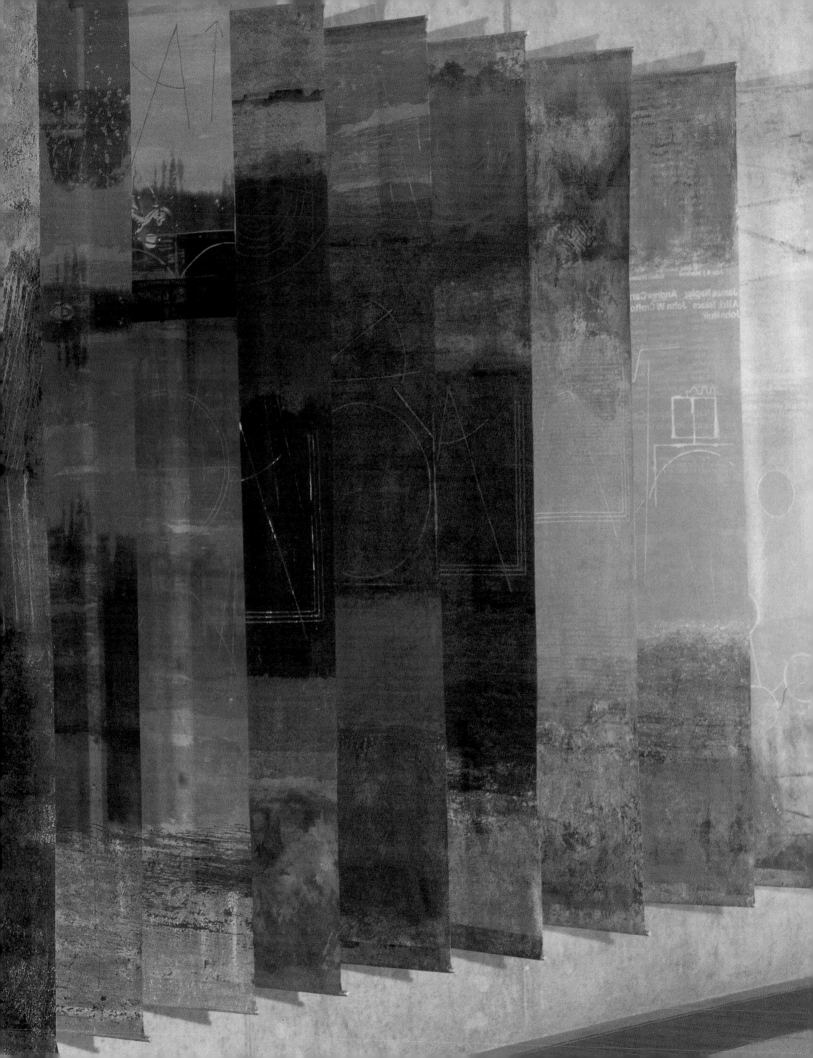

Introduction

I am labouring here to contradict an old proverb,
and make a silk purse out of a sow's ear.

<div align="center">SIR WALTER SCOTT (1771–1832)</div>

opposite Part of "Hinterland" by Norma Starszakowna, 2004, a permanent installation of 18 silk organza panels in the Scottish Parliament, Edinburgh; it is printed and patterned on both sides.

below A silk *kesi* mount was added in the 12–13th century to protect a Chinese scroll painting, "The Admonitions of the Court Instructress," rendered in ink and colors on sized silk, c. 6th century.

Without necessarily being aware of it, we are all "experts" in silk, for every culture with more than a passing acquaintance with this fiber—and that is most of them—has adopted the word to proclaim one or more of its qualities. "Silken" tresses, for example, are widely understood to be shiny, strong, and long, and these are the very characteristics that set silk apart from other natural fibers. These same distinctive features, together with elasticity, allowed for very diverse uses of silk— among the earliest, fishing lines and bowstrings, then strings in musical instruments, and last, at more than

two thousand years ago, the world's first paper. In China, where the domestication of the *Bombyx mori* moth began nearly seven thousand years ago, *sse* is the word for silk; and so fundamental is silk to Chinese life that among the five thousand most common characters in the Mandarin language, 230 incorporate the symbol for silk. In Greek, *sse* became *ser*, giving us "sericulture," the rearing of silkworms. To the Romans, silk was such a marvel that they named the eastern world, then its source, Seres.

Thereafter the term made its way around the world for a multitude of things. In nature, these range from the Americas' corn silk and the silk-tassel bush (which, as its name implies, has cascading bell-shaped plumes) to the satiny silk-bark, a small evergreen native to southern Africa, and silkwood, the Queensland maple, not only sleek but moderately elastic. There are birds, fish, and insects that have also had the word "silk" added to their names, in each case denoting a brilliantly colored or reflective surface. In the world of commerce, the association of silk with elegance and luxury has been exploited by marketing minds to sell everything from cigarettes to air travel. Most recently, a brand of soy milk and an electronic sketching tool have been named "silk," here suggestive respectively of smoothness of texture and action. All of these examples—and there are many more—reveal the widespread understanding and appreciation of the appearance and behavior of silk.

right Detail of a silk velvet embroidered with silk satin stitch and gilded paper wrapped around a silk core, worked during the later part of the Ming dynasty, c. 1550–1644.

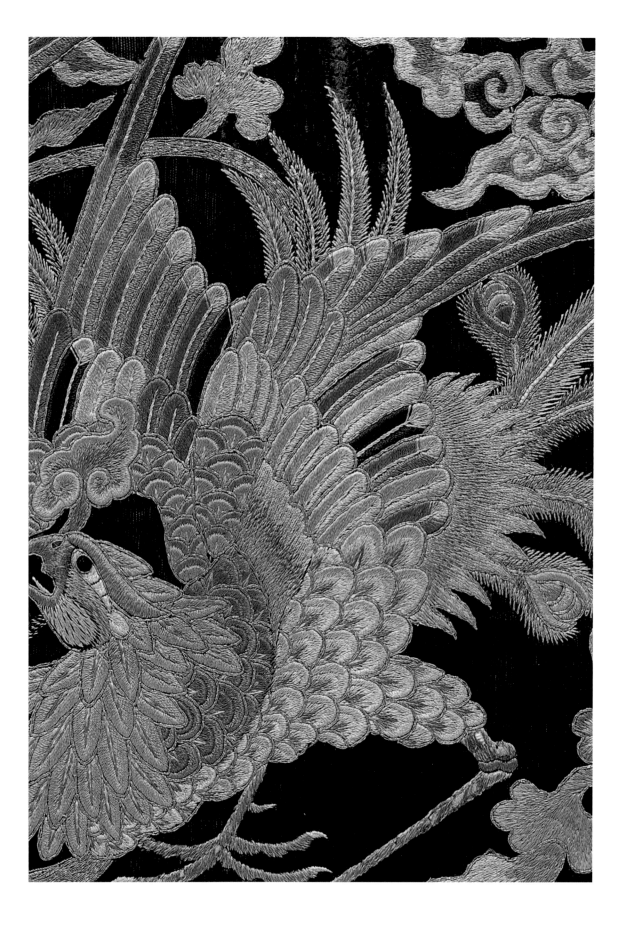

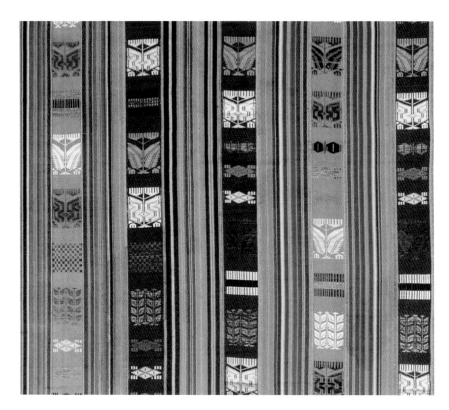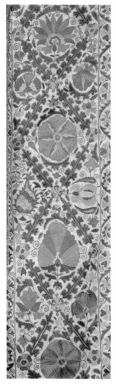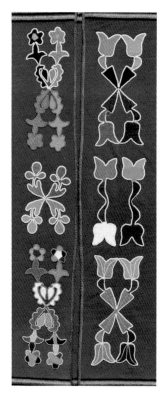

Yet, as the introductory proverb reminds us[1], much may be compared to silk but nothing is its equal. Even after more than a century of attempts to provide an artificial substance replicating its qualities, no single synthetic fiber replicates the entirety that is silk.

The fascination silk still holds for many is partly due to its sheer beauty; but as if this were not enough, its long history is laden with tales of romance and adventure. Take, for example, the legend of the fifth-century prince of Khotan—today's Hetian, on the edge of the Taklamakan Desert—who so successfully wooed a Chinese princess that she risked her life by smuggling silkworm eggs in her elaborate headdress, to establish sericulture in her new domain. This is but one instance of the association of silk with royalty and, in particular, with aristocratic women. Nor is it simply a matter of the wearing of silk finery. For some five thousand years, sericulture itself has had female champions, from the Chinese goddess of silk (Lady Hsi-Ling-Shih, wife of the mythical Yellow Emperor) to Japan's Empress Michiko, who today continues once annually to feed silkworms and harvest cocoons, as a symbol of her predecessors' traditional command of the secrets (as they once were) of silk rearing.

Unique to silk, too, is its rightful claim as one of a handful of commodities that have shaped world history. Fifteen centuries of global exchange not only caused designs to disperse both eastward and westward but also resulted in the transmission of technologies and ideologies and even the migration of groups of people.

As a carrier of cultural influences, silk was further embedded into transactions between diverse cultures through its three-thousand-year role as a currency. Today's banknotes owe much to this practice and, in particular, to the Mongol leader Kublai Khan. It was during his rule, from 1260 to 1294, that paper money began to circulate widely; his first note, the *sichao*, or silk note, was backed by silk, which in turn could be exchanged for silver.[2] In this way, the modern concept of commerce became viable. Some six hundred years later, the sheer value of silk played a noteworthy but nearly forgotten role in the completion of North American transcontinental railroads, which were intended partly to serve as a "land bridge" between the Orient and Europe, for the transportation of tea, raw silk, and silkworm eggs. The trains that carried these goods were arguably the first for which high-speed engines were vital; silk cargo carried an insurance premium for each hour it was in the railroad's possession, to offset any downward turn in the market value at its destination, New York. "Silk trains" ran across the United States and Canada until about 1935, when the price of silk on the American National Silk Exchange dropped from about $7.50 per pound to $1.25.[3]

Along with its monetary role, silk has for centuries played a key part in military matters. The significance of the silk routes, which were developed over the period between c. 650 and 100 B.C., has never been lost on military strategists, for the defense of these lucrative routes also secured passage for armies. Not surprisingly, then, the

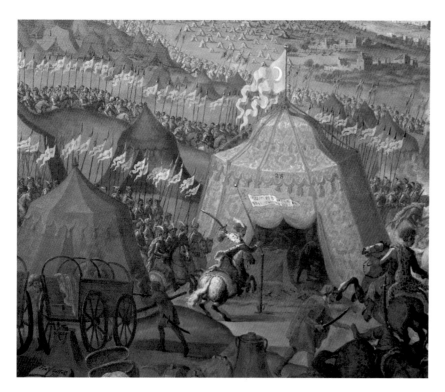

above Silk tents, flags, and caparisons dominate this scene from the Second Seige of Vienna, fought nearby at Kahlenberg on 12 September 1683. Painted by Franz Geffels, it records the defeat of a numerically superior Ottoman force by the troops of King Jan III Sobieski of the Polish-Lithuanian Commonwealth, and the Habsburgs and their allies, led by Charles V, Duke of Lorraine.

right This sweetmeat purse of c. 1600–30 was worked in silk, using tent stitch (*petit point*), by a skilled British amateur. Sometimes used as decorative sachets, such purses were filled with powdered rose petals, perfumed batting, or fragrant lavender.

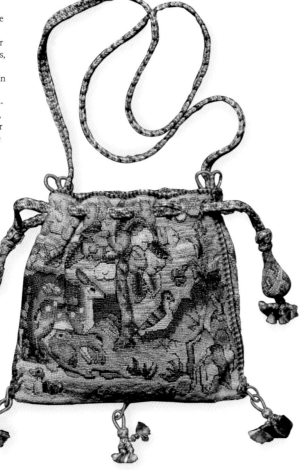

trade route through the pivotal point—the Caspian region—provided a strategic bridge for Alexander's armies in the early fourth century B.C. Indeed, the control of the silk trade and sericulture has long been recognized as a motive in itself for territorial aggression, particularly in this part of the world, where sericulture was established by the Sassanid Persians shortly after A.D. 272. Subsequent rulers, from the Mongols, the Mughals, and the Ottomans to, more recently, the Soviets, maintained both sericulture and military strongholds there.[4]

On a more personal level, silk's strength and its ability to carry vivid color made it the warrior's choice, for protective garments and tents, as well as for pennants and flags, which were essential to identify friend and foe. It remained a military material into the Second World War; and although parachutes ceased to be made of silk soon afterward, the phrase "hit the silk" still remains current among sky-divers. And silk continues to interest the military—now in the form of spider silk, which has a tensile strength of potential value in many applications.

However, silk is better known for its ceremonial and symbolic value. As a backdrop to diplomacy and an emblem of enduring nations, customs, and institutions, silk remains an unrivaled symbol of power and vitality. This is underscored by the enormous sums expended on silks for the restoration of historic interiors, an activity that sustains a handful of specialist hand-weaving concerns. Among these are Garín, founded in Valencia in the mid-eighteenth century, whose most elaborate hand-brocaded silks require a day's work to produce a mere 22 centimeters (8¾ inches). Aside from their use in palatial settings, these are also still made for important religious occasions. For both their splendor and significance, they are essential, too, for newly made Valencian regional costumes.[5]

Equally, silk has been the stuff of intimacy, from exquisite hand-worked tokens of love and esteem to undergarments both luxurious and practical, being soft, warm, and dry. Notwithstanding their value, silks have also long been cherished as treasured examples of human ingenuity, national pride, worldly sophistication, or spiritual advancement—as exemplified by the contents of the famous imperial "treasure house" in Japan, the Shōsō-in Repository, which was built in the eighth century as a storehouse for the Tōdai-ji Temple, in Nara. Such collections attest to the physical longevity of silk, as do archeological finds, the earliest of which are over 5500 years old. Not content with such evidence, a century ago an historian offered a bizarre anecdote to substantiate this fact, noting that "silk fabric when not exposed is said to have surprisingly durable qualities. We read in Watson's Annals . . . that Gov. Dennis' daughter, after having been buried for 30 years was re-interred and the

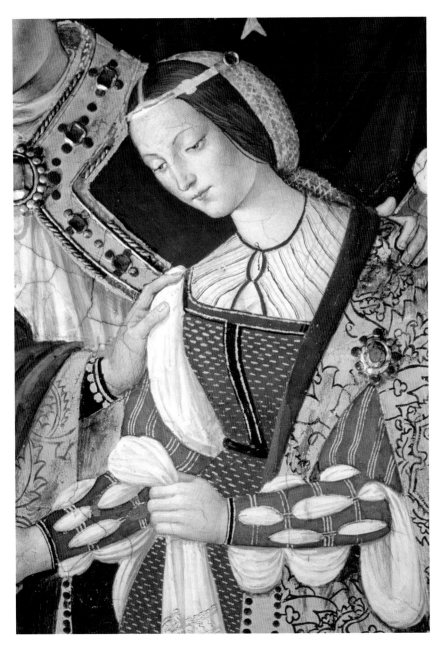

ribbon [found in her coffin] was so well preserved that the grave-digger's daughter wore it afterwards."[6] Luckily, science has long since established less intrusive ways to demonstrate that silk lasts when protected from sustained exposure to light and moisture (and pests such as household moths are not attracted to this fiber).

With such a pedigree, it is little wonder that silk has attracted creative minds throughout its history. Inventors, scientists, and artists alike have contributed to its progress; among these are Leonardo da Vinci, who was an avid researcher in the mechanics of the silk throwing process. One of the most highly innovative machines he designed for the manufacturing of textiles was the winged or fly spindle, executed in about 1500. This device performed stretching, twisting, and winding operations simultaneously on three consecutive stretches of thread, operations repeated as the silk was fed into the machine. Without any important modifications, the winged spindle he designed was the basis for the later development of the continuous spinning machine and is still in use in today's systems for throwing, or silk thread making.[7]

Appropriately, the explanation of throwing and discussions of other aspects of modern silk production in this book have been generously provided by several Italian silk scientists. These include Gian Maria Colonna, Giuliano Freddi, Maria Rosaria Massafra and Bruno Marcandalli, Director of *Stazione Sperimentale per la Seta* and Professor of Chemistry and Technology of Coloring Substances at the *Università dell'Insubria* (Como), who coordinated this material. The discussion of sericulture in the following pages was contributed by Silvio Faragò, comments on the text came from Dr. Flavio Crippa, an authority on textile technology, and the chapter on the future of silk is by Professor Marcandalli.

The remainder of this volume outlines silk's history, use, and characteristics, showing how its manufacture and significance have survived by adapting to economic and social changes. Most recently, for example, the search for environmentally friendly fibers and cloths has attracted further attention to silk. In addition, by embracing technological innovation and providing a material of excellence for haute couture and textile artists (as illustrated in the concluding section), silk has entered a new and exciting phase, which, with da Vinci in mind, might rightly be called its own "renaissance."

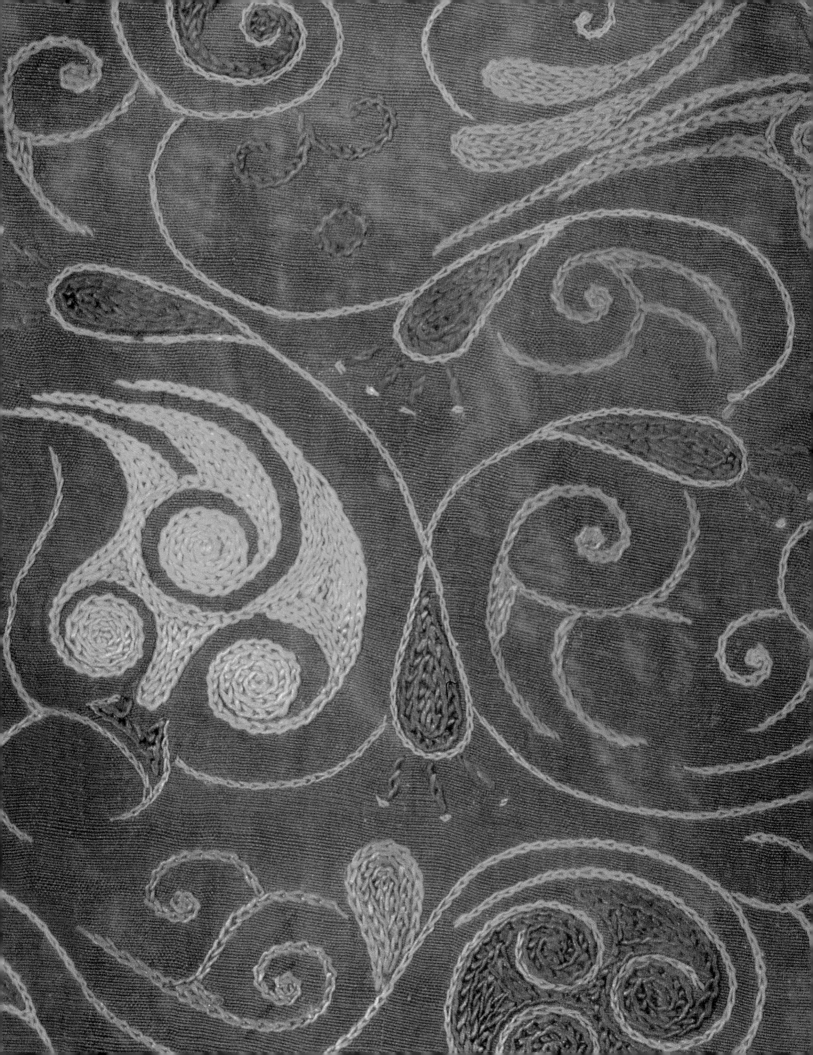

Silk in History

The silk craft is a very noble art, worthy of being plied by any true gentleman, for gentlemen are the ones who use silk…it has its own court of law that administers justice without anyone who interferes, and it enjoys many exemptions and very great privileges, and deservedly so because it is a craft that exalts the rich and helps the poor; and great skills are needed to ply it.

LEONARDO FIORAVANTI, SIXTEENTH-CENTURY ITALY

opposite Chain-stitched cloud motifs in vividly toned silk threads adorn this Western Han dynasty silk, which has been carbon-14 dated to between 151 B.C. and A.D. 121. Similar embroideries, also containing the circular motif, probably denoting the sun, have been excavated over a wide area, from Mongolia to the tomb of the king of the Southern Yu Kingdom in Guangzhou, Jiangsu province.

Among all textile fibers, silk reigns supreme. It has been coveted ever since the late Stone Age, when silkworms began to be cultivated in China for the gossamer strands contained within their cocoons. A substance of great value, and hence a symbol of status, silk has from earliest times partaken of an almost mythical quality, thanks to the seemingly magical creation of this most luxurious of threads by creatures related to household moths. Although the silkworm native to China, *Bombyx mori*, has never relinquished its role as the world's greatest producer of silk, the secrets of silk production long ago spread beyond China. Elsewhere, too, other species of silkworm were cultivated, and by about 1850 the story of silk had encompassed the globe. In the first section of this book we explore this history, tracing the movement of trade goods and examining the importance of status-laden gifts of silk and the great civilizations and royal courts that prized this finest of natural fibers.

Ancient silks

To conjure up the world of some six thousand years ago, in the age known as the Neolithic, one must imagine small communities employing little more than stone and stick tools to serve their needs. Yet weaving implements already existed, and among the precious fragments of cloth to survive from that time are Chinese silks. The earliest surviving cloths made from the gossamer-thin filaments produced by *Bombyx mori* are fragments dated to about 3630 B.C., and come from the Henan province, in east-central China. Earlier still, an ivory bowl of about 4900 B.C., carved with images thought to be of silkworms, suggests that the silkworm had been domesticated on the east coast of China, at Hemudu. It is in these areas—from the eastern coast near modern-day Shanghai, extending to the northwest, beyond today's Beijing, a distance of some 1,461 kilometers (908 miles), that artefacts attest to the widespread manipulation of cocoons and silk during the Neolithic period (c. 5000–1700 B.C.). Among these finds, the best to date come from Wuxing Qianshanyang, not all that far from Shanghai. There, silk threads, a braided silk belt, and a piece of woven silk were found, dated to approximately 2570 B.C.: "The piece of woven silk, on investigation, has been shown to comprise warp and weft yarns of straight, smooth, untwisted silk fibers reeled from at least twenty cocoons. The fragment is small—2.4 by 1 centimeter—but with a warp density of fifty-three threads per centimeter and a weft density of fifty-nine, it is close to the specifications of some modern silk fabrics in its compactness."[1] Although such finds are small and hardly glamorous, they testify to the sophistication of cultures such as the Hemudu and its successor, the Liangzhu, both of which also produced objects in fine jade and polished pottery.

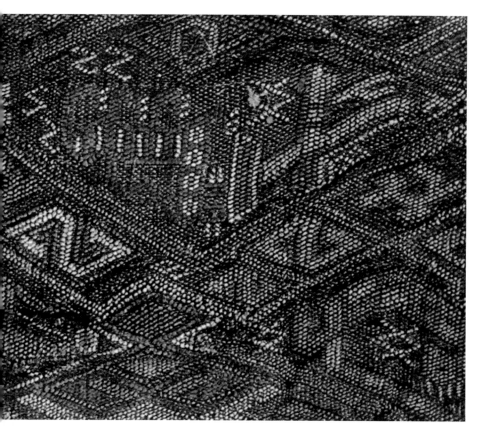

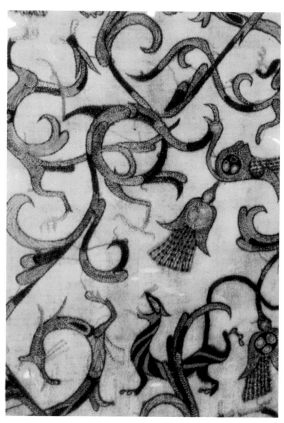

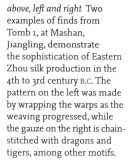

above, left and right Two examples of finds from Tomb 1, at Mashan, Jiangling, demonstrate the sophistication of Eastern Zhou silk production in the 4th to 3rd century B.C. The pattern on the left was made by wrapping the warps as the weaving progressed, while the gauze on the right is chain-stitched with dragons and tigers, among other motifs.

opposite Dating from about 170–140 B.C., these painted wooden figures from the tomb of Lady Dai, Changsha, illustrate the appearance of silk robes during the Han dynasty.

More than two thousand years pass by, leaving behind only small pieces of silk and other evidence of its production—too little to allow concrete interpretation but enough to pique the curiosity of scholars. For example, speculation continues about the significance of finds at Sapalli-tepe, in modern-day Uzbekistan, where four Bactrian graves of c. 1500–1200 B.C. contained skeletons wrapped in silk garments. Were these items carried by the nomads who we know were in contact with China at this early date? Made locally from Chinese silk? Or made from another kind of silk entirely? The one thing we do know is that the prestige of *Bombyx mori* silk during these millennia cannot be doubted. It is found amid excavated royal burial grounds associated with the Shang dynasty (c. 1500–c. 1050 B.C.) and the Western Zhou (c. 1050–771 B.C.), and is already, by at least as early as about 1100 B.C., being interwoven with small geometric patterns, dyed in rich colors such as purple, and produced in a variety of weights, including a light open-weave known as gauze. From the same date comes the earliest evidence of chain-stitch embroidery, worked with silk threads.

A tantalizing glimpse of life among the Western Zhou elite survives in a fragment of scarlet silk, both embroidered with yellow silk floss and painted. Songs and poems from this period, recorded in the *Shi jing,* or "Book of Odes," document not only silkworm rearing

and weaving (as women's work) but also garments of silk, vividly toned and richly patterned and embroidered.

Other luxuries could be obtained by bartering with silk. The first reference to silk as currency—a role it was to retain well into the second millennium A.D.—is an inscription recording the exchange of Zhou silk for horses from the northwest plains.

The move of the Zhou capital eastward marks the beginning of what is known as the Eastern Zhou dynasty (771–221 B.C.), and excavations from this period are the first to illuminate silk production in south-central China, in the present-day states of Hubei and Hunan. These finds are not only more numerous but also more advanced technically. The finest of the Hubei tombs include one (c. 433 B.C.) for the Marquis Yi of Zeng, containing 234 silk fragments, and another (of the fourth or third century B.C.) for a noblewoman of lesser rank. The latter, at Maschan, in Jiangling, surrendered the earliest known complete examples of formal attire. Many of the articles of clothing on the body were quilted: two outer garments, trousers, and thick shoes. These, like the body's inner garment, skirt, and belt, were all made of silk. Miniature versions, also of silk, clothed the seven accompanying wooden burial figures. Among other items, the coffin contained a braid-bound parcel of thirteen layers of silk clothing covered with a gown and a quilt decorated with additional embroidery.

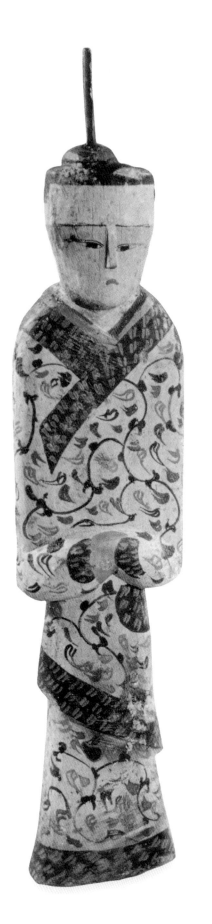

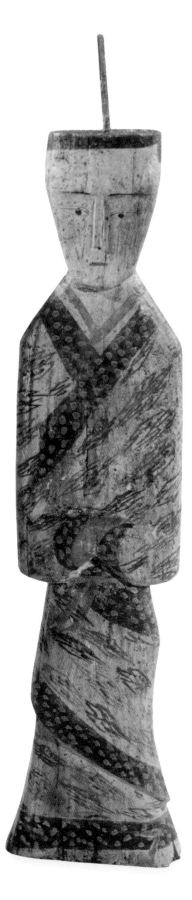

Whereas Marquis Yi's tomb had preserved predominantly plain, or common-weave, silks, some gauze, one embroidery—the design depicting a two-headed dragon—and lozenge-design "brocades" (here meaning interwoven with multicolored patterns), this opulence was surpassed by the possessions of the lady of Maschan. In addition to plain weaves, gauze, and embroidery, her tomb contained various other types of woven and embroidered silk, including leno, *qi*-damask, braid, and cross-knitted cords, as well as a full spectrum of colors. Cinnabar red dyes, malachite greens, indigo blue, black from acorn cups, and yellows from the pasture weed, *Arthraxon hispidus*, were rendered more brilliant in effect by, in the case of the embroideries, being worked on a gleaming silk ground tinted white with concoctions of lead or clamshell powder. The woven patterns are also more elaborate, intermingling images of dancing figures, dragons, and other beasts among geometric motifs. The complexity of such patterns not only surpasses those found on any earlier extant silks but also demonstrates that an advanced loom was used.[2] With patterning rods and shafts, and operated by several people, this treadled pattern-rod loom, later developed into what in China was known as the pattern-frame loom (and elsewhere as the Chinese draw loom), provided the mechanism for the even more intricate weaves for which China was soon to became renowned.

Both of these Eastern Zhou tombs were created in the Warring States period (475–221 B.C.), so named for the breakup of ancient China into rival states. This political instability characterized the entire Zhou period. For example, their eastward relocation in 771 B.C. had occurred because raiding northern nomads had finally conquered the first Zhou capital, founded after the Zhou had moved some 275 years earlier, when gifts— including silks—had not deterred marauders. Considering this fragmentation of China, and the resulting migration of its workforce, it is not surprising that Zhou rule coincides with the appearance of sericulture in regions beyond China, including modern-day Thailand and Vietnam, in Indochina to the south. For example, in northeast Thailand, the excavations in Ban Chiang included unwoven and undyed silk threads that, through association with other grave goods, are dated to 1000–500/300 B.C.

In the Indian subcontinent, oral history of the Vedic period (1700–500 B.C.) recorded in the *Mahabharata* that the "Chinas and the Hunas from the mountains [the Himalayas] brought tribute to Yudhistira, silk and silkworms."[3] Aside from a lone bead-thread from Navesa (1500–1050 B.C.), in central India, composed of an undetermined type of silk,[4] no tangible evidence

below Lady Dai's tomb contained both complete garments and lengths of silk. This design, chain-stitched on a plain silk ground, was also found embroidered on a gauze robe; its stylized cloud form is known as *xinqi*.

opposite The mallow flower motif was a favorite during the Warring States and Western Han periods, 475 B.C.–A.D. 9. Here it is shown in a detail of a complex gauze weave from the mid-2nd-century B.C. tomb of Lady Dai.

survives to quell the debate as to whether this passage—linguistically dated to the fourth century B.C.[5]—refers to "mulberry silk," meaning that produced by China's *Bombyx mori*, or to one of the undomesticated, or wild, silks for which India later became known. At any rate, India's acquisition of mulberry silk, which some scholars place in the early 300s A.D. and others as late as the Delhi Sultanate (thirteenth–fifteenth centuries),[6] was not the first time—and certainly not the last—when social change and upheaval transmitted prized silk-related skills to other lands. Earlier, and far to the northeast, silk rearing and weaving are said to have already spread from China to Korea during the transition from Shang to Zhou dynasties in about 1000 B.C. (although some authorities date this transmission to the end of the Warring States period).

Whatever the truth as to how and when the cultivation of *Bombyx mori* began in these other lands,

it is undisputed that China developed the first thoroughly organized silk industry. Royal and private workshops were established there from the Warring States period (if not earlier). Later developments include the standardization of widths—begun under the Zhou and made comprehensive during the short-lived Qin dynasty (221–207 B.C.)—and the use of silk for payment of taxes, a practice begun in a small way at the end of the Western Han dynasty period (206 B.C.–A.D. 9) and subsequently extended. It was under the Han that governmental control became far-reaching, and the resulting volume of tax revenues paid in silk had the effect of increasing the amount of silk in general circulation among classes other than the nobility. Much is known about Han silks, partly from surviving documents—many of these written on paper made from silk and linen, which can be dated to at least as early as about 100 B.C.[7]—and partly from surviving

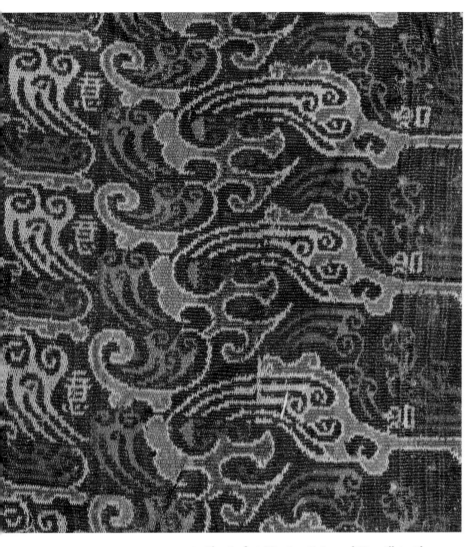

textiles. In fact, Warring States and Han silk textiles form the largest body of extant fabrics of this period, and of any fiber, found anywhere on the globe. Significant "firsts" among the Han finds include cut pile (and thus the earliest known paradigm for silk velvet weaving), satin-stitch embroidery, and printed silk— all from the tomb of a noblewoman, called Lady Dai, at Mawangdui, in the city of Changsha, and dated to about 170–140 B.C. By about this time, the making of silk in China had already become well established enough to provide a surplus; raw silk, processed— or "thrown"—threads, and woven cloths began to be exported in a systematic fashion.

Vital to this expansion was the existence of the spindle wheel, which had been developed for bast (woody plant) fibers and subsequently adapted for silk during the Zhou period. Since *Bombyx mori* silk needs no spinning, this wheel, which merely twists the thread, should not be confused with the spinning wheel, which creates thread from short fibers. The invention of the

latter, at some point after 500 B.C., is credited to India, where, although not essential, it made the processing of wild silks (as well as cotton fibers) much more efficient.

Concurrently with the diffusion of *Bombyx mori* silk rearing to other lands, the production of wild silk also developed in various parts of the world. There are many different types of wild silk, including several indigenous to China and regions to its north; one form is that produced by *Antheraea pernyi*, the source of a purple-dyed wild silk fragment found in northern Mongolia and dated to about 120 B.C. Threads of wild silk dated much earlier (c. 1070 B.C.) have been discovered in Egypt and among the Hallstatt graves of 600–500 B.C. unearthed in modern-day Austria. Among the latter examples (thought by many to be of mulberry silk[8]) are some resembling silk finds of c. 700 B.C. from Phrygian Anatolia, where proximity to the Aegean island of Cos suggests Coan silk, which was made from the cocoons of the wild *Pachypasa otus* moth. Nearby Syria also had its own wild species. This multiplicity of sources leaves in question the ultimate source of many early western finds, rare though these are.

However, in Kerameikos, Greece, are fifth-century B.C. finds that are agreed to be of Chinese *Bombyx mori* silk, including a fragment of repp-woven cloth embroidered in red and a skein of red-dyed threads.[9] In the Altai Mountains of Kazakhstan, at the Scythian site of Pazyryk, excavations of stone burial mounds, or *kurgans*, produced figure-woven and plain Chinese silk cloths, one decorated with chain-stitch embroidery, also dating from 500–400 B.C. Other kurgan finds revealed textile techniques associated with Anatolia and Syria, and thus carried there on an eastward journey.

One way in which silks may have circulated at this period was via the Persian Empire's "Royal Road," which ran some 2,800 kilometers (1,740 miles) westward from Susa (located on the lower Tigris, in the center of the empire) to Smyrna (today, Izmir, in Turkey) and the Aegean Sea. There, several eastern Mediterranean ports had already established themselves as pivotal centers in a textile trade that extended as far north as Britain and south to the Indian Ocean. Silk was not yet a primary cargo in this seaborne trade, yet Etruscan and contemporaneous fifth-century B.C. finds in Altrier, Luxembourg, indicate that silk of some description was indeed in circulation in Europe.

Although an ancient route, the Royal Road was not maintained and protected until the Achaemenid Persian Empire (648–330 B.C.) established (rather like the much later American Pony Express) "postal stations and relays at regular intervals. By having fresh horses and riders ready at each relay, royal couriers could carry messages the entire distance in 9 days, though normal travelers

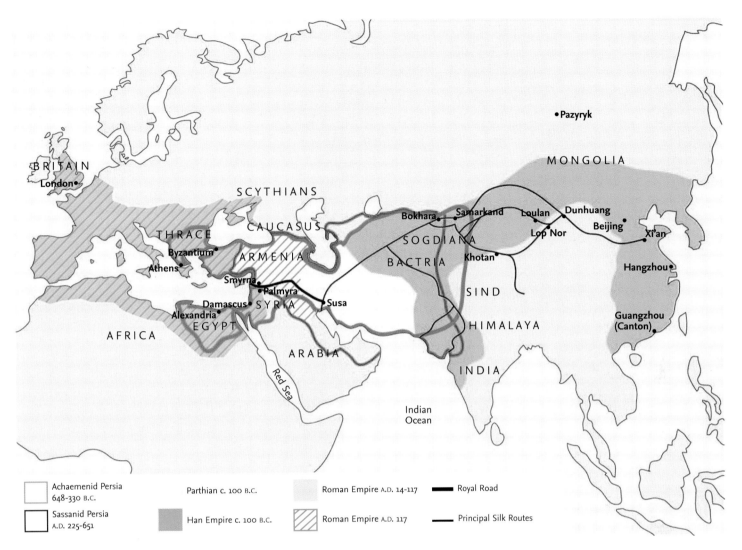

▢ Achaemenid Persia 648–330 B.C.	Parthian c. 100 B.C.	Roman Empire A.D. 14-117	▬ Royal Road
▢ Sassanid Persia A.D. 225-651	Han Empire c. 100 B.C.	Roman Empire A.D. 117	── Principal Silk Routes

above Shown here are the Achaemenid Persian Empire, 648–330 B.C.; the Han Empire c. 100 B.C.; the Roman Empire, A.D. 14–117; and the Sassanian Persian Empire, A.D. 225–651, together with the Royal Road and major silk routes.

took about three months."[10] Between Susa and China there was as yet no equivalent road. Then, in 138 B.C., diplomatic contacts with peoples on the western border of China were established by the Han emissary and explorer Zhang Qian. By about 112 B.C. annual missions to accomplish the westward expansion of Han territory not only carried vast quantities of silk, with which to bargain, bribe, and befriend, but also had made contact with more than thirty tribes and kingdoms. Horses from central Asia, of a type now extinct but immortalized by Han and later Chinese artists, were returned with envoys from Ferghana, Sogdiana, and Bactria (in modern-day Uzbekistan and northern Afghanistan) and from Persian Parthia (150 B.C.–A.D. 224), which at its height stretched from Armenia to northern India. In a manner that established the pattern of international exchange for centuries thereafter, each caravan made only part of the journey. The need for secure resting places created or greatly expanded trading centers such as Khotan, in the southwestern Taklamakan Desert, and Samarkand,

in Sogdiana. Eventually, sericulture and silk weaving were to blossom in each of these areas, the first being Khotan in the mid-first century A.D.

Dubbed the "Silk Road" in the latter part of the nineteenth century by the Austrian geologist-turned-geographer Ferdinand von Richthofen, the more aptly named "silk routes" were various relatively protected land routes going westward from the Han capital (at modern-day Xi'an, Shanxi province). Trading in *Bombyx mori* silk reached as far as Rome, and beyond to Africa, and became embedded in the rituals surrounding territorial expansion, the garnering of loyalties, and the rewarding of allies. Chinese traders, skirting the Taklamakan Desert to its north or south, might go as far as Loulan, at the eastern end of the desert. From there onward, middlemen traded goods procured in the west for items, including silks, coming from the east. Sogdians, Kushans (whose empire included Bactria), and Parthians (whose battle banners were the Romans' first sight of silk, in 53 B.C.), carried

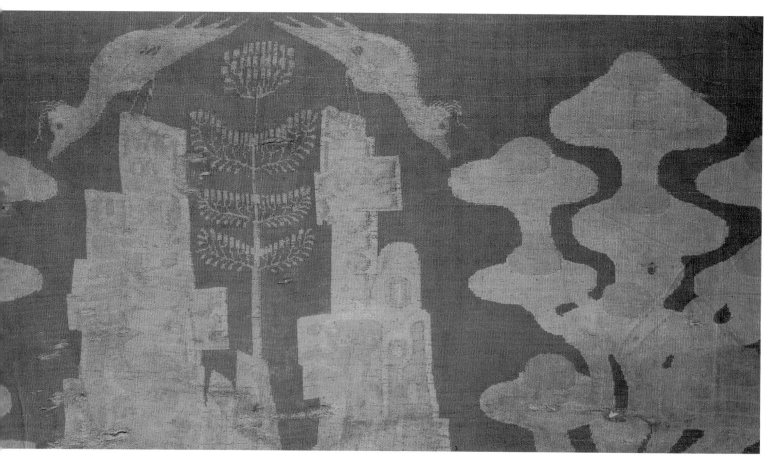

above This fragment of Chinese silk dates from the 1st century A.D. and is one of the oldest known pictorial loom-woven silks. It found its way westward from China to Noin-Ula, where it was probably an official gift or peace offering to the ruling Hun.

opposite A detail of a silk woven in Sogdiana or Sassanid Persia in about the 6th century A.D. shows Pegasus, the winged horse often found in Sassanian decoration. Its weave structure, a weft-faced compound 1:2 twill, was unknown in China before the 7th century.

Bombyx mori silk to Syrian and Greek merchants. The Kushans, followed by the Parthians, also had access to the Arabian Sea, via their control of lands around the Indus River, allowing goods to flow south to India's western seaboard, where Egyptian ships traded.[11]
All of those involved extracted good profits, making silk equal in value to gold by the time it reached Rome. Many of the silks making the journey were unprocessed and unwoven threads, or plain and very simple weaves, but elaborate Han cloths were also carried westward and have been unearthed in locations ranging from the northern Mongolian royal burials at Noin-Ula (c. 100 B.C.–A.D. 100) and the slightly later cemetery at Niya, the best preserved and one of the largest ruins of the Silk Routes' city-states, located at the southern tip of the Taklamakan. Here were found Eastern Han silks (A.D. 23–220) with inscriptions intermingled with images of clouds and beasts; of the same period are finds from Palmyra, Syria, also interwoven with calligraphic inscriptions.

The end of the Han period, in A.D. 221, almost exactly coincided with the rise to power of the Sassanid Persians, who in c. 224 became the second nomadic tribe to control the lands from western Iraq to central Asia. From the defeated Parthians they inherited a tradition of weaving Chinese silk threads; and it may have been in Syria, which they controlled from 241 to 272, that they acquired knowledge of the western draw loom and of sericulture. (Chinese history records the use of domesticated mulberry silkworms in Syrian Antioch—now Antakya, Turkey—when it was still part of the Eastern Roman Empire.[12]) With the loss of Syria, the Sassanians established sericulture in their Caspian satrapies, or provinces. Under Sassanid rule, weavers in Persian imperial workshops began producing pictorial silks, which were subsequently to influence the design of textiles from Spain to Japan.

Having become the eastern terminus of the silk routes during the early Eastern Han period, Japan took another step forward in the silk trade at the end of the Han period by establishing its own sericulture. Despite this, and the other developments to the west, Chinese silk production continued to flourish and expand; the southwest became known for its polychrome patterns (sometimes called "brocades" but different from a western brocade)[13]. Official workshops in the southeast increased by tenfold, and it was here, in A.D. 353, that the calligrapher Wang Xizhi penned his famous work, Lanting xu, establishing calligraphy in ink on silk as the means of creative and official expression for the

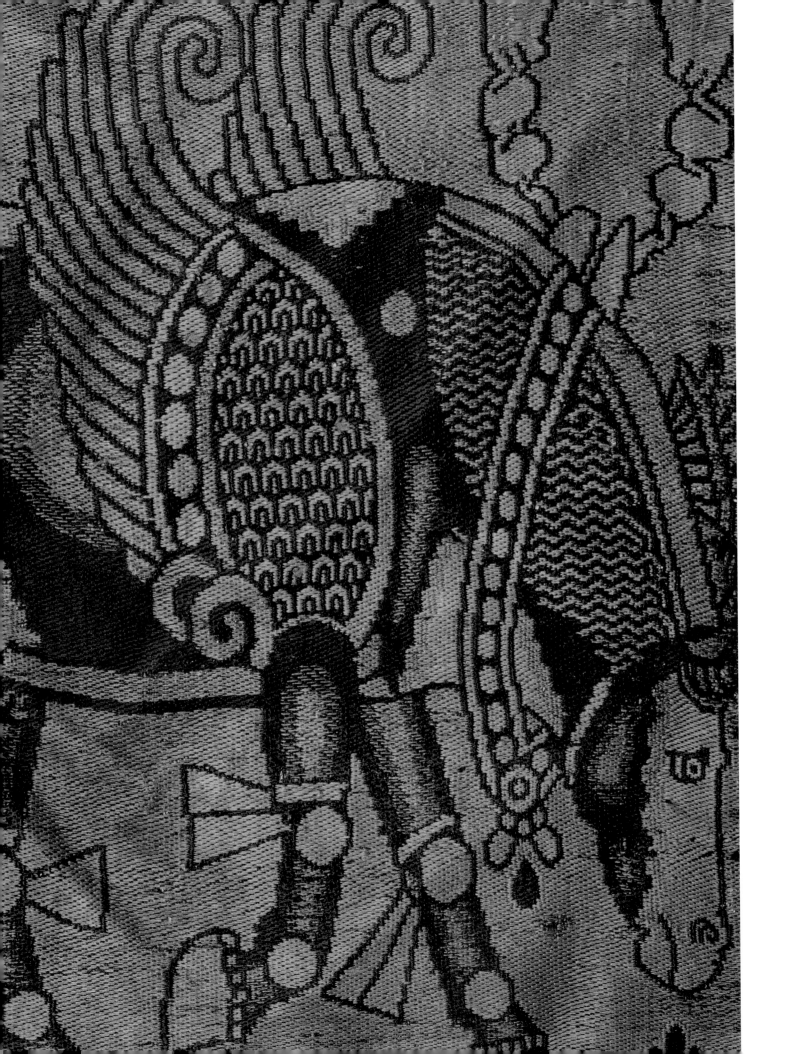

following seven centuries. Not long afterward, silk production mushroomed in northern China, in Northern Wei dynasty workshops.

Meanwhile, the Sassanians were growing rich on the tolls charged to traders of silk, making it so costly that in about A.D. 240 the Egyptians, who imported silk from both Syria and Persia, began to obtain it directly from China, sailing there by way of their established Indian route. They continued to do so for another two hundred years.

In the story of silks in this period, one often-retold episode asserts that silk production in the Mediterranean began in 553, with the introduction of sericulture to Constantinople from central Asia by two Nestorian monks. It is said that this countered Sassanid Persia's monopoly on the most prized silks, against which heavy duties had been imposed early in the sixth century by the Byzantine emperor Justinian.[14] However, a history of the later Han Dynasty (written in the fifth century) "recorded that the Roman empire had a flourishing sericulture and that people wore

embroidered silks. . . . If the Chinese thought that sericulture was already established in the Roman empire, there was no point in keeping its technology a secret."[15]

The tale of the monks overlooks the existence of sericulture in Syria, then (and until 661) part of the Byzantine Empire.[16] There was certainly enough silk thread available through imports and local production to sustain the imperial workshops established in Constantinople, Syria, and Egypt during the fourth century. However, Byzantine chronicles do record an increase in sericulture during the sixth century, allowing a flourishing of private workshops outside Constantinople, such as those noted at this time in Tyre and Beirut. Certainly, by the fifth century A.D. the complexion of the silk trade was changing rapidly. Political disarray was widespread all along the silk routes, severely disrupting the supply of Chinese silks until this region was reunited by the Tang in 618. Meanwhile, what can be seen as an independent eastern Mediterranean silk industry had been born.

below This map shows the extent of Khazaria c. 850, the Late Abbasid Caliphate c. 900, Byzantium c. 1025, the Seljuk Turks c. 1100, and the Mongolian Empire c. 1294.

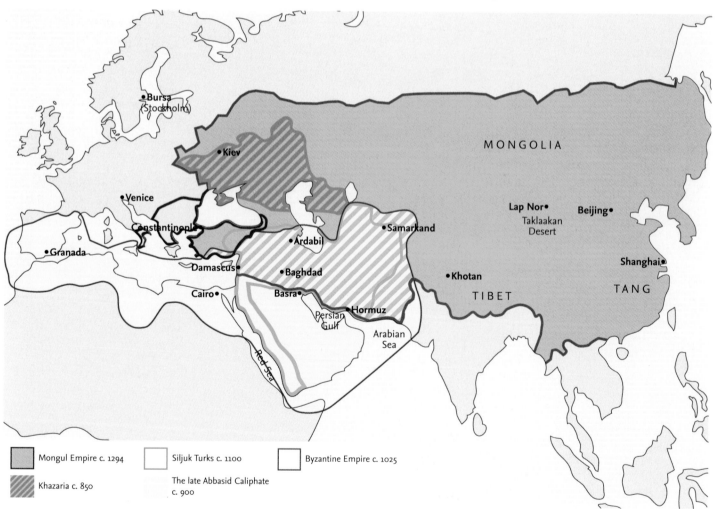

Mongul Empire c. 1294

Khazaria c. 850

Siljuk Turks c. 1100

The late Abbasid Caliphate c. 900

Byzantine Empire c. 1025

Diffusion

Throughout most of the Middle Ages, Constantinople (now Istanbul) was the largest and wealthiest city in the world. Founded in the seventh century B.C. by the Greeks, who named it Byzantium, it was established as the second capital of the Roman Empire in A.D. 330 by Constantine the Great, who renamed it after himself. As the western part of the Empire declined—Rome itself falling to Visigoth invaders in 410—Constantinople flourished. Capital of the Eastern Roman Empire (subsequently called the Byzantine Empire) and the first great Christian city, it was also the world's leading commercial center, thanks partly to its location astride the Bosporus, the strait separating Europe and Asia. Through Constantinople crossed land and sea routes on which depended the wealth of western Asia and the eastern, or Levantine, Mediterranean. Until it fell to the Ottoman Turks in 1453, the city withstood invasion from nearly all quarters (apart from a period, from 1204 to 1261, when it was held by Crusaders).

Constantinople's commercial success was closely interlinked with its manufacture and deployment of silks. Although Byzantine silk production is now known more through records than through surviving cloths, there is little doubt that the city acted as both a nursery and a conduit for designs and weaving practices that—in their brilliance of color, use of gold threads, and style of pattern—characterize the millennium during which this city served as the capital of the Byzantine Empire.

As was the case in China, Byzantine legislation determined that the finest silks were solely for the use and disposal of the court. The application of colors was also codified, giving Byzantine imperial dye works a monopoly on the application of murex purple. This expensive shellfish dye, prized for its rich shades of purple, had already been used in Syria and elsewhere in the Levant for about two thousand years; but under Byzantine rule it became especially associated with the nobility. As a consequence, purples were widely imitated with other, cheaper dyes, even in official workshops. Purple also signified nobility among some Middle Eastern tribes. By contrast, under the Tang dynasty (618–906) comprehensive regulations made yellow exclusive to the imperial robes of the emperor, who otherwise wore purple, as did officials occupying the three highest levels in the bureaucratic hierarchy. Lesser officials were clothed, in descending order of importance, in crimson, green, and black. This was a reversal from the previous relegation of purple and crimson to the lowest status (because these deviated from pure Chinese red, or vermillion, a pigment used in painting and calligraphy) and presents the tantalizing possibility that this relatively new taste for purple in

the Chinese court was one of the effects of the contact between east and west facilitated by the silk routes.

The patterns emanating from Byzantine workshops were also emblematic of power—and of universality and longevity—not least because many depicted strong and swift beasts of the type admired by military lords and often adopted as royal and civic insignia. Characteristically organized within a decorative roundel, these motifs were indebted to Sassanian silks, in which hunting and oasis scenes incorporated "tree of life" imagery, winged horses, lions, and other imaginary and real animals. Fate did not favor the survival of any such silks within Persian territory, with its continual wars, but these survived elsewhere, in dry climates such as that of Egypt, or entombed with European rulers and saints. They are identified by comparison to Achaemenian, Parthian, and Sassanian imagery in other decorative arts and in architecture, but are not considered to be earlier than about 250 because the weaving itself required a complex loom of the type acquired by the Sassanians from Syria. In such cloths, often called *samitum*, the different-colored wefts that create the pattern almost entirely cover the warp. This is the first loom-woven cloth construction to rival the pictorial capacity of embroidery and tapestry, and it is based on the twill weave. Samitum and other twill weaves also typified the products of Byzantine workshops.

Although by 651 all of Sassanid Persia had fallen to Islamic forces, its designs lived on. Textiles were traditionally a significant part of the Arab "tented" life; and they continued to be so under the caliphs who now ruled Persia and Mesopotamia (roughly modern-day Iran and Iraq) and soon would rule Syria, Palestine, and Egypt and, a century later, North Africa, southern Iberia, and other territories extending over south-central Asia as far as modern-day Pakistan. In the Muslim world there was never a single ruler, and as divergent caliphates established control in different areas across this vast region, indigenous textile traditions were enfolded. Despite some caliphs' interdiction against representational imagery, and the general Islamic taboo against religious images, Persian arts (which did contain images of humans and animals) remained influential, especially after 767, when the Abbasid dynasty of caliphs founded their new capital in Baghdad, not far from Susa. In this region, called Khuzistan, previously established silk weaving was well maintained. Across Arab states, silk production increased. No attempt was made to limit the circulation of cloth, and even commoners could obtain half-silks (typically with a cotton weft) from Persia and linen with tapestry-woven silk borders from Egypt: "Even whole silk garments were more readily available in Islamic countries than in Byzantium and Christian

below With its animated rendering of a hunting scene and decorative roundel, this silk typifies those often woven in Byzantium. Its imagery, symmetrically disposed on either side of a central vertical, indicates that it was woven on a draw loom; it dates between 450 and 850.

opposite This central Asian silk samitum, or weft-faced compound twill, has been carbon-dated to 653–828. The motifs are based on Persian imagery but the use of these five colors and the formality of the design are typical of Sogdian silks.

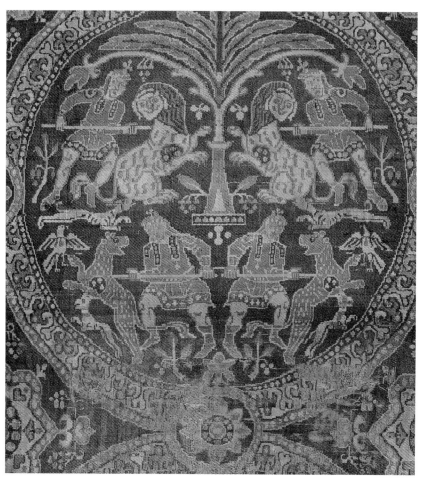

Europe. In fact, silk was so common in Islamic countries that a certain gentleman in Cordova, Spain, clothed his slave girl in brocade and tiraz silk and Jewish traders ordered silk garments for their religious festivals."[1]

"Tiraz," meaning embroidery, came to denote any Islamic textile with an embroidered or inlaid tapestry inscription, as well as the caliphate workshops (*dar-al-tiraz*), some of which worked only for the court (*khasa*) and others for general sale (*amma*). Tiraz functioned as a social contract, being distributed from the caliph as patronage as well as given back in lieu of taxes and as tribute. Silk played an essential role in this sign of fealty, not only for its lustrous presence in cloths often also laden with gold threads, but as a symbol of Islam itself. At Mecca, the shrine of Muhammad, the Ka'ba, is covered by a black silk cloth, embroidered in gold with passages from the Koran. This cloth is renewed annually, and pieces of the old one are distributed to pilgrims. Its format perpetuates a tradition dating back to pre-Islamic Egypt, where Coptic Christian weavers included Greek inscriptions in wool tapestry borders, which were inlaid on linen cloths; under Islam, this custom was reinterpreted, with inscriptions worked in silk.

The change from wool to silk (especially associated with tiraz during the two centuries of Fatimid rule from 969) was as emblematic of new loyalties as was the substitution of Arabic for Greek. Thousands of tiraz have survived. Those made in Sunni regions bear richly colored and intricate abstracted patterns, but where the Shia branch of Islam took root—notably in Persia—old pictorial traditions often prevailed. This can be seen, for example, in the realistic imagery in the so-called "Shroud of Saint Jesse," preserved for centuries in a Parisian church. Woven in Khorasan (northeastern Iran) in about 950, it depicts large confronting elephants; one border carries the inscription and the other a series of camels linked caravan-style.

Persian motifs also travelled beyond the borders of Islam. Sogdian merchants, (from the loose confederation of states that included formerly Sassanid Samarkand and Bokhara) had already distributed them in central Asia and, through the favor they enjoyed among the Turkic Uighurs, eastward. During the fifth and sixth centuries, Sogdian variants of Persian designs (and Chinese silks with related patterns) were similarly being exchanged along the silk routes; examples of these have been found in excavated oasis sites along them, including Dunhuang, Khojo, Turfan, and Dulan.[2] Wall paintings of the late 500s, depicting the more geometrized roundel motifs typical of Sogdian work, were preserved in the Khotan oasis, a pivotal point from which silks were carried south to India. There, this exchange is known almost entirely through documentation; but not so in Tibet and China. In Tibet, so many silks survive that it has been described as "a vast storehouse" of textiles.[3] A Tibetan royal child's silk coat (c. 600–842) illustrates the magnificent effect of Sogdian five-color roundel designs. In Sui-dynasty China (581–618), copies of Persian-Sogdian silks were made by a Sogdian, He Chou, who in 605 was given control of those workshops in Sichuan that specialized in silks in "western" style.[4] The more fluidly drawn Sassanid-type designs that appear early in the subsequent Tang period may be attributable to Dou Shilun, who designed for the official workshops in Yizhou.[5] Such patterns quickly made their way farther east to Korea and Japan.

The Tang silks incorporate not only characteristic Persian imagery, such as mythical winged creatures, but also the Persian weave, that weft-intensive way of working so different from the warp-intensive weaves typical of Chinese silks up to this date. *Kesi*, or silk tapestry, is a weft-faced weave, too, and emerges during this period. The weft-faced weave construction allowed for a double width,[6] which resulted, in the eighth century, in designs in which the roundel was dominant, having become entirely floral and much larger. This new

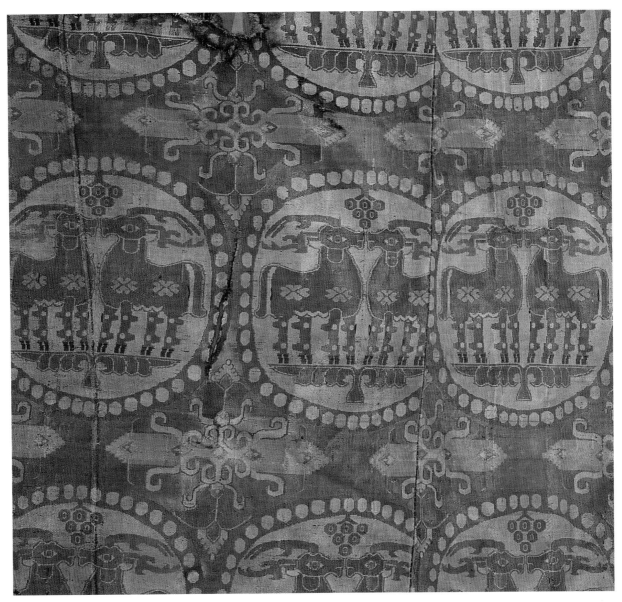

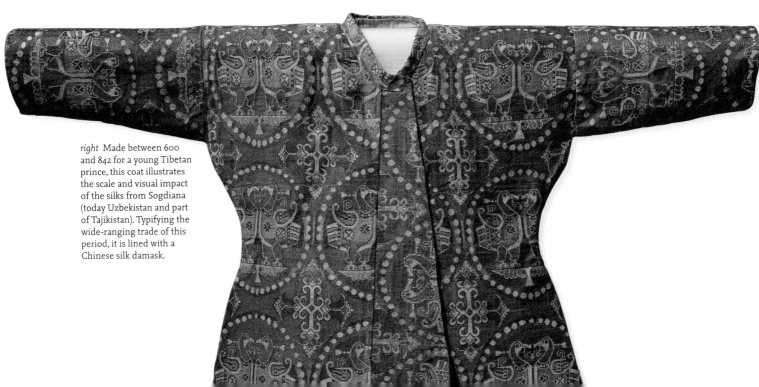

right Made between 600 and 842 for a young Tibetan prince, this coat illustrates the scale and visual impact of the silks from Sogdiana (today Uzbekistan and part of Tajikistan). Typifying the wide-ranging trade of this period, it is lined with a Chinese silk damask.

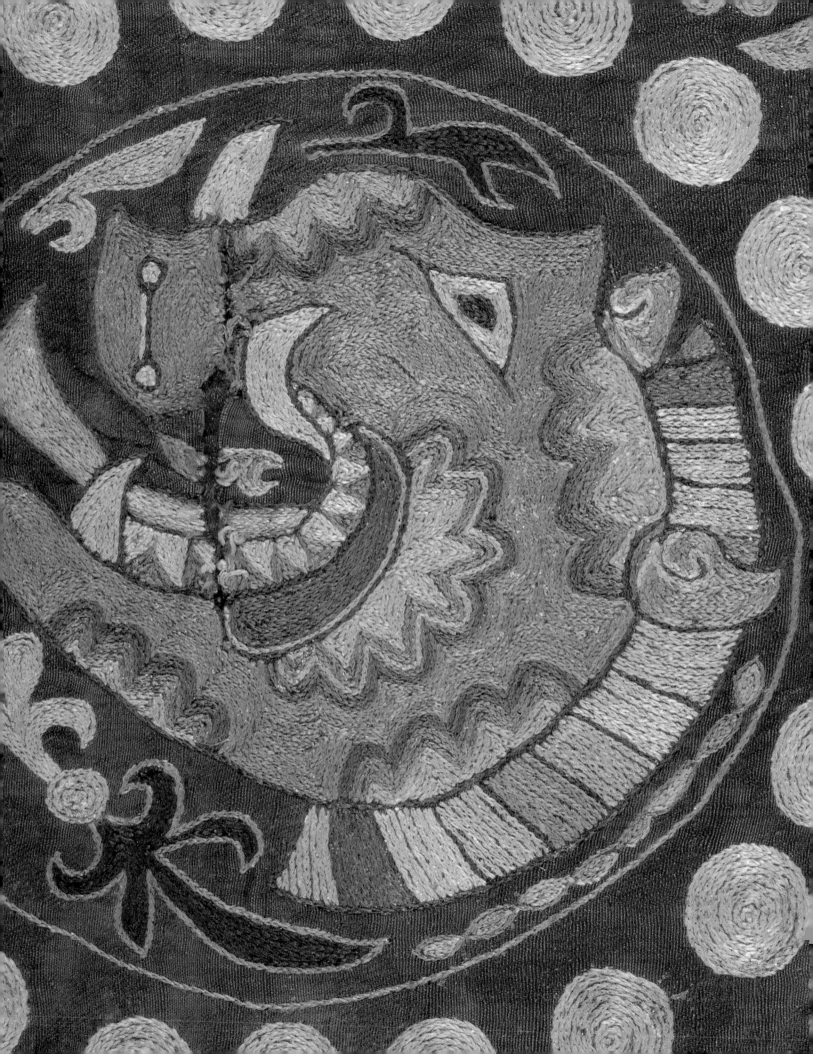

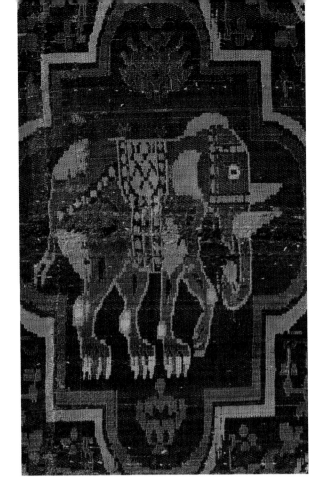

floral medallion style was equally influenced by designs
produced in central Asia, Persia, and India; so, too, were
the following century's more naturalistic and freely
composed flower patterns showing imagery such as
hawks and geese—designs still made in the Liao period
(907–1125). It has been suggested that even the Liao
designs of boys in pomegranates, which more typically
in Song (960–1279) and Jin (1115–1234)[7] textiles become
boys in lotus scrolls, were inspired by eastern Roman
Empire Bacchic figures that, by way of the silk routes,
had made their way to China by the late fifth century.[8]

Despite a gradual loss of its territories, the
Byzantine Empire acted as the principal channel
through which this creative east-west exchange was
extended farther west into Europe. Its own silks were
highly desirable and of the highest quality, which was
regulated, beginning in the fourth century, by separate
guilds for silk twisters, silk weavers, and dyers in purple,
and, later, for dealers in silk clothing, raw silk, and Syrian
silk (meaning Islamic silks generally). These last three,
which reflected the ninth-century revival of private
workshops and new support of mercantile activities
in Constantinople, also reflected the maturation of
the region's sericulture—despite a continuing partial
reliance on imported supplies.

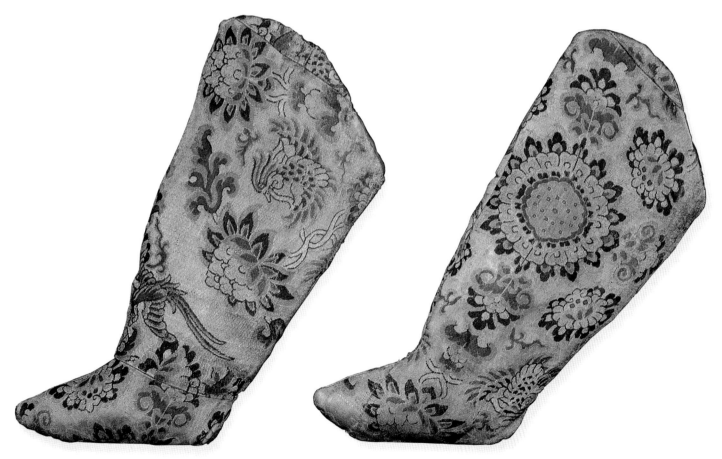

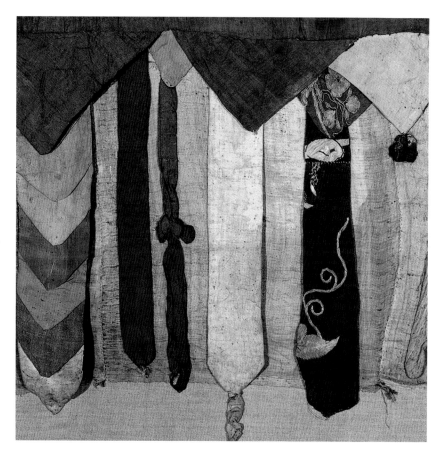

above This detail of an 8th-or 9th-century Buddhist altar valance was found in Dunhuang, at the eastern end of the Taklamakan Desert where three routes from the west met. The entire panel incorporates pieces from three different embroideries and over a dozen plain and figured silks, several of which are seen here. It illustrates the great variety of such textiles traversing the silk routes at this time.

Few elaborately patterned Chinese and central Asian cloths made the entire silk routes journey to Constantinople; however, plenty of raw silk and—quite probably—some astonishingly large amounts of plain silks were given annually to the Uighurs and other nomadic tribes on China's northwest border in exchange for horses and peace. (In 824 alone, 500,000 bolts were given; ten years earlier the mercantile use of these silks was made clear by the charge, from an irritated Chinese official, that "all they care about is profit. This is the second year that their normal yearly consignment of horses has not arrived. Can it be that they have become satiated with the profit of silken fabrics?"9)

The bargaining power of silk also operated between the Byzantine Empire and its European neighbors. From the eighth to the twelfth centuries, when many Sassanid-type patterns were still produced in Byzantine workshops, the Italians, Bulgars, and Russians provided military and naval support in defense of a beleaguered Constantinople "in exchange for privileged silk-trade concessions and impressive silken gifts. The Venetians, especially, carried Byzantine silks to the West in exchange for naval assistance against enemies of the empire, while the German emperors provided moral support to Byzantium in the face of Arab, Norman and Turkish threats."10

Viking attacks against Constantinople were rebuffed both by force and by admitting the Swedes to limited trade, one that carried mainly silk and silver. These northern silk routes passed over the Black Sea through the Khazarian Empire (c. 583–965) and then ran northward via the Dnieper and Don–Volga river systems, eventually turning westward to cross the Baltic Sea to Birka (within today's Stockholm), from where goods were dispersed. The Viking traders dealt not only with silks from Constantinople. During the most lucrative period for the northward routes, from about 770 to 970, they occasionally travelled as far as Baghdad, whose opulent bazaars were immortalized in the *Arabian Nights*. Silks—Chinese "*qi*-damasks," Indian "brocades," silk ikats from Yemen, tiraz from Egypt—"so much . . . from Hind, Sind, China, Tibet, the Turks, Dailam, the Khazars, the Abyssinians, and other countries, that more articles of merchandise are to be found there than in the countries of origin themselves."11 But traders did not need to journey so far south for such dazzling variety. The Khazarian Empire occupied the junction where the roads to Birka met the northern caravan routes from China—a route preferred by traders wishing to boycott the Muslim-held sections. Here they could obtain the silk threads and Chinese qi-damasks, such as those found in ninth- and tenth-century graves in Scandinavia and Britain.

Close allies of Byzantium into the ninth century, the Khazars facilitated silk trade through their merchant houses in Baghdad, Constantinople, and elsewhere in the Mediterranean. They had also founded ports of transit to the north, including Kiev, on the Dnieper River, and Birka (lost to the Vikings by this time). At its largest, their empire extended from Kiev eastward to Bulgar, on the Volga, and southward to embrace the northern shores of the Black and Caspian Seas and the western shores of the Aral Sea, adjacent to Sogdiana. The Sogdians' new Islamic rulers, the Abbasid Caliphate, had already battled with the Khazars over large portions of modern-day Georgia, Armenia, and Azerbaijan—motivated in part, perhaps, by the lucrative taxation of passing silk traders. Although Khazaria had lost ground, it had gained many skilled artisans fleeing Islamic rule, including many Jews, who were renowned in particular for their knowledge of dyeing. Ultimately, it was the breakaway of Kiev, in 965, that fatally wounded Khazarian silk trading and their empire. They migrated westward in the eleventh and twelfth centuries, just as the historical record begins to give evidence of the sericulture, weaving, rug making, and embroidery that had taken root during their stewardship.

Meanwhile, the Sogdians had roamed eastward, pursuing their own silk-lined prosperity. They were

to be found settled from Canton to Bangkok to Sri Lanka, along the sea routes established in the eighth century. These routes now served the increasingly commercialized silk industry of the Northern Song (960–1127), who reopened Canton after its sack in 878, and the Southern Song (1127–1279), who brought kesi to its fullest pictorial expression and transferred the making of fine patterned gauzes to the lower Yangzi silk-weaving region, which was already known for plain cloths and twills. With stretches of the overland silk routes becoming inhospitable, unprotected, or engulfed in turmoil, ships provided a more effective method of distributing these goods. To supply Korea's own export trade in finished silk cloth, Chinese ships off-loaded raw silks and processed yarns there. Along with great quantities of plain silks, Chinese cargoes included much smaller quantities of silks made specifically for particular tastes: gauzes for Japan, twills for the islands now known as the Philippines, samitum for India's Coromandel Coast. From India, different traders continued on, either through the Red Sea toward the ports, such as Alexandria, that served the Mediterranean, or to Basra, as bustling and vibrant as Baghdad to its north and the

hypothetical point of departure (Bassorah) for Sinbad the Sailor, in the *Arabian Nights*. Returning ships brought dyes and patterned cotton cloths, both important to the development of Eastern painted, pattern-dyed, and warp-dyed silks.

By the mid-eleventh century, cargo ships sailed between lands held by the Fatimids, centered in Cairo, and, on the eastern shores of the Red Sea, lands recently conquered by the Seljuk Turks. The Seljuks had, for the first time, brought unity among the Turkic nomadic tribes of central Asia; and although independent, they retained allegiance to the Baghdad-based Abbasid Caliphate until 1194. Across the Sunni-Muslim Seljuk domain—from conquered Byzantine territory in Armenia and Anatolia (Seljuk from the 1070s until 1307) down through Damascus, in Syria, and beyond Baghdad to the borders of former Sogdiana—new weaves developed, among them satin. This is the ultra-smooth weave construction characteristically incorporated into true damask (named after Damascus). Used alone, the satin weave is found in rare fragments from eighth-century Dunhuang, the westernmost fortified Chinese silk routes settlement, but true damask is documented

below Marco Polo's accounts of his travels during 1298–9 described both his passage over the silk routes and journeys by sea. A latter volume of c. 1412, illuminated in the Parisian studio of the Boucicaut master, includes this trading scene in the harbor of Hormuz, then a strategic port located at the entrance to the Persian Gulf from the Indian Ocean.

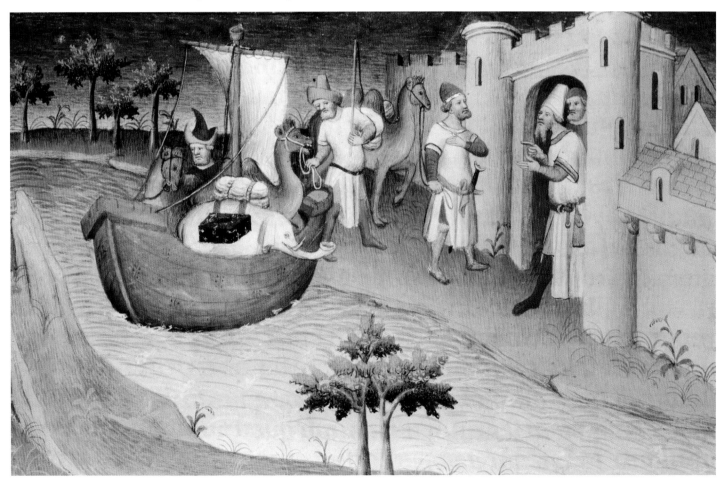

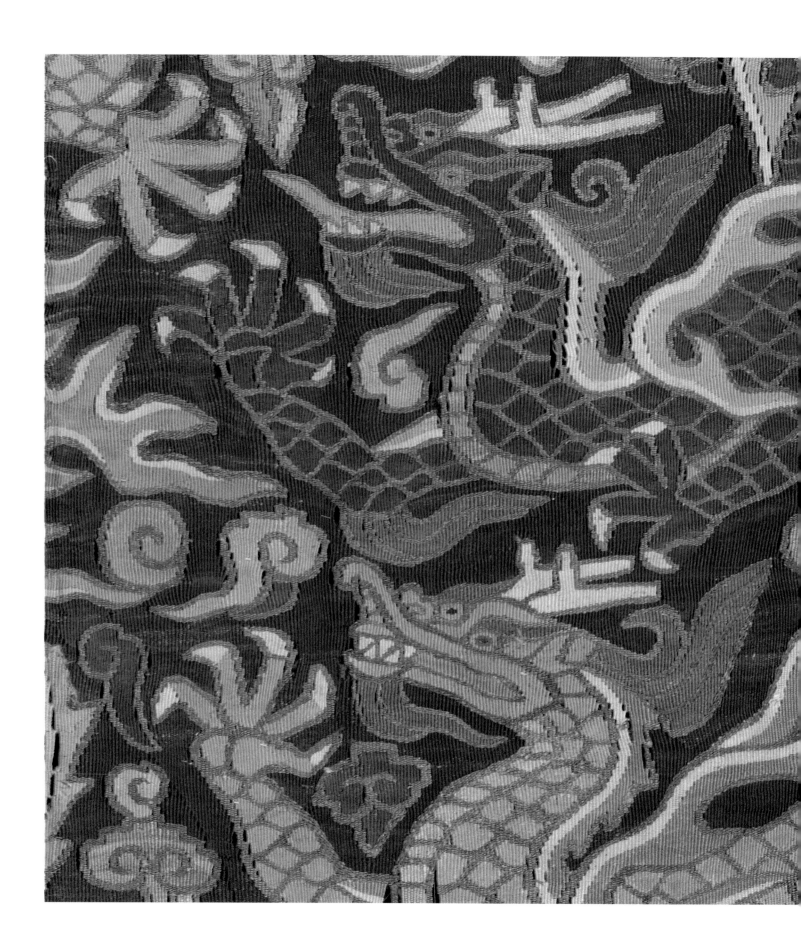

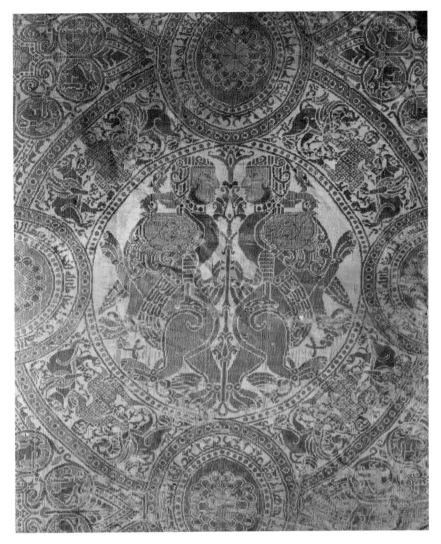

opposite An 11th- or 12th-century *kesi*, this was woven in western China, in the present-day Gansu Province. It employs a tapestry weave in polychrome silks and, for the outlines and dragons' scales, silk threads wrapped with gilt paper.

right Although *tiraz* silks were typically striped, the inscription around the smaller roundels indicates that this silk also originated in an Islamic *tiraz* workshop. Woven in about 1100, it was interred in a tomb in the cathedral of El Burgo de Osma, in Soria, northern Spain.

in China itself only with the coming of the Ming dynasty in 1368. In the intervening period, from the eighth century until the legendary sighting of true damask during the Second Crusade's brief sortie against Damascus in 1148, how had the satin technique passed to weavers far to the west? By land westward from central Asia, perhaps with captured artisans? Or eastward with Sogdians through China and by sea back around India, up the Red Sea, and thence to Seljuk Damascus? The answer may never be found. Nevertheless, that the question can be asked is an indication that the interregional sea routes, as much as the overland silk routes, played an essential role in the diffusion of textile techniques at this time.

Over the same five centuries, maritime connections were also enriching the Islamic Mediterranean's contribution to silk culture. In particular, this contact spread the knowledge of how to protect the long filaments of silk by baking the cocoons under the sun to kill the worms (rather than treating them with smoke or boiling them, as in earlier methods). Spain, Tunis, Sicily, and southern Italy were becoming sources of raw silk and cloth. Sericulture had already been introduced into Iberia in 712 by the Moors and was so expanded by the Abbasid Caliphate that Andalusia soon became the unrivalled purveyor of European-made silks, remaining so into the thirteenth century. North Africa reaped the same benefit from Islamic invasion; tiraz production expanded to such a degree that by the twelfth century silk weaving guilds existed in Tunis, while Fez, in Morocco, "boasted 467 inns for merchants and over 3,000 houses of *tiraz*."[12]

Sericulture was introduced into Sicily after that island was conquered by the Saracen Arabs, whose undisputed rule dates from about 835. In the next century it became a Fatimid province and was able to supply raw materials to workshops in Egypt as well as to its own royal tiraz in Palermo. This workshop was later renowned for fine silks (like Spain's, mostly based on Sassanian/Byzantine prototypes) and embroidery.

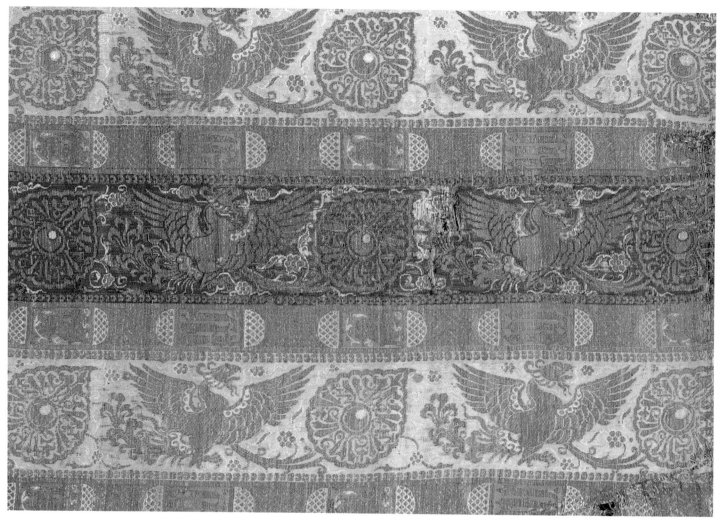

above The combination of a *tiraz*-like striped format with an oriental phoenix motif suggests that this lampas of silk and gilt-parchment threads was made in Sicily, where weavers of differing origins and religions worked together. It dates from the 12th century.

opposite The flying phoenix amid foliage, together with lotus and peony motifs, typifies early 15th-century Ming decoration, which through trade spread to Korea and beyond. Here the use of satin and tabby (or plain) weaves makes this Chinese silk a true damask.

An example of the latter is a coronation mantle dated 1130 and probably made for Roger II, king of the relatively short-lived but culturally rich kingdom of Norman Sicily (1071–1266). There, Byzantine and Arab artisans mingled: Byzantine Jews captured by the Normans from Thebes, Athens, and Corinth in 1147 brought to Palermo additional expertise in dyeing, silk processing, and weaving, which they monopolized under a royal grant from 1194 to 1250. Earlier, in the eleventh century, a similarly cosmopolitan mixture of artisans had established silk crafts in the northern Italian city-states of Venice, Genoa, Bologna, and Lucca. Of these four, the most important was Lucca, whose preeminence was enhanced after 1266 by the arrival of immigrant Sicilian silk workers discontented with their new ruler, Charles of Anjou.

One can dip into history at virtually any point and find examples of artisans' being forced to emigrate. Sometimes relocation was due to economic or climatic changes. For example, silk workers departed from fifth- and sixth-century Byzantium when private workshops were starved of silk supplies by imperial monopolies; they abandoned the oasis towns of the Taklamakan Desert over the tenth–twelfth centuries as glacier-fed streams changed course or ran dry entirely. Yet so valued were the skills in silkworm rearing and silk throwing and finishing that possession of these guaranteed welcome elsewhere. Sometimes it could even make the difference between life and death. In c. 756 the ability to weave, paint, and embroider silk spared the Chinese workers already settled in Samarkand; they were sent to Baghdad when troops of the Abbasid Caliphate crushed this Tang protectorate and became the dominant force in central Asia. From both Baghdad and Islamic Egypt, weavers were sent to Spain. Such migrations often introduced new ways of working. For example, under Islam Egypt abandoned cross-looped knitting (made with one needle) for two-needle pattern knitting, possibly as a result of artisans' moving there from neighboring Syria, where a simpler form of this technique had been practiced since the second century. The dynamic flow of skills is illuminated by the dispersal of pattern knitting,

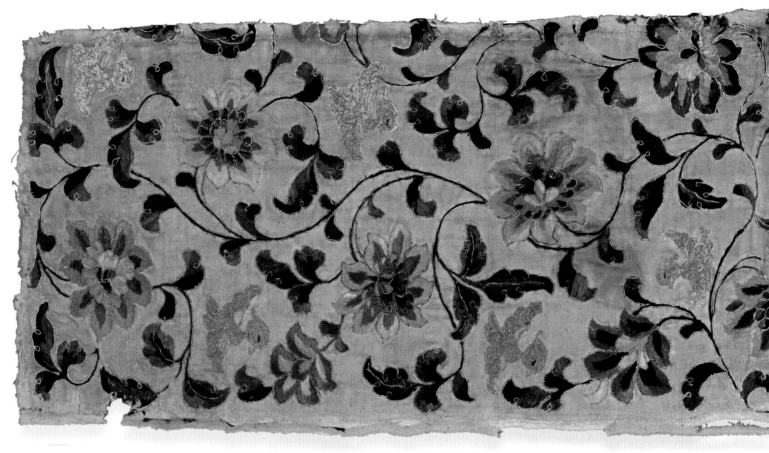

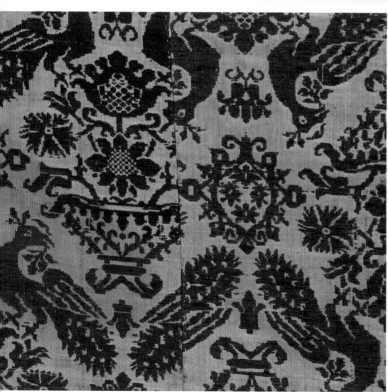

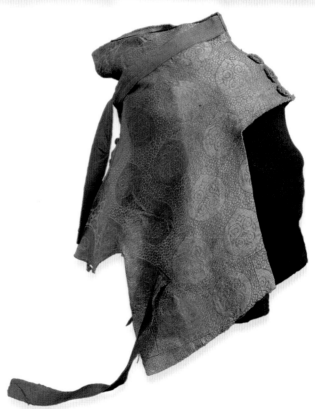

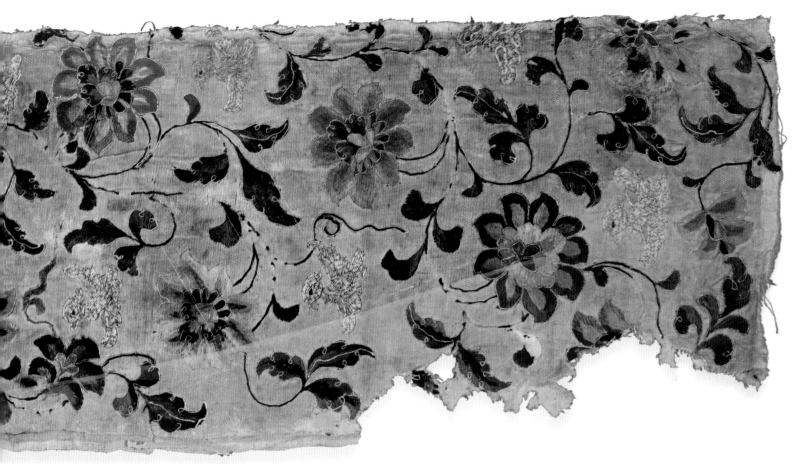

above Innovation abounds in this 8th-century silk from Dunhuang. White silk damask is worked with slip-stitched stems and satin-stitched leaves and petals. Couched silver-wrapped threads outline these motifs, and what is now called Japanese gold thread (silk core wrapped in gilded paper) was used for the birds.

opposite, right Gold-wrapped silk thread once shimmered across this Mongolian mid-13th-century silk headdress, made from different pieces of *nasij*. Lined with silk, it owes its shape to Scythian and Parthian dress; the silk patterns went on to influence western weavers.

opposite, left With paired stylized birds and delicate curling vines inspired by Middle and Far Eastern sources, this textile reveals its southern European origins only in the prominent flowering vase. Such patterns emerged in late-14th-century Lucca and by the 1500s were popular across Italy and Spain.

which was being used in Arabia and India by the ninth century, in Spain soon afterward, and in southern Italy from at least 1200. Less well charted is the spread of dye patterning, whether woven (ikat) or printed, but it is safe to say that the movement of silk workers was key to the dissemination of dye mastery.

For a time, such displaced people might adhere to their own technical or stylistic customs, without having any influence on those of the host country or being influenced by them. Gradually, however, these distinctions were to fade; and in these tumultuous times the exchange of skills and tastes was extensive, as was the movement of cloths. By the mid-thirteenth century, Italian merchants, mainly from Genoa, were travelling to both north and south China to obtain silks,[13] and over the next hundred years this increased trade resulted in the development of an "international" style. Several features of this style, which had been passed on from Byzantium, Islam, and China, can be seen in Italian silks of about 1350 onward. They include a number of "new" cloth types that had developed slowly over the previous 350 years. Like the early Chinese warp-faced compound weave, as well as samitum, its weft-faced equivalent, all of these innovations were variations on the same principle: that in addition to the essential warp and weft,

one or more extra sets of either or both could be introduced. This principle could be applied to produce either textural (monochrome) or colored patterns. Among the former, in which the pattern is expressed solely by contrasting surface textures, are the "incised" and *qi*-damask designs of c. 1000 (double weft), associated with Syria and Constantinople, as well as monochrome figured velvets (double warp), originally made in China by Yuan-dynasty weavers and, by 1350, also in India. An early example of multicolored patterns produced according to this principle is the diasper, known in Byzantium from the tenth or eleventh century, which uses a double warp and double weft. Some other multicolored silks of the following two centuries, thought to be Spanish, have only the weft doubled.`

Thus, by the eve of the Renaissance, Italian weavers had access to a more efficient means of producing elaborate patterns in an expanding range of weights and effects. This was an essential step toward diversification—of styles, of specialization among weavers, and of price—and beyond that, to industrialization.

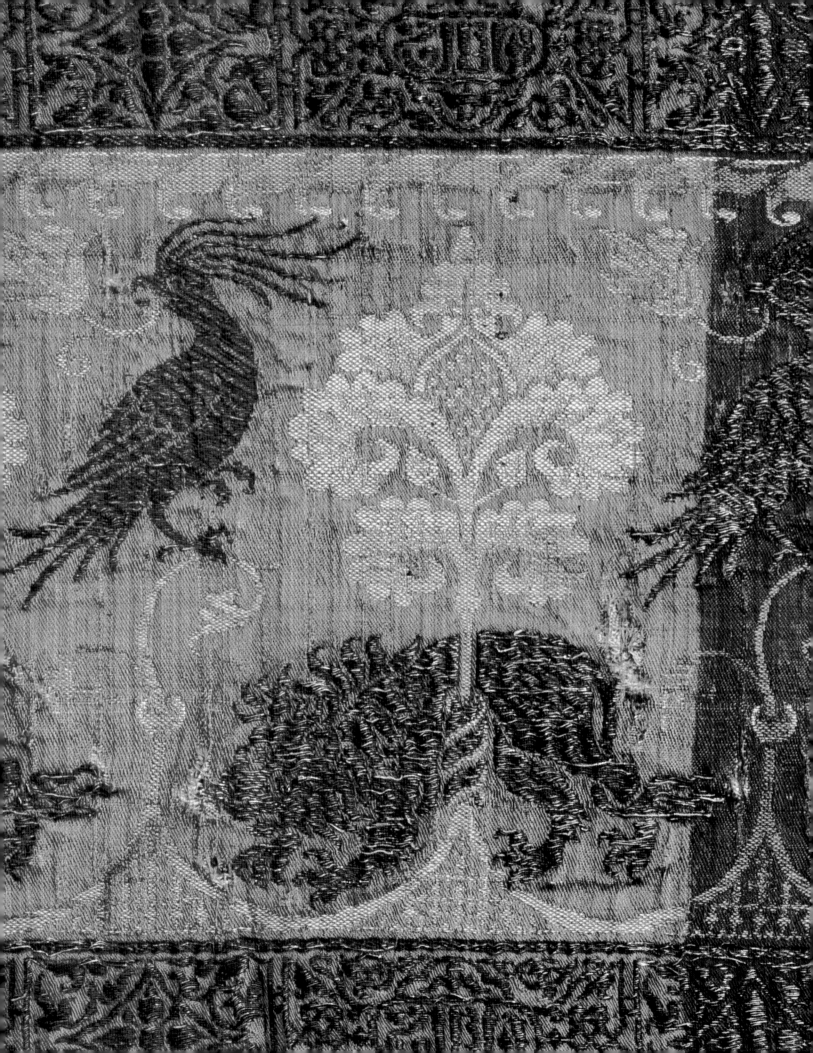

Expansion

Both the relocation of captured artisans and the willing emigration of skilled workers were crucial to the establishment and expansion of the Italian silk industry, which, as we have seen, began in the thirteenth century. Initially, foreign contacts contributed to the enrichment of silk weaving techniques and designs in the main centers of Lucca, Bologna, Genoa, and Venice. Later, internal migrations disseminated this knowledge to other Italian cities. The dispersal of skills—some originally Chinese, others central Asian, Jewish, Byzantine, or Islamic—turned out to be essential to the future of silk when famine struck the Mediterranean and Asia in the early 1300s, followed by the Black Death. This virulent epidemic of bubonic plague emerged from the Gobi Desert, in Mongolia, and in 1333 reached China, where it killed 90 percent of the population of the Hubei province, an important silk-producing region. It then spread along the very routes that carried silk. By sea, it struck the Coromandel Coast and Basra, then proceeded inland to Baghdad and Damascus and crossed the Mediterranean to Cairo and Palermo. Travelling

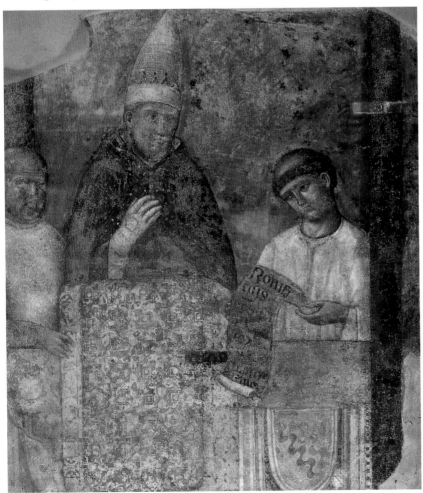

overland from China, via Samarkand, it reached Caffa (or Kaffa, now Feodosia), a Genoese cathedral city located on the Crimean Peninsula of the Black Sea, since 1291 a port vital to the Genoese trade. From here it was carried northward to Moscow and westward past Constantinople on Genoese ships, which infected not only their home port, but also Venice, where it is estimated that three-quarters of the population died.

The plague ultimately killed millions in western Asia and Africa and, between 1347 and 1349, an estimated one-third of the European population—up to one-half in Italy.[1] Yet a century later Italy was to give birth to the modern silk industry. Emigration from this industry developed other centers in northern Europe and, later, elsewhere, including North America. The two most salient features of this industry—its mixed heritage and its habit of dispersal—both depended on communication (intellectual and geographical) and the expanding desire for silks. Such technical and visual literacy laid the groundwork for the development of fashions in textile design. Fashion itself is covered in the next chapter; here we look at the geographical and industrial diffusion of silk manufacturing up to the point when it became a truly global industry, in about 1850.

The inherent stylistic conservatism of the first millennium A.D., as seen in the longevity of patterns designed to serve formal, hierarchical societies, such as those of China and the Byzantine Empire, was less evident in the Islamic world. In fact, it was already beginning to wane in China and Byzantium when the nomadic tribes of Mongolia followed Genghis Khan in conquering much of Asia, from Beijing to Bukhara, between 1206 and 1227. Genghis's heirs continued this path of conquest to the west and south, and by 1271 they had united, for the first time, the lands from Russia to India, Anatolia to China. There, his grandson established the Yuan dynasty (1280–1368). The tradition of treating artisans as booty, perpetuated under this regime, once again spread textile techniques, including the making of gold-worked silks, or *nasij*. Embroidery with gold thread had ancient roots, dating back to at least 400 B.C., and even the use of gold in weaving was several centuries old. The technique of using a second, gold weft—which might be flat gilt membrane or gilt membrane twisted around a core of silk—had been known in China's Shaanxi province in the ninth century,[2] but it is more often associated with Muslim weavers:

> "Weavers from Herat (in Afghanistan), who were known for their gold-woven silks and silver brocading, were removed to the Chinese Uighur region in 1222 and returned fifteen years later when their city was rebuilt. By 1260, Chinese craftsmen were at work in Tabriz, also famed for its golden

opposite, left In the Mongol period, *nasij*—or cloths of gold—were produced in Chinese and central Asian cities, often by weavers resettled from conquered territories. In this example, the gold thread consists of strips of gilded translucent paper wrapped around a yellow silk core.

opposite, right With its mainly geometric design, this silk lampas bears the hallmark of an Islamic caliphate *tiraz* workshop in Spain. However, the lack of inscription and the inclusion of plants and animals in the central bands indicate that it was probably woven in Seville or Cadiz within some decades after these Muslim cities were conquered by Christians, in 1248 and 1262 respectively.

cloths or nasij. The Mongolian preference for these – as tributes, taxes or in trade – ensured the maintenance of conquered cities' imperial workshops (such as those in Baghdad) and the introduction of such techniques as far west as Armenia."[3]

What was new were the Sino-Mongolian patterns, incorporating dynamic arrangements of birds, beasts, and foliage. These flowed along the overland silk routes, now reinvigorated as a result of the safe passage afforded by the Mongols to all merchants and travellers, including the Venetian Marco Polo (1254–1324).

By about 1260, these so-called "tartar cloths" had reached Italy, some of them being presented as gifts to the pope from the Mongol rulers of Persia (the Ilkhanids; 1256–1353). The supply became plentiful after 1291, when the Venetians and Genoese began trading over the Black Sea, and included the half-silks made in central Asia (where until the late nineteenth century pure silk cloths were still called *podshoki*, or "emperor's cloth"[4]). Soon various complex cloth structures and asymmetrical designs were being woven in Spain (which traded with Genoa) and in Italy. Lucca, in particular, became known for cloth of gold and for luxurious velvets; previously woven there, but plain, velvets now began to be patterned, initially with stripes or checks. Over the next half century these techniques became more widespread and patterns more innovative. Designs began to break away from the long-standing formula based on an obvious geometric structure, whether circle, square, diamond, or a combination of these. Lucchese velvets, for example, began to be figured with floral sprigs worked in gold.

It was while this freer approach to design and weaving was becoming established in southern Europe that the Black Death struck. Coincident with the plague came the demise of the Mongols, who lost control of their western regions during the 1330s and of China, to the native Mings, in 1368. The world that emerged from these crises was radically changed. In Europe, feudalism was breaking down, leaving the survivors with opportunities for upward mobility and leading in turn to the growth of towns and cities. Thereafter, the demand was for silks of greater variety of weight, composition, and price, and for new designs, in keeping with the growing desire for a less hieratic, more individual style and with the beginnings, in Europe, of an affluent bourgeoisie—among the features that would characterize the Renaissance.

What made Italy able to capture this new market? Other regions also provided "tartar" patterns and were more established as purveyors of silk. Italy's ascendancy was built on three factors: trade routes, recruiting, and

technology. By the early 1200s Lucchese silks had already begun to circulate in northern Europe, through trade fairs such as those in Champagne, France (important between about 1135 and 1285). But the sea route between the Mediterranean and northern Europe was then dominated by Islamic traders, operating from ports such as Tunis and Málaga. The conquest of Muslim Seville and Cádiz by Castille (in 1248 and 1262 respectively) led to the opening of this route, in the 1270s, to Christian traders. Genoa—strategic to innovations in trade and banking—became the first Christian city to navigate the sea route to Bruges. By the early 1300s Venice and Barcelona were employing the same route and Bruges had become the principal northern trading port.[5] The Italians also benefited from improvements to Alpine passes, over which mules packed with goods were driven to distribution points such as Basle and Cologne. These developments coincided with the decline of Islamic Iberia and Constantinople (both of which nevertheless continued as sources of raw silk and cloth).

Italian cities also offered financial incentives to attract silk weavers. For example, Milanese weavers of sendal, a light, plain-woven silk, emigrated to Bologna in 1230–1 as a result of benefits promised by the governors of that city, thus establishing Bologna as a center for this kind of cloth. Such policies (later emulated by other European states) continued to shape the Italian silk industry for at least another four hundred years.

In the long run, however, the greatest reason for Italy's success was its attention to thread making. Although by the tenth or eleventh century China had adopted a treadle-operated multiple-spindle wheel, this was surpassed, in the thirteenth century, by more advanced silk-twisting frames, developed in Lucca. By 1272 a Lucchese emigré had introduced this technology to Bologna. Much later, in 1456, a Bolognese helped Verona to establish its first undershot water wheel to power silk-twisting frames; by this time these were also in operation in Vicenza and Florence. The result of powered silk twisting was a reduction in labor costs and an increase in consistency. By 1450 raw silks, each with a different character, were being obtained from numerous sources: Persia, Syria, Palestine, Greece, Albania, the Balkans, the Iberian Peninsula, southern Italy, and Terra Firma (Venetian lands, including Verona and Vicenza, stretching from the Istrian peninsula of Slovenia and Croatia to the borders of Milan, and from the Po River to the high Alps). From this unprecedented range of options, threads could be tailor made for specific uses: a satin, for example, might consist of a warp made of a silk from Almería, in Andalusia, and a weft made of a Persian silk called *crespolina*.[6]

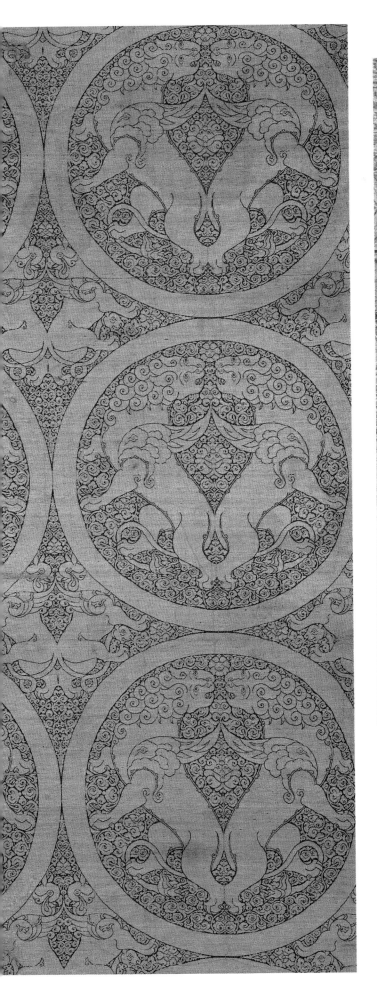

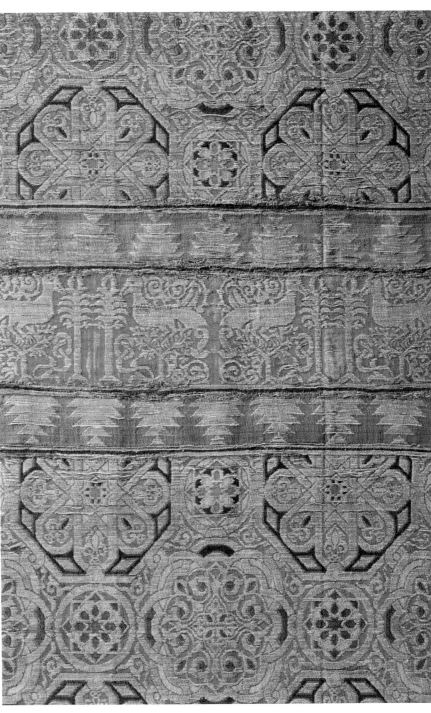

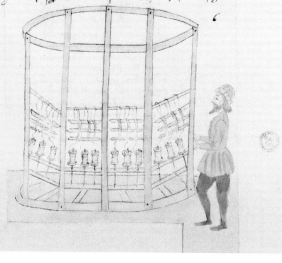

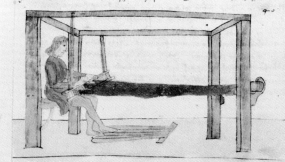

Given these improvements in thread production, it is little wonder that Italian silk weavers now gradually abandoned the earlier focus on design innovation in favor of greater exploration of weaving techniques calculated to show off the high quality and variety of the threads themselves and the beautiful colors they could be dyed. Satins—plain and glossy or juxtaposed with areas of tabby and twill in patterns originally inspired by "tartar cloths"—were among the most fashionable of these. Brocades became more elaborate, as did figured velvets. The latter might be multicolored, a practice that had appeared in Lucca by 1376 (as recorded in the city's statute books of that year) but which later—as Lucchese weaving declined—became associated with Genoa. Designs might appear through the arrangement of cut and uncut areas of the velvet or by voiding altogether to reveal areas of satin. The latter style is recorded prior to 1400 and was made in several cities, but by the 1450s it was so closely identified with Venice that even the Florentine weavers of such velvets called them *alla viniziana*: "in the Venetian manner." Most demanding of all was *alto-e-basso*, with different heights of pile, a technique also known in Lucca by at least 1390 and dispersed from there.

All of these fabrics could be further enriched with metal threads. Gold loops—glistening amid a silken pile or massed together at one or two heights—appear

in the late 1420s, and were added to the already-sumptuous cloths of gold. These, too, are recorded in Lucca's 1376 statutes, and were then being made with an additional weft of gilt membrane or parchment wrapped around a silk or linen core. This method of making gold thread was the same as in Mongol and Islamic territories, but by the next century Italian thread makers were producing *filé*, narrow gilt metal strips wound on a yellow silk core. Their effect was extended in the 1430s by interspersing filé with yellow silk wefts, in a manner strikingly similar to nasij of some two centuries earlier; this technique began to be used to create gold cloths in which the pattern was formed of narrow outlines of the (non-metallic) ground weave or velvet pile, producing an etched appearance.

With older weaving centers, such as those in the Balkans, Constantinople, and Anatolia, distracted by assaults from the Ottoman Turks, Italy was able, by the mid-1400s, to monopolize the making of cloth of gold and fine velvets—a position it was to hold for several generations. In 1492, the expulsion of Moors and Jews from Spain dealt a blow to that country's silk industry—Italy's only nearby rival—while augmenting the workforce in other regions, particularly North Africa. (However, silk weaving did survive in Seville, Granada, Valencia, and other main Spanish centers and would be revived in the mid-1700s.) In the rest of Europe,

only Cologne, in the Rhineland, specialized in weaving with gold and silver threads, a trade already established there in the 1300s. The flow of luxury silks reversed, at least for a time: Genoa, Milan, and Florence exported great quantities of these to Turkey between about 1450 and 1500.

Nowhere is the development of the Italian industry better summarized than in Luca Mola's detailed study of the Venetian trade:

"It was only in the 1440s that the spread of silk manufacturing in Italy began to quicken at a remarkable pace, surpassing the primitive artisan phase almost everywhere and coming to be organized according to more entrepreneurial standards. At the end of the fifteenth century, silk-cloth production had been set up with success in Milan, Ferrara, Modena, Siena, Perugia, Naples, Catanzaro, Messina, and even in a small town such as Racconigi in Piedmont, while in the sixteenth century it spread everywhere, from a number of minor urban centers in the Duchy of Savoy and Trentino to Como, Pavia, Cremona, Crema, Bergamo, Brescia, Vicenza, Verona, Padua, Mantua, Reggio Emilia, Pisa, Rome, Palermo, and Catania. By 1600 the silk craft played a vital economic role throughout the Italian peninsula, from the Alps to Sicily."[7]

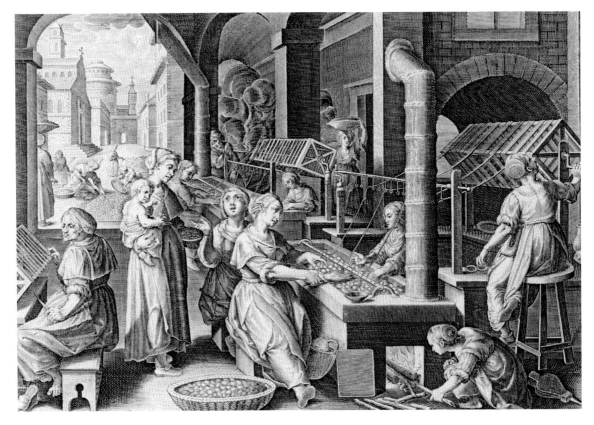

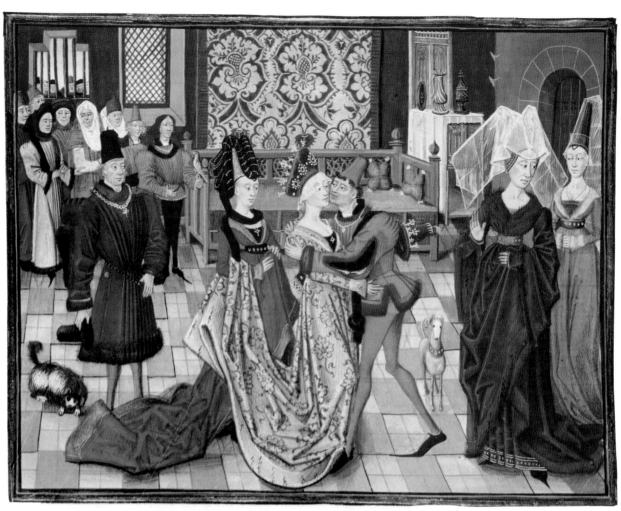

Increasingly, this role was underpinned by the exportation of threads, such as Bologna's even, thin, and expensive warp thread *orsoglio*, which was much in demand by the mid-1550s. Less costly alternatives were equally desired for lighter silks and mixed-fiber cloths. Thicker threads, such as those for sewing, were also in demand, particularly in northern European regions, where embroidery and tapestry (which, like embroidery, uses relatively soft threads) were the leading textile arts.

Here, too, however, the manufacture of all-silk cloth was gradually becoming established—thanks initially to immigrant Italian artisans. Although there were makers of silk ribbons and other haberdashery in Paris in the late thirteenth and fourteenth centuries, and others nearby who made thin silk fabrics, it was in the mid-fifteenth century that the first weaving center in France devoted to high-quality silks, especially velvets, was initiated. This was in Avignon (a papal possession until the French Revolution) and was launched by artisans from Florence, Venice, and Lombardy. From Avignon, silk-weaving skills dispersed to nearby places, including Orange and, by 1498, Nîmes. Having established

themselves in Avignon, the Italians went to Tours (1470) and then to Lyon (1536). All grew rapidly—Avignon helped in the early 1500s by an influx of weavers from Genoa and Milan, and Lyon by its nearby silk thread mills, the first of which had been started in the previous century by one Gayotti, a Bolognese. These same mills, located within what was to become the center of French sericulture, were also instrumental in stimulating silk ribbon making in and around Saint-Etienne.[8]

Meanwhile, other countries besides France were starting their own silk weaving enterprises, again often with Italian help. Italian weavers participated in the late-fifteenth-century creation of *satin de Bruges*, which had a silk warp and a wool or linen weft. The making of this cloth spread from Bruges to Antwerp, where its guild dates from 1532 and where, in 1535, silk dyeing and throwing were initiated by yet more Italians. Not long afterward, Italian arrivals in Switzerland underpinned the silk industries begun in Basle (1570), Geneva (1544), and Zurich (1555), the last built upon the making of silk trimmings and light veils, which had been undertaken since the 1200s. Having already absorbed Italian

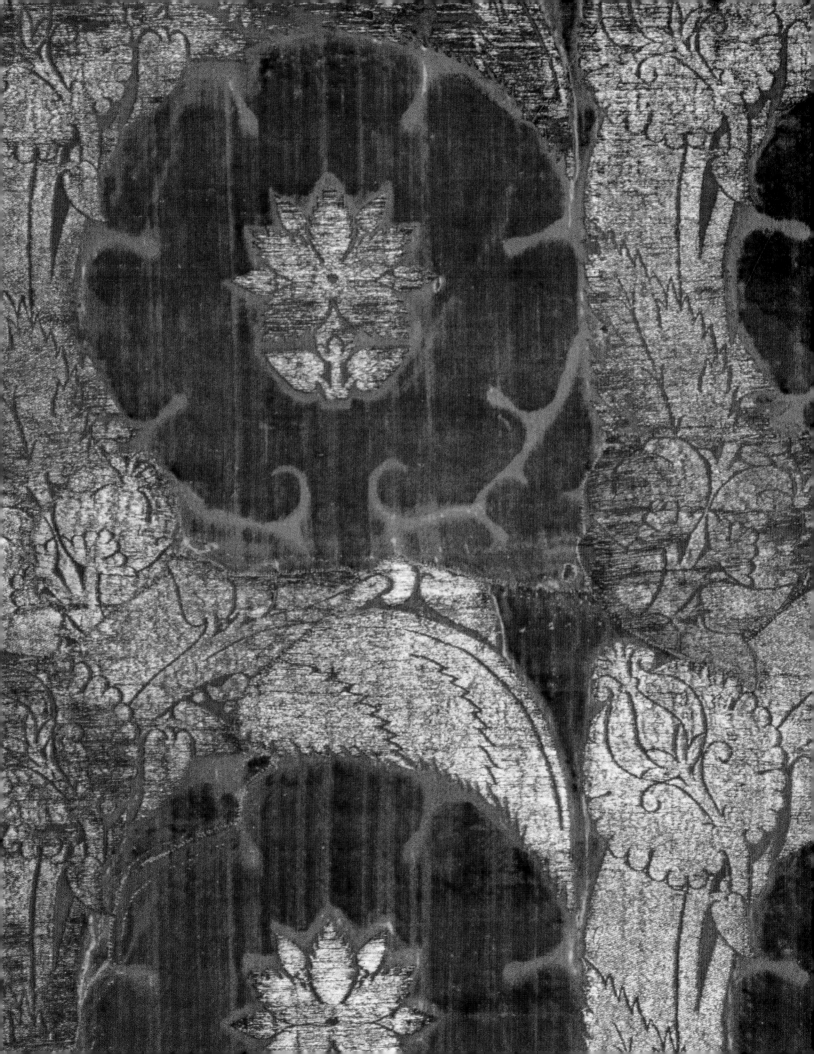

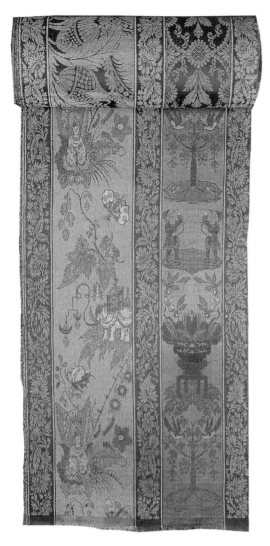

above This rare double-sided *lampas* was woven in 1725–50 by Louis Liottier of Edingen, now in Belgium. It was commissioned by Leopold Philippe, Duke of Arenberg, who financed Liottier's workshop.

right Painted by Lucas Cranach in 1514, this portrait of Katharine, Duchess of Mecklenburg, shows high style as worn in Saxony, northern Germany. Her gown is of costly Italian silk and gold-thread brocaded velvet, but her narrow waistband is of the sort long woven in Cologne.

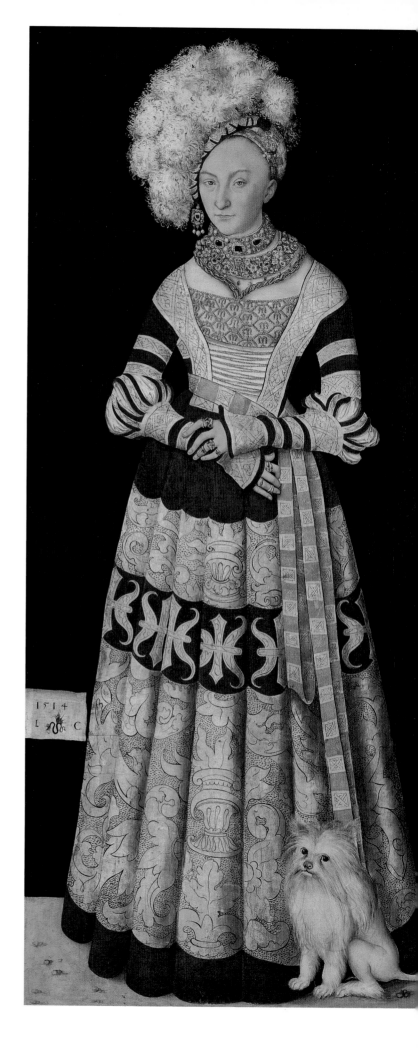

methods, weavers from Flanders and French Protestants, or Huguenots, also contributed to the Swiss industry.

During the mid-1500s this pattern of dispersal—northern skills in trimmings and mixed cloths blended with southern skills in throwing, dyeing, and high-quality silk weaving—gave rise to enterprises in England's Canterbury, London, and Norwich, as well as in German cities such as Hamburg, Augsburg, Nuremberg, Ratisbon, Frankfurt, and Berlin; in that city and to the south of it, velvet making flourished. A century later, in Holland, workshops based on Dutch-Italian expertise could be found in towns such as Amsterdam, Leyden, Haarlem, and Utrecht. To the north, silk weaving was begun in Denmark in 1619 and in Sweden in 1649. By this time Dutch merchants were trading in the neighboring German town of Krefeld, where, in 1724, they established silk dyeing, so contributing to the Rhineland's growing importance

as a center for silk and velvet weaving. Meanwhile, a second wave of Huguenot emigration, following the revocation of the Edict of Nantes in 1685, had further contributed to silk industries outside France. In particular, it boosted Britain's existing ability to produce silk velvets, taffetas, half-silks, and cloths woven with gold and silver threads (this last having been launched in 1611 by Milanese artisans in London). Weavers of fine silks now congregated in London's Spitalfields; Norwich specialized in worsted-silk cloths; Coventry (where silk weaving had existed since at least 1627) ultimately came to focus on small-wares, such as ribbons; in Macclesfield the making of silk buttons (first recorded in 1617) and yarn preparation (from mid-century), became but parts of a more diverse industry.

The French weavers brought with them knowledge of the draw loom that had been perfected in 1607–10 by Claude Dangon, an Italian working in Lyon.

right Part of a large suite of bedroom and dressing-room furniture made c. 1689 for the 2nd earl of Nottingham, this chair was made in London, probably by Thomas Roberts. It adopts a style made fashionable by Daniel Marot, a Huguenot who worked in Holland and England. The covers are Genoese cut velvet, but the fringe was probably made locally.

overleaf, page 50 Anna Maria Garthwaite, active from 1726 to 1756–63, is one of a handful of known designers who supplied weavers in Spitalfields, now part of London. Shown here is a design of about 1730, when lace-like elements were fashionable.

overleaf, page 51 Woven in 1788–90 by Gaudin et Savournin of Lyon, this silk was used in 1805 for Empress Josephine's state bedroom in the palace of Fontainbleau. Its design, attributed to Philippe de Lasalle, incorporates chenille threads amid the brocading.

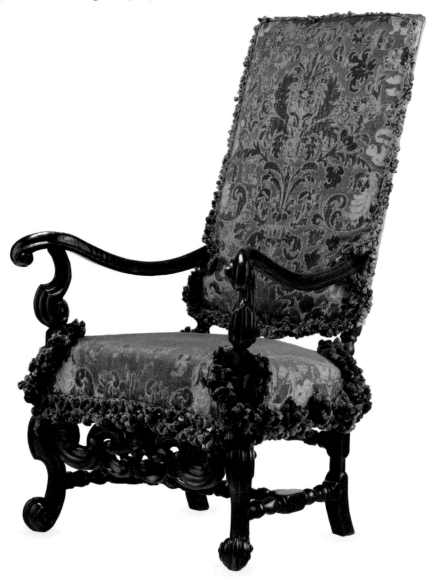

Royal statutes issued in 1667 gave that city a monopoly on the making of velvets and taffetas (as Paris enjoyed with gold-brocaded silk), by which time this loom had been improved yet further. Thereafter improvements to another hand loom, one capable of weaving dozens of parallel ribbons and other small-wares, were made by the Dutch (the "Dutch engine") and then the Swiss (the "Zurich loom" or "engine loom"); the former had reached Macclesfield by 1731. There, by 1748, Charles Roe had two silk mills, each based on the expired patent belonging to Thomas Lombe, who earlier, in Derby in 1718, had opened the first English factory of any kind, a water-powered silk throwing mill, which he set up with the aid of Piedmontese workmen.[9]

By the mid-eighteenth century the French and English were rivals in design innovation, and, along with the Italians, producers of the highest quality silk cloths. Elsewhere in Europe, too, merchants and weavers prospered throughout the century. Even a relative latecomer, Austria (where silk weaving began only in 1666), had built a thriving silk industry, with the aid of French and Italian expertise; from the 1750s Viennese silks were being exported, especially to Russia and Poland. Records of designers and firms survive in abundance from the eighteenth century onward— documenting, for example, the contributions of designers such as Jean Revel and Philippe de la Salle to Lyon's reputation for fashionable silks, and of James Leman and Anna Maria Garthwaite to the success of Spitalfields. Among the notable silk entrepreneurs of this period was the English weaver John Sabatier, of Huguenot descent, who in the mid-1700s, with some one hundred looms, supplied most of the leading London mercers with Garthwaite-designed silks and exported to Ireland as well.[10]

While the Italians everywhere still maintained an almost complete control of European raw and semi-finished (or thread) silks, Italy's historic rivals to the east continued active. The city of Bursa, not far from Constantinople, had until the late 1600s weighed and taxed all silk cocoons, threads, and fabrics passing through the Ottoman Empire (successor to the Byzantine Empire from 1453). These included those from its own territories (which encompassed Syria, Egypt from 1516, and, by the mid-1550s, a corridor to the Persian Gulf including Baghdad and Basra), as well as those from Persia (under Safavid rule from 1502 to 1736) and China. The city's own weavers employed Italian techniques to produce some ninety types of luxury fabrics—from satins to velvets—and both Ottoman and Safavid Persian silks could be purchased there. Although the Venetians and Genoese traded with Bursa, the Russian tsar monopolized this trade, sending on raw

opposite The inclusion of gold thread in this silk *lampas*—woven in the 16th century, when the Ottoman Empire was at its greatest extent—suggests that it was made in an imperial workshop. It would have been weighed and taxed in Bursa.

above This 17th-century Safavid Persian silk makes lavish use of gold thread, which entirely covers the ground. The realistic rendering of flowers and animals sets it apart from stylized Ottoman designs, although both cultures were Islamic.

and finished silk threads to Finland, Sweden, Britain, and Holland—in effect revitalizing the old northern silk routes used by Viking traders. Although Bursa would remain important for its sericulture for another three centuries, until the late nineteenth century, a decline in Bursa's fortunes as a trading center began in 1595 with the Safavid conquest of Ottoman Georgia, Azerbaijan, Armenia, Herat, and Meshad—and thus the silk-producing regions around the southern Caspian Sea. This made silk processing and weaving the largest source of Safavid state income after 1600 and prompted their attempt, via Armenian merchants, to monopolize trade in their own silks and those from eastern sources. The Ottoman response was an embargo on Persian silks, lasting from 1595 until 1629. As a result, Dutch and English merchants already established in the Ottoman Levant competed for direct access to, and control of, Persian exports, but with little success; luxury cloths instead went primarily to central Asia and also to India, where Persian voided velvets and brocaded shawls influenced those made in the best workshops of the Mughal period (1526–1857).

Russia was another key player in the silk trade. Moscow remained a thriving center in silks of all nations, especially after about 1650, when Russia also traded directly with China (where the Yangzu Delta had become that country's most important silk region). In a period of fundamental change in the patterns of global trade, cloths and raw silks—including mulberry silk from Bengal—did arrive in Europe via seafaring merchant adventurers, including those who formed the English, Dutch, and Danish East India companies, all founded between 1600 and 1616. Nevertheless, Moscow remained a hub of additional silk supplies destined for Sweden (which did not form an East India company until 1731) as well as for weavers in the Rhineland, Vienna, Denmark, and elsewhere into the eighteenth century.

There was little to stop the growth of the silk weaving industry save the limitations on supplies of raw silk. The Portuguese establishment in 1498 of a sea route around Africa to the east gave Iberia direct access to Ming China and the damasked and painted silk satins that were to inspire imitations well into the nineteenth century. Yet the lure of more certain supplies of silk was ever present. The Spanish, for example, attempted—although without success—to introduce sericulture to the Caribbean island of Hispaniola as early as 1501 and to the Carolina coast in 1521–5. However, silk rearing was established in Mexico by about 1523 by, among others, Hernán Cortés, and by mid-century it had spread from Nueva Galicia (modern Guadalajara) to Yucatán and from Pánuco to Oaxaca. Although this initiative was abandoned in 1592 in favor of Chinese raw silk carried

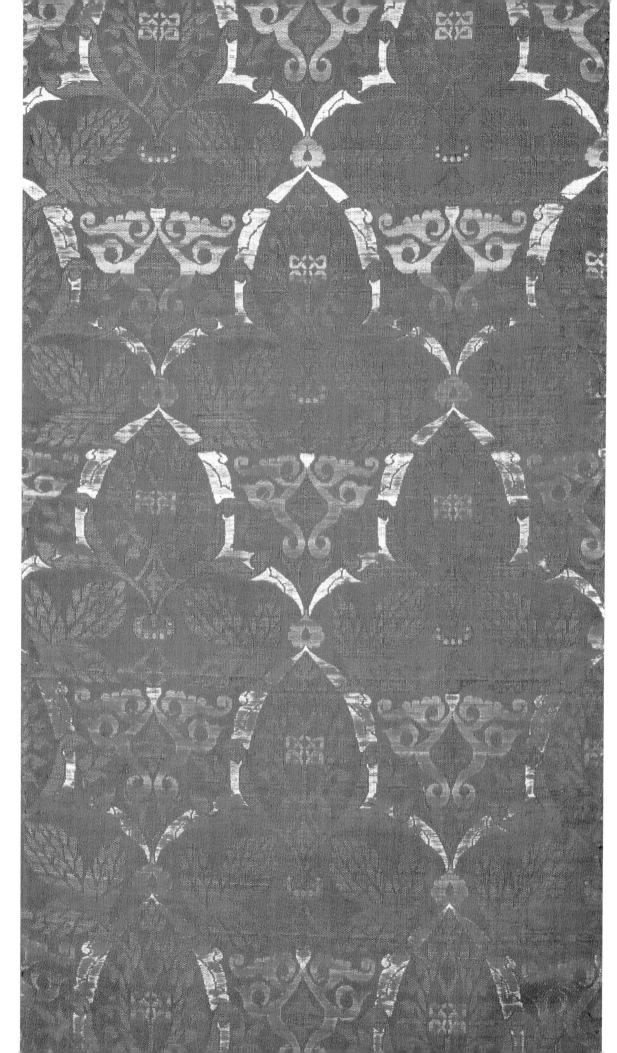

right This late-15th century silk tissue, or lampas, typifies the highly stylized Spanish "Moresque" patterns produced by Muslim weavers in Granada, where they served the Islamic Nasrid dynasty and their Christian overlords, as well as Jewish clients. Silks of this type still adorn walls in the palaces of Granada, Sevilla, Toledo, and Zaragoza; in the following two centuries such patterns were of influence in the Americas and later, as a result of mid-19th century design studies by Owen Jones, in Europe.

below The Jacquard loom, widespread by the late 1830s, prompted the weaving of pictorial silks. This example, a c.-1850 Lyonnaise silk *lampas*, with gold lamella and metal *filé* of various colors, incorporates a portrait of Queen Victoria.

overleaf A silk patchwork coverlet, made in Holland in about 1845, illustrates a variety of dress silks, all thought to be French.

to Acapulco by Spanish galleons sailing across the Pacific Ocean from the Philippines, it had instigated the weaving of velvets, satins, and taffetas in Mexico City before 1542, followed by Puebla and Oaxaca (by 1552), and finally, in Peru. During the next two centuries these workshops flourished and, in addition, encouraged the native population to process indigenous wild silks.[11]

A similar story can be told of British attempts to establish sericulture in North America, which began in Virginia, again unsuccessfully, in 1608—only a year after the founding of the Jamestown colony. Better results were obtained after 1623, but in general it was a pattern of "boom and bust" in every colony that was mandated to supply raw silk to England (where sericulture had also been initiated under royal decree, but did not take hold). Despite this, some limited hand weaving, predominantly of trimmings, was established in many colonies by the year in which independence was declared, 1776. It was this event that interrupted Benjamin Franklin's plan to establish Italian-style filatures, or silk-reeling mills, in Philadelphia.

Another thirty-four years would elapse before the first reeling mill was erected in the United States, in Mansfield, Connecticut; and yet another thirty-odd years before any large-scale silk manufacturing centers—initially producing sewing and embroidery threads—were established in the United States; of these Patterson, New Jersey, and South Manchester, Connecticut, would become the best known. Once again, immigrants were crucial, in this case largely from England.[12] The Napoleonic Wars had deprived Britain of its European and American markets, and, at their end in 1815, returning soldiers created a glut of labor, a combination of factors that was particularly damaging for many silk ventures. Little wonder, then, that Britain gave financial and technical assistance to Madagascar, when that island kingdom, under Radama I (r. 1817–25), introduced the rearing of *Bombyx mori*. French artisans, and merchants, had also been on the move since the beginning of the Revolution in 1789. By 1802 the population of Lyon was so depleted that Napoleon urged the return of weavers and began placing large orders to ensure the retention of skills in that city.

Into this period of upheaval, a new hand-operated loom was introduced: the Jacquard. An improvement on the draw loom, it was first exhibited in Paris in 1801 and further refined over the following two decades. The ribbon weavers of Saint-Etienne applied its principle to their hand looms in 1815, but it was not widely adopted in France until the 1820s, by which time it was also in limited use in England and the United States.[13] Despite this innovation, and the establishment of sericulture and silk weaving around the globe, the complexion of the silk industry retained much in 1850 that had been familiar centuries earlier. The principal centers of sericulture remained the same: Japan's increase in silk rearing, begun in 1700, had not yet enabled it to displace China as the foremost supplier of mulberry silk, and silkworm diseases had evidently not yet begun to ravage crops. Silk frame-knitting, broadloom weaving, and embroidering were still done by hand. Yet many changes were on the horizon, propelled in part by the important role silk had to play in social and political affairs, in art and interiors, and most importantly, in fashion.

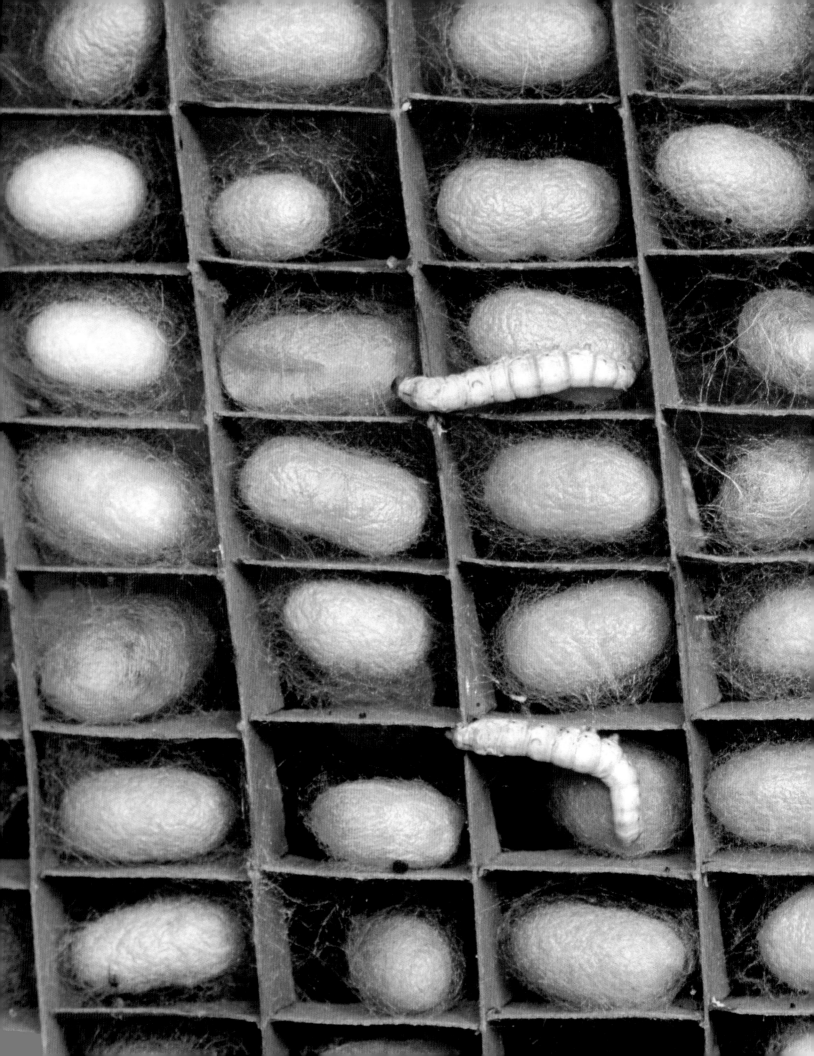

Sericulture

by *Silvio Faragò*

The silkworm

The silkworm is an insect, of the order Lepidoptera. The most widely raised type and the producer of the finest silk is *Bombyx mori*, or mulberry bombyx, a name that indicates the total dependence of this species on the leaves of the mulberry tree. Because the silkworm has long been domesticated by man and bred to augment the amount of silk produced, it is no longer adapted to life in the wild and is especially vulnerable to predation, so it depends entirely on the care and attention lavished upon it by its keepers.

Like all species of Lepidoptera, a silkworm undergoes a complete metamorphosis. When growth has reached maximum, the larva anchors itself to a support and closes itself into a silk cocoon, inside which it transforms itself into a pupa or chrysalis. This is the setting for one of nature's most astonishing transformations: after about ten days, the cocoon spun by a worm is split and a moth (or butterfly) emerges. Using an enzyme-rich liquid secreted from a small gland, the moth creates a hole between the filaments that form the cocoon, through which it emerges.

The adult *Bombyx mori* moth is a creamy white color, with two pairs of wings, and is about 5 centimeters (2 inches) long. The female is larger and slower than the male, although both have lost their original ability to fly. Like many other Lepidoptera, the silkworm moths have no mouth and do not feed. They live for only a few days: the time needed to mate, lay the eggs, and ensure the survival of the species. Their antennae are feathered, and the males are equipped with receptors that can localize a female at great distances.

Egg production

The production of raw silk requires the cocoons to be subjected to a drying process to make them storable and suitable for drawing. Alternatively, for the production of eggs, in genetics laboratories, the normal biological cycle is allowed to run its course, and the chrysalis completes its metamorphosis. As soon as they emerge from the cocoons, the moths mate and deposit their eggs, completing their life cycle.

The females lay about five hundred fertilized eggs, each with a diameter of about 1 millimeter (less than ⅟₁₆ inch). Initially, these

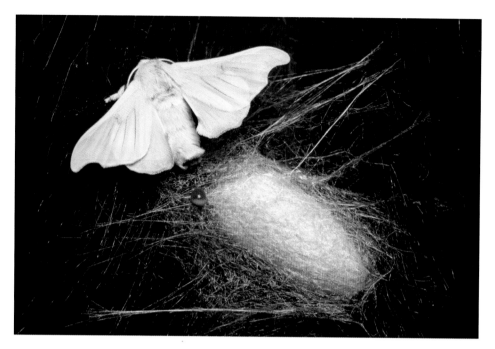

are yellow, though after only three days they turn a dark gray. Each female's eggs are kept separate by encircling them with cardboard or metal, so that they can be examined for disease or poor egg quality. Then only the suitable eggs are incubated, in specially equipped rooms, at a temperature of 25°–28° C (77°–82° F) and relative humidity of 75–80 percent, for eleven or twelve days. The eggs are sold in boxes of 20,000.

PREVIOUS SPREAD A specially designed cardboard support containing silkworms and newly spun cocoons.

TOP A *Bombyx mori* silk moth emerges from its cocoon. It is thought to descend from the *Theophilia mandarina*, a species still present in Asia and producing a very similar cocoon and filament.

ABOVE Silk moths lay their eggs, each within its own ring.

LEFT At the INRA silkworm-breeding unit in Lyon, a foreign gene is injected into a *Bombyx* egg to create a transgenic silkworm.

Bombyx mori breeding

The breeding of silkworms absorbs a great quantity of natural, human, and technical resources. Among the principal resources are the eggs, without which the life cycle cannot begin. These must satisfy strict sanitary and production specifications, guaranteed by the genetic centers that specialize in their production. The production of hybrids of high quality requires, to begin with, selected pure races that display a set of specific positive characteristics. Genes from one race can be injected into another *Bombyx* egg. The races used are hybrids, resistant and productive and free of pébrine (*Nosema bombycis*) and other pathogenic micro-organisms. At present little used, a production process for hybrid eggs is nevertheless one of the principal obstacles to the spread of silkworm breeding to new geographical areas, because many countries interested in developing this industry are unable to obtain these particular bloodlines and the entire production know-how.

The insect we know today conserves signs of its long history in its genes. Over many centuries, the *Bombyx mori* species has differentiated into several different races, quite distinct from each other, each of which spins cocoons of a characteristic shape, size, and color. One of these mutations—perhaps the most important one—concerns the number of life cycles the species completes in one year. The number of generations per year, or season, which is called voltinism, depends on the silkworm strain and on environmental conditions, particularly temperature.

Strains that produce only one generation in a year are univoltine and are typical of temperate countries. In this case, the eggs enter a state of long hibernation. The bodily functions of the embryos come to a near-total standstill (diapause). They must be stored for several months at 5° C (41° F), simulating the winter season, in order to destroy the diapause hormone and hatch. From the first days of winter, they will be kept at this low temperature until the following spring, when they will hatch, beginning the cycle once again. By contrast, those living in tropical areas have developed "non-hibernating" eggs, which begin their embryonic development as soon as they are laid, making it possible to raise many generations in a single year. These strains are called polyvoltine or multivoltine.

Wild Lepidoptera

Bombyx mori probably descends from a wild moth known as *Theophila mandarina*, which is still present in various areas of Asia. Paleontologists confirm that man collected and used the cocoons of several of these free-ranging moths in the Neolithic era. The thread obtained was used to make ropes, belts, and simple fabrics. Many cultures were familiar with wild Lepidoptera and their cocoons. In Europe, long before the introduction of Chinese silk, small quantities of silk were produced on the Greek island of Cos, made from the cocoons of a wild moth, the *Pachysapa otus*, which the Romans called *Bombycinae vestes*. Today, the wild silkworm most cultivated in Asia and South America is the *Antheraea pernyi*, which produces tasar, or tussah, silk. It is semicultivated, and the larva feed on the leaves of the arjun tree, asan, or oak.

Insects have rigid exoskeletons, which must be shed periodically during the larval stage. When the covering becomes too tight, the insect discards it and forms a new one, which is at first soft and elastic, permitting a period of ulterior growth. The phenomenon is known as molting, and it is repeated several times before the larva reaches its maximum development. The period between two molts is called instar. The body, like that of other insects, is segmented, consisting of three parts: head, thorax, and abdomen.

The head is round and dark, with a mouth made for mastication which allows the silkworm caterpillars to devour leaves rapidly. The thorax has a slight hump on the dorsal side, and the six legs are attached to the ventral side. The abdomen, the largest part, is cylindrical in shape, with many folds and, toward the end, a small, inoffensive spine. As in *Bombyx mori*, we find some dark spots in the shape of a quarter moon. Along the sides of the body are visible stigmata, little air ducts through which the silkworm breathes. The last few segments of the abdomen also have five pairs of false legs, which, when used in combination with the thoracic legs, permit the silkworm to climb with ease.

There are at least five hundred other wild Lepidoptera, including the ailanthus moth, *Samia walkeri*. This species is used in China to produce a coarse grade of silk. Along with the Chinese ailanthus tree, it was exported to the United States during the mid-nineteenth century, in an attempt to establish sericulture there. Since at least as early as 1861, its glistening wings, shown in detail overleaf, have been sighted in New York City. Another legacy of sericulture in New York is the name of Mulberry Street, a thoroughfare in that city's "Little Italy," once home to many Italian immigrants skilled in silk processing.

Domestication, nutrition, and habitat

The domestication of the ancestor of the silkworm, about five thousand years ago, is ascribed to some agricultural communities in China, whose members raised silkworms in their houses and devised a complete system for their care and for the production of silk yarn and precious fabrics. It was an important and extraordinary turning point, which led to a primary role for silk and its producer, *Bombyx mori*. Since that time, the relationship has become increasingly close, and today the dependence is complete.

RIGHT Detail of a wing of an American ailanthus moth.

OPPOSITE, LEFT AND RIGHT
The traditional habitat of the silkworm is illustrated in woodcuts of c. 1800 by the Japanese artist Kitagawa Utamaro. He depicts women harvesting mulberry leaves (right) and preparing these amid trays of feeding silkworms (left). Until the third instar, the little caterpillars are raised in similar specially designed structures, rigorously controlled and managed by skilled personnel.

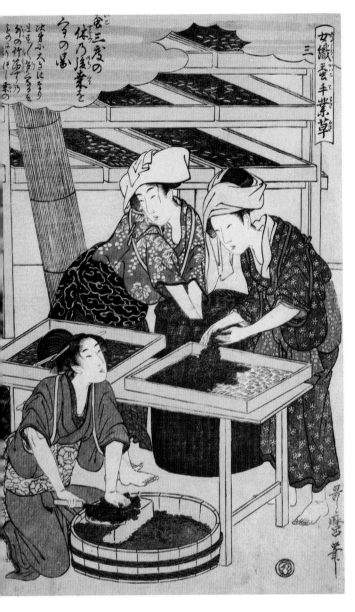

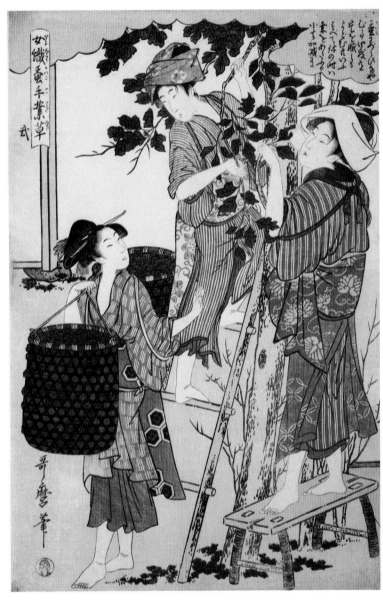

In wild species, the adult moths can fly and move about, but they do so at night, when there is less chance of being eaten. Following mating, the female deposits the eggs in a concealed area, on twigs, where they pass the winter in a dormant state. Thus, like all wild creatures, these insects are perfectly adapted to live in their natural habitat. However, if we were to attempt to raise silkworms directly on mulberry trees, in the open, they would soon be eaten by birds or washed away by rain. This is because, as with many other domestic animals, which rely on humans for protection, their defense systems are no longer effective.

Farmers raise silkworms in clean sheltered areas, barring access to predators, controlling temperature and humidity, airing out the rooms regularly and feeling the silkworms frequently, sometimes up to six times a day. Until the third instar, the little caterpillars are raised in specially designed structures, rigorously controlled and managed by skilled personnel. Then, they are distributed among small cultivators, who continue to raise them in structures of various types, all designed to provide optimal environmental conditions.

The mulberry

The silkworm is a monophagous insect, meaning that, like its progenitors, it feeds on the leaves of a single type of plant: the mulberry. The type of mulberry used in silkworm cultivation is an Asian tree or shrub originating from the regions surrounding the Himalayas, which, thanks to its extraordinary adaptive ability, has spread far and wide, becoming almost ubiquitous. There are about twenty species in the genus *Morus*, and though they present significant morphological differences, they can all be used to feed silkworms, to a greater or lesser degree.

Their leaves are whole or lobed, with toothed or serrated borders, smooth on the upper side and covered by delicate hairs underneath. The flowers form separate female and male clusters; the latter, elongated and

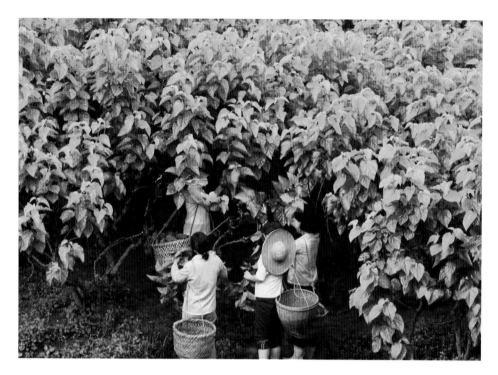

pendulous, are called aments, or catkins, while the former are rounded and become succulent and juicy fruits.

Mulberries are traditionally grown in rows along the borders of fields and beside country roads. This is the norm in temperate countries, whereas in countries with ample water and land to dedicate to this use, such as those in subtropical climes, a more intensive form of cultivation is now practiced. One hectare (2 ½ acres) of land cultivated with mulberry trees permits the raising of about four hundred thousand silkworms, which translates into a production of 700 kilograms (1,540 pounds) of fresh cocoons, which can be spun into 100 kilograms (220 pounds) of silk.

The biological cycle

The silkworm is a holometabolous insect, meaning that its life cycle includes the stages of egg, larva, chrysalis, and adult. The newly hatched worms are small and dark; after ten days they take on a whitish color. During growth, they molt four times. During each molt, the silkworms are immobile and must not be touched or disturbed in any way. A larva measures 8–9 centimeters (3–3½ inches) at maturity; since hatching, its weight has increased by eight thousand times.

Having reached its maximum size, the larva stops eating and takes on a yellowish,

slightly transparent color. These signs indicate that it will soon form a cocoon. The breeders call this the "mounting" phase. The larvae climb up onto supports placed in their cages, fasten onto them, and spin their cocoons. The supports provided for this purpose are of various kinds, including vegetable matter, such as twigs and straw, and specifically designed plastic or cardboard structures. In Thailand the support is often a large shallow basket with concentric interwoven "walls," a detail of which is shown, right.

The silk filaments are produced by two special glands, one on each side of the intestine, and are extruded through a fissure located under the mouth, called a spinneret. The core of the silk fiber is composed of two strands of fibroin proteins, which are bound together by "glue" proteins, called sericin. Initially moist, the filaments of semiliquid proteins dry quickly in the air and harden. Using a throwing motion of its head and a slow, circular motion of its body, the silkworm takes about two or three days to spin its cocoon, during which time it might turn as many as 200,000 times.

The finished cocoon is constituted of a single thread, which can be as long as 1,200 meters (1,308 yards). Depending on the species, the color of the cocoon may be white, yellow, pink, or green.

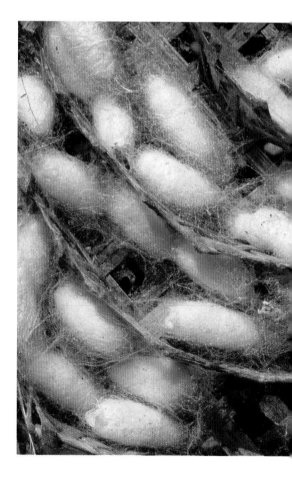

Preparing the cocoons

After harvesting, it is necessary to kill the chrysalis before metamorphosis is completed and the moth pierces its cocoon. The drying process also eliminates moisture, thus prolonging the possible storage time. Drying in hot air is the most common procedure, although sun drying and steam stifling are still used, especially in tropical and subtropical countries, where multivoltine cocoons are more common.

Silk is a natural product and is therefore subject to several possible variations due to many natural circumstances. Yet to obtain a finished product of high quality, drawn silk must be as uniform as possible and free of defects. To this end, it is crucial to select with care the cocoons to be used, eliminating not only the damaged ones but also the smallest and largest ones, as well as the double cocoons, spun by two worms simultaneously. Double cocoons are used for manufacturing a particular silk yarn called "dupion" or "dupioni". Defective cocoons that cannot be used for subsequent processes include those that are stained, malformed, flimsy, or pierced. A cocoon may be pierced because the moth has emerged or as a consequence of attack by a parasite.

A preliminary sorting is done by the farmers who have cultivated the silkworms, but a second sorting is necessary before reeling. The selection is done primarily by hand and requires many skilled workers. Since the mid-twentieth century, this operation has been carried out—in the most advanced plants—using backlit ground-glass plates, which permit the identification and elimination of cocoons with internal irregularities or which have an extra thick or extra thin skin. Also, a process called peeling (see page 235) is necessary.

The cocoons are then automatically sorted according to size (riddling). It is known that the filaments of larger cocoons have a greater thickness (although they are still extremely fine) than those of smaller ones; as a result, it is necessary to eliminate the latter to obtain silk of uniform high quality. The discarded cocoons will be used in the manufacture of silk waste.

Drawn thread formation

The cocoons, selected in the previous stages so that they will be suitable for spinning, must first undergo a process called cooking (maceration) which is intended to soften the sericin and to allow a fast and uniform reeling. Traditional pan cooking is carried out using open vats, in which the cocoons are immersed for a few minutes in boiling water, using a perforated paddle. An expert operator decides how many minutes the cocoons must soak, depending on the aspect of their exteriors. Machine cooking, which requires much greater investments, consists of a succession of treatments which yield cocoons that are softened uniformly. Cooking is very important for subsequent reeling. In fact, a high proportion of waste is produced when cooking has not been performed properly. Overcooked cocoons increase the number of breaks during reeling, while undercooked cocoons do not unravel easily, reducing reeling efficiency. Brushing, the process by which the reelable end of the cocoon filament is found, also produces a considerable quantity of filature waste.

Once the reelable ends of the filaments are secured ("clearing"), the prepared cocoons are transferred to the reeling basins. In this process a certain number of cocoons are unwound simultaneously and the obtained filaments are grouped together to produce a single thread. The end filaments of the cocoons are captured by the machine's feeding device, the threader, and transferred to reelers. Once the desired weight has been obtained, silk thread is removed from the reeler and is subsequently laced and folded in a skein. An automatic system, with submerged cocoons, designed in Japan, is now the most widespread. Nevertheless, the *charka* system, where silk is drawn by the traditional mechanical system with "floating cocoons", is still used in India. Hand reeling is still practiced in some southeast Asian countries, such as Thailand.

Finally, the reeled threads are thrown (see pages 236–37). Throwing consists in twisting two or more threads together to give the obtained thread a greater covering capacity than a single thread of the same title. The twisting operation prevents the silk

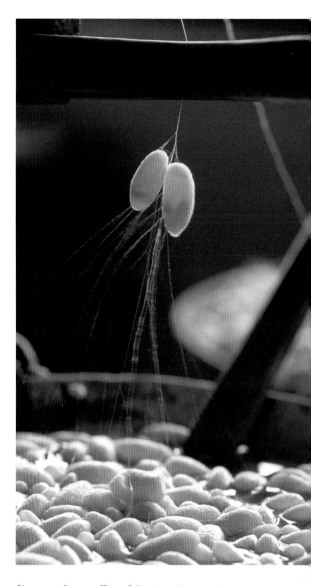

filaments from ruffling following degumming and dyeing, resulting in a stronger thread. Further, by varying the number of turns and throwing together threads already twisted (double-thrown thread of the organzine type), threads of greater or less softness and lustre can be obtained. Except for some fabrics that use raw silk, or for the warp of certain textiles, silk is sold twisted.

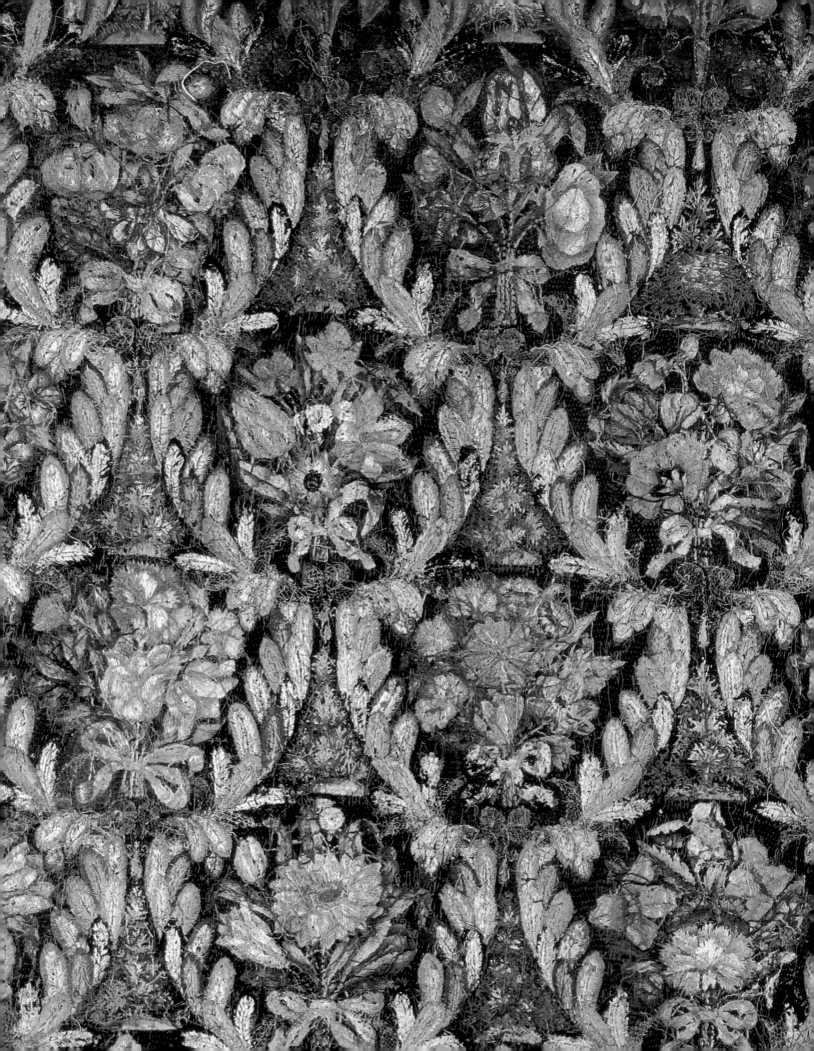

Silk in Use

*Satin underclothing…scarlet tunics and hoods, sleeves with
silk stripes, shoes edged with red fur, hair carefully arranged on
the forehead and temples with the curling iron – this is the modern
habit. Dark veils yield to headdresses white and coloured, sewn
with long ribbons and hanging to the ground; fingernails are
sharpened like the talons of hawks or owls seeking their prey.*

ST. ALDHELM DESCRIBING NUNS IN EARLY EIGHTH-CENTURY ENGLAND

Much that we know about the way silk was used in the past comes not only from surviving images and objects but also from texts. Among the latter, many are complaints about excessive finery. The example above, written by an abbot of Malmesbury and bishop of Sherborne, who lived from c. 639 to 709 and was a kinsman of Ine, king of Wessex, describes the extravagant self-indulgence that could be conveyed by silks. They were used for thrones, altars, banners, the finest of clothes, and the most luxurious of accessories. In all these guises, they not only provide evidence of status and the existence of trade in silk but also illustrate the ceremonial displays to which textiles have always contributed. The most ancient of such displays formed part of nomadic life, in which both wandering and hospitality are sacred acts. Silks—light, strong, and highly prized—were ideal both to transport and to transfix the beholder. From these qualities the diverse uses of silks in many cultures evolved.

Setting the stage
Over the past centuries, silks have become important within contexts that vary from the religious to the economic. Often the two areas were connected; a modern Chinese scholar, Xinru Liu, notes that under the reign of the Byzantine emperor Justin I (A.D. 518–27), the empire "supported the Ethiopian war against the Jewish Himyari kingdom of Yemen in the name of Christianity. Historians agree that the struggle between the Christians and the Jews was on account of the silk trade." Xinru Liu's study of the significance of silk to religious practice finds parallels between Buddhism and Christianity, in particular. Both place great emphasis on the afterlife, or "other world." Yet both displayed, from early in their existence, considerable regard for worldly goods, including silk; for example, when Sui and Tang China and the Byzantine Empire "effectively monopolized and regulated the production and transaction of silk, restrictions on exquisite silks were implemented through the law. The purpose was essentially political—both China and Byzantium enacted a set of codes for clothing to distinguish their bureaucratic echelons and ecclesiastical hierarchy, and thus consolidated the political order in their countries."[1] As already noted, when dealing with outsiders—whether nomads, barbarians, or states, hostile or friendly—rulers often used silk textiles and clothing as negotiating tools; at the same time, cloths were also dispersed, irrespective of political boundaries, by religious rituals that incorporated the use and donation of silk. "As a result, government monopolies on its production and use, which were already difficult to enforce, began to give way. The relaxation of controls, in turn, allowed the volume of the trade to increase and facilitated the use

opposite Until about 200 years ago, grand beds were not hidden away but dressed in finery, intended as much to impress as to keep the owners warm. Shown here is a detail of a set of bed hangings from the northern Netherlands, entirely embroidered with silks and gold thread on wool and executed between about 1650 and 1700.

below The rich material culture of Buddhism is epitomized by this c.-700 bronze Buddha and Adorants, all of whom are robed in silks. From Kashmir, it also preserves in its cushion a rare glimpse of the Sassanian-Sogdian roundel-style silks that are known to have been transported to this region by pilgrims.

of silk as currency. Collectively, these changes enabled silk to become a global commodity."[2]

One of the most notable examples of the impact of religious beliefs on the transmission of silks across long distances is revealed in the dynamic relationship among India, Tibet, central Asia, and China (and adjacent regions to its west and south) that arose through the spread of Buddhism. Originating in northwestern India in the years around 500 B.C. and India's official religion by the third century B.C., Buddhism had already spread to China by the first century A.D. There, it achieved its "golden age" under the Tang (618–907), having previously reached Japan by about 600. Cave temples at central Asian sites along the silk routes, such as

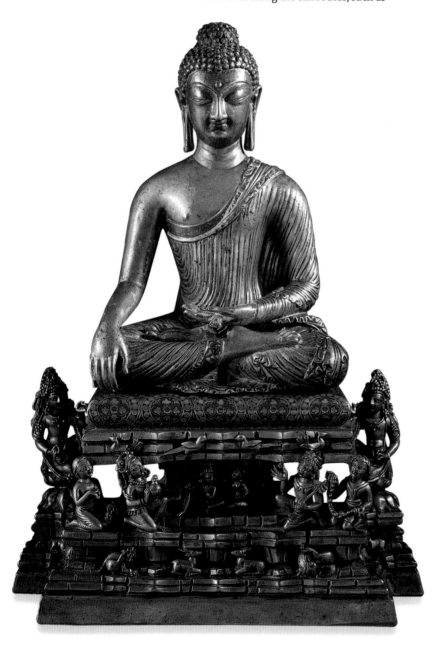

Astana, at Turfan, and Dulan, in Quinghai, testify to the regard for silk that was imbedded in Buddhist ritual by the Tang period. Those at Dunhuang were carved out between the fourth and eleventh centuries and contain silks that marry imagery and techniques originating from both China and India, as well as central Asia itself: kesi, painted silk, and striped silk are combined in the remains of an eighth-century Buddhist banner, while brocades, damasks, twills, satin weaves, and embroidered and printed silks are juxtaposed in a monk's robe, or *kasaya*, its patchwork construction intended to denote humility. The faithful earned merits by donating silks to monks or envoys embarking on pilgrimages to India, and these pilgrims earned merits for themselves and their patrons by gifting silks as they travelled. The amounts thus exchanged were prodigious. On his way to India in the early 600s, for example, the Chinese pilgrim Zuanzang stopped in Turpan, where the local king gave him more than 1,000 bolts of silk—all of which he then donated along his way to Buddhist establishments and to various authorities in order to ensure safe passage. Tang emperors bestowed silks and silken robes on Chinese and Indian monks—among the latter, most notably, to the Tantric teacher Amoghvaira. After Amoghvaira's arrival in China in c. 720, observes Xinru Liu, he "received so much silk from the emperor that the pieces piled up like a hill." Even in death, it was believed, silks obtained merits; and these were listed in inventories deposited in graves. Bundles of silk yarn held in the hand were also noted; these—in one instance, nearly 30,500,000 meters (more than 1,000,000,000 feet) long—were intended to form a rope for climbing to heaven.[3]

Despite silk's eventual long-term association with Buddhism, its use by Chinese Buddhists was not without some initial controversy, because mulberry silk, which predominated in that country, violated the prohibition against taking life. The situation among Indian Buddhists was somewhat different. Although few early silks have survived in India, literary and artistic evidence documents its widespread use throughout society by the Gupta period (fourth to sixth centuries), including by monks, who had previously worn only cotton, the abundant fiber of the subcontinent. Significantly, however, a contemporary account describes monks' robes as of "rough silks," meaning those made from the broken cocoons of wild silkworms, which were not killed in the process. As devout Buddhists, the earliest Burmans of Myanmar, the Pye (500–900), refused to wear mulberry silk for this reason; they were known as weavers of fine cotton cloth. But cottons were rare and costly in China at this time—not a practical alternative to silk. "Facing this dilemma, I-ching tried to persuade

Painted silk and bands of *kesi*, or silk tapestry, make up this headpiece of a Buddhist banner, which was found in Cave 17, in Dunhuang, and dates from between 750 and 900. The finely worked *kesi* bands are 2.7 cm. (just over 1 in.) wide, within which are 60 two-ply warp threads.

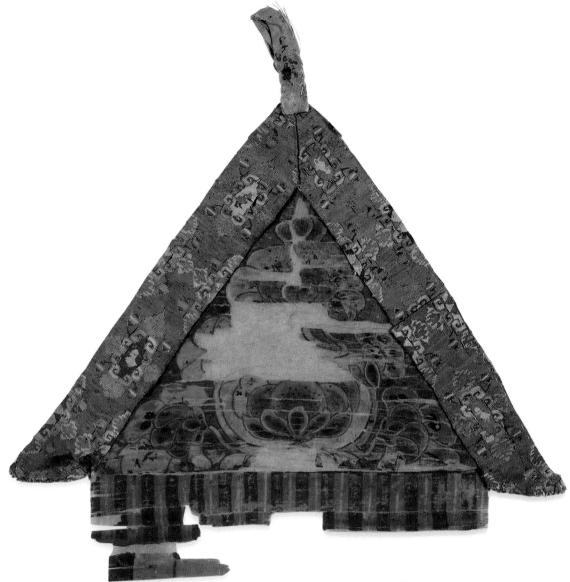

his fellow Chinese monks to accept silk. . . . As for the problems of killing silk worms, I-ching argued that only deliberately killing them would create one's [bad] karma – the negative score for one's future lives" and that it was the good intentions of the donor of silk that should be accepted.[4] This appears to have solved the problem, and thereafter, like the Taoists, Buddhist monks typically wore robes of silk. One legacy of this debate did, however, remain: in modern India, now predominantly Hindu, silks made from broken cocoons are still highly prized, especially by Vaishnavite Hindus (devotees of Vishnu) and Jains.

Ancient Vedic texts enjoined Hindus to use silk on ceremonial occasions, and many Hindu leaders continue to hold that only Indian silks and those made without an admixture of other fibers are suitable at these times. This gave the indigenous silk manufacturing industry what was described, in about 1900 by an Indian writer on Bengali silks, as "a peculiar vitality of its own." Noting that Benares embroidered handwoven silks were extensively used by the higher and middle classes and

those of Bombay (made on European principles and mainly with Chinese mulberry silk) by middle-class women, the writer went on to emphasize that "the whole rank and file of the Hindu population . . . have to use indigenous silk fabrics on certain occasions, however coarse or cheap these fabrics may be, and it is for this reason that there is a large internal trade in silk fabrics."[5] Although the above-mentioned Benares silks are no longer the most expensive of Indian's sari cloths, they did incorporate, at their most luxurious, metal brocading threads, producing, in effect, a variant of the Mongol silk *nasij*, laden with gilt thread. Customarily made of silk from nearby Bengal, many still contain motifs of Islamic and Mughal origin; indeed, the weavers by tradition are Muslim. (There is irony in this fact, since some followers of Islam wear half-silks only, while other sects do not allow men to wear silk at all.) Benares silks encapsulate the exchange of cultures as readily as do the Buddhist caves along the silk routes, coming as they do from a city where several faiths meet. Although Varanasi (as it is now called) is best known as a holy city for the millions

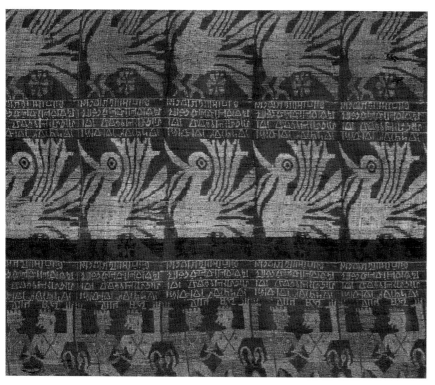

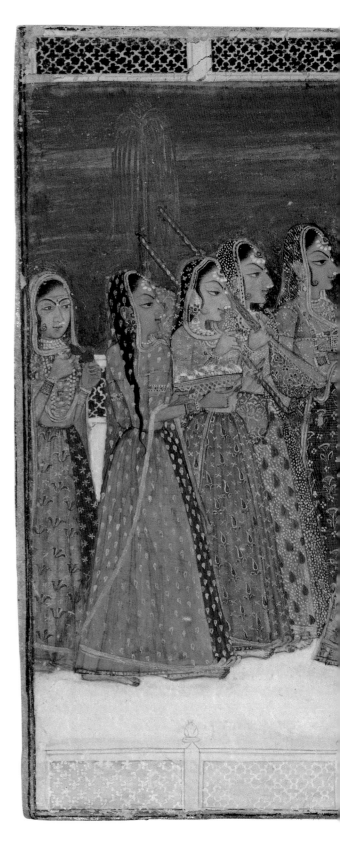

above This detail of a Vaishnavite silk *lampas*, or *Vrindavani vastra*, was woven in Assam, in north-eastern India, between about 1685 and 1715. Set into its red lac-dyed ground are two rows of *Bakasura*, the crane demon, and another of crowned monkeys in armed combat. It was originally a lining for a loose robe.

right The rulers of Kishangarh, in India, were followers of the 15th-century Vaishnavite sage Vallabhacharya, who promised salvation to those who worshiped Krishna. The role of richly worked silks in the ceremonial splendor of this cult is captured in a gold and watercolor painting of 1782–88.

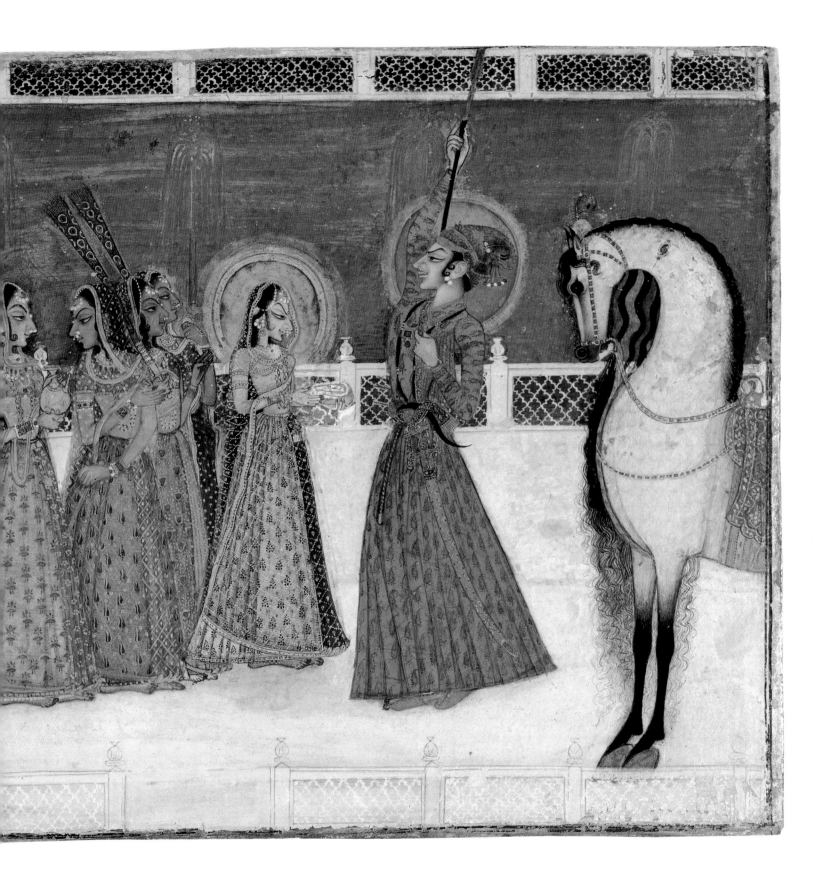

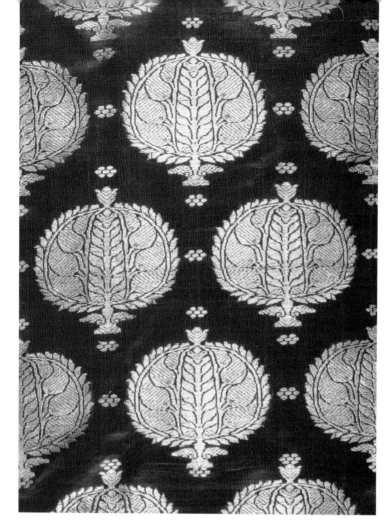

above Eastern India has for centuries been a center for silk cultivation and weaving. In Uttar Pradesh, Varanasi (or Benares) remains known for its distinctive designs based on Mughal patterns, such as seen in this detail of a man's silk turban cloth or sash. Enriched with gold threads, it was woven in the late 19th century.

opposite Considered the finest example of medieval embroidery surviving today, this orphrey (detail) depicting the Tree of Jesse was worked in England between 1315 and 1335. Stitched on a linen ground, the silks are shaded to suggest contours, while the gold threads are couched in decorative patterns.

of Hindu and Jain pilgrims who flock there to bathe in the Ganges, it also attracts members of other religions. A large mosque stands in the city, and nearby is one of the four important Buddhist pilgrimage centers in India, Sarnath, where Buddha is believed to have preached his first sermon. Within this context, the still-handwoven silks of Varanasi are more than souvenirs of a religious journey, but rather powerful reminders of the antiquity and cross-fertilization among faiths of this region.

Christianity, too, has long associations with silk. Whether or not it was Nestorian monks who introduced sericulture to Constantinople, according to the legend, the cloth itself played an important role in the visual aspects of the new faith. Not only the celebration of the Mass but also the various rituals surrounding the cult of saints and their relics—a feature of both the Orthodox and the Roman branches of Christendom from the ninth century—entailed the use of silk vestments. The splendor of some of these vestments is evident in the mosaics, frescos, and, later, the religious oil paintings of western Europe, as much as in the arts of the Orthodox world. The most coveted of vestments between about 1225 and 1350 were of *opus anglicanum*, or English work, which was closely worked in silk floss and metal threads. These serve as a reminder of the great contribution of

embroidery to ecclesiastical silken spectacle. Between 1238 and 1260 King Henry III of England purchased many such items from Adam of Basing: "chasubles, copes and miters – or the decorative elements to adorn them, destined to be presented by the king to esteemed clerics visiting his court or to churches visited by the king."[6] The Vatican's inventory of 1295 is dominated by *opus anglicanum*, some actually made in England and other examples made by English embroiderers in Italy. From the fourteenth century, there were competing centers of ecclesiastical embroidery, such as Florence. From this period increasing numbers of vestments survive, attesting to the gold and silver trimmings, precious stones, and silk embroidery that were lavished on already sumptuous woven silks and velvets.

When the age of colonization began in the late fifteenth century, this taste for embellishment accompanied the Spanish and Portuguese missionaries. It was absorbed in all the countries where their influence was profound, most notably in Latin America. In time, some of these missions developed their own silk enterprises; richly brocaded silks were woven for export during the eighteenth century by a Jesuit community in Portuguese Macao (at 1557, the earliest European settlement in China). As in Buddhism, private individuals also donated silks to the church, although in the more worldly late Renaissance and afterward, this was often after these fabrics' fashionable life had ended, rendering them undesirable for costume but still appropriate for religious vestments. In fact, such "heirloom" silks became so esteemed that many Spanish weavers came to specialize in them. Later enjoying a revival in nineteenth-century Lyon, where they were called *ornaments d'église*, the new silks replicated earlier patterns especially for church use.

The processional element in religious ceremonies ensured that silks were widely seen. Similarly, they have traditionally enhanced royal, military, and civic processions, not only as clothing but, importantly, as flags and banners. Even plain silks symbolized authority, and many professions have come to use silk as a mark of distinction. For example, a direct link between rank and silk can still be found in the British legal system: a senior barrister who is appointed a Queen's (or King's) Counsel is said to be "taking silk" because he or she abandons their cotton robes for the silk ones that denote their privileged position. The use of plain silks by Shaker communities in Kentucky, Ohio, and Tennessee—and by similar sects elsewhere—was a mark of distinction of a different sort. It was emblematic of their self-sufficiency when, at various periods during the nineteenth century, they engaged in sericulture (some of these ventures even continued until the Depression).

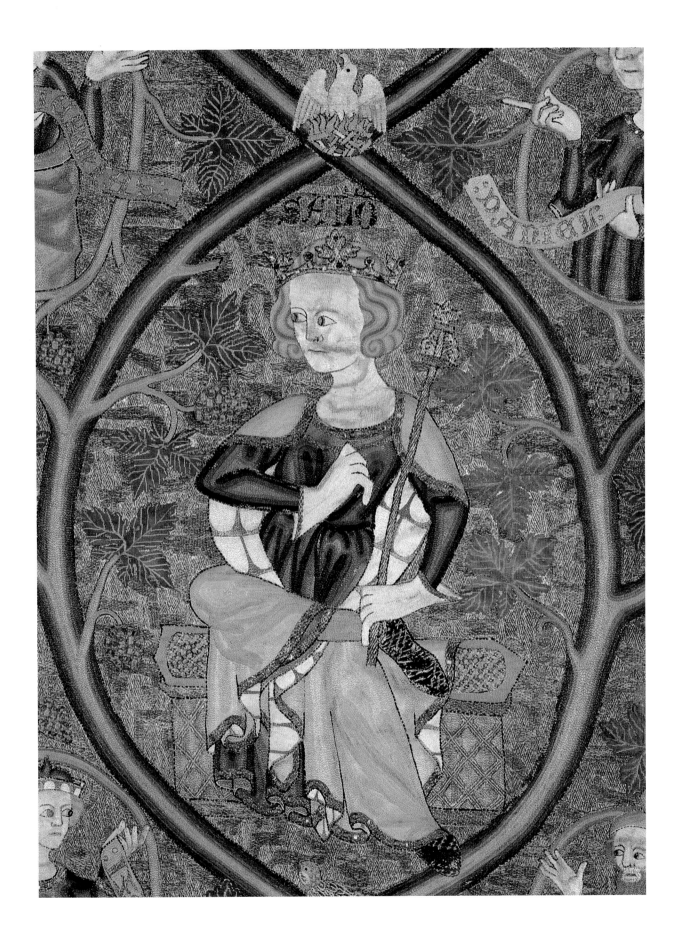

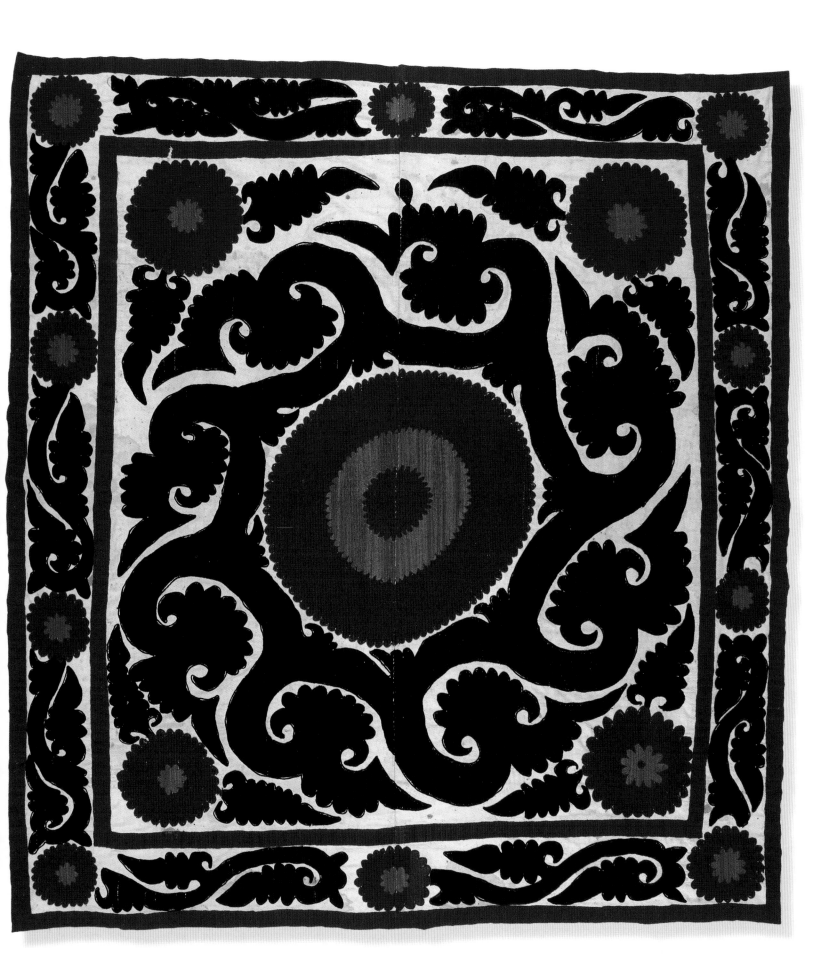

Bridal garb, too, suggests an elevation of status,
and in many cultures around the world it is traditionally
of silk. Silk bridal garments are essential at Hindu
weddings; and documents dating from medieval times
attest to their equal importance for Jewish brides. North
African traditions are especially well documented.[7]
A painting by Delacroix, inspired by his attendance
at a Jewish wedding in Tangier in 1832, preserves an
impression of the rich effect of the bride's dress of velvet
overlaid with gold braids and embroidery, with voile
sleeves and a long, fine silk headscarf, or *festoul*, flowing
down her back. A sheer white veil over the face is an
element of this ritual attire—as it is still at many
weddings, whether Jewish or Christian.[8] The assumption
that a bride warrants the most extravagant expenditure
is also preserved in haute couture catwalk shows in
which the final presentation is a wedding dress.

The wedding veil is the last vestige in the west of
a tradition still current in many cultures around the
globe, in which lengths of cloth are presented as part
of a much greater variety of ceremonies:

"Cloth is often imbued with a sanctity of its own.

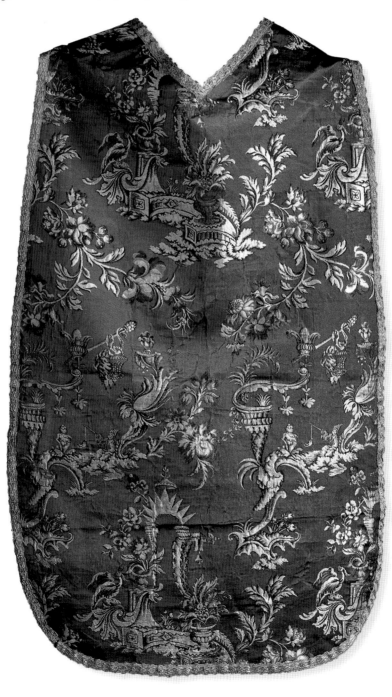

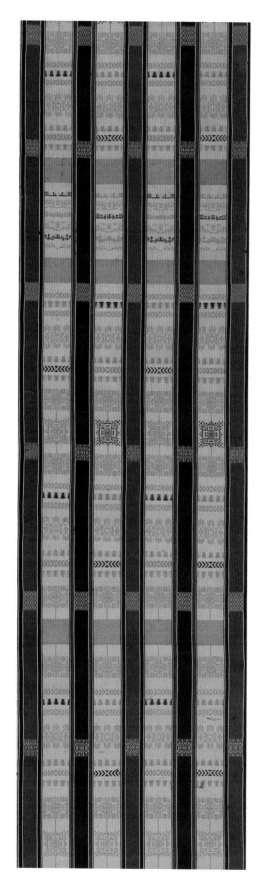

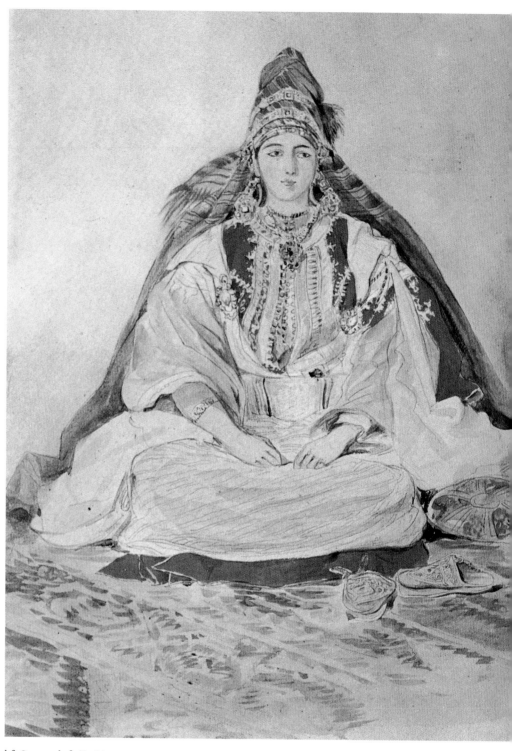

left One panel of a Tunisian
wedding veil, this silk was
woven between 1850 and
1900. Its decorative motifs
are influenced by Andalusian
design, and the inscription
translates, "God makes our
good fortune increase and
our happiness endure."

above A Moroccan Jewish
bride, sketched by Delacroix
in 1832, wears attire donned
in strict order as part of
a long wedding ceremony.
Her mitre-like headdress
captures beneath it a fine
silk *festoul*, or sash, similar
to the example shown left.

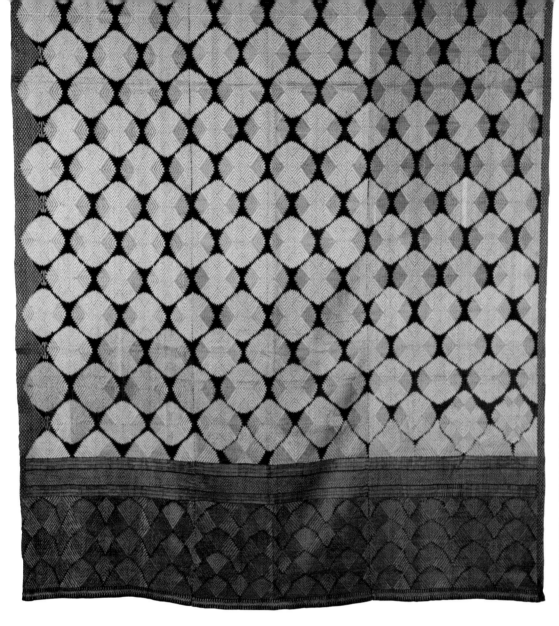

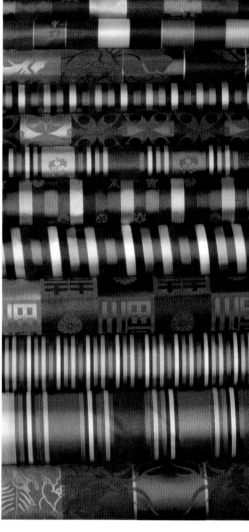

In the unsewn form, especially, it is considered holy or sacred and gifts consisting of lengths of cloth have deep-rooted resonances. . . . It also constitutes an important form of social interaction, conforming to relationships dictated by family and community ties."[9]

A related respect for cloth can be seen in the Japanese kimono, an ancient garment form that is constructed from uncut loom-widths of cloth. This custom not only has maintained the weaving of narrow-width silks especially for the kimono, but also has had another effect. By the 1880s, Japan had supplanted China as the largest supplier of raw silk, and by 1938 it produced 76 percent of the world's output of mulberry silk; by 1978, due to industrialization, this had dropped to 32 percent, and by 1996 to 0.03 percent. Yet Japan today consumes the greatest amount of silk per person in the world.[10] Despite a decline in the use of the kimono, more than nine centuries of its significance within Japanese culture has ensured that the associated appreciation for the noblest of kimono cloths—silk—has perpetuated a consumption of this fiber surpassing that of any other nation.

The power of silk as a religious and social symbol is matched by its monetary might. In China, as we have seen, it was used as currency two thousand years ago, and it continued to serve this purpose there until the late 1500s, when silver from New World mines entered the Chinese economy.[11] Elsewhere, silk was for many centuries closely intertwined with the development of individual fortunes, powerful dynasties, and long-lived banks. For example, there was the Bonsovi family of Lucca, who were merchants and bankers, as well as dealers in silk, among other items. William Servat of Cahors, in southern France, was a silk, spice, and wine merchant who lent money to the English king in the 1280s and ran the bishop of Durham's mint in 1300–02. The founder of the Cossimbazar raj family, influential

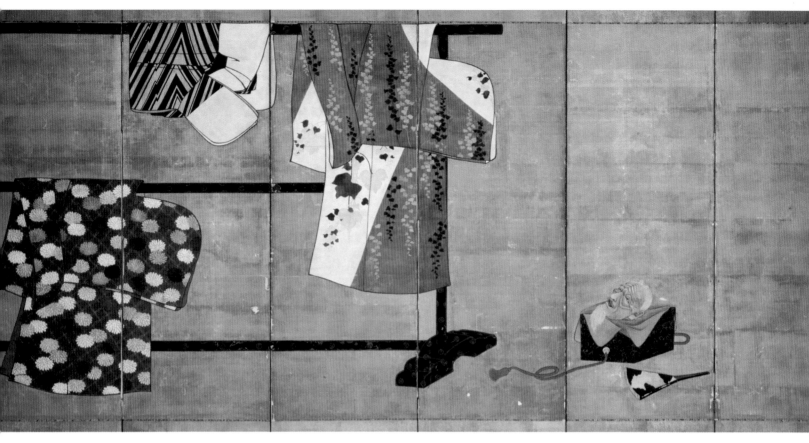

above Three kimono are depicted on this 18th-century Japanese six-leaf screen, painted in *sumi* color and *gofun* (Japanese chalk) on gold silk.

right This 1816 sample card of silk plaids, intended for scarves and shawls, illustrates one aspect of the production of Salomon Escher, one of an extended family in Zurich involved in silk manufacture from 1710 and, by the early 19th century, in banking.

opposite Nakajima Kiyoshi, a fourth-generation kimono fabric weaver, lays out cloth for cleaning and bleaching in the snow in Shiozawa, one of the most important remaining kimono-textile villages in Japan. In 2005, some 12.5-m. (approx. 13⅝-yard) silk lengths cost about £25,000.

in Bengal in the eighteenth century, was Cantoo Babooj Kantababu, a salt merchant; however, his "family business in silk," according to the Oxford Dictionary of National Biography, "was much larger.... The family had depended on the silk trade for 100 years. Their fortunes rose with the importance of silk." Calcutta's Paikpara family are descended from Ganga Bovind Singh, the son of a Bengal silk merchant, who was the revenue administrator for the East India Company from 1765 to 1786. The most successful Greek merchant house in nineteenth-century London, Ralli Brothers, began as traders in silk, while the Dent family, English merchants in Canton from c. 1820 to 1927, played a leading role in the establishment of the Hongkong and Shanghai Bank.[12] In Zurich, Johann Jakob Pestalozzi, a nineteenth-century silk industrialist and owner of an exchange bank, stands as but one representative of the close relationship between silk and currency in this city, which dominated the European trade in raw silk until the recent deregulation of the silk market in China. Bernhard Trudel, considered the doyen of Zurich raw silk traders, recalls that even at the beginning of the third millennium, raw silk from Azerbaijan was being used as payment for textile machinery.[13]

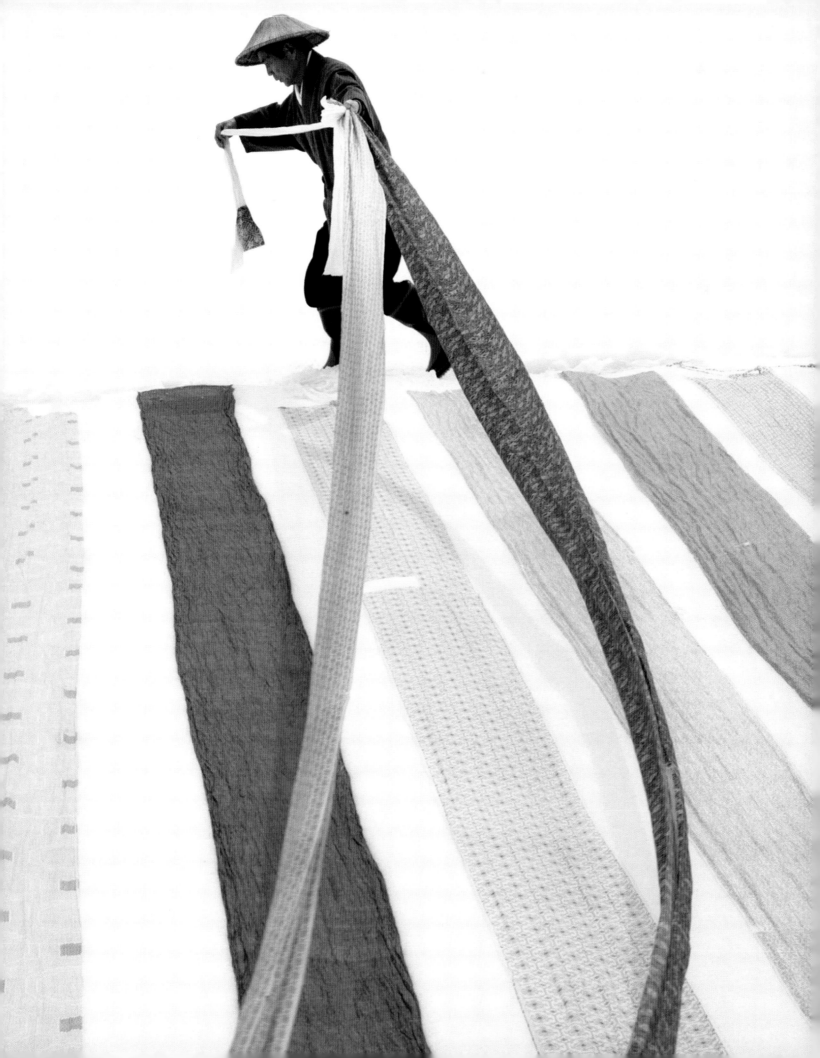

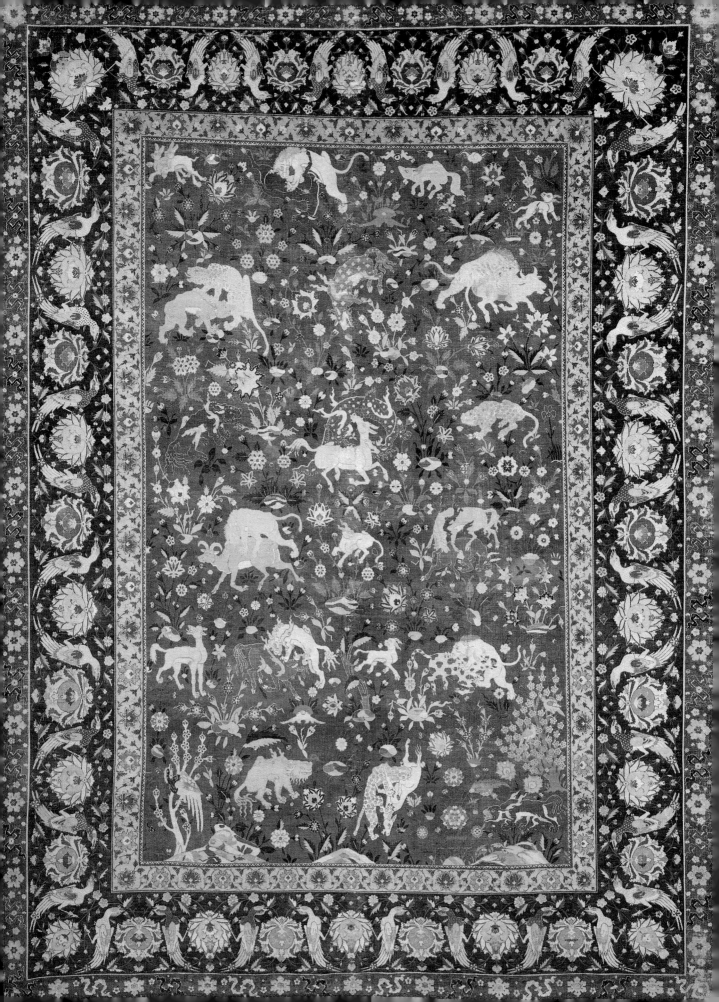

Art and interiors

The importance of silk to art and interiors is without question. Silk cloth was the medium of choice for the first great Chinese calligrapher, Wang Xizhi (307–65); it would be another seven hundred years before Chinese artists began to use paper more often than silk as a surface for ink and watercolor. At about the same time—that is, during the eleventh century—kesi, the silk tapestry technique known in the Far East four centuries before, in the early Tang period, began to be used for more painterly imagery, typically composed of animal and floral motifs. While some kesi were used as mounts and covers for paintings, others, such as those designed by the twelfth-century embroiderer Zhu Kerou, were prized in their own right. "It is their apparent equivalence with paintings in terms of status ... that sets these silks apart from other textiles: the 'artists' are not only recorded but the tapestries were collected alongside paintings and even eventually form the subject of a section in the imperial paintings catalogue."[1] The Uighurs—the peoples from east-central Asia who are believed to have introduced this technique into China—also used kesi for imperial portraits. The earliest record of this practice dates to 1294, and the portrait in

this case took three years to weave.[2] By about 1400, kesi had been introduced to Japan, where its name, *tsuzure-ori*, means "fingernail weave."

Tapestry weaving was already at this date well established in Europe, but was made mainly with wool; however silk threads were included in many of the finest examples to add lustrous details. Among the most highly prized of these are some still to be seen in Hampton Court Palace, near London; thought to have been designed by Bernaert van Orley in about 1541–3, *The Story of Abraham*, woven in Brussels in a set of ten, glistens with both silk and metal-wrapped thread amid the woollen weft.[3] Tapestry was used not only to make pictorial hangings but also, in both east and west, to cover furniture. In eastern lands, long, narrow silk panels were draped over chair backs; in Europe, by the mid-1500s, pieces of tapestry began to be woven to fit a padded form, replacing loose cushions.

The burgeoning of global trade in the sixteenth and seventeenth centuries was to transform the interior of European homes, filling them with all manner of exotic furnishings. In 1543, the Portuguese landed in Japan; their subsequent domination of the silk trade between China and Japan lasted until 1650, when the Shogun rulers curtailed contact with westerners. Nevertheless, by this time numerous European companies had been chartered, all intent upon gaining trading rights to precious commodities—foremost among them, silk. In England, for example, there was the Moscovy (or Russia) Company, founded in 1553 by men such as Sir Rowland Hayward, a merchant-adventurer who had previously dealt in silk at Antwerp, and Thomas Bannister, who from 1560 to 1571 was in Persia. There Bannister amassed 200 camel-loads of goods including raw silk from Arrash and items from Kashan, Tabriz, and Ardabil (known for hand-knotted carpets, the finest of which were all or partly of silk).[4] The raw silk trade—along with a sideline in Greek Island currants, mohair, and cotton—was the focus of the British Levant (or Turkey) Company, which operated from 1581 until 1821 with warehouses in Constantinople, Smyrna (now Izmir), and Aleppo. By the mid-1600s, restored trade between the Ottoman Empire and Persia, with Smyrna beginning to overtake Bursa as its center, made a wide range of exotic silken goods—and the manner of their use—widely known in Europe. The Dutch traded here, too, and, from 1670, the French Levant Company; the last country to enter into this entrepreneurial frenzy was Sweden, which chartered its own East India Company in 1731.

With the several East India companies increasingly active from the early 1600s, the following two centuries were a boom period for oriental wares—that is, anything originating from lands lying east of Italy—and such

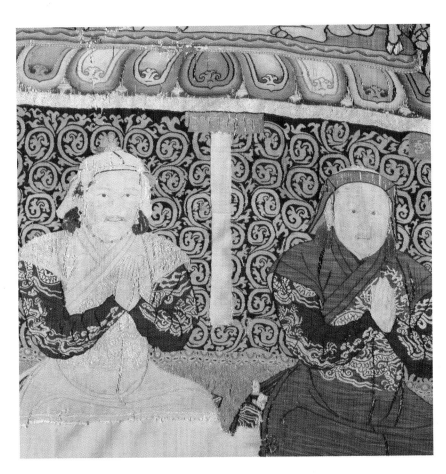

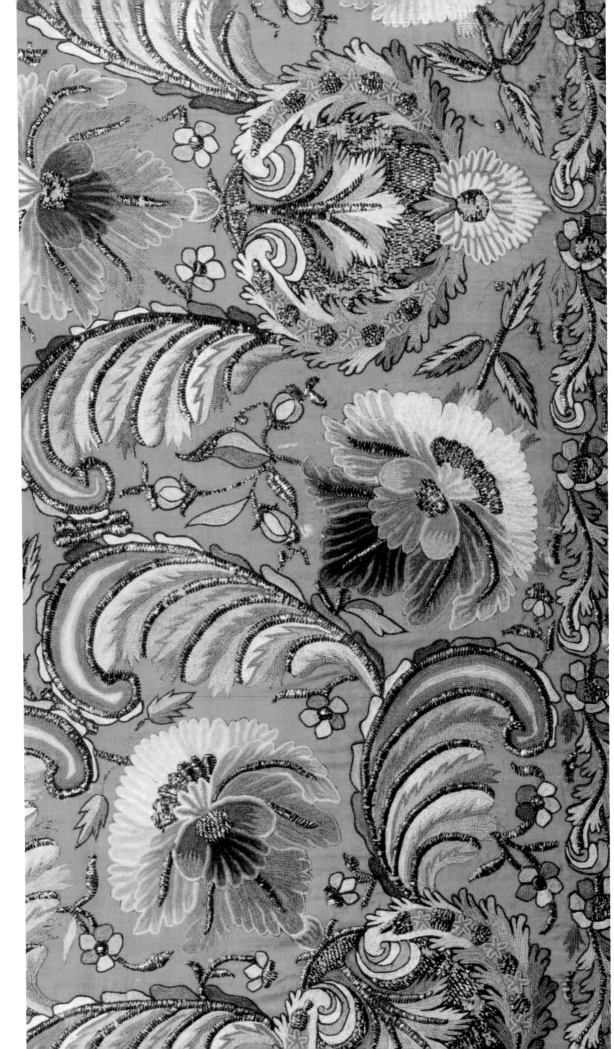

opposite Ham House, set along the Thames not far from London, contains rare 1670s silk furnishings in the "en-suite" style, as established in Italy over a century earlier and indebted to nomadic conventions farther east. The allover disposition of the pattern recalls Mongolian Yuan silks, while the feathery leaf suggests the influence of Ottoman textiles.

right In this Turkish Ottoman *bogha*, or cover, the orange wool ground is decorated with tambour-stitched silks and flat metal strips over raised, undyed silk threads. By the time it was worked, between 1750 and 1800, stylistic influences flowed in all directions; here, it is the rococo "shells" that show European influence.

trade introduced and then disseminated dozens of items now fundamental to western lifestyles: tea, chintz, porcelain, coffee, lacquered screens and cabinets, carpets, and the Ottoman-inspired chaise longue. Not only did silks often form part of the cargo; in many cases the silk trade itself funded the initial voyage and attendant commercial activities. The sheer expense of silk had already made it a luxury, but now it had added cachet as imported wares became so widely available as to perpetuate a demand for them.

Silks of all origins became the cornerstone of fashionability, the essential exotic element in the *haute mode* interior. Although few intact interiors survive from Renaissance Europe, many painters, from the mid-1550s onward, captured the new furnishing style that was so dependent on silk. Indeed, during the seventeenth century, the portrait artist's convention of including a curtainlike swathe of silk—often single-colored and lustrous—not only hinted at a richly furnished setting, but also alluded to the "polish" of the sitter. This allusion was no mere artistic fancy. It suggested, at the very least, an awareness of the silk trade, which made one cosmopolitan, a citizen of the world. One such person was Samuel Vassall, who acquired a fortune through East India and Levant trade and became a founder member of the Massachusetts Bay Company in 1629. Another was Sir Paul Rycaut, who, through his position in the English Levant Company, authored *The Present State of the Ottoman Empire* in 1666. "From 1670 translations began to appear, and by 1678 it was a best-seller in English, French, Dutch, German, Italian and Polish. A Russian translation followed in 1741, and it was also paraphrased in other languages. . . . It shaped European perceptions of the Ottomans for a century."5

In non-western cultures with nomadic origins, such as the Ottomans, the lavish use of textiles in the home was long established. These might take the form of recognizable furnishings or that of a social currency,

carefully stored (often visibly so) to represent the receiving and giving of significant gifts, which could range from an individual woman's dowry to a sultan's store of magnificent silks. Walls were covered with precious textiles. Yuan-dynasty palaces had them on the ceiling, too, creating an effect reminiscent in its splendor of their Mongol forebears' silken "gold on gold" tents, recorded by the Persian historian Rashid-al-Din near Samarkand and Balkh in 1255 and 1256.6

It seems no coincidence that as the western world became more conscious of eastern modes of living—as well as more prosperous and, to a degree, more peaceful—one noticeable change was the introduction of an abundance of material. A spectacular example of this is the 1520 meeting in France between the French king, Francis I, and Henry VIII of England (resulting from a treaty of 1518 aimed to stop the northward progress of the Ottoman Empire); complete with Mongol-like golden tents, it became known as the Field of Cloth of Gold. Such princely magnificence set the tone for the future:

"In the 16th and 17th centuries, the greatest sums of money spent on furnishing the interiors of houses and palaces were for textiles and fringing. Rooms were hung with luxurious panels of silk and velvet, bordered with embroidery or fringes of gold and silver threads, and beds and chairs were upholstered in sumptuous fabrics. Inventories show that in the second half of the 16th century in Rome, furniture was supplied en suite – complete with hangings. This practice was introduced into France in the 1620s as contemporaries emulated the famous blue rooms of Madame de Rambouillet (1588–1665) who, like the French queen [Marie de Médicis], was Italian."7

This style was further disseminated by the dispersal, in the late 1600s, of French Huguenot upholsterers,

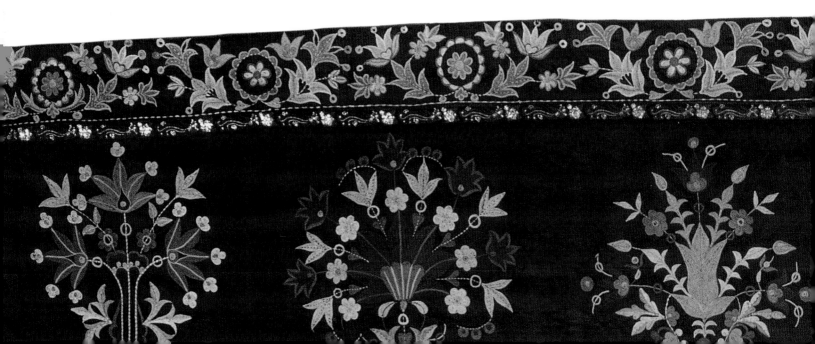

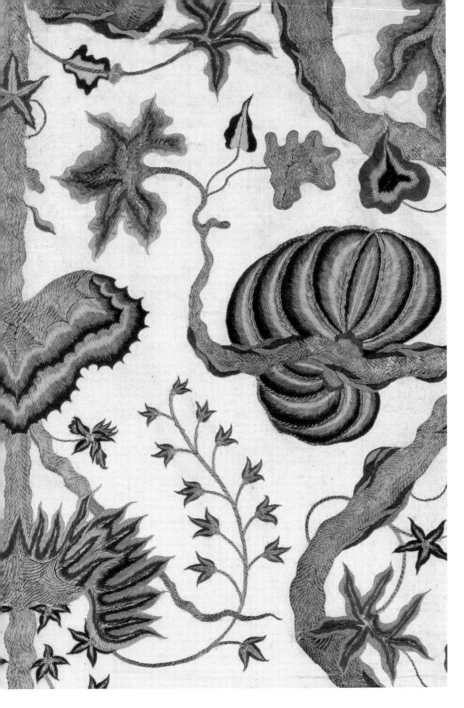

such as Francis Lapierre and Daniel Marot, who worked for the courts of Holland and England.

Along with this tendency to clad rooms entirely in silk went a taste for the exotic, which—one way or another—ran as an undercurrent throughout the design and construction of the seventeenth- and eighteenth-century silks used in European interiors. Some cloths were overtly oriental, such as *pekin*, the painted silk taffeta imported from China, which by the mid-eighteenth century was being imitated in France, especially in Valence. Others were more subtle derivatives. From styles popular in the seventeenth century—gleaming satin embellished with boldly contrasting cartouche and canopy shapes and the delicately articulated and rhythmically arranged exotic blooms and palmette patterns—to the late baroque and succeeding rococo designs of the eighteenth century, either the composition or the subject matter was of Eastern inspiration. The Orient-inspired visual language of silk persisted even when the cloth was made of other fibers.[8] For example, designs for silk by the Frenchman Philippe de la Salle, including those woven in Lyon in 1773 by Camille Pernon for Catherine the Great's palace near Saint Petersburg, were copied faithfully by cotton printers in France and elsewhere.

Beds, in particular, were the focus of expenditure (as were coaches, the equivalent "comfort zone" when outdoors). The finest of these, for most of the 1600s, were hung with Italian silks, until France and then England became the leaders in design innovation and much increased their production. That the English were able to do so depended in part on now-reliable supplies of raw mulberry silk from Bengal—these having, by the mid-sixteenth century, displaced China silk in India's own looms. "Silk 'factories' were established at Kasimbazar [North Bengal] and the Dutch found a market for Indian silk in Japan, while the English started the export of raw silk to Europe. Indian silk products –

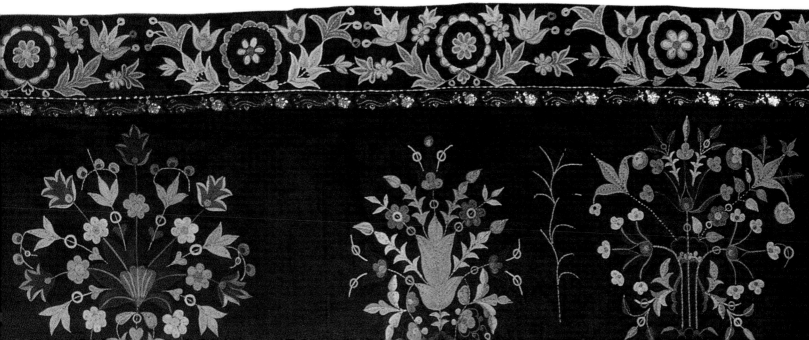

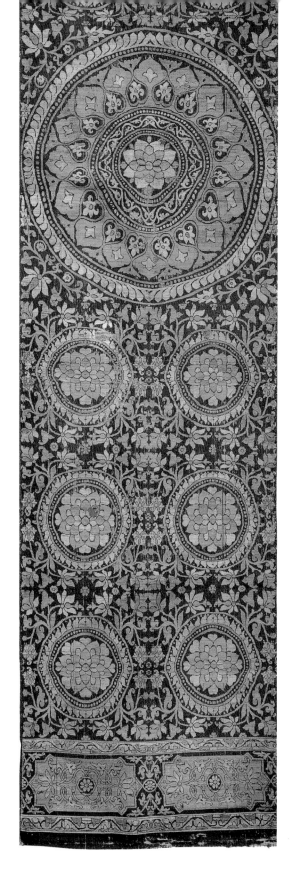

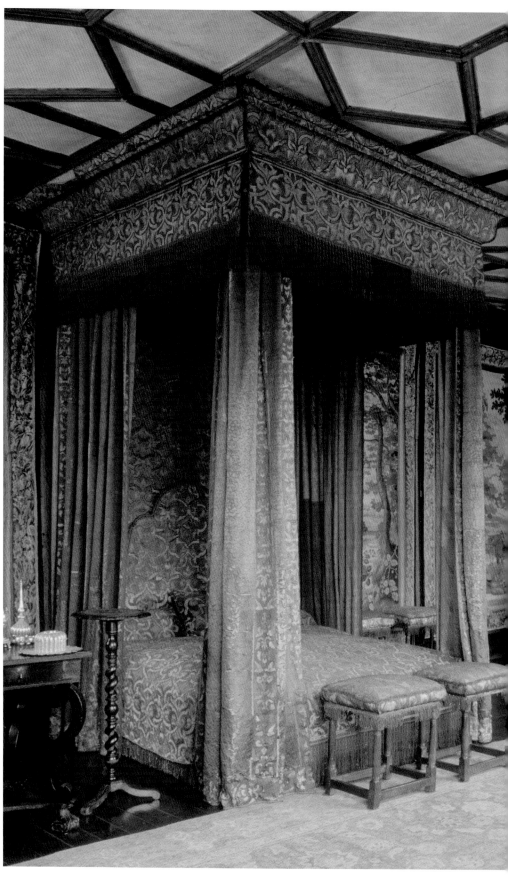

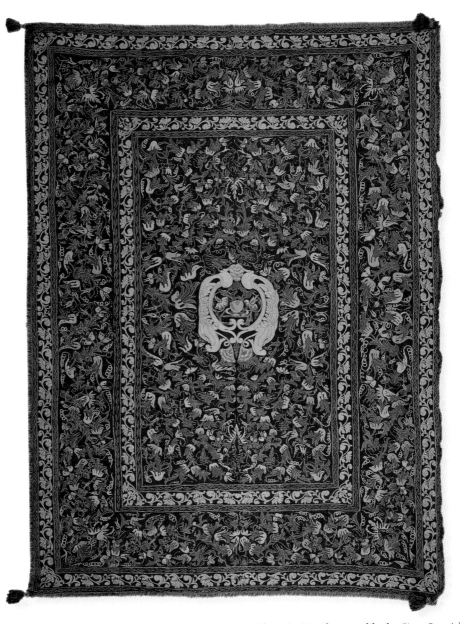

opposite, left This north Indian silk *lampas* panel was probably designed for a Mughal palace wall or canopy center, but was used as a ceiling panel in Tibet and Nepal. It incorporates Hindu, Muslim, and Buddhist motifs, and although woven between 1580 and 1650, it employs an arrangement of motifs typical of Mongol silks three centuries older.

opposite, right The hangings and companion furniture for this rare English state bed date from about 1620. Of crimson and white silk, laden with thousands of tiny precious-metal sequins, the "Spangle Bed" at Knole, in Kent, is reminiscent of a lavish tent—a resemblance that would have been even more apparent before its canopy was raised in about 1700.

right Coverlets such as this were made in India primarily for trade; this example was made between 1750 and 1800 for the Portuguese market, probably in Bengal. Its lac-dyed plain red silk ground is embellished entirely in chain-stitched silk threads.

carpets, velvet pavilions, satins, taffetas with bands of gold and silver, patolas . . . of Gujarat, herb-cloth (now known as tasar), and Assam wild silk (muga) – became famous."[9]

Adding to the choice among the ever increasing number and variety of imports were the items made specifically for European consumption. Between about 1660 and 1800, the tambour-worked (chain stitch) silks of Mughal India reflected western tastes, intermingled with Persian and Chinese influences—the latter reinforced by the Chinese embroiders working in Surat, in Gujarat. Many surviving examples are coverlets; and often these were made in India for the Portuguese, who were favored customers, well able to pay with silver from the Americas. For the same reason, by the seventeenth century, when there were some thirty thousand Chinese

residents in Manila to enable the Sino-Spanish silk trade, many Chinese designs reflected Spanish taste, and continued to do so until shortly after 1800.[10] This Pacific trade, landing primarily in Acapulco, left its legacy in "gala" Mexican embroidery, characterized by vividly colored satin-stitched flowers—often including the peony—inspired by the Chinese silk shawls transported across Mexico on their way to Spain. Indeed, while the exchange of silks was now global, their use in each region retained different characteristics; the patchworked silks for Buddhist robes, for example, became associated with cloths used for the tea ceremony in Japan. In the west, where the patchwork technique was used for coverlets, many of the earliest examples used silk—a reflection of the desire to preserve even small pieces of these cherished fabrics.

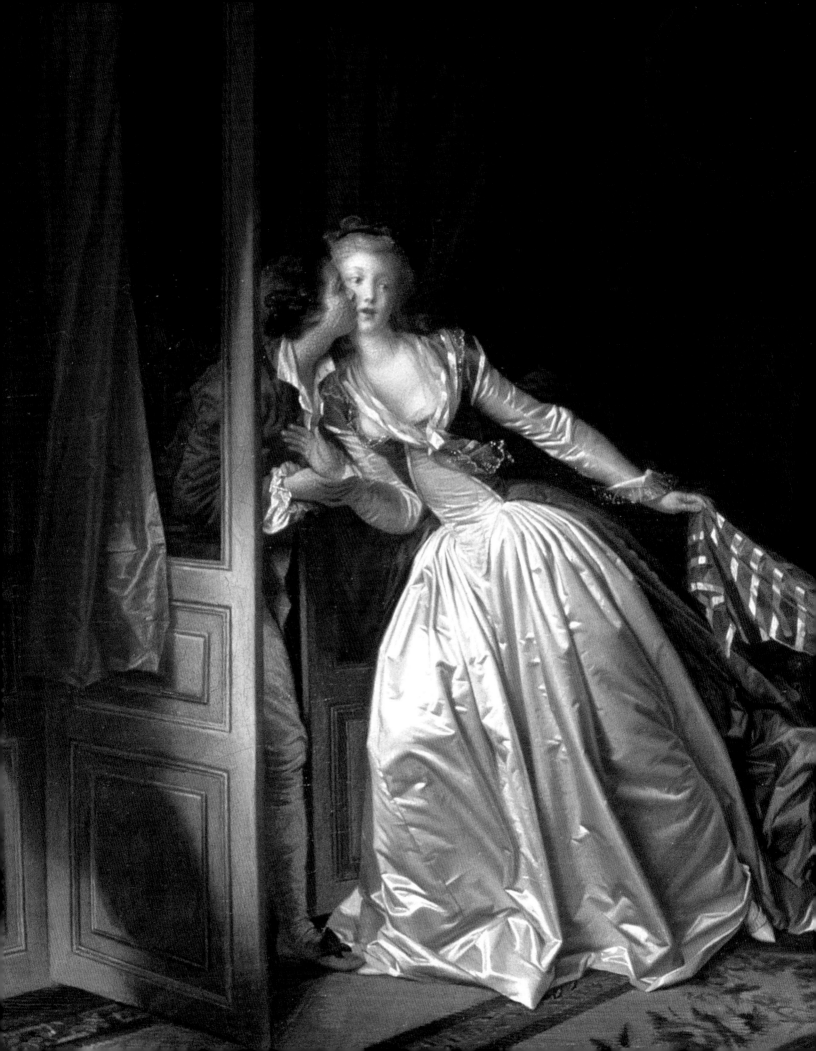

left Fragonard's "The Stolen Kiss," c. 1786–88, underscores the constant contribution of single-colored silks to aristocratic interiors, whether unpatterned or damasks. The young woman's shawl incorporates an alternative, the stripe, which became associated with Empire and Regency interiors a generation later.

above Single-colored silks were frequently enlivened with elaborate silk passementerie. This 18th-century example demonstrates in its complexity why such embellishments were then, as now, frequently the most costly elements of an interior.

right One of a suite of "Verdures du Vatican" panels commissioned for the billiard room at the *Casita del Labrador* (Farmer's Cottage) in Aranjuez, a residence of King Carlos IV of Spain (1784–1819), this silk *lampas* was designed by Jean-Démosthène Dugourc and woven by Camille Pernon in Lyon in 1799. The top, bottom, and central vignettes are embroidered in silk and chenille.

far right Reinterpretations of classicism often incorporate architectural motifs and scenic devices. Here, on a French mahogany and gilt-molding armchair of c. 1820, these are rendered by painting on silk velvet, a task for which the many painter-designers of the period were perfectly suited.

opposite Hong Yin's c.-1725–50 embroidery "Hundred Birds Admiring the Peacocks" typifies the Chinese naturalistic depiction of birds and flowers, which not only had long been admired and collected in China itself but also profoundly influenced European textile design, whether woven, printed, or stitched.

With beds representing the pinnacle of the upholsterer's art, their component techniques encompassed all the textile arts of the period. The making of passementerie—the gimps, fringes, lace, and other embellishments with which to edge or pattern—became highly developed and typically constituted the most expensive component of any decorative scheme. Embroidery was practiced both by professionals and by many skilled amateurs, it being one of a lady's accomplishments. In the seventeenth century, women often stitched raised-work scenes and motifs on satin to cover boxes and mirror frames, while fire screens were embellished with all manner of embroidery.

At a time when there was as yet little distinction between the fine and applied arts, many painters designed textiles following in the footsteps of the Florentine artist Sandro Botticelli, who had produced designs for ecclesiastical vestments. The much-admired seventeenth-century Dutch flower painters included silk embroideries within their domain; later, their counterparts in France did the same, and sometimes much more. The Ecole de Dessin in Lyon, established in 1756 to serve that city's silk manufactures, included

flower painting in its syllabus, and its professors of this subject included Jean François Bony (1760–1825; retired as professor in 1810), who not only designed silks and embroideries, but also was a partner in the weaving firm Bissardon et Cousin. By Bony's day, copperplate engravings were being printed on white silk, which could then be embroidered by amateurs using silk thread or, occasionally, human hair. The resulting delicacy of imagery, sometimes with the engraved facial features and hands left unstitched, may have been influenced by the work of the Gu family of embroiderers, in China. Initially amateurs, they become known in the mid-1500s, and by the next century had become professionals, famed for their water-colored and stitched paintings using silk threads and hair for the embroidery.

Despite a supply of silks from various European ports—with ships' cargoes including Indian and Chinese goods, too—the use of silk to decorate rooms in the Americas was relatively rare until the nineteenth century. There, as elsewhere, a series of revivalist styles characterized this period. Among these, the most persistent was the neoclassical and its variants. The continuing popularity of this style, launched in Europe in the late eighteenth century, owed much to the policy of Napoleon Bonaparte, who by 1810 ruled all of continental Europe except the Balkan Peninsula and Portugal. Revolutionary forces had sacked Lyon in 1793, and except for a few fine silks made in the following nine years for Spain, Russia, Prussia, and Switzerland, Lyonnais weavers were primarily making plain taffetas in 1802, when Napoleon placed the first of several large orders for patterned silks. By 1813 he had furnished (or at least planned the furnishings for) four palaces in Italy, one in Strasbourg, and one near Brussels, as well as Saint-Cloud, Fontainebleau, the Tuileries, and Versailles.[11] For these projects he had ordered so many silks from Lyonnais weavers that more than half remained in state hands and were used later. Thus, Fontainbleau, in 1855, and Compiègne, in 1858, were among the French palaces to receive new beds and seat furniture upholstered with fabric woven by Grand Frères in 1812 and 1813, which had originally been intended for Versailles. Such exposure fuelled a revival of the neoclassical style, which coexisted with revisits to Gothic, Renaissance, and rococo styles during the nineteenth century. These revival-style interiors were not necessarily faithful to the original versions, but were made more comfortable and informal with densely placed, deep-buttoned seat furniture, its articulations highlighted by the sheen of silk.

Neo-rococo was a particular favorite of Eugénie, empress of France from 1853 to 1870. With Paris, through

left This Florentine interior, painted by Michele Gordigiani in 1879, captures the informal use of a brocaded silk damask, used as a slipcover for a banquette. Both the seating and the silk's pattern are variants of Empire designs. Panels of plain silk form a backdrop.

overleaf, page 94 While other British silk-weaving firms were closing, in 1870 a new entrant to the field was Benjamin Warner, already a London designer and Jacquard harness maker. Warner & Ramm commissioned many leading designers, including Bruce Talbert. His design for this Aesthetic-style silk tissue was supplied in 1876, and its hand-weaving began in May 1877.

overleaf, page 95 George Theaker, whose children's illustrations included stories from *The Arabian Nights*, here used silk damask and velvet for a young woman's gown, in this pseudo-medieval scene of c. 1905. The composition is in the Aesthetic style, as is the pattern of the silk curtain.

mid-century, being the world's largest manufacturing city and capital of Europe's most populous nation, French taste had far-reaching influence. Exports of French silks increased fourfold between 1830 and 1870, despite the 1848 revolution and the uprising of 1851, although, as elsewhere, there was a trend toward fewer, larger firms, and a more diverse range of products within each. Lamy et Giraud, for example, were among the Lyonnais who began to weave more mixed-fiber cloths in this period, catering to a wider clientele, which now included the bourgeoisie. Nevertheless, it was France's expensive all-silk cloths that were fêted. Queen Victoria obtained an Empire-style cut velvet in 1864 from a firm that still exists in Lyon today, Tassinari et Chatal (successors to Grand, itself a successor to Pernon), while one of England's own foremost silk weaving firms, Daniel Walters & Sons, ordered a vividly toned brocatelle not long afterward (from the present-day Prelle, successors to Lamy et Giraud[12]). Indeed, the archives of both these firms preserve orders of this period from Russia and all the major European courts and cities. Empire and rococo patterns were particularly liked for public places, such as hotels, and for railway carriages. In the United States, hotels, together with steamboats (both considered the "palaces of the people") were often decorated with French silks. America's first department store, Stewart's of Broadway, which opened in New York City in 1823, soon became known for its French silks. Guidance in the manner of their use could be obtained from the influential publications of the French designer and publisher Désiré Guilmard.[13] Some French emigrés took advantage of this admiration for French silk by opening, in 1840, the first silk factory (initially making thread only) in Patterson, New Jersey; other newcomers, including many English, subsequently contributed to making Patterson a thriving silk center for a century more.[14] Empire and rococo styles were revived for a second time toward the end of the nineteenth century. Each of these had two modes: a light, delicate style, used in tandem with appropriate furniture (and less of it) and an ostentatious version, using gilt-brocaded cloths, many destined for the mansions of American millionaires.

In parallel came the Arts and Crafts and Aesthetic movements, the latter influenced by the relaxation of Japan resistance to western traders in the 1860s. This was a time of significant change for the silk industry. Many British firms did not survive the removal, in 1860, of protective tariffs on French silks, and many Continental firms failed during the depression of nearly two decades that followed the Franco-Prussian War of 1870. Tellingly, by this date figured velvets were being imported into Britain and the United States from Krefeld, in the

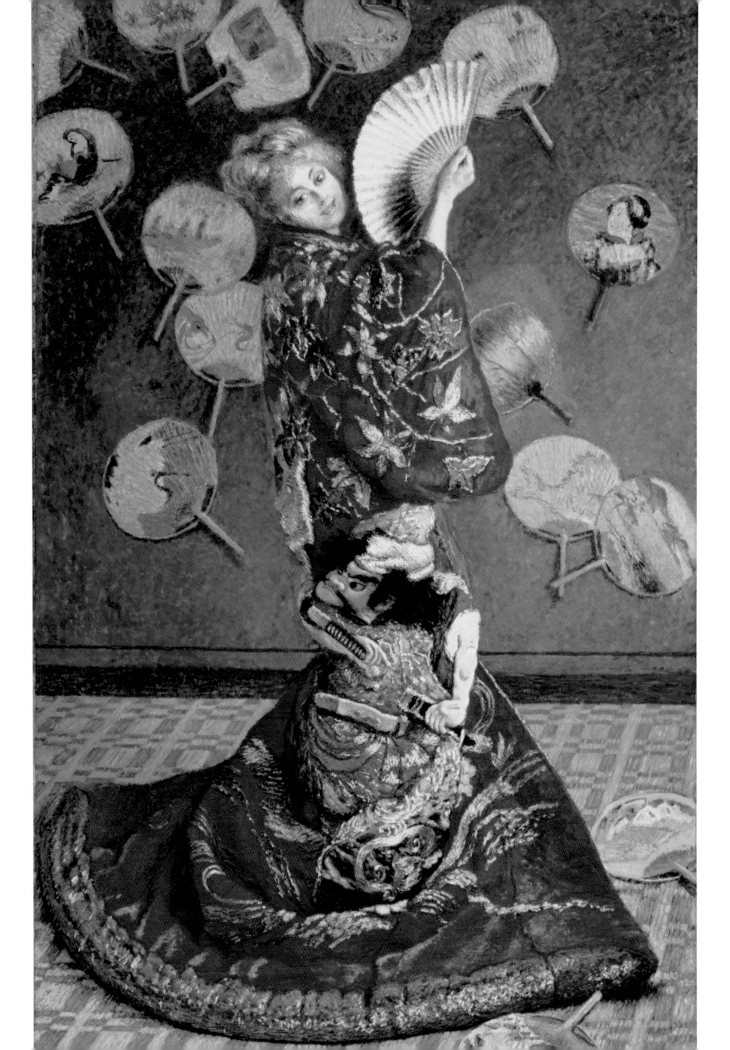

previous spread, page 96
Artists' studios of the late
19th century were known
for their array of props, many
of them imported from the
Orient. Monet's 1876 portrait
of his wife, Camille, makes
artful use of such items,
including the embroidered
silk Japanese kabuki kimono
she wears.

previous spread, page 97 The
sinuous line characteristic of
Art Nouveau owes much to
Eastern influences, and in its
later phase become restrained,
as this furnishing silk of
1900–04 illustrates. It was
designed in London by the
Silver Studio, possibly for
Vanoutryve et Cie of Roubaix,
one of several French firms
that used the Studio's
resources.

Rhineland, rather than from Lyon. They also began
to be woven in Manchester, Connecticut, by Cheney
Brothers (founded in 1837 as makers of silk thread),
who were soon producing designs by the American
designer and writer Candice Wheeler and, by the early
1900s, in the modern Viennese style.

The potential impact of Art Nouveau—in which
French weavers might have been expected to take a
leading role—was curtailed by this competition from
outside France, and by the First World War. French
dominance in the design of silks for interiors was briefly
restored in the wake of the 1925 Paris Exposition, but in

the meantime, the taste for more "rustic" silks had
developed. Although thereafter, grand interiors
continued to be clad with silk damask, this new trend—
and the diversion of vast quantities of silk for stocking
manufacture—made color and texture, rather than
elaborate pattern, the paramount characteristics of
many furnishing silks and of those used in textile arts.
(These features are dealt with in Silk in Detail, beginning
on page 117.) What remained true, however, was the
fundamental connection between silken furnishings
and prestige, a legacy based on silk's imperial past
and its use as an artistic medium.

right "Les Colombes"
was designed by Henri
Stephany for the 1925 "Art
Deco" exposition in Paris.
A furnishing fabric, it is a silk
and metal-thread brocaded
brocatelle. Subsequently it was
exhibited in the New York
showroom of F. Schumacher,
Inc., and became exclusive
to the firm's American range.

opposite Resplendent in
embroidered and brocaded
silk court attire, the 3rd earl
of Dorset posed in 1620
for his portrait by William
Larkin. The fashionable
stance was calculated to
display the elaborate "clocks,"
or ankle decoration, on his
silk stockings.

Fashion

No brief survey can do justice to the contribution of silk to fashion, since these two are so closely intertwined as to be inseparable. Certainly, the development of fashion would have been constrained without silk, since the physical characteristics of silk offer the greatest range of weights, drape, and color effects of all the natural fibers, and thus provide scope for change and exploration unique among them. Moreover, the profits to be made on silk make the creation of a particular design or effect in small amounts a worthwhile undertaking for any firm supplying the couture houses, and it is this aspect of exclusivity that underpins all that fashion represents. Few people are immune to the vagaries of fashion, which for over four centuries has demanded innovation in garment form or detail. Fashion theorists acknowledge the impact of social, economic, and political events on changes in style, as well as the significance of individual fashion leaders and the consumer's need to proclaim allegiance to a particular subculture. Here, the focus is the role of silk itself: the interplay between certain fabrics made in the past and how each has contributed to the panoply of fashion since about 1600.

The first ready-made clothing was provided by knitting, which produces a garment with sufficient inbuilt elasticity to allow it to fit well without individual tailoring. Knitted nether-garments and undershirts had been worn in Europe since before the 1200s; for example, Swiss knitted leggings survive, dated 1192; and the first Parisian guild of knitters (evidence of enough demand for a professional organization) dates from 1268. Not surprisingly, given Iberia's long experience with both silk and knitting, a skill probably introduced there by Muslims, garments knitted of silk seem to have emerged first in Spain.

By the 1500s, the knitting industry was associated with Barcelona, Toledo, and Málaga. In Italy, the city of Mantua, new to the silk business in the 1500s, soon became that country's foremost supplier of silk knitwear, followed by Naples and Milan, the latter two known for silk stockings. These hand-knitted luxury items, especially those from Spain, were worn in courts across Europe. In England, they were owned by Henry VIII and also by his daughter Queen Elizabeth I, who reportedly, in about 1560, declared silk stockings "so pleasant, fine and delicate, that hence-forth I will wear no more cloth stockings."[1] A decade or so later, silk stockings—now often featuring interwoven or embroidered decoration, or clocks, rising from the anklebone—played an essential role in some new fashions: shoes for the first time with heels, slightly shorter skirts for women, and, especially, short, padded breeches for men.

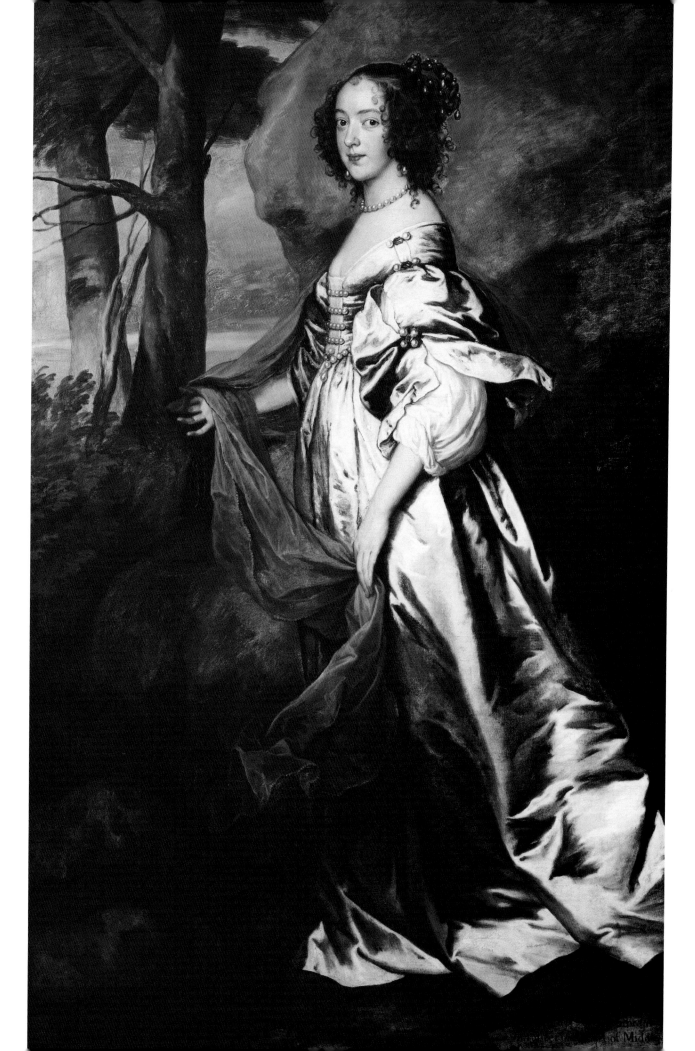

above Knitted silk "night jackets," for informal or semiformal occasions, were worn by European royalty and courtiers of both sexes from the late 1500s until the early 1700s. This c. 1640 example, seen from the back, was made in Italy or Spain for an English aristocrat and is patterned with gold and silver threads.

opposite Anne, countess of Clanbrassil, was portrayed by Anthony van Dyck in 1636, when unadorned silk satins were prized for their sheen and liquid-like draping qualities. The making of such silks was then relatively new to northern Europe.

In about 1600, the making of silk stockings became a mechanized industry, when the Englishman William Lee's knitting frame, invented in 1589, was adapted to silk. By the time Lee died, in 1614, his machine was working in London, Rouen, and Paris; later improved, it was introduced to the English Midlands, and in the 1650s, in many places across France. Spreading throughout Europe over the next several decades, it arrived in Basle and Zurich with Huguenot silk knitters and was acquired by the Portuguese in 1678; it reached Catalonia in 1687, becoming much used in and near Barcelona. Knitted silk doublets, tunics, and accessories, including belts, sashes, bags, and gloves, were produced variously by frame- and hand-knitters in other centers, from Norway to Switzerland and eastward to Bohemia, Poland, and Russia; but stockings remained paramount. The focus in men's fashions on a silk-stockinged leg would last for another two centuries (and thereafter silk socks remained an essential part of gentlemen's attire). Knitting in other fibers was influenced by these developments; since "some of the oldest and best-preserved examples of fine, decorative knitting are silk, it is not unreasonable to suggest that more artistic knitting and more plentiful silk stimulated each other. They inaugurated a reappraisal of the potential of the craft, and it was transformed into a commercial enterprise."[2]

Men's fashions also saw the next significant change in styles, from the doublet-and-hose variations, which dated back to the beginning of the fifteenth century, to the coat-vest-and-breeches style, which began its evolution in the English court in 1666 and was soon taken up in France. The style was dubbed "Persian" by contemporaries such as John Evelyn. In truth, it was equally indebted to Europeans' firsthand acquaintance with Ottoman attire, already adapted by the Prussians and worn by men in the Balkans as Ottoman territory expanded after 1620 to include the areas east and south of Vienna. (That city itself was not far from the empire's borders between 1666 and 1683.) Polish noblemen, for example, took to, and long retained, the silk sash with elaborately decorated ends, which because of its association with the Ottoman court in Constantinople, came to be known as a "Turkish towel." (Even so, this accessory, as well as the similarly shaped Kashmir shawl, was indeed indebted to Persian weavers.) Such geographical imprecision was a natural result of the convoluted routes by which goods arrived in Europe. Moreover, the taste for such a mixture of influences had already been established by the patterns on silks themselves. The most costly and elaborate of these were the velvets—still originating in Italy and Spain, although the latter's weavers were declining in number from the mid-1600s; and designs for these and other types of silk cloths did became more markedly Persian in style by about 1600, perhaps as an opportunistic response to Ottoman refusal, between 1595 and 1629, to trade Persian silks. This taste continued thereafter, with the compact and undulating stylized floral motifs gradually becoming more widely spaced—a style that had the advantage of making gold-brocaded cloths less expensive than heretofore. With the popularity of Persian/Ottoman designs in silk cloths, it was perhaps inevitable that Europeans would, within a generation, adopt the authentic manner of wearing them.

Parallel to the use of luxurious patterned silks was a more informal seventeenth-century fashion exploiting the beauty of plain silks. This, too, depended on a ready supply of thrown silk, and of good quality, since the impact of the cloth relied solely upon the smooth, reflective surface. In some respects, this fashion represents a northern European innovation, being composed from the type of textiles that predated Italian influence, namely simple fabrics that relied on trimmings for embellishment. That said, the finest garments were made from the newer all-silk satin and mixed *satin de Bruges* (both the result, partly, of Italian initiative), the fluidity of which was captured by numerous Low Countries painters. Among the artists most adept at representing such silks was Anthony van

Dyck (1599–1641), whose facility may have owed something to the fact that his father and paternal grandfather were silk merchants in Antwerp. Often, after the later 1620s, his sitters—both male and female—wear spectacular bobbin lace collars. These were made of the finest linen; but as with so many textile innovations, they, too, were indebted to a silk industry. The technique of making bobbin lace, closely associated with northern linen lace makers such as those in Brussels, had "emerged from the Italian passementerie industry by about 1500 . . . [threads were] plaited and twisted together to form narrow, open-work braids or laces, which were sewn down flat on the surface of clothes and furnishings. The earliest examples were made with threads of silk, gold and silver."[3]

After the mid-seventeenth century, so many weavers in Florence gave up the making of gold- and silver-laden silks to weave, instead, the highest quality, fashionable taffeta, that this kind of cloth was known as *taffeta Florence*. Some attribute this change to the impact of policies initiated in 1665 by Louis XIV's finance minister, Jean-Baptiste Colbert, which aimed to focus each French weaving community on a particular cloth, to improve quality, eliminate internal competition, and—through sheer superiority of the domestic products—fend off imports.[4] But it seems more likely that the Italians, with both a keen eye for the market and access to the very best silk threads, were once again capitalizing on their technical prowess. The Dutch silk weavers, located mainly in Haarlem and Amsterdam, also focused on plain silks after about 1650. Lyon outmaneuvered Tours and Nîmes to become the center for these (and velvets) in France, laying the foundations of manufacturing success that made it able, when it took up patterned weaving near the end of the century, to establish and maintain an enviable reputation in this area also. Colbert's statutes had another long-term effect: they ushered in the concept of national policies in support of high-quality, design-led industries that ultimately transformed into the federation representing French couturiers, fashion designers, and associated skilled workers today.[5] This longevity is matched only by that of plain silks in fashion—so fundamental that there remain specialists in this type of cloth in Lyon and other silk centers, such as Como (now the heart of Italy's silk industry); there, amid the most modern high-speed shuttleless looms, are the old shuttle looms at Taroni, kept because they are best for making just such cloths.

The use of trimmings continued, and even increased, as the "Persian" style took hold in Europe. Zurich prospered further as a result of its ribbon weaving, while Coventry, in England, and Saint-Etienne, in France, became dependent on the production of these

above A silk and silver-gilt thread Polish sash, 1750–1800, incorporates Ottoman "lip" motifs and large stylized plants characteristic of the Persian and Mughal *palla*, or shawl/sash. It is 430 cm. (172 in.) long and only 35 cm. (14 in.) wide.

opposite In this Gobelin tapestry of 1670, François Mansart presents his plans for Les Invalides to the French king, Louis XIV. Attendants wear the newly fashionable "Persian" style, while the king's richly brocaded attire is adorned with an Ottoman or Persian *palla*.

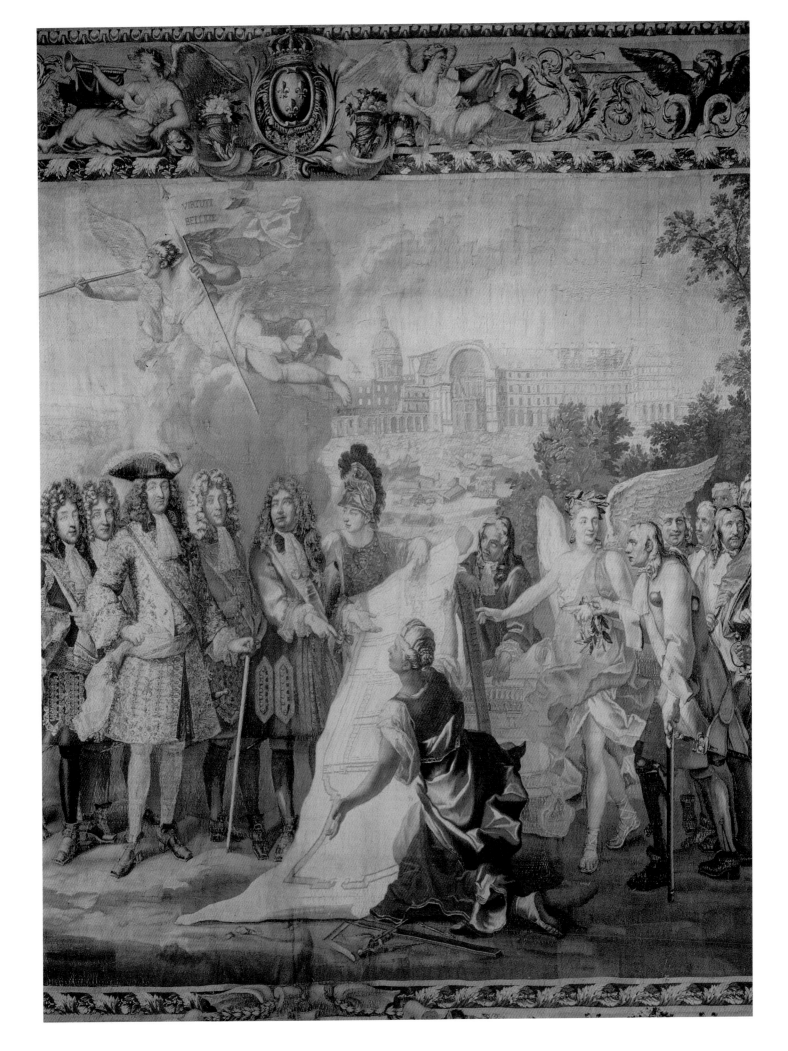

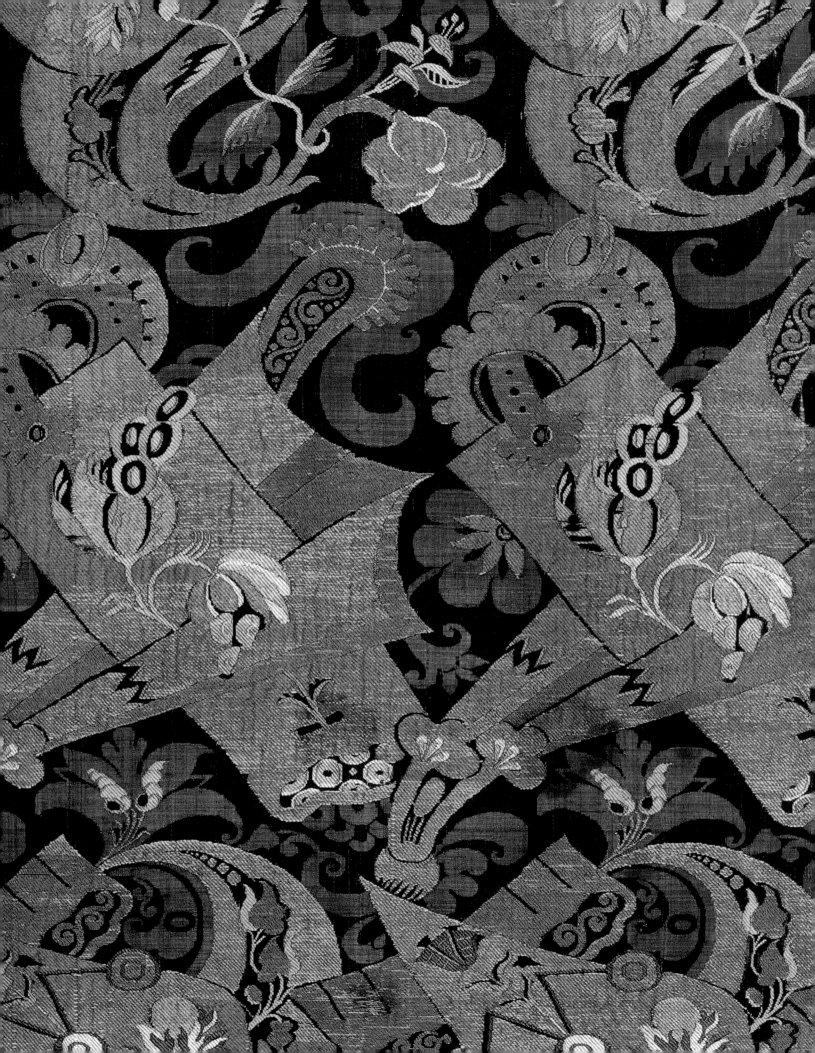

small-wares; in Saint-Etienne the number of master weavers roughly doubled between 1640 and 1660.[6] By the 1680s, trimmings were being overlaid on richly patterned silks in fashions for both men and women. The latter also acquired a new garment, a waisted gown, or mantua, open at the front to display a decorative underskirt. This formula was to remain in place over the next hundred years, changing its form slowly but, to mark the wearer as fashionable, being made of the latest silk. In 1700 silk designs were large and "bizarre," a term applied to bold, convoluted patterns inspired by a mixture of Eastern styles, including the Japanese. Although this trend and subsequent themes each remained constant for a dozen or so years—lace-inspired patterns emerging in 1720, rococo in 1743 (with English patterns more botanical than those of France), stylized floral meanders in 1755, and floral bunches over stripes in 1770—within these there were new designs appearing every six months until about 1780.[7] By about 1730, for the first time, there was also a clear distinction between furnishing and fashion silks. Within the latter, those for men and women also now differed; increasingly, it was embroidery that set the fashionable

tone for men's coats and vests (or "waistcoats"). In both cases, however, the slowly changing garment form provided the "canvas" for the designer's artistry, showing off silk cloths, stitchery, and passementerie.

In the closing decades of the eighteenth century, the industrialization of cotton spinning combined with the influences of neoclassicism and the French Revolution to produce a new attitude toward fashionable clothing. Styles became more informal and patterns much smaller. A volume of 1782 containing cuttings of fabric used for Marie Antoinette's dresses proves that even the most fashionable of silks had "barely there" designs: *chiné* stripes and specks were her frequent choice for the informal wrapped gown (*lévite*), and those for formal occasions bore embroidery or brocading that was scarcely more noticeable.[8] By the next decade men had abandoned breeches for the more egalitarian trousers; and of the coat and vest, only the latter remained a showplace (and a discreet one) for silks. The neoclassical woman adopted a high-waisted dress derived from the even more informal 1780s' chemise. Often associated with cottons, this "Empire" fashion (which actually appeared about ten years before

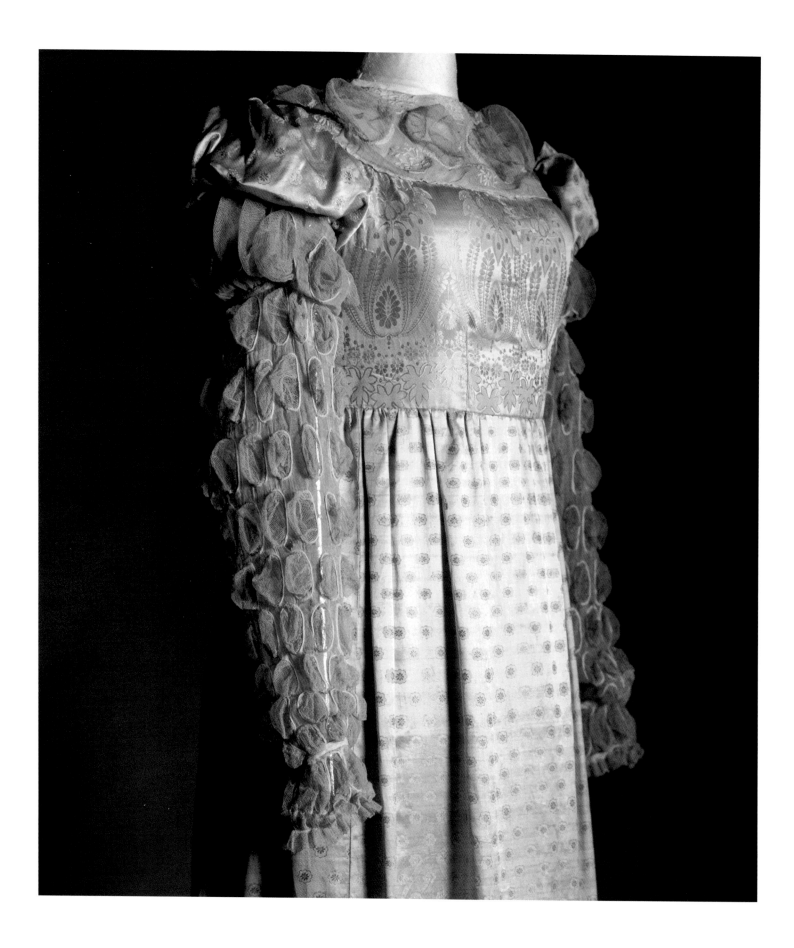

Napoleon became emperor in 1804) was also made in lightweight silks. As so often occurs in fashion, a radical change in garment form had been proposed in plain or inconspicuously patterned fabrics; then once it was widely accepted, the decorative elements returned. Thus, little spots and sprigs, some glistening with the addition of metal threads, also characterize the designs produced from the mid-1790s until about 1815. None of these simple cloths required the use of a draw loom, and so their fashionability initially hastened and then reflected a decline in the number of draw-loom weavers during this period.

The new century was to see major innovations, not only in fashion itself but in its dissemination and its contributing industries. During the ten years following the peace of 1815 came power weaving and machine printing for cottons, but not yet for silks. Nevertheless, the resulting flood of cotton fabrics would ultimately lead to a wider appreciation of silk and a greater demand for it. To begin with, it brought brightly patterned fabrics within the reach of many more people, increasing the amount of attention paid to fashion itself. Here, the printed word—and image—played a crucial role. Although fashion periodicals had been launched in 1770, there were three times more publications between 1820 and 1870 than in the previous fifty years, and these later magazines had a much larger circulation.[9] Such periodicals not only did much to promote silk, fêted as the most desirable of fabrics, but also underpinned the establishment of couture, which by consensus dates from 1857, with the foundation of the house of Worth. So the end result of these developments was an increasing demand for silk among a wider cross-section of society, and silk that, to distinguish it from cotton, looked distinctively "silk-like": vividly colored, lustrous, and, at its most costly, full of special effects. Among these were patterns woven *à disposition*—that is, appearing only where needed on the garment itself.

The democratization of fashion thus ushered in an exceptionally fertile period, lasting from the mid-1820s until the early 1860s, when the widest variety of silks was available and many improvements were made to hand-powered silk looms and silk processing. Among these was Bennet Woodcroft's patent (1838) for improved tappets for looms, which in the silk field was significant for ribbon weavers. In Saint-Etienne this was but one modification of the "Zurich loom" (another was the Jacquard attachment) that allowed much showier ribbons to be made at greater speed, even as their width increased from 4 centimeters (1½ inches) in 1815 to 17 centimeters (6⅗ inches) in 1848. Ribbons were the means by which the less affluent could enjoy silk, whether as an individual addition to a cotton or wool garment or

opposite This early-19th-century dress, made in Spain, is composed of "plain" silks, in keeping with the taste for simplicity that characterized the Empire style. The sleeves and neckline are inset with organdy.

above Madame de Pompadour, painted by François-Hubert Drouais in the early 1760s, wears a gown and petticoat quite probably of painted silk. Silk ribbons secure her hood and embellish her stomacher. She embroiders at a frame produced by the royal cabinet-maker Jean-François Oeben.

overleaf Samples from the pattern books of a Spitalfields silk weaver, probably Jourdain & John Ham. Those on the left, of about 1792–94, include warp-printed motifs, one with color changes along the horizontal that are not part of the pattern, but illustrate different colorways. Those to the right date from 1817 and 1825 respectively.

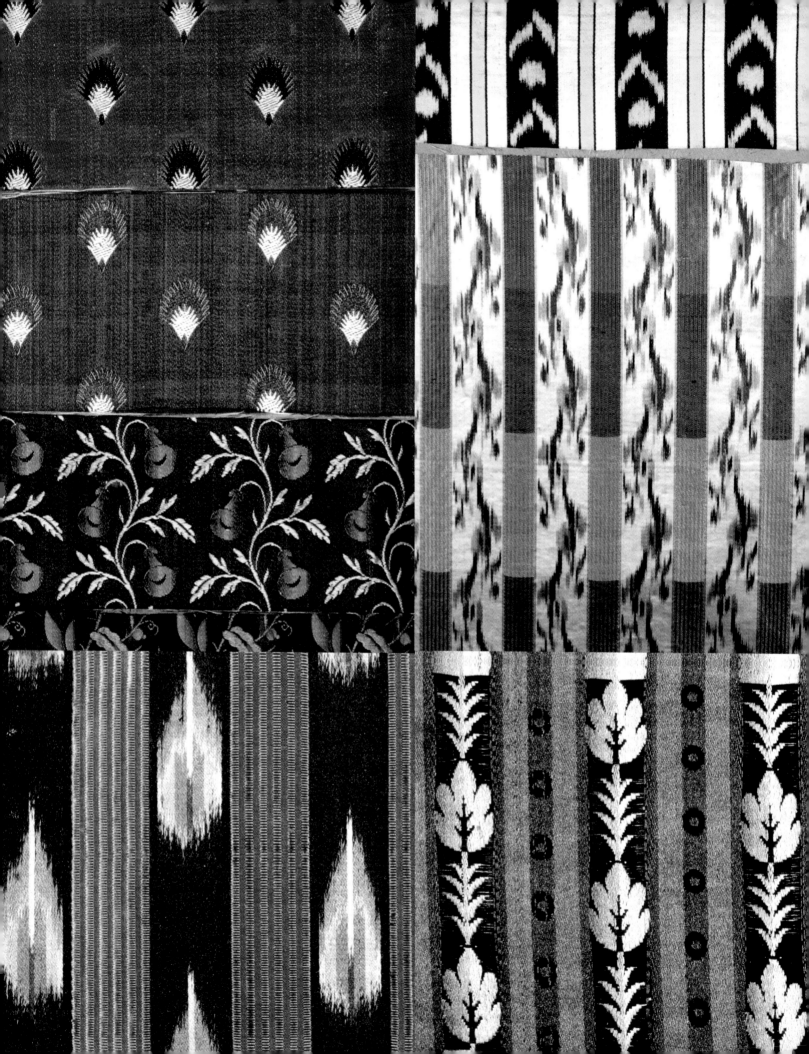

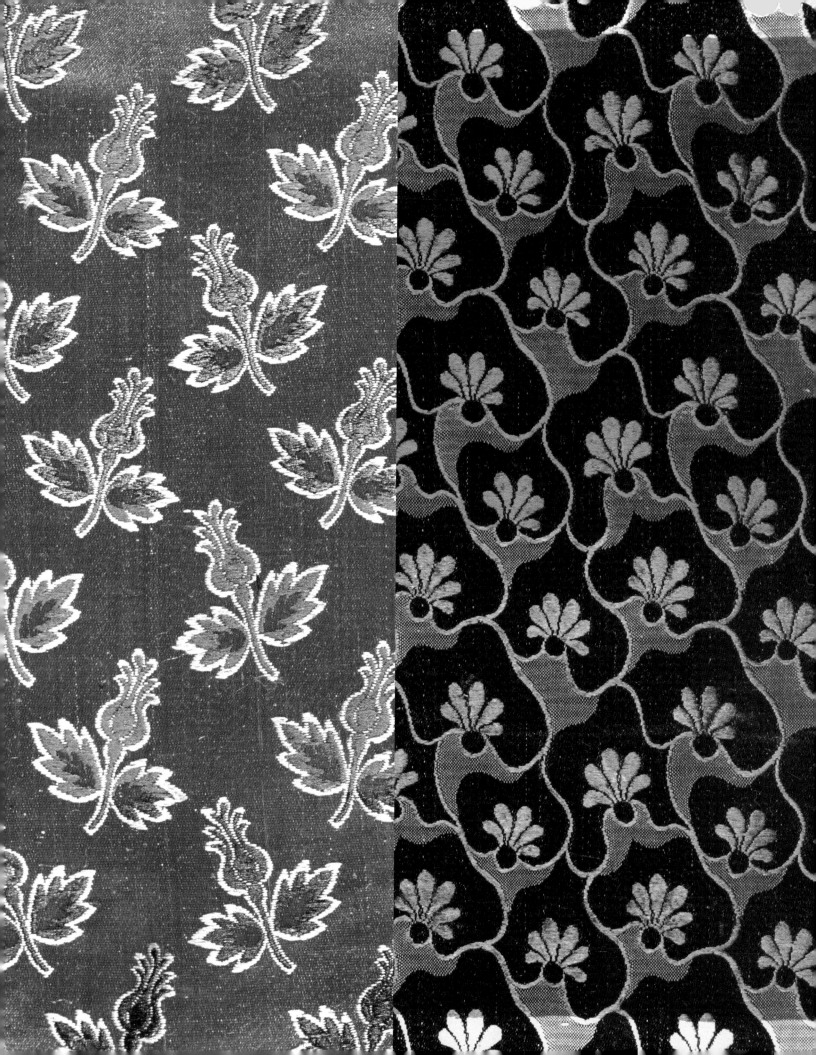

as an effusive display on a bonnet or hat. As a result, ribbon makers everywhere experienced a "boom"; in Saint-Etienne alone, the numbers employed in this trade nearly trebled between 1820 and 1860, while the amount of silk they consumed over roughly the same period rose by just over five and a half times.[10] As handmade laces went, the light, airy silk variety called blonde, after its typical hue, was relatively inexpensive and therefore also suited these more egalitarian times. (Silk laces had been made since the mid-seventeenth century in Spain, Venice, and the region north of Paris, notably at Chantilly.)

Velvet, too, was the focus of several inventions controlling pile height, allowing figured grounds to be woven with figured pile, creating a sheer ground, and, in plain velvets, pursuing an idea developed in France in 1793 and by Frenchmen in the Rhineland in 1808: that of simultaneously weaving two pieces of velvet face to face. With the arrival of peace and prosperity after the

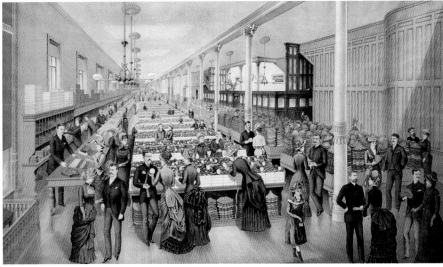

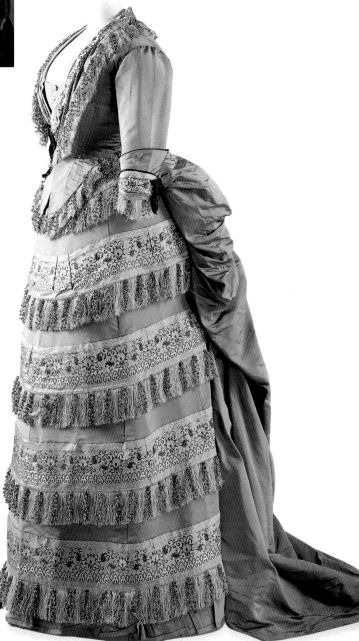

Napoleonic Wars, this technique had been revived; several subsequent patents (including two granted to J. B. Martin, of Tarare, not far from Lyon) improved this means of making velvet more quickly, and by 1857 the process had been fully mechanized in Barcelona. This new loom—twelve times faster than the traditional hand-weaving process—was soon at work not only in Spain, but also in France, Germany, and Italy.[11] A similar expansion in production occurred for other fabrics, too. For example, in and around Zurich—a major source of black taffeta by 1830, when it recorded eleven thousand weavers—the number of such weavers had swollen to forty thousand within four decades.[12] As such developments made more silks available, skirts became larger, and for most of this period they consumed even more fabric through the addition of flounces or tiers gathered around the entire skirt.

By the early 1860s the first successful power looms for plain weaves, such as taffeta, were operating in Switzerland; by about 1900 similar looms could be found throughout the western world and elsewhere, including China and Japan. Hand weaving continued for specialist silks, such as narrow kimono cloths and elaborate couture styles, in part because the European industry, until about 1890, could not invest in costly power looms. Hard hit by a devastating silkworm disease (a solution for which was identified by Louis Pasteur in 1865), its fortunes had taken a downturn by 1870, largely due to high duties levied by the United States government to fund the American Civil War of 1861–65. This legislation stimulated the beginning of broad-silk weaving (by hand) alongside the country's own established silk thread making and small-wares weaving, and deprived many European manufacturers of an important market. With the introduction of some power weaving, by 1919 more silks were woven in the United States than in

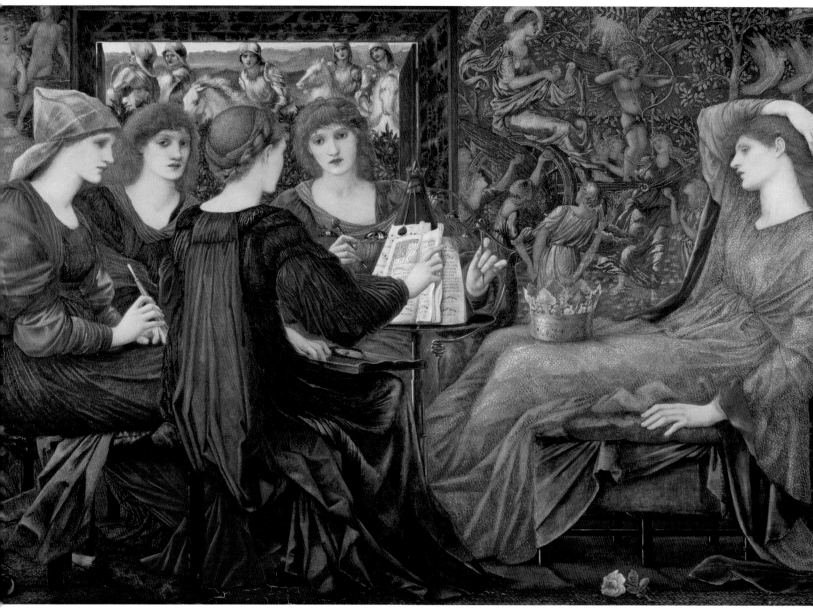

above In "Laus Veneris," Edward Burne-Jones depicts five women wearing, not artists' historical costumes, but real garments made of tussah silk in the anti-corset "reformed," or "rational," style. It was painted in about 1875, just as Liberty of London opened and began selling such dresses; its customers included the artist.

the whole of Europe.[13] A parallel increase in Japanese sericulture provided the raw material for this industry, and by the 1880s had also made Japan the world's largest producer of mulberry silk.

Nevertheless, France, as the largest manufacturer among the Europeans (followed by Germany, Switzerland, Italy, Russia, the UK, and Austria-Hungary) still dictated fashions in silk designs. With a reduced volume of silk being produced there, as elsewhere, the stylish silhouette began to abandon its dependence on the lavish use of fabric. The disappearance of tiered skirts in about 1863 marks a turning point, after which, over the next sixty years, gradually decreasing amounts of fabric went into a woman's fashionable garment. The making of costly effects found in elaborate ribbons,

exquisite hand-made laces and *à disposition* velvets gradually ceased, but Jacquard patterning and high-quality simpler fabrics continued. And so, fashion—responding to a silk industry now producing still-luxurious but more restrained silks, many of which were solid or near-solid in color—resorted to a rapidly changing series of silhouettes. Embellishments, when desired, were added by overlays of beading, narrow ribbons, embroidery, and lace (although Chantilly, from the 1870s, was almost entirely machine made). However, with the advance of dress reform, advocating healthier, less restrictive attire, and of women's suffrage, as well as sports, even such fripperies played a decreasing role, until finally, in the 1920s, these had a relatively small field of play in the pared-down "flapper" style.

The interplay between silk and fashion then changed completely between the two world wars. Most of the raw silk was absorbed by American manufacturers and went into the making of women's silk stockings and underwear. Changes in retailing methods gradually ensured that each successive season's hit catwalk garments were quickly copied— and often in other fibers; but silk nevertheless remained the ultimate expression of a fashion concept. Taking the place of ribbons as the important small silk items were neckties, handkerchiefs, and scarves, as well as the silk lapels on men's formal attire. Despite the arrival of man-made fibers (regenerated from wood pulp and other plant materials) at the beginning of the century and synthetics (created by polymer chemists, mainly from fossil fuels) midway through, a renewed appreciation of natural fibers during the 1970s turned attention once more to silk. It flourished not only in its established role, creating fashion trends in color, texture, form, elaboration, and weight of cloths, but also as an artistic medium in its own right as the later sections of this book illustrate. In addition, its physical characteristics—strength, warmth, length of fiber, and fineness—contributed to the development of techno-textiles. These subjects are explored in the following pages.

right The sophisticate of 1928 wore short evening gowns, which employed far less silk than garments of a decade before. Compared to the Goupy lace garment (center), the Lelong silk crêpe dress is strikingly simple, with only narrow interwoven bands of metal thread for decoration.

overleaf From demure to daring, these two images encapsulate the role of silk in the radical change in fashions in the first half of the 20th century. Lady Agnew of Lochnaw, painted by Sargent in 1892 in her full-length satin and chiffon gown and silken surroundings, represents turn-of-the-century elegance, for which silk cloths were essential. By contrast, in spring 1948, Dior placed a strong emphasis on silk hose, which he offered in a range of colors. Here the model swirls in a light blue crêpe dress to display navy blue stockings.

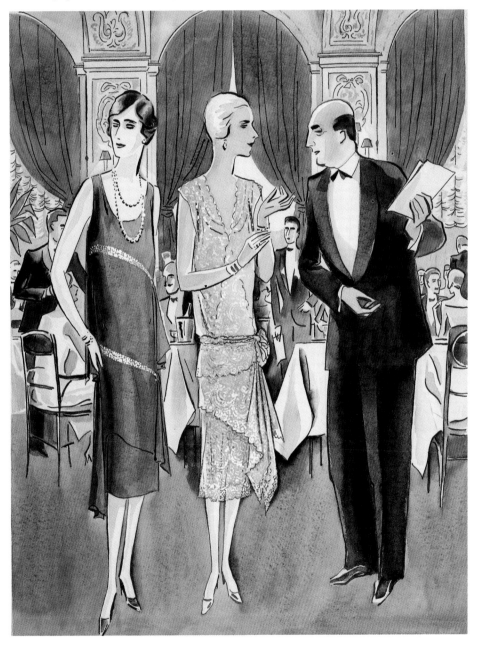

Silk in Detail

Natural fabrics have been the fashion designer's frequent choice but silk has always remained the designers' dream. "The odeur of silk is magnifique," says Hubert de Givenchy. . . . "It is living, it moves, you know how it will react, immediately you want to do something not only for the colour but also for the hand [that is, the feel] of silk. It immediately suggests the design of a dress."

MAHESH NANAVATY, PRESENT-DAY
INTERNATIONAL TEXTILE TRADE CONSULTANT

Givenchy's response to the physical characteristics of silk cloth underscores the remarkable enchantment this fiber holds for many designers: the same commentator continued, "Even during the 1980s, when the supply of quality silk was scarce, at least half of the models in Paris' haute couture shows wore silk," adding Oscar de la Renta's statement "Silk does for the body what diamonds do for the hand."[1] Unlike synthetic fibers—which today can be finer than silk in diameter—silk appears alive; this is because no single fiber is uniform. Its variations may be barely discernible, as in the highest quality mulberry silk, or more evident, depending on its processing or its source. This provides an enormous variety of options for the designer. So, too, does the weight of a silk cloth, which can range from the gossamer thin to a thick satin comparable to fine, supple leather. Like wool, silk is an animal fiber, which makes it warm to the touch. Its length makes it strong, a feature that has been exploited in numerous ways. Of all the natural fibers, mulberry silk is the most receptive to dyes; and because in cross section it is more triangular than round, its surface, prism-like, intensifies the effect of any color. These qualities attract the eye and the hand, appealing to the human instinct to seek out the detail, and this explains why different aspects of the look and touch of silk are as influential as pattern in creating stylistic changes.

opposite Because they so effectively exploited the play of light and shadow, many rococo point-rentré patterns have had long lives. This example, a brocaded damask supplied by Cartier et Fils between 1850 and 1860, employs eight tones of silk and a metallic thread to realize its nuanced effects.

Color and texture

In any fiber, color and texture are inseparable, because the smoother the surface, the clearer the color will appear. Yet for silk, this simple fact leads to a multitude of results, all dependent on how it catches the light. Consider, for example, velvet. Because of the subtle slant of its pile, even a solid-colored velvet (made of whatever fiber) appears darker when seen from one direction than it does seen from the other. Flattening some of the pile exploits this feature; a pattern created in this way is seen solely as a result of the contrast between the pile—darker because seen end-on—and the side-on, more reflective view of the strands, which therefore appear lighter or brighter. Early on, this quality of contrast was exploited by juxtaposing areas of looped and cut pile, and for the past four hundred years it has been mimicked by stamping with blocks or impressing a pattern with hot rollers, a technique known as gauffering. On ribbed and flat silks, a moiré effect is produced in a similar way. The concept of disrupting or enhancing the light-reflective fibrous surface is also the principle behind woven damask and quilting techniques such as trapunto. All of these cloth types might be made of any fiber, but they are most effective in silk. This is demonstrated by many rococo silks, which incorporate elaborate background effects based on textural weaves. Such fabrics also illustrate how the very fineness of silk strands allows

above This French sample book shows "miniature velvets" woven between about 1775 and 1793. With areas of cut and uncut silk velvet and multiple colored warps and wefts, these seemingly modest designs were among the most costly of cloths woven for men's garments.

opposite Structurally complex, this Lyonnaise silk of 1740–50 exploits the fineness of threads to create a delicately textured ground, over which vividly toned supplementary wefts create realistically shaded flowers by dovetailing, or *point rentré*, of adjacent colors. The *rocaille*, or shellwork, is brocaded with silver and silver-gilt threads.

the close juxtaposition of different colors and textures in a woven cloth, as do the eighteenth-century so-called "miniature velvets" made for men's suits, with their tightly intermixed colors giving an impression, from a distance, of texture alone. Today, finely executed men's tie fabrics continue this "pointillist" approach.

When, after the industrialization of the later eighteenth century, cottons began to emerge as the fabric of the people, silks also became more widely available. The greater sheen and the glowing colors of silk are the critical visual distinction between it and cotton—and the distinction is critical in social terms; so, almost inevitably, these aspects became emphasized in the production of silk during the nineteenth century. Casting an eye around the globe around the beginning of that century, one can find equally showy silk clothing and furnishings of this period in Africa and North America, in Japan and Europe. In Europe, however, colors at that time more obviously reflected changes in taste and the use of new dyestuffs. Beginning when,

in medieval southern Europe, the ancient shellfish dye murex purple gave way in status and desirability to the red insect dye kermes, the pace of development was initially slow. It was not until the introduction of new dyestuffs from the Americas that other colors competed with the rich kermes reds and scarlets associated with Florence and Venice (the latter, because of a difference in water, producing a distinctive coral-tinged red).[2] The first of these was logwood (*Haematoxylon campechianum*), which is native to Mexico and Central America. Initially used to produce an inferior blue, it was banned in England from 1581 until 1662, then in France, and as late as 1758 in Germany. Yet someone—probably a Spaniard, judging from the fashion for black established by the Spanish court during the 1500s—discovered that with copper as a mordant, or fixative, it easily produced a brilliant and fast black. By the nineteenth century, logwood was the most widely used of all dyes.[3] It underpinned the fortunes of the Zurich manufacturers specializing in black taffeta—much of which went to the

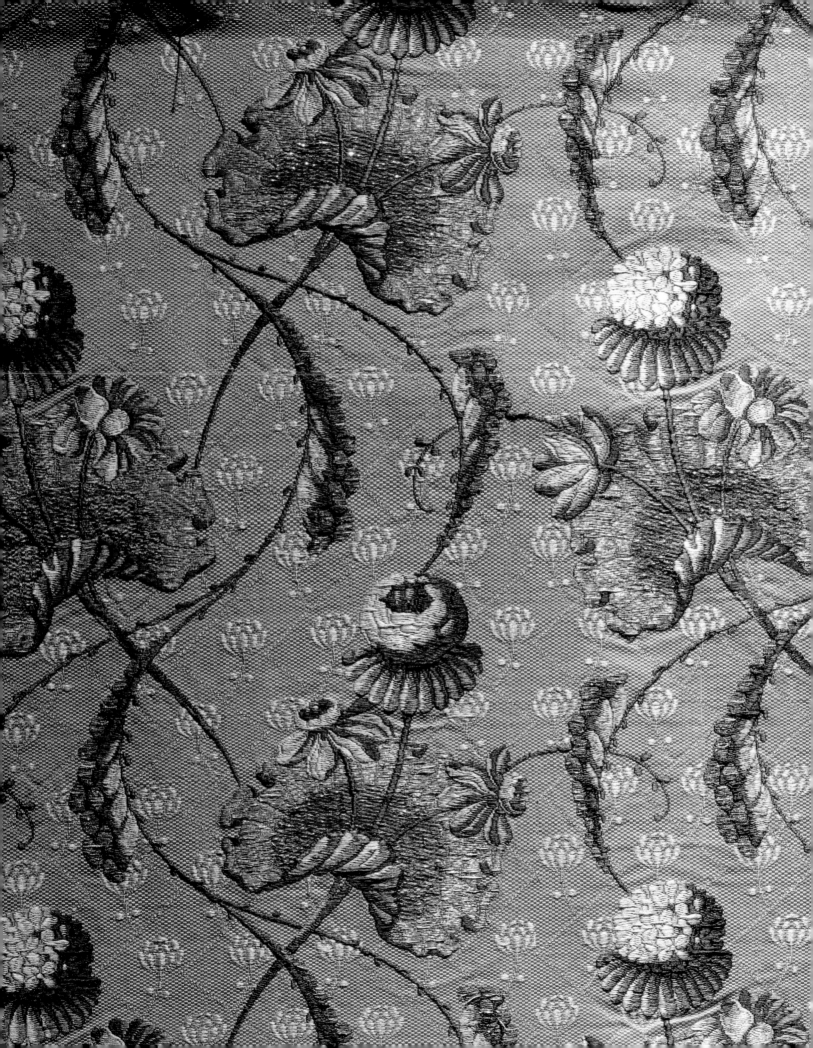

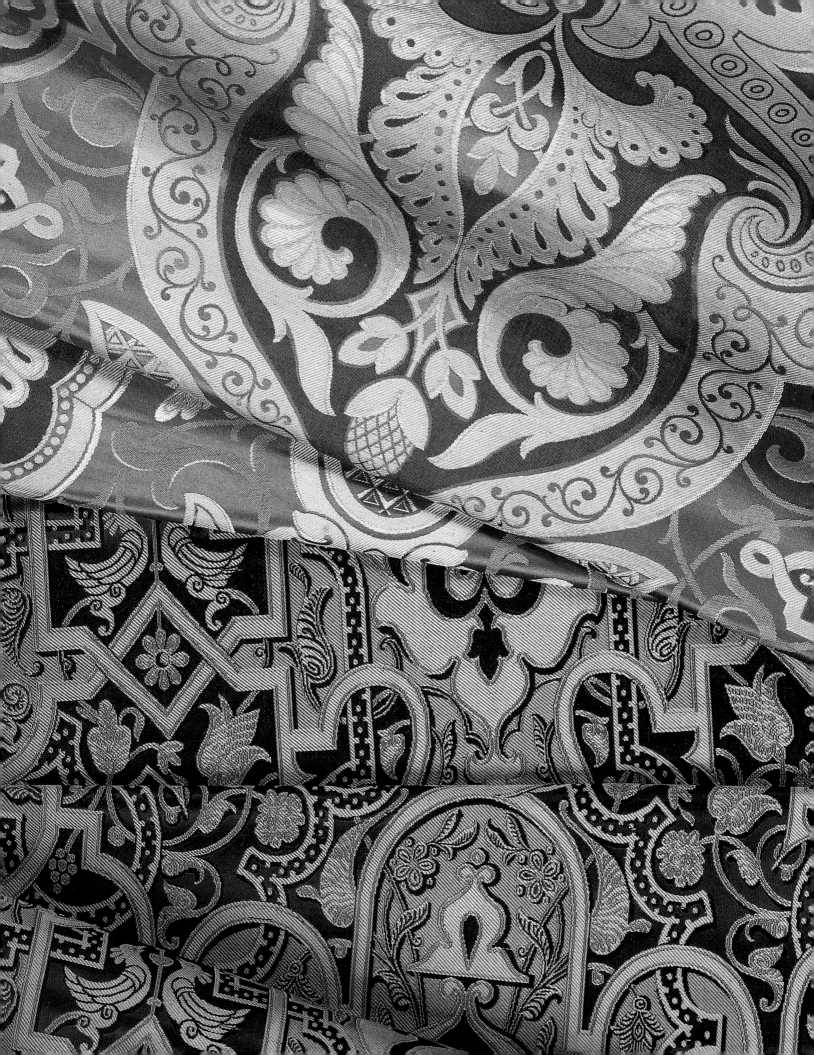

United States—and of Samuel Courtauld & Company,
based in southeastern England and the inventors of a
device for crimping black silk crêpe. It could be argued
that the nineteenth-century mourning ritual, so
dependent upon black cloth, was in turn dependent
on logwood. Yet black was also esteemed as an elegant
color—so much so that there was a "black department"
in E. Meyer & Cie., who supplied fine materials to
leading fashion houses in late-nineteenth-century
Paris and also (presumably because his sons had been
apprenticed at Meyer's), in the department stores in
London and Newcastle belonging to John Fenwick,
known as "the Worth of the North."[4]

Offset against the fashion for black was an equally
strong taste for vibrant color; and although a love of
bright colors would resurface occasionally during the
twentieth century, it was during the nineteenth that
the brilliant hues characteristic of mulberry silk were
combined in the most emphatic and exuberant way.
Many new dyes were discovered and created during this
period. Among the most important was cochineal, the
other important dyestuff from the Americas. An insect
dye related to kermes, it is much more concentrated,
producing a striking scarlet when dissolved in a solution
of tin, a fact that had been uncovered in the seventeenth
century. During the "golden age" for many European silk
manufacturers—from about 1830 to 1870—many new
dyes were developed, first from minerals and then as
synthetics, the first of which was Perkin's mauve, from
coal tar, in 1856. More widely used was magenta (or
fuchsine) developed a few years later by a Frenchman,
François-Emmanuel Verguin; both this dye and the next
synthetic, Lyon blue (1860), were first applied to silks.
Two shades of violet appeared, in 1861 and 1862, and in
1872, Methyl green, which is still used today. But until
1878, when a chemist in Germany (then becoming the
leading source of synthetic dyes) created a new, strong
red,[5] there was no rival to cochineal. This expensive,
exquisite red contributed to the distinctively nineteenth-
century character of the various revivals seen in
furnishing silks of the day, often serving as a vivid
backdrop to realistically rendered eighteenth-century-
style florals or as a contrast to other equally bright colors
in Moresque patterns, in which more or less abstract
patterns might be detailed with areas of closely
interwoven "textural" colors.

Texture itself occurs naturally in wild silk, which
is of three main types: tasar (or tussah), muga, and eri
(also known as eria or endi). The last must be spun,
but the others are reeled directly from the cocoons of
various *Antheraea* species. The first is the most widely
produced today—in China, followed by India. However,
only India also provides eri, naturally colored white to

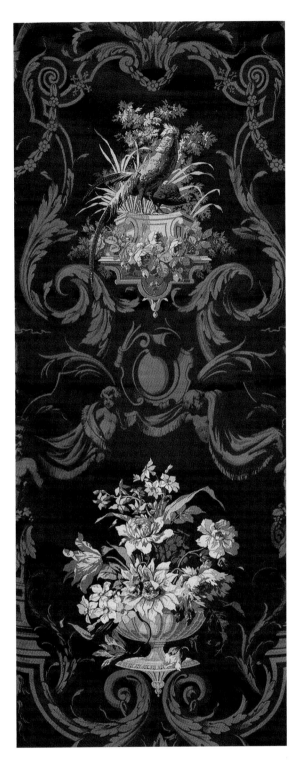

THOMAS WARDLE.

Pattern No. _____
Patt⁰. Book No. *1215*

THOMAS WARDLE.

Pattern No. _____
Patt⁰. Book No. *1217*

THOMAS WARDLE.

Pattern No. _____
Patt⁰. Book No. *1216*

THOMAS WARDLE.

Pattern No. _____
Patt⁰. Book No. *1218*

above Thomas Wardle not only taught William Morris how to dye, but in c. 1878 printed these Morris patterns on Indian tussah silk cloths. Wardle was the son of a dyer in Leek, which was an important center for the production of English silk sewing and embroidery threads.

brick red, and muga, a golden yellow silk mainly from Assam. These wild silks had a long history of use in countries where they existed naturally; the species found in Japan was, in fact, highly prized. However, none had much impact in Europe until 1872, when the resistance of India's tussah to dyes was overcome. This was accomplished—using natural dyes—by Thomas Wardle, a silk manufacturer in Leek, England, who is today best known as the person who taught William Morris how to dye. Having succeeded in block-printing fast, if subdued, colors onto tussah cloth, Wardle then promoted tussah in Paris during the Exposition of 1878, and this catapulted India's wild silk into European use. It was taken up with enthusiasm in Lyon, Saint-Etienne, Milan, and elsewhere. In Britain it became one of the cloths closely associated with Liberty & Co., and thus with the artistic dress and designs—and an appreciation for Japanese wares—that came in Europe to be known

as "the Liberty Style."[6] Textured silk threads were already known on the Continent, as a result of the spinning of the waste from mulberry silk; and the making of this filoselle or schappe had increased with the onset of a silkworm disease called pébrine and the resulting shortage of raw mulberry silk. Pébrine affected sericulture not only in France and Italy but also, in 1875, that of India. The timing was perfect. Only about eight percent of a tasar cocoon can be reeled; the remaining waste must be spun. The efficient spinning of tussah waste, from 1877—as well as the dyeing and printing of both reeled and spun fibers and fabrics—had been developed in Europe during the very period when it was starved of mulberry silk. At the same time, India needed to make the best of its reduced stock of silkworms and could do so by exporting large amounts of waste silk and some reeled tussah. For the first time, these slightly slubbed silks became sought after outside India. Thereafter silks of this nature remained associated with an artistic or bohemian lifestyle. Because their profile is flat or spiralling, instead of circular or triangular, wild silks were thought less suitable for power weaving. As a result, when mechanized weaving increased after 1900, so too did the perception of a slubbed silk as a handwoven silk. Indeed, hand weavers reinforced this view by often preferring wild silk over mulberry silk. This was certainly true during the 1920s and 1930s, when the weavers Ethel Mairet, in England, and Paul Rodier, in France, championed hand weaving both as a method of designing for mass production and as a means of creating color- and texture-rich cloths.[7]

The ability to produce rich textural effects—either from the weaving or from the use of wild silk—was key to the use of silk in modern interiors in the interwar period, which also saw a corresponding preference for more muted colors. This was for a variety of reasons, including the loss of German dye works during the war, and thus the rationing and "watering down" of dyes; the introduction of electric lighting, which made some vivid colors look garish; and the preference for less obtrusive patterns that followed in the wake of the Art Deco style. The same trends were apparent in fashion fabrics, especially after the New York stock market crash of 1929. These events aside, there was also a growing appreciation for tribal arts, within which context silks once regarded as humble "country cloths" became essential ingredients in fashionable interiors and clothing. One example of these newly popular weaves was shantung. It was named for a province in eastern China, where, in its original form, it was made from the undomesticated *Bombyx croesi*, which produces a rich yellow silk and an uneven texture in the plain (or tabby-woven) handwoven cloth. Later, shantung came to be

right This detail of a St. Edmundsbury Weavers' handwoven silk shows the use of a supplementary weft of silk floss to impart a softer, more textured quality to areas of the cloth. It was designed in 1902 by Edmund Hunter, who founded his firm in that year.

below "Ask Me No More," a romantic impression of the ancient world painted by Lawrence Alma-Tadema in 1906, displays a pleated silk gown of the type made famous by Mario Fortuny, in Venice. Like Fortuny's "Delphos" dresses (produced from c. 1907 to 1949), this gown was probably made of pongee, woven with raw tussah silk.

opposite Arthur Lasenby Liberty, who founded his "art emporium" in London in 1875, was influential in promoting the use of tussah silks. This Liberty length, probably printed by Thomas Wardle & Co. in about 1890, illustrates the warmth lent to the coloration by the unbleached tussah ground.

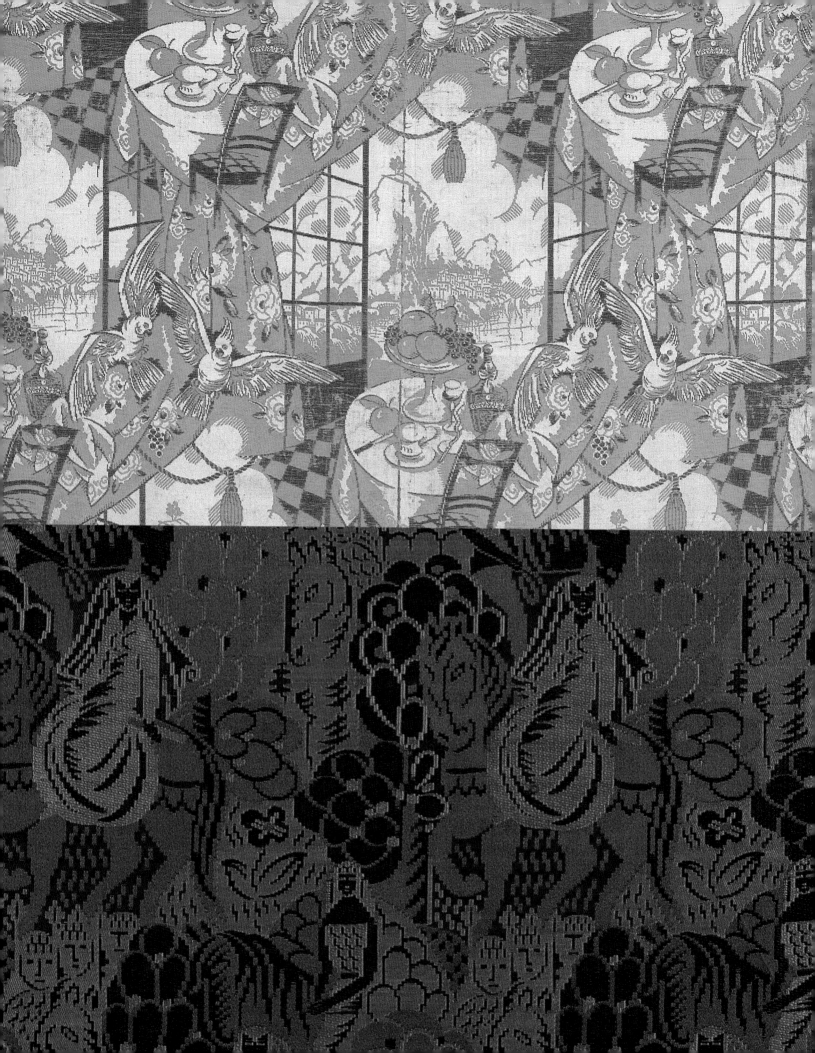

made from silk waste and unthrown tussah, and was one of the simple cloths power-woven in Shanghai and Japan during the interwar period. This humble cloth thus found its way into society—being used, for example, as curtains in the dining room at Eltham Palace, the luxurious home near London built in 1935 for the textile millionaire Sir Stephen Courtauld and his wife, Virginia.

When, in 1948, the American entrepreneur Jim Thompson founded the Thai Silk Company, these handwoven cloths had an uneven surface not because they were woven from wild silk but because the mulberry silk, much of it initially from Laos, was hand reeled and therefore less consistent. The silks produced by Thompson's company used the highest quality dyes from Switzerland. According to one of Thompson's biographers, "the great majority of the brilliant and often audacious combinations for which Thai silk became famous . . . were so widely copied by numerous rival companies that they have come to be regarded as traditional." The patterned fabrics were devised by Thompson himself, drawing on traditional designs. "He changed them in sometimes subtle ways, working with spindles of colored thread much as a painter uses [a palette]. . . ."[8]

A resident of New York prior to the war, Thompson had contacts in that city, and arranged to have his silks introduced to the fashion editor Diana Vreeland and the costume designer Irene Sharaff. Her use of Thai silks in *The King and I*—both on stage and in the 1951 film— catapulted his shimmering silks into fashion, interiors, and films. Pierre Balmain used them often. It started the rage for using silk for large scatter cushions and for casual men's jackets. And Thai silk was used around the world as a wall covering and for curtains and draperies in prestigious locations: the Savoy Hotel in London, Windsor Castle, the Hong Kong Hilton, and (interwoven with aluminum threads) by the Reynolds Metal Company for their headquarters in the United States. It was perhaps the first "celebrity" silk. Special weaves were created for the film *Ben Hur*; and luminaries such as Ethel Merman, Anne Baxter, Barbara Hutton, and Cecil Beaton, visited Thompson in Thailand. Such was the demand that by the 1980s—having started with weavers working in their own homes—his was the largest hand-weaving factory in the world.

Although the colors have changed, machine-woven silks and silk blends with the character of a handwoven cloth—dependent upon subtle textures, the introduction of metallics and other non-fibrous materials, and,

above Bonnie Cashin's early
1950s reversible striped
shantung shirt is presented in
a Thai setting, indicating that
the term "shantung" had ceased
to be known solely as a Chinese
wild silk fabric. Cashin was
among the leading American
designers of stylish sportswear.

sometimes, special finishes—remain in the vanguard of furnishing fabrics. In Switzerland, which consumes more silk per person than any country bar Japan, such cloths are designed and woven for leading furnishing fabric houses by the 182-year-old firm Weisbrod-Zürrer AG. In India they come from one of the largest integrated mills in the world, Himatsingka Seide Ltd. (HSL), in Bangalore, which lists the notable modernists it supplies, including JAB, Zimmer & Rhode, Sahco Hesslein, and Jack Lenor Larsen. HSL also produces traditionally styled silks, the sophisticated option since

the 1980s. True to the global and circular history of the silk industry, its spinning division, Himatsingka Filati, was established in technical collaboration with Filati Buratti of Italy. Some one hundred years after fears were expressed over the future of India's silk industry, HSL is widely recognized for its high standards and, in keeping with the diversity of India's silkworms, the breadth of its designs. This mixture of a handwoven aesthetic with modern technology can also be found in the innovative cloths emanating from Japan, where such fabrics are considered suitable for interiors and fashion alike.

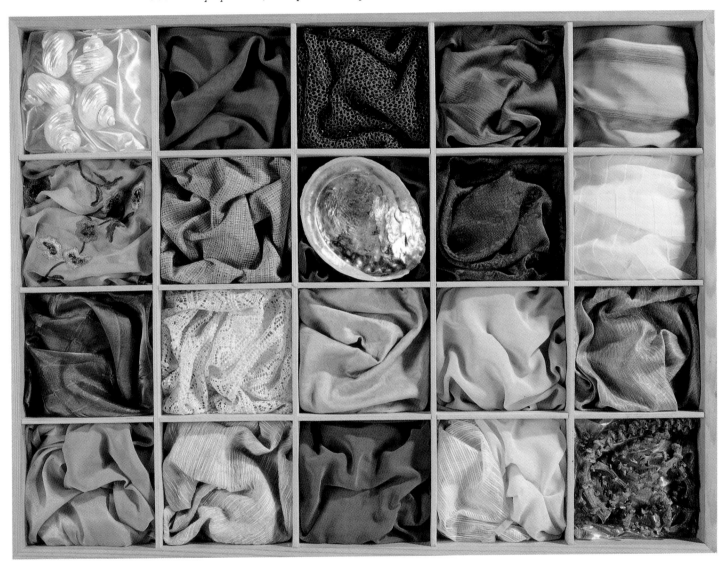

above Silks for modern interiors focus on texture, metallic effects, and innovative constructions and finishes, as shown here. All were designed and produced by Weisbrod-Zürrer in Switzerland, and available in 2006.

Printed and dyed patterning

Throughout many centuries, as we have seen, colored patterns have been created in silk through the process of weaving. The alternative means of integral pattern making is to apply color selectively to the woven cloth (or in some cases to the threads themselves). Of these techniques, the principal option today is screen printing. In the past hundred years, this method of printing has been the source of major changes and innovations in the use of silk.

The origins of screen printing can be found in four ancient techniques. The first of these is dyeing only designated areas of the cloth by clamping or binding, techniques developed in many regions—most notably in the Indian subcontinent, where tie-and-dye is still widely practiced—but today known by the Japanese inclusive term *shibori*. The second technique, generally known as ikat, or chiné, involves dyeing designated areas of yarn prior to insertion in the loom. The third

is the application, before dyeing, of a dye-resistant paste or a dye-attracting substance; out of this basic method arose Indian *chint* and its western imitation, block-printed chintz. Finally, there is direct painting onto silk, as can be seen on many Japanese kimonos of the seventeenth to nineteenth centuries, on which dyes were applied cold, freehand, with a brush. Each of these techniques is a subject in itself;[1] and all are still practiced today. Nevertheless, each technique also underwent transformations designed to speed up the process, and in doing so contributed something to the development of screen printing.

Simply put, each of the four ancient processes explored what kind of marks could be made with dyes. The first two, shibori and ikat, are related in one sense: they both entailed the use of binding to prevent dye from reaching certain parts of the material. Shibori, in its classic form, rendered patterns through the grouping of dots, each formed by poking a small area

opposite This detail of a silk belt from Fez, in Morocco, shows the varied tonal effects and "shadowy" edges that indicate it was dyed using the ikat method, in which sections of yarn are dyed prior to weaving.

below Women in Udaipur wear silks patterned by tie-and-dye, a widely used form of physical resist that results in minute white rings on a colored ground. These are made by a tight wrapping of thread around a protruding area of cloth and can be further colored by repeating the process, as the left-hand Rajasthani sari shows.

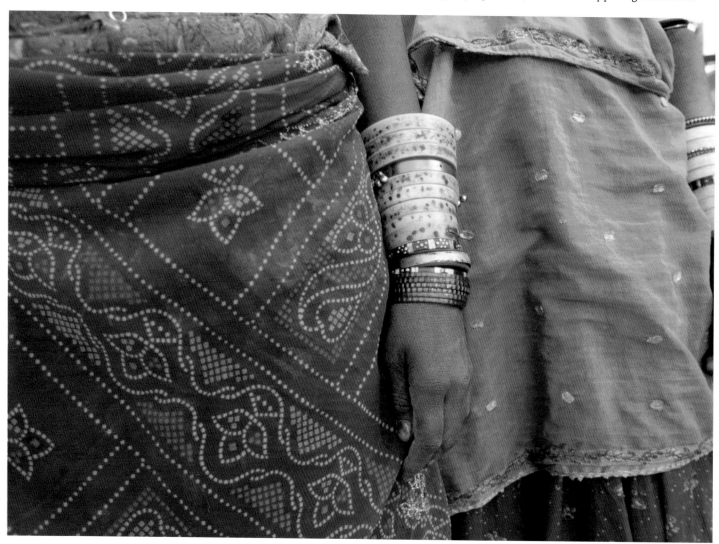

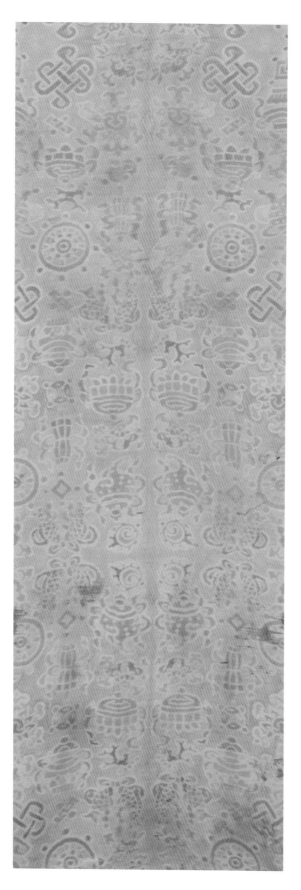

of the silk forward and binding it tightly to prevent the dye from reaching it, thus creating an undyed circle; other patterns are made by wrapping the cloth around something and binding against that. Ikat uses the same concept, applying it to yarns, rather than whole cloths. Bundles of threads for the warp or weft are bound in places, prior to dyeing. (Thus, ikat is actually a hybrid form of pattern making—achieved by a combination of weaving and the selective application of color.) In the most complex of patterns, both the warp and weft are treated this way; and this is how the famous Gujarati *patola*, or double ikats, are still made today. (Additional colors in both shibori and ikat are obtained by the laborious process of adding more bindings to preserve the previous color and/or new bindings to hold some areas undyed.)

By at least the 600s, clamping—waffle-iron style—could be used instead of binding to fend off the dye in chosen areas of cloth. Because silk takes dye so readily, small amounts of different colors could be "inserted" into separate, unclamped sections to create a multicolored pattern more quickly than could be done with other fibers (for which a vat of boiling, or near boiling, dye would be required). The clamp itself was typically made of wood, with the design outlines formed of metal inserts standing proud of the block.

The results of clamping can resemble batik, the third technique, in which an outline of wax is drawn onto the cloth to prevent those areas from coming into contact with the dye. In time, it was discovered that this could be done more quickly by using a stamping process, in this case to repeatedly press wax into the cloth to create an overall pattern. The same purpose was served by other dye-resistant substances, such as mud or clay, which was widely used in the Indian subcontinent. There, the use of carved blocks to apply the resist material increased during the seventeenth century to satisfy the growing demand in the west for Indian printed cottons, in particular. But the significant development was the Indian method that replaced clay (to deter dyes) with a mordant (to attract dyes)—knowledge that Europeans acquired in the later part of the same century. From this point, western hand block printing and then machine printing evolved. Once industrialization was under way, by the 1820s, even a speedier means of printing warp threads for ikat was patented, in the following decade.

Thus by the 1830s, shibori, ikat, and hand-applied resists had each been semi-industrialized. Only hand painting had not, although the Japanese had developed stencils to speed the hand application of dyes. These stencils included intricate cutouts, which were tied together, and thus stabilized across the void, with

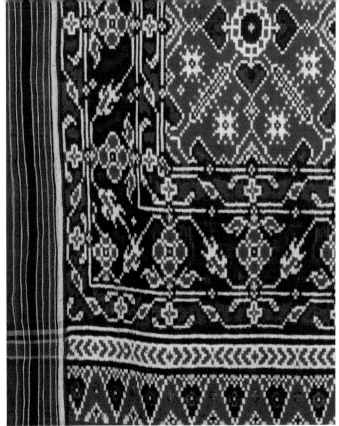

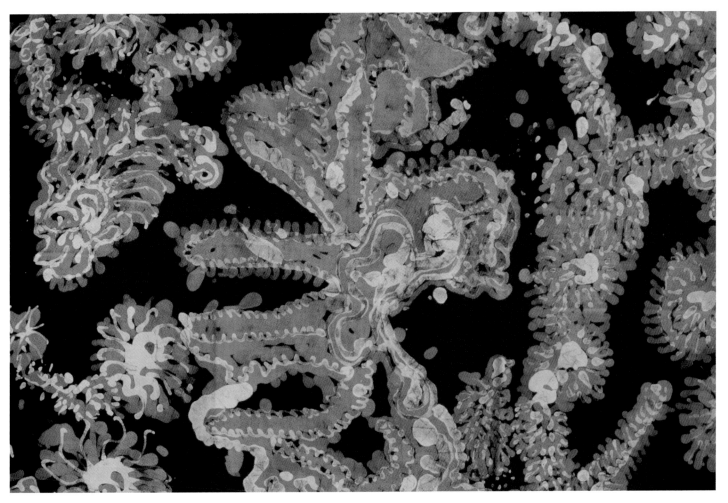

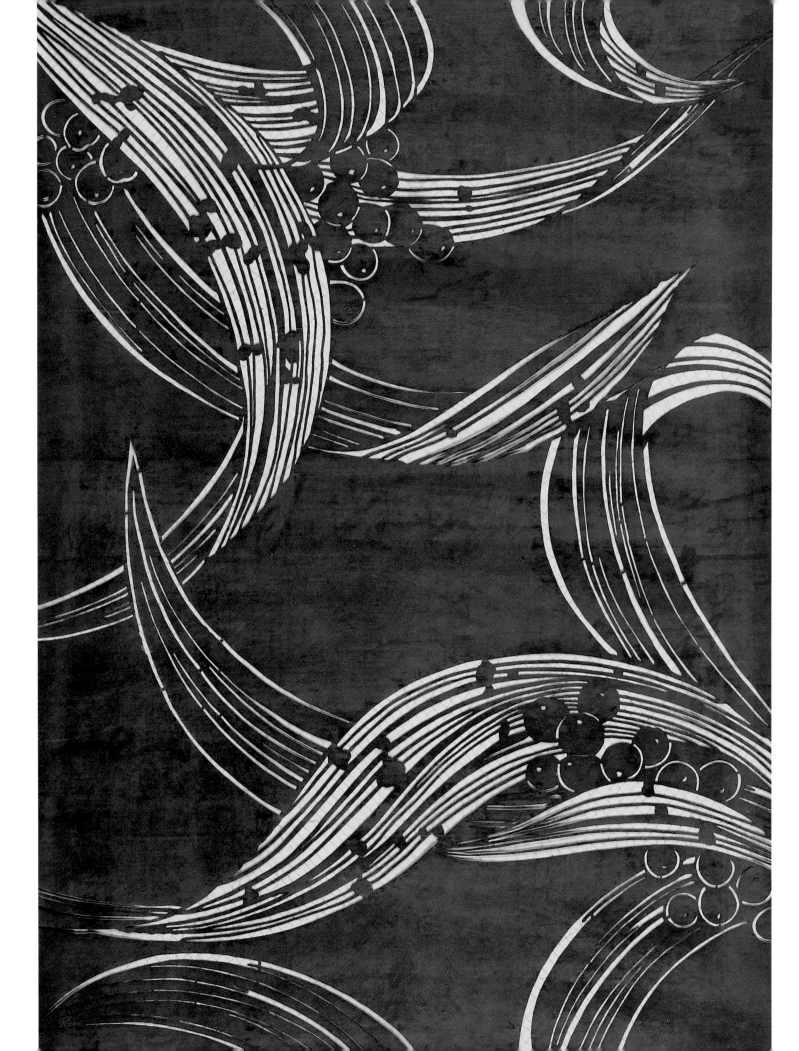

above Screens for printing are similar to stencils, but the allover support of a screen allows for very fine details. When this photograph of Ornella Pizzagalli was taken, in 1983, his company, near Como, produced enough silk-screened fabrics for eight million ties.

opposite Notes on this Japanese mid-19th-century stencil indicate that its pattern was intended for both kimono and interior use. Made of waxed paper, the cutouts are stitched across with silk, to hold them in place.

strands of silk—an expedient that served as a vital element in the development of screen printing. However, it was not Japanese stencils alone that inspired its creation. Instead, it was a combination of factors, including the wish to satisfy more efficiently the age-old urge to make pictorial textiles (which the Jacquard had provided in weaving technology); the proliferation of posters, magazines, and packaging—which put every manner of printing to the test on paper and cloth; and the existence and improvement of dyes that could be applied without having to dip the cloth in a vat. Silk, of course, was the one fiber that had been dyed in this way, without recourse to immersion, for centuries. However precise engraved roller printing had become, it could not capture the free, gestural brush marks made by an individual hand, and the high-speed and high-volume roller printing was, in any case, never appropriate to the exclusive, more limited runs needed for silk.

Silk was thus already associated with painterly textiles and, as a structural element, with stencils, when,

in the 1870s and 1880s, the Americans began to search for faster ways to produce marketing material and the Dutch took a renewed interest in batik, as made in their (then) colonies. By the 1890s the British were toying with Japanese-style stencils—a technique they pursued (sometimes applying dyes with spray guns) as late as the 1930s—even though a silk printing screen had been patented by Samuel Simon of Manchester in 1907.[2] In Venice, by 1910, Mario Fortuny had created his own "stencilling machine." Out of all this came silk screen printing. The silk ties in a stencil were replaced by an entire stretch of silk, which could be painted, batik-like, with a block-out substance. Dye could then be applied to the cloth through the areas of the screen left unblocked, and different colors could be created with the use of more than one screen stencil. At last, a quick way of duplicating the artist's spontaneous mark had been achieved. By the 1930s hand screen printing was spreading, first on textiles and, late in the decade, on paper; and by the 1950s flat-bed machines were

previous spread Mario Fortuny hand-dyed his printed silk velvets, which he produced from 1910 to 1949. Most employed historical patterns; shown here is a rare original design of c. 1920–30. It was printed with a natural glue, such as albumen, to hold the powdered gold in place.

right Johanna Straude, painted by Gustav Klimt in 1917–18, wears a coat made of the Wiener Werkstätte block-printed silk "Blätter," which had been designed seven years earlier by Martha Alber. Klimt was associated with the Werkstätte, an influential source of modern designs until its closure in 1932.

opposite In 1925 the American Stehli Silk Corporation, a Swiss subsidiary founded in 1840, set about to break away from flower prints and polka dots by collaborating with artists and the eminent photographer Edward Steichen. Promoted as "Americana Prints," these included Clayton Knight's 1926 "April" (top), complete with umbrellas, rain, and rainbows. In 1927 Steichen's "Buttons and Threads" (right) was produced, together with Dwight Taylor's depiction of Coney Island rides, "Thrill" (bottom), and Kneeland (Ruzzie) Green's "It" (left), a reference to the name given by the novelist Elinor Glyn to sex appeal and to Clara Bow, the "It Girl" of silent movie fame. All were hand-printed on silk crêpe.

above Velour au sabre is a costly satin weave with a low, hand-cut pre-printed warp pile, allowing for a shaded design. A technique developed in Lyon in the 1840s, it was revived in 1946 with Dior's "New Look"; this French example was woven between 1950 and 1955.

above right Zika Ascher introduced a range of hand-screen-printed, artist-designed scarves at the end of WWII. He procured designs from Picasso, Miró, and others including the British painter Ivon Hitchens, whose "Summer Azure" scarf of 1947 is shown here in detail.

opposite Jacques Fath's c. 1954 gown is of organdy striped with satin and hand-printed with a dusky rose motif. The pattern is printed, rather than woven, so it does not diminish the buoyancy of the silk, which Fath exploited in the slightly trained skirt.

becoming commonplace. Rotary machines followed.

Two striking changes occurred as a result. Hand block printing—slow, costly, and requiring specialist skills to make the blocks—gradually gave way to screen printing, in which the image could be either painted on by hand, as described above, or photographically reproduced. In the latter method, the entire screen is covered with a light-sensitive gel and overlaid with a large negative; after the uncovered areas are exposed and thus fixed to the screen, the mask is removed and the gel washed away. Also, being independent of the cloth structure, artists' designs could be printed without thought for the demands of weaving. And many were printed, especially from the late 1930s into the 1950s, just when, because of restrictions in place during the Second World War, the headscarf became the "must have" accessory, giving a much-needed lift to austere wartime and postwar clothing. From about 1940 until 1946, most of these were of rayon, although in the early days of the war, some existing supplies of silk were used.[3] Scarves have remained a site of innovation among silk printers, and for some fashion labels, such as Versace and Hermès, their signature.

Screen printing also made it possible to produce intricate patterns on lightweight and sheer cloths. This turned the tide toward printing in general, as opposed

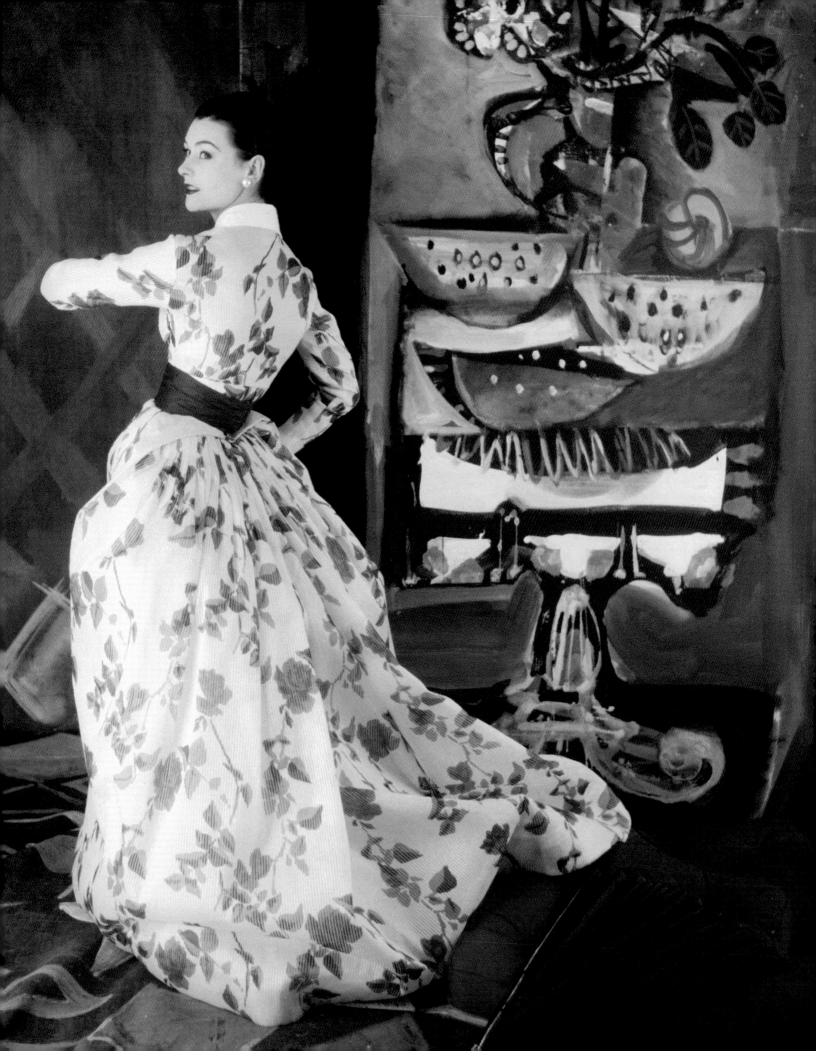

below As screen printing became the dominant method of adding pattern to cloth, in the 1950s, its ability to reproduce a loosely rendered mark became widely understood. Typifying the resulting "painterly" silks are these examples produced by Liberty of London, clockwise from top left: "Nicotea", 1959, and "Trinidad" 1964, both designed by Althea McNish, and "Cherokee," 1959, by Colleen Farr.

left and above Zandra Rhodes began to hand-screen-print silk chiffon in the mid-1960s, and it was soon to become her "signature" cloth. "Tutankhamoun's Leopard" (above) and "Byzantine Swirls" (left) are from the Spring/Summer 1987 and 1990 collections respectively. Her use of hand-patterning as the springboard for her garment design greatly influenced the emerging art-to-wear movement in North America.

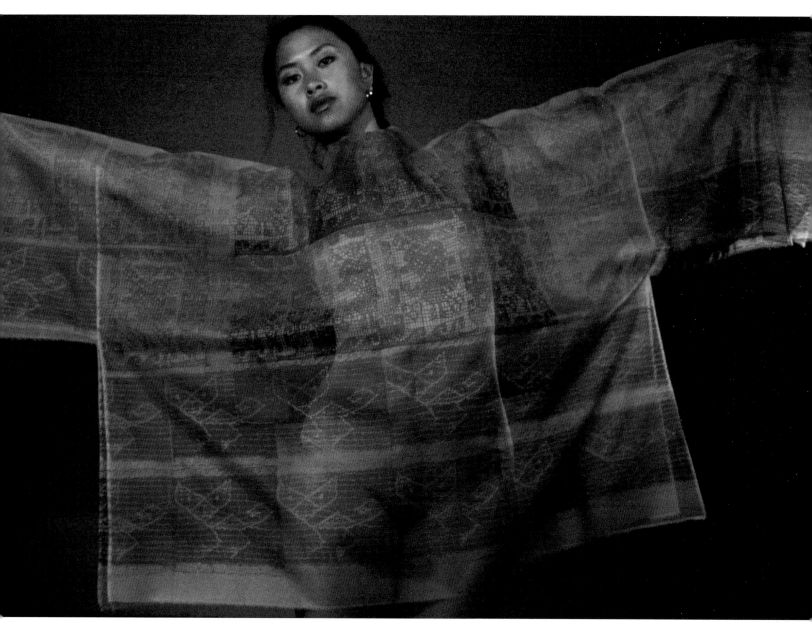

above By screen-printing a photograph on silk organza, Jo Ann Stabb, in 1977, captured, in "Faux Peruvian Gauze Poncho," the contrast of scale between many Peruvian ponchos that were designed to be layered over a deceased "mummy bundle" and the size of the actual human body; the transparency of silk organza allowed this comparison to be visually evident.

to woven patterns, as more and more "gray" (unfinished) silks were imported from Japan and China. The silk weaving industry in the United States faded away, and in Europe only the most innovative and quality conscious of weavers survived. Yet within this context arose a new generation of silk machine-printers, hand-printers, and painters who, since the 1970s, have represented the only steady area of growth in western silk manufacturing. Pushing artistic boundaries with their medium, as if freed by the possibilities, they have also explored a range of other methods, from the newest of digital printers to the revitalization of ikat and shibori. The results of these developments are explored in Silk in Action (beginning on page 188).

Sculptural silks

The sculptural possibilities inherent in clothing have long been explored through the medium of silk. In fabrics ranging from crisp taffetas and sheer organzas to robust ribbed failles, silk provides a combination of lightness and strength that can sustain complex forms with ease and is forgiving of the most tortuous of treatments. Creating striking silhouettes or buoyant details with silk has also proved advantageous for other reasons. Since it has always been the case that a couturier's concept might be adapted in other fabrics, working with silk's unique sculptural qualities imposes a subtle but significant barrier to copyists. As one fashion journalist recently put it, "Haute couture has no need

opposite For the Dior haute couture collection of winter 2003–4, Galliano exploited the sculptural qualities of silk in this extravagant jacket, its impact derived from layering and folding.

to fear the 'impressionists.' Who could even begin to attempt a version of a Galliano ballgown of pink silk, twisted, pleated and folded with origami-like intricacy, and encrusted with thousands of hand-sewn silver and crystal beads?"[1] The ballgown in question was inspired by just the sort of elegant evening gowns created in the mid-1950s by Christian Dior himself.

Galliano is not alone in appreciating the striking silhouettes of some fifty years ago. Over the past two decades others have revisited the 1950s and 1960s, finding a spark of inspiration in the work of couturiers such as Dior, Yves Saint Laurent, and Balenciaga, each of whom astounded the fashion world at the time with season upon season of new garment shapes. What is striking is not so much the visual comparisons that can be drawn but, rather, the way, in each case, such sophisticated manipulations use silk's full-bodied handle to maximum effect. Looking back to preceding eras that produced sculptural fashions, one can observe that most of these, too, were constructed from densely woven silks. Whether supported by crinolines or bustles—as they were in the second half of the nineteenth century—

or used to create the sharply smooth outline of later nineteenth-century tailored long-skirted suits for women, such silks flowed gracefully over the under-structures that were worn to nip in waists and expand skirts. Equally, they held their shape when puffed in enormous sleeves or looped into extravagant bows. That couturiers respond as often to the nature of their materials as to specific historical moments is most readily seen in garments of today that display these characteristics without seeming the slightest bit old-fashioned. Galliano again provides an example with the Egyptian-themed garments in his Dior collection of autumn 2003, in which one model incorporates gigantic silk ribbons looped out at the elbows to evoke the shimmering yet sturdy wings of the scarab.

This physical character of cloth—its weight, sculptural behavior, and elasticity (enhanced or restrained)—is referred to as its "handle" (or "hand"). The way a couturier responds to a fabric's handle has long been recognized as a defining part of his or her style. Fortuny, for example, is remembered for his pleated silks with a liquidlike softness derived from

below Madame Paquin, depicted in 1906 by Gervex, stands in her fashionable Paris salon, surrounded by clients examining lengths of silk. On the left, one of her assistants drapes a full-bodied silk brocade, to demonstrate its effect in use.

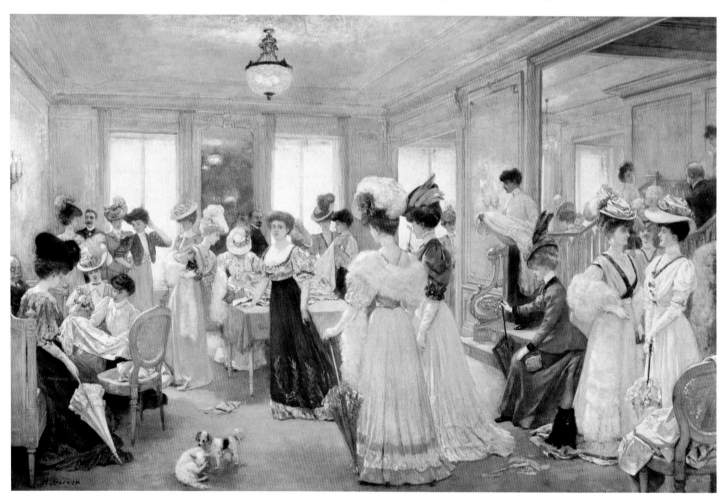

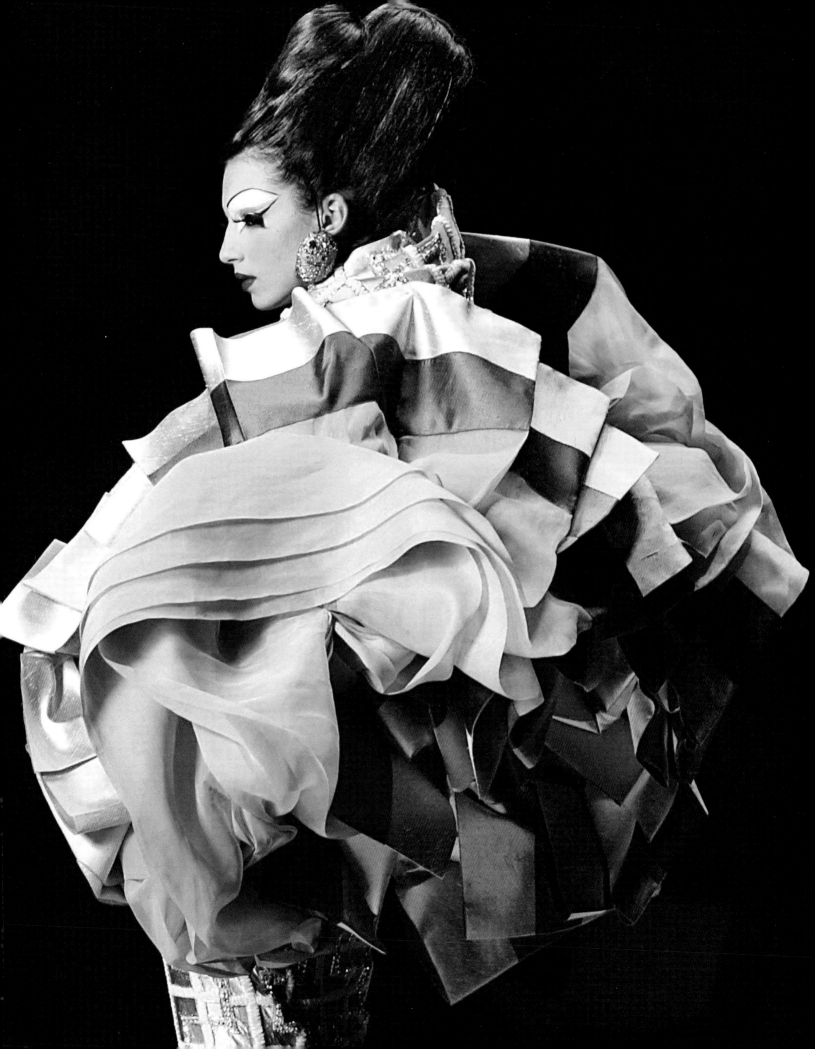

opposite In this 2003–04 Dior dress by Galliano, the extravagant bows, made of silk and metallic threads, derive their contours from the cloth, which combines sheer, stiff organdy with soft satin stripes.

the use of tussah silk. At the height of the fashion for his figure-hugging "Delphos" dresses (see p. 1), in the interwar years, he was a rare example of a designer of fabrics who also produced garments. Fortuny's legacy can be found in today's "art-to-wear" movement, which by definition is textile art in garment form.

For the couturier, however, the historical footsteps to follow are those of Worth, who was generally content to select from among the offerings of Parisian merchants who represented manufacturers—or fabricants—of all types of cloth, but who did occasionally commission special silks directly from Lyon. This latter route became more common after Worth's death. In 1897 Bianchini-Ferrier became the first Lyonnais fabricant to open a showroom in Paris specifically to serve couture houses, supplying silks with both woven and printed designs, including, from 1912 to 1928, many designed by Raoul Dufy. Bianchini-Ferrier was at this time closely associated with the couturier Paul Poiret. Another Lyonnais fabricant, François Ducharne, opened a competing establishment in Paris in 1920 and "over close to a half-century, he furnished textiles, silks and wools, to successive generations of couturiers, to Poiret, Vionnet, Lelong, Schiaparelli, Molyneux, Patou, Chanel . . . Rochas [working for Dior], Balenciaga, Givenchy, Fath, Balmain." According to Ducharne's son Pierre, Balenciaga "was incredible for his choice of textiles. He touched them for a long time before he decided."[2] In other words, he was among those couturiers for whom the sculptural quality of silk was paramount. Another of these was Christian Dior, who in 1956 wrote that he was resistant to what he called the "charming and insidious . . . I respond only to the weight; I never choose a cloth solely because it has an exquisite color, but only because its quality allows me to create exactly the form that I envision."[3]

Balenciaga's concern for the handle of a cloth eventually led him to collaborate with the Swiss firm Abraham to introduce especially firm silks to both his evening wear and leisure wear collections of 1960–68.[4] These silks, called "Gazar" (sometimes "gazaar") and super-gazar, or "Zagar," have a near claylike ability to hold their form. As one of Balenciaga's biographers explained it, they were "suited to very simple, sculptural shapes, as they stood out from or hung from the body on their own," adding that the "best-known examples of Balenciaga's mastery in handling this fabric are his trapezoid bridal gowns from his last collections in 1967 and 1968."[5] Gazar has remained in use ever since, both in garments solely exploiting its gleaming weightiness and in others that show off its elegant simplicity through contrast with silks of an entirely different character.

The latter approach is exemplified by Gilles Mendel,

of J. Mendel, whose background as a fifth-generation furrier led him first to treating fur as fabric—by slashing or shearing—and then to treating fabric as fur, rendering it into a textural mass.[6] Such juxtapositions have increasingly defined the work of many leading couturiers, resulting in innovative manipulations that often alter the cloth to such a degree that it becomes an entirely new material. In the last ten years, Julien Macdonald has become known for just such reinventions, initially as a knitwear designer, "achieving delicate cobweb effects with shredded lace, tattered chiffon, and tulle."[7] Many others, however, depend on the fabricant for a palette of inventive silks to inspire each season's artistry. Often, as many as two thousand samples will be prepared each year, some so complex and costly that only a few meters will be made for a single haute couture showing.

Nevertheless, it is often when silks are used en masse that their sculptural qualities are most apparent. Take tulle, for example. Like all lightweight silks, it can be arranged into very dense gathers, but the effect when tulle is tightly bunched is unique, because its stabilizing hexagonal structure renders it buoyant. This quality was exploited to the full by Hussein Chalayan for his spring/summer 2000 collection.[8] Known for his architectural attitude to materials (having even fashioned a garment out of wood), Chalayan used hundreds of tiny silk tulle rosettes to create a soft-to-the-touch but seemingly rigid dress. The bouffant nature of gathered tulle represents one end of a spectrum of behavior that runs from the brisk bounciness of organdy—with the silk gum, sericin, left in the threads to keep it so—through drifting, ethereal chiffon—a sheer plain weave—to the languid allure of crêpe, its "spongy" surface achieved by alternating threads twisted in opposed directions, or too tightly twisted, so that they buckle and bubble against each other.

Some of silk's intrinsic attributes are so well known as to have entered into literature. For example, the novelist Edward Bulwer-Lytton, writing in 1843, declared, "He who has little silver in his pouch must have the more silk on his tongue."[9] He conjures up not only the smoothness of silk (as in a "smooth talker") but also, by way of the reference to oratory, the classical world; and assuming that his readers will imagine the fluid drapery surrounding the bust of a Roman senator, he stresses the fluidity of a persuasive speaker. Such suppleness is the forte of satin, with its densely packed floating threads enhancing the elasticity of silk, giving an ease of motion to the cloth that makes it ideal for relaxed, artfully arranged folds and turns. High-quality taffeta, on the other hand, has no such floating threads: each is tied down on every throw of the shuttle. With all this

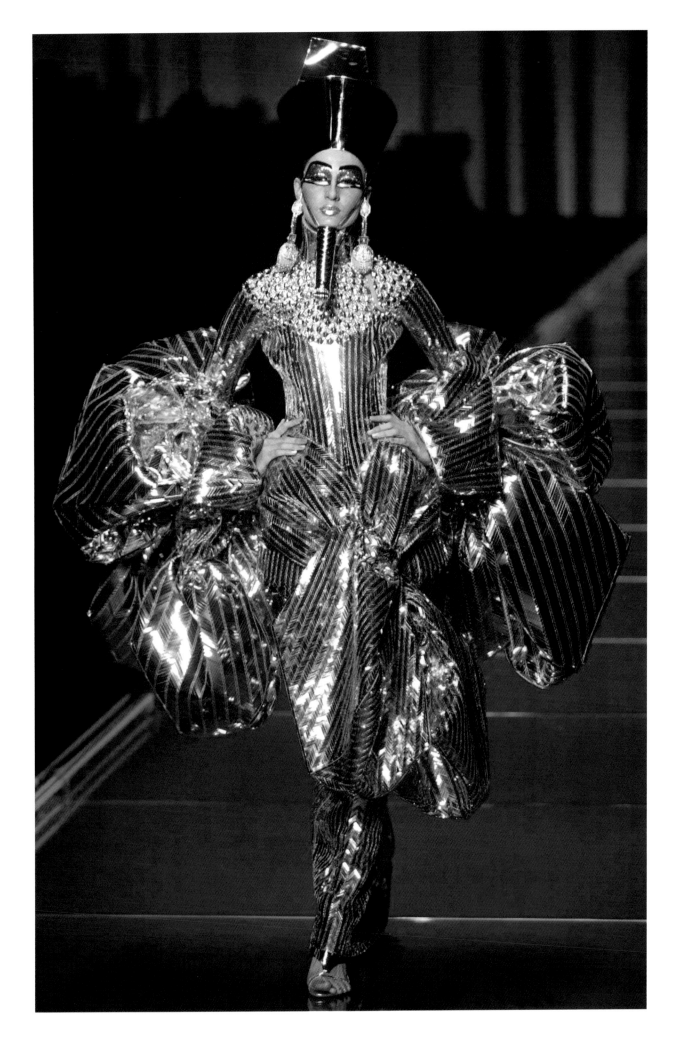

right Designed by Claude
Montana for Lanvin's 1991
spring/summer haute
couture line, this jacket
illustrates the smooth
and weighty elegance of
silk gazar, which is made
with un-degummed silk.

below left Slashing, or
shearing, is a trademark of
Gilles Mendel, of J. Mendel,
New York. His winter 2005
collection included this
gown, which combines the
simplicity of silk gazar with
a lively mass of sheared
organza petals.

below right In his spring
2006 London show, Julien
Macdonald included further
evidence of his influence
on the fashion for
"deconstructed" silks. In
this example, cascading tiers
of brocaded and shredded
silks provide a bouncy skirt
for this "baby-doll" dress.

right For his 2000 spring/ summer London collection, Hussein Chalayan massed together hundreds of minute rosettes made of silk tulle for this dramatically contoured gown. The tulle itself, while soft to the touch, maintains the desired form.

interlocking among closely set fine threads, the resulting plain (or tabby-woven) cloth is ever so slightly inflexible, which accounts for its rustling resilience. Taffeta will thus stand up or out with little encouragement. Both its handle and its sound are so widely recognized and evocative that they served the modern American writer Belva Plain as an analogue that has become a favorite quotation for many: "I stand and listen to people speaking French in the stores and in the street. It's such a pert, crisp language, elegant as ruffling taffeta."[10]

At the other extreme from the crisp malleability of taffeta is the flowing languor of silk jersey. Being knitted, jersey is the most elastic of silks and thus the most formfitting. This aspect of jersey has made it perhaps the most characteristic of changing attitudes to fashion and the body over the last hundred years. Its introduction into haute couture is associated with Chanel (although Lanvin and others had previously used it), because she understood that jersey needed little shaping and that it perfectly suited the more relaxed lifestyle women sought in the 1920s. It was only in the 1930s, however, in the hands of other designers, such as Elsa Schiaparelli (whose 1937 dark blue silk jersey suit for the Duchess of Windsor's trousseau received extensive publicity), that its figure-hugging capacity was first fully exploited. As the body itself gradually came to provide

opposite, above left
Lightweight and stiff, gathered silk organdy produces a full skirt without the need for under-support, as illustrated in this early-1920s Lanvin dress. The same fabric has long been used for cutwork, which is also shown here.

opposite, above right
Modeled during the *Elle* fashion week of 2005, held in Bangkok, Thailand, is this extravagant pun on the term "ball gown." The spherical shape was made entirely of gathered tulle.

opposite, below left
Shown here is the actress Leonora Corbett, dressed for her role in Noël Coward's *Blithe Spirit*, which opened at London's Savoy Theatre in 1941. Appropriately blithe are the casual folds of her silk crêpe costume.

right From Christian Lacroix's 2005–06 haute couture collection comes this essay in silk chiffon. Soft and lightweight, it drifts gently, making an ever-changing silhouette as the model moves.

opposite Two 1947 ball gowns by Charles James illustrate the different sculptural qualities of three solid-colored silks. In the foreground, taffeta stands out crisply in the flaring skirt, while a matte ribbed silk faille and heavy satin cling to the figure in the background.

below left Spain has long been a source of innovative knitwear, here epitomized by a transparent silk jersey designed by Kina Fernandez for winter 2002–3.

below right The fluidity of silk satin is highlighted by the Italian designer Roberto Cavalli in this winter 2004 ensemble. Another master of historical references, he alludes here to his own country's ancient past with the swathed neckline, reminiscent of the drapery on a Roman sculpted bust.

the under-structure once purchased in the form of corsets and crinolines, jersey became the quintessential fabric through which to show off a lean physique. And "show off" it can, for the sheerness of silk allows for the knitting of "second-skin" garments that can be variously opaque, translucent, or even transparent. It most closely returns us to sculpture, in that it can reveal the human form with ease.

For all that silk can conform to the body or, at the other extreme, reshape its contours in the most imaginative of ways, it is also the cloth most sought after for the satisfaction of its touch. The flowing dressing gown or generously sized scarf is sheer pleasure for its sensation next to the skin, which makes these items perennial favorites.

Equally classic are silk velvets and damasks—the latter a play of one weave structure against another, which not only produces a pattern but also results in a cloth that has something of the swoosh of taffeta yet can approach the languid undulations of satin. For cloth and fashion designers alike, originality springs from their fluency with the rich sculptural vocabulary of silks, of which only the most fundamental have been touched upon here.

To this tactile appeal is added the visual vocabulary: printed and dyed effects, stitched and stuck-on embellishments. Heat setting and other finishes can bring further transformations. The resulting array offers a veritable world of choices. Like a great chef, the couturier seeks to capture a flavor, and it is the fabricant who provides the most delectable ingredients. The comparison might also be made to the most audacious of florists, whose genius often expresses itself in contrasting new hybrids and exotic accompaniments with beloved standard blooms and foliage. And, like food and flowers, fashion is fleeting. Silk, however, is not (and it is telling that blooms made of silk have long been a means of capturing the fragile beauty of nature). The modern couturier, too, draws upon a wealth of materials, from classic satins and gauzes to the most experimental new fabrics, constructing three-dimensional works of art that capture an equally fragile thing: the mood of the moment. The couturier's ability to amaze, shock, and delight is all the more important today, with couture clients reduced to a fraction of their numbers some fifty years ago; more than buyers, couture now courts media attention.[11] What remains true, nevertheless, is that silk—the most beautiful of natural fibers, the most varied in its sculptural possibilities—has proved itself to be a constant inspiration within the fashion spectacle.

opposite Gucci's 2005
menswear collection includes
these two caftans for spring/
summer wear. A modern
rendition of an African tie-
and-dye technique alludes
to hot climates, where silk
garments are prized for
their comfort as well as
their luxurious feel.

Strength and warmth

Quite apart from its visual appeal and sculptural
qualities, silk has more practical characteristics that
make it suitable for many different uses, not only in
apparel and interiors, but also for electrical, medical,
and military purposes. This range of applications derives
from the fact that silk in its natural state, with its gummy
sericin intact, is the strongest of all natural fibers and
also very elastic. (Weighting—adding metallic salts of
the kind used when dyeing—decreases both of these
characteristics.) Silk also provides excellent insulation,
even when made into a thin cloth. This feature, together
with smoothness, which allows it to slide easily over
other materials, makes silk the traditional choice for
the lining of high-quality clothes. In the days when
department stores had special silk departments, silk
was also recommended for its cleanliness, because the
same smoothness deters dust from accumulating on its
surface.[1] Nor do germs increase rapidly on silk (as they
do on other animal fibers, such as wool), which makes
it ideal for situations in which hygienic conditions are
essential. Finally, because it is made of protein fibers,

right The firm of Jakob
Schlaepfer, which reached
its centenary in 2004
and is based in St. Gallen,
Switzerland, is renowned
for its provision of unique
silks for the couture industry.
Shown here is a selection
of composé, cloths of silk
and other fibers, sewn with
applied details, embossed,
ruched, or glued with sequins.
Dating from 1987 to 1992,
all were created under the
direction of Martin Leuthold.

it is not as readily combustible as the plant fibers, such as cotton and linen. Taken together, these inherent advantages made silk the first "techno-fiber" and an inspiration for technical innovation and social change.

The combination of mulberry silk's extreme lightness and length (well over a thousand meters/yards per cocoon), ultra-fine diameter, and great tensile strength is epitomized in its use for fishing line. Perhaps the most ancient practical use of silk, this one is still current today in fly fishing, despite the development of synthetic lines. The advantages of silk fishing line over synthetic encapsulate many of silk's practical benefits: it is unaffected by extreme variations in temperature,

below Testing the pliability of silk, Norma Starszakowna's "White Bowl" of 1983 was one of a series of vessels of silk organza. Glazed and varnished to render it translucent and transparent, the silk was molded into forms and then hardened with resins.

quicker and smoother when lifting from the water, does not crack or stretch, has less wind resistance, and lasts three times as long as synthetic line. Its precision in casting distance and power is improved by tapers incorporated by braiding, and its behavior in the water can be altered by greasing, to make it float.[2]

The latter treatment is a form of caulking, or waterproofing, that also has a long history. In December 1783, just eleven days after the first manned ascent of a hot-air balloon, made by the Montgolfier brothers from paper-lined linen, another balloon took to the skies over Paris. This second passenger-bearing balloon, designed by a French physicist, J. A. C. Charles, was made of waterproofed silk and filled with hydrogen. Among the many witnesses was Benjamin Franklin, who was sufficiently impressed to send an account of it not only to the Royal Society, in London, but also to scientists in the United States, pointing out its potential military significance.[3] (One result of Franklin's publicizing of this new technology may have been the patent granted in 1793 to Ralph Hodgson of New York, for oiled silk and linen, although silks impregnated with linseed oil had been used for umbrellas since the early 1700s.)

Such balloons did indeed become important, both for military observations and for weather forecasting; and, not surprisingly, rubberized silk balloon cloth was used as a wing covering on early airplanes, such the Silver Dart, which made the first Canadian powered flight in 1909.[4]

By this time, earlier methods for waterproofing silk had been improved by the work of Charles Macintosh, a prolific Scottish inventor who, in about 1820, "while experimenting with the by-products of coal gas…came upon or rediscovered the method of sealing a layer of rubber in between layers of cloth that still carries his name (quickly modified by the public to mackintosh)."[5]

His method, patented in 1823, was soon being used on silk, as evidenced by a celebrated trial thirteen years later, at which a London firm of silk mercers, Everington & Son, were found guilty of infringing Macintosh's patent. This kind of rubberized silk made a contribution to the development of cameras, in the form of thick shutter curtains, for which it was still being used into the 1960s. It can still be found in clothing for protection against chemicals and in medical equipment, including inflatable resuscitation devices.[6]

Nevertheless, oiled silk, which was resistant to dust and water, had also continued in use—as medical dressings, sleeping bag covers, freezer containers,

right An oiled silk trench coat became *de rigueur* at society gatherings after the First World War, the trenches of which gave this garment its name. For this 1920 magazine cover, Guy Arnoux also depicted a jockey's "silk," used for its lack of weight and the vibrancy of its identifying colors.

far right Actress Lynn Whitfield wears a vivid rubberized silk trench coat at the Hollywood premier of the 2006 film *Medea's Family Reunion*.

spinnakers, and trench coats. This version of a coat originally designed for military wear became fashionable during the First World War, when there was a shortage of wool for traditional winter outer wear—available supplies being required for uniforms. The waxy translucence of oiled silk taffeta also appealed to designers for stage and screen, who welcomed its glowing shimmer when lit. More recent fashions have returned to rubberized silk; its use in Donatella Versace's first collection for Versace in the autumn of 1997— gleaming "like leather, with brash, neon-bright silk linings"[7]—was that season's sensation.

The robust nature of silk has given rise to a number of important developments in textile machinery itself— in one case, that of screen printing, actually forming part of the technology. Initially the screen was made of a silk mesh: fine enough to allow colorants to pass through with ease; strong and elastic enough to be stretched taut and withstand the printing process. Earlier, these same physical qualities contributed to the development of copperplate printing on cloth, a process that ultimately led to high-speed engraved roller printing, perfected during the nineteenth century.[8] Copperplate printing on paper had evolved in German and Italian states between 1425 and 1450. Within a century, this method was being used on silk (strong enough to withstand the high pressure involved) to print large silk squares with various types of useful information, including maps, tables of fares, and almanacs. These were not only decorative but ideal for travellers and mariners. Maps

on silk continued to be printed for soldiers and airmen into the twentieth century.

Silk was also vital to the invention of machine-made nets and laces, the first of which were produced on hand-powered knitting frames. Beginning in the 1750s, some fifty years before cotton threads were machine spun and therefore strong enough to be used in this way, silk threads were the basis for numerous British patents and improvements to a modified form of the knitting frame. Initially plain, these knitted fabrics could be machine-patterned by the 1760s. Silk warp knitting was perfected by 1795, and by 1800 had inspired mechanisms for making warp-knitted jersey (smooth) and tricot (ribbed), fabrics also made in other fibers but still important in silk manufacturing today.

above Able to withstand the pressure of a printing press, large silk squares were printed with decorative and informative imagery from the 16th to the 19th century. In this example, copperplate-printed by J. Cluer in London between about 1675 and 1727, the images of the months are after engravings of c. 1640 by Wenceslaus Hollar.

opposite Mary, Countess Howe, as painted by Gainsborough in 1763, wears crisp taffeta as a foil for a fashion innovation of the period: embroidered, machine-made silk net.

below The fluid drape and transparency of silk chiffon velvets complemented the streamlined fashion of the interwar years; this moderne design was woven in 1935 by J. B. Martin. In the late 1830s this French firm's founder patented improvements to the velvet loom, including a means of cutting the velvet on the loom, eliminating the need to interrupt the weaving process.

Even the lightest of silks, such as chiffon, net, and tulle, can support heavy beading, embroidery, and other applied materials, and these fabrics remain important in couture for this reason. Alternative means of juxtaposing sheer and opaque areas are "yanked" silk chiffon-velvet and its imitation, devoré. In the former—a technique perfected in Lyon in the 1890s—pile threads are interwoven into the ground cloth only where they are needed, passing loosely on to the next section of pile, and then later the excess is yanked away. This process gives the pile motifs an edge more sharply defined than that achieved by clipping, the previous method, used since the early nineteenth century. The result is a diaphanous silk (usually a crêpe chiffon) patterned with pile and—despite its frail appearance—a strong, fluid cloth that can easily tolerate printing or pattern dyeing. Silk chiffon velvet figures prominently in the work of Marion Clayden, a British-born Californian couturiere who over the past two decades has designed such silks for manufacture in Lyon, dyed them, and fashioned them into dresses that have captivated the stars: Meryl Streep, Catherine Zeta-Jones, Cher, Sophia Loren, Sigourney Weaver, and many others. In devoré, a paste printed on a plain velvet "devours" designated areas of pile to produce a similar effect, one that has been widely

used since its revival in the early 1990s, most notably by Georgina von Etzdorf. Here the pile and ground must be of different fibers so that the paste bites only into the pile. Silk is typically chosen for the ground (which is exposed once the chosen areas of pile are removed), not only because of its strength-to-weight ratio, but also to avoid using it in quantity for a pile that will be partially destroyed in the patterning process.

Such sheer-and-pile silks reflect the development of weaving and patterning techniques that were inspired partly by the wish among cloth manufacturers (in this case velvet weavers) to make a "summer-weight" cloth to counter the association of heavy silks such as velvet with winter wear or the most formal attire. Weavers of wool have attempted the same, but without the natural advantage of silk, which is cool to wear in hot weather and yet warm in the coldest of climates. This apparent paradox rests on the fact that silk does not conduct heat, but rather acts as a shield, keeping the body's own warmth trapped next to the skin when the surrounding temperature is low and, when it is high, preventing heat from passing through to the skin. Highly absorbent—which is why it takes dye so readily—silk also attracts moisture away from the skin, which makes it comfortable to wear even in humid conditions. It is

opposite Marion Clayden's late-20th-century ensemble incorporates a sheath of silk crêpe chiffon velvet of her own design, which was Jacquard-woven in Lyon and then hand-dyed in her studio in Los Gatos, California.

right Outfits fashionable for the American cruise season in 1929 included these, all made of silk. On the left, a bright blue and white pajama ensemble with a printed surah coat, and red and white checked overalls with a matching cardigan, both by Bonwit Teller. On the right, two pajama suits: by Patou, in black and white and, from Saks Fifth Avenue, in red and white gingham.

thus the only natural fiber perfectly suited to any climate. This has resulted in remarkably divergent uses as well as users. Knitted silk undergarments, for example, have been worn by British royalty since at least the time of King Charles I to combat the chill of damp winters[9]; but by Queen Victoria's time these had became equally prized by polar explorers, and they remain so today. Broken cocoons serve as extremely light fillings for comforters and also, being warmer and cheaper than down, are just as functional for padding cold-weather jackets, among which are those still made in the traditional Chinese "mandarin" style.

Equally practical, despite their associations with the height of luxury, are silk lingerie and pajamas. Indeed, the fashion, in the west, for pajamas (originally of silk) was triggered by a combination of events during the First World War. For centuries, men as well as women had worn nightgowns, or nightshirts, to bed. Then, in the winter of 1917–18, France, Britain, and the United States were hit by a severe domestic coal shortage, caused both by the diverting of resources and manpower to the war effort and by exceptionally bitter weather. To protect people's extremities from the cold at night, the respective governments advocated the wearing of pajamas, specifically ones of silk velvet or jersey. This not only marked the beginning of the end of the traditional man's nightshirt but also ushered in one of the most significant changes in women's apparel, namely their wearing of trousers. Key to this transition was the fact that initially these female "trousers" were in pajamas style—generously cut and making reference to Eastern garb—rather than in imitation of western male attire.[10]

The American silk industry began promoting boudoir pyjamas (also referred to in fashion magazines as "in-time wear," meaning not for sleeping but as very informal day wear for indoors only); and by March 1918 *Harper's Bazaar* was illustrating "harem" culottes gathered in just below the calf and cuffed pyjamas of a similar length, all worn with fashionable short tunic tops or smoking jackets. Another hard winter followed, after which such attire became commonplace; and soon it was making a subtle contribution to street wear. Lanvin, for example, is noted early in 1920 as being fond of tunic dresses with the embroidered cuffs of silk "pantelettes" revealed below the hem.[11]

Fast-dyed washable silks, brought to the fore by the promotion of silk pyjamas, became more widely available, and for some silk-weaving centers, such as Macclesfield, England, a product for which they became known.[12] In keeping with their link with pyjamas, these were generally striped silks, used also for making shirts and blouses and, after the Second World War, for "shirtmaker" dresses. This last fashion, with its jaunty air (known as a "shirtwaist dress" in the United States), was just one example of the market for high-quality silk leisure wear that had emerged in the interwar period. A newly added third fashion season—initially known as cruise wear, after the popularity of this pastime among the "bright young things" of the 1920s and 1930s—made great use of silk's performance qualities. Comfortable, stylish, washable, and hard-wearing, especially when made of wild or waste fibers, silk set the tone for avant-garde sportswear, including swimwear. Far lighter and stronger than wool, which was still being used for bathing suits in this period, knitted silk jersey was the preferred option among elite swimmers. Among them were several participants in the 1924 Paris Olympics, where the notable medallist was Johnny Weissmuller, later better known for his film portrayals of Tarzan.

Hollywood itself played a part in spreading the fashion for silk swimwear, especially when silk jersey began to be replaced in the 1930s by silk satin, made elastic by the inclusion of Lastex, a fine elastic yarn made with a combination of latex rubber and ammonia.[13] The Californian swimsuit manufacturer Mabs of Hollywood used this fabric—which also revolutionized foundation garments—to make swimsuits for Joan Crawford, Loretta Young, Jean Harlow, and Marlene Dietrich, among others. Nevertheless, knitted swimwear made a comeback in the 1970s, when the Italian sportswear designer Emilio Pucci produced soft silk jersey bikinis emblazoned with his ebullient trademark prints and colors.[14] Today, silks continue to be featured in chic beach wear. There were rumpled shirts in iridescent shantung and rubberized silk included by the Italian designer Roberto Cavalli in his Florida-inspired 2000 collection, and a peek behind the scenes at Ratti, in Como, reveals that many fashion and fabric designers continue to explore this trend.

In its role as a high-performance fiber, silk has adopted many guises: from dental floss and surgical sutures to typewriter ribbons and bicycle tires. It was used to make bullet-proof vests and cartridge, or artillery gun, powder bags, and it proved ideal for parachutes, since it was light and could be packed down to a manageable size. Its insulating qualities made it an essential component for the management of electricity, from Benjamin Franklin's use of a silk ribbon as insulation, when he famously flew a kite in a thunderstorm in 1752, through the role of silk threads in the nineteenth-century development of the telegraph, to

PYJAMAS

*BATISTE D'ÉCOSSE
SOIE ET FIL ET SOIE
FLANELLES TAFFETAS
FLANELLES CACHEMIRE*

*SOIES FANTAISIES
DISPOSITIONS NOUVELLES
COLORIS EXCLUSIFS*

right A member of the 15th Scottish Battalion was captured during a mass jump in 1954, being carried to ground by a silk parachute.

the twentieth-century electricians' insulating tape. Many of these functions have been taken over by man-made and synthetic fibers, which are extruded and perform in ways that, to a large degree, have been inspired by silk. In fact, the first successful man-made fiber, made in 1883 by Joseph Swan's nitrocellulose process, was not sought for textiles but for electric lamp manufacture, as a substitute for a silk fiber. Yet not one of these new fibers has, on its own, duplicated the breadth of applications that silk can embrace. In addition, none of the synthetics are biodegradable. Finally, among all the processes used for producing fibers—natural or engineered— sericulture produces the least pollution. Wild silks are increasingly appreciated for certain uses: eri silk for its softness, durability, and insulating qualities; tussah for its absorbency and light, "airy" handle; and muga (the strongest of all natural fibers) for its shimmering golden color, which, along with its handle, improves with age and washing. For these reasons, as well as for its ecological soundness and the sheer beauty of lustrous *Bombyx mori*, silk remains a uniquely valued fiber.

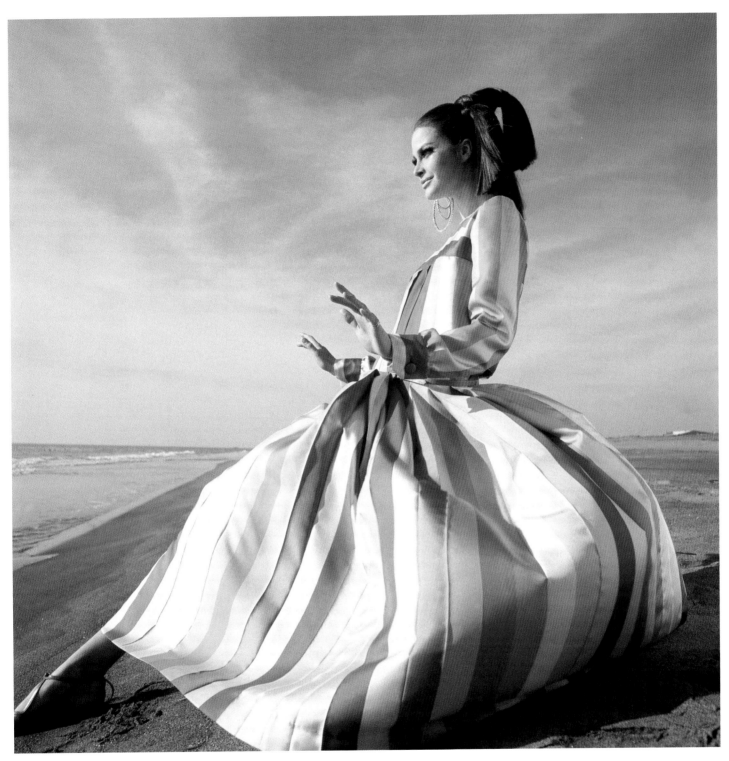

above Washable silks became associated with the "shirtmaker" or "shirtwaist dress" after the Second World War, adopting both the styling and the cloth of the best men's shirts; here the model Susan Murray wears a c.-1966 version by the Italian designer Tiziani. Such silks are typically striped or checked to allow for dyeing in the yarn state, rather than printing of the woven cloth, to ensure a fast color.

overleaf Because it does not conduct heat, silk remains favored for lampshades and the like. This selection of silk lanterns was on display in a market in Hoi An, Vietnam, in 2001.

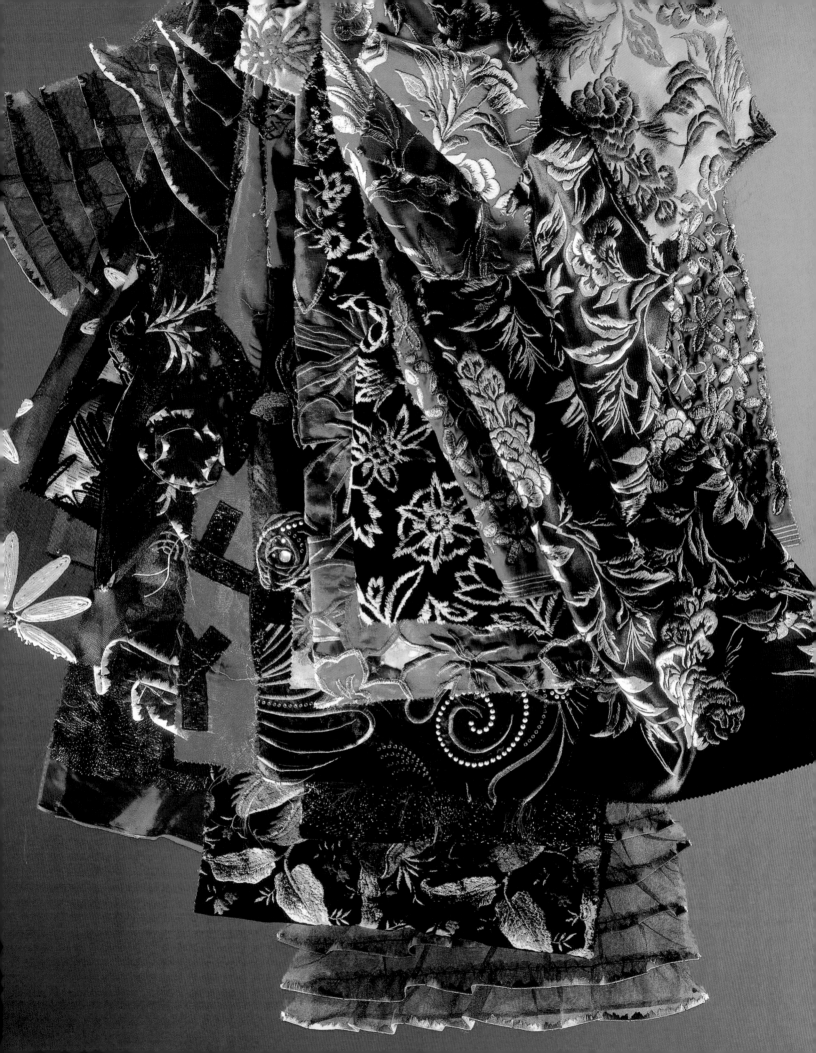

The Potential of Silk

The reader of this history can scarcely fail to notice the general similarity of the experiences that have been narrated. As the alternating periods of adversity and prosperity sweep with storm or sunshine across the whole field of silk industry, the story of one individual becomes the history of all. Bound thus together by community of experience as well as of interest, the silk manufacturers...also share a common hope that is the basis of all their endeavors—the hope that the products of their textile art may meet the ordinary needs as well as the highest tastes of their countrymen and countrywomen.

L. P. BROCKETT ON BEHALF OF THE SILK ASSOCIATION OF AMERICA, 1876

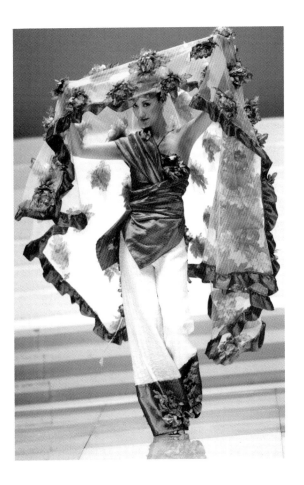

opposite Created between 1979 and 1990, this group of samples from Jacob Schlaepfer, of St. Gallen, Switzerland, includes woven, embroidered, and pleated silks, several of which were made for the Saudi Arabian market.

right At the New Silk Road Modelling Competition, held on southern China's Hainan Island in September 2004, local designers provided the garments, showcasing the growing number of Chinese designer fashions now produced in their country.

Although the author of the passage above captured both the character and the global interdependency of the silk industry, he could not know that, seventy years later, the United States government would adopt a policy that would bring about significant changes in the world of silk.[1] In 1946, while assessing the future for silk consumption, American economic policy makers decided that among their then allies, "China will be hard-pressed to find sufficient exports to pay for her gigantic import needs—particularly capital goods—during these early years of reconstruction; silk could be an important source of dollar exchange." The conclusion was that it "would be better for China—and ultimately for us as well—if she would export silk to us in the form of wearing apparel and other manufactures and thereby add greatly to its dollar value."[2] This view not only put an end to North American silk manufacture within a decade or so (and to its last sericulture project, in California, immediately) but also laid the groundwork for a dramatic shift in international silk trade, apparent by 1986. In that year, for the first time in a century, world production of raw mulberry silk was dominated by China; since that date Japan and the Republic of Korea have nearly abandoned commercial production of raw silk in favor of heavy machine industries. By 2005, Chinese raw silk accounted for roughly 82 percent of the world supply. During the same period Chinese

right Pupae on sticks, photographed in Beijing, serve as a reminder of the silkworm's importance in China as a rich source of protein. The mulberry tree is equally important: its inner bark providing bast fibers and bark cloth, its leaves being used in Micronesia for an intoxicating drink, and its juice being used for tattoos.

manufacture of finished silk goods more than doubled; today these are exported in greater amounts than are their raw silks, silk yarns, and silk fabrics combined. Despite this, the silk industry today remains global, varied, and vibrant—themes explored in this chapter.

Storm and sunshine

The 1990s were undoubtedly a stormy period for the silk industry. The decade opened with soaring sales of sandwashed silk. This process had been developed by New York-based entrepreneurs in 1982, in an effort to provide a preshrunk, crease-resistant, machine-washable silk. Produced mainly in China, sandwashed silk entailed a process of fibrillation, or sueding, by washing in machines containing sand, pebbles, tennis balls—and occasionally tennis shoes. Whereas the 1980s' silks had been meant largely for women and were a luxury product, these new silks, with their combination of a soft handle and worn-in look, suited the coming vogue in the United States for the elegant leisure wear now associated with "casual Fridays," as well as the more widespread return to favor of natural fibers. Then Shamash & Sons, a New York-based converter said to be the largest importer of silks into the U.S., launched its own range of washable silks for the 1988 season, using a process developed in Germany. Simultaneously, the perfection of sandwashing for volume production (and thus lower price) was achieved in South Korea, facilitating a new concept of silk that encompassed both tailored garments and sportswear—and these were for men and teens, as well as women. It was called, by one trade paper, the "not-so-quiet washed silk revolution. . . ."[3] To satisfy demand, raw silk production mushroomed. While it had been steadily increasing throughout the 1980s, by about one-third, between 1989 and 1993 the world supply of raw silk doubled again, to just over 100,000 tonnes/tons in that year.

As production reached an historic height, China began decentralizing its method of selling raw silk. One consequence of this destabilized position was the loss of a levy on all silk sold by China's National Textile Import and Export Corporation to Europe, where these funds had financed the European Commission for the Promotion of Silk (CEPS), formed in the 1960s through the efforts of a Swiss/Italian delegation. There, Zurich's centuries-old supremacy as the major entrepôt for Asian silk skeins destined for western mills had already been declining since the end of fixed exchange rates in 1973. China's now more open economy also engendered a competitive market, which had global impact. Deals were struck directly between western companies, on the one hand, and, on the other, silk yarn, cloth, and garment manufacturers in India, Korea, and China.

The result was to guarantee affordable piece goods and clothing in exchange for enormous orders. The low price of such finished silk goods ushered in the "pluralization" of silk. At the height of the boom, in the mid-1990s, silk garments were sold not only in department stores, but through mail-order catalogues, in supermarkets, and even, according to the International Trade Forum, in German coffee houses. However, despite their promotion as "easy care," many such silks—and the garments of which they were part—were of low quality, easily stained, and apt to be rent at the seams. The bubble burst. Consumption and raw silk production dropped, and the price of raw silk tumbled; compared to its 1989 trading value ($51 per kilo [2.2 pounds]), raw silk could be purchased for half that price by 1998.[4]

Concerns were voiced for the future of the silk industry. Could the nobility of silk be restored? Or would the decline continue and millions of jobs be lost, together with skills that had taken millennia to develop? This is no small matter. In China, sericulture is estimated to employ 20 million people, with production employing another half-million. Sericulture alone occupies some 6.3 million people in India, which has so many silk weavers that despite producing over 13 percent of the world's raw silks (making it second behind China), to satisfy internal demand it is also the largest importer of raw silks. Sericulture is important in Brazil, North Korea, Thailand, Uzbekistan, and Vietnam, which together produce about 4 percent of the world's raw silk. Providing both a buffer against poverty and a potentially lucrative trade, silk also contributes to the economies of Bangladesh, Bolivia, Bulgaria, Colombia, Côte d'Ivoire, Indonesia, Iran, Israel, Kenya, Nepal, Nigeria, Pakistan, Peru, the Philippines, Sri Lanka, Turkey, Uganda, Zambia, and Zimbabwe.[5] The total number of people directly dependent on silk rearing

right This Ratti Braghenti silk plaid cloqué derives its undulating surface from the combination of silk, polyester, and polyamide fibers, which have different degrees of elasticity and shrinkage. Ratti, based in Como, undertakes all production processes from spinning to weaving and printing.

below Jamini Ahluwalia, previously well known for her jewelry, has recently turned to designing shawls such as these, which utilize India's rich array of silks and hand-weaving talents. Both employ a warp with spaced-out sections; they are composed (left to right) of mulberry and tussah silk.

and processing worldwide is easily approaching 35 million: greater than the entire population of Canada.

The answer, of course, is that the long-established traditions surrounding silk could not be easily cast aside. The storm passed, and today silk once again basks in a "sunshine" brought about through collaborations, developments in yarns and finishing, and an acknowledgment of the new breadth of consumer interest that remained once the "storm" of inexpensive silks had passed. Among the positive results of the pluralization trend is the consumer's acceptance of silk as a year-round fabric, a "career staple" as well as a boon to stylish casual wear. It has also become clear that those who work with it must aim for the highest possible quality. This latter point was made as early as 1990, when advice to new silk exporters included a warning regarding exporting silk products at a low price: "In this case the quality of your product does not have to be very

right From the Marioboselli group comes this cloth designed to show the specialties of Silk 2000, in Como, one of the few schappe-silk producing companies in Europe; it also creates mixed yarns combining silk and cashmere, as seen here.

below, left By 1970 looms were fifteen times faster than in 1900, and thereafter the adoption of computer-aided Jacquard systems made detailed patterns such as this one much quicker to set up; from Seteria Bianchi in Italy, it was woven from the 1980s as a tie fabric for nautical clubs.

below, right Georgina von Etzdorf's "Ukelele Lady" scarf was made in 1999 from silks in the company's store of stock from previous collections; it was part of a recycled collection that shaped components by ripping, slashing, or, as here, laser cutting.

high, and you do not have to work hard on improving [it]. But this approach also means that you are at the mercy of the large-company international buyers who go from one company to another, and from country to country, in search of the lowest price."[6] Thus gradually many more eyes have become set on quality manufacture. For the power-weaving and finishing of high-quality silk cloths, it is the Europeans and the Japanese who still lead the way, while India and Thailand are known for their handwoven cloths of equal stature. India's power looms are on the increase, and everywhere there has been a shift, when possible, toward products that make the best use of silk.

However welcome the move away from high-volume, low-priced silks, there is no mistaking the threat to the remaining European and Japanese manufacturers, one that was heightened with the general removal of trade barriers in 2005. Their response has been to focus on their traditional strengths: design and technical innovation. Energetically defending their role in these realms, they have continued to set trends not only in patterns and colors, but in equally important elements of modern silks—namely yarn development, lighter

previous page This detail of a knitted scarf shows the lively character of yarns made from recycled silk saris.

right Mantero, founded in Como in 1902, is one of Italy's leading suppliers of high-fashion silks, including, as shown here, printed scarves.

right These Jacquard-woven silk tie fabrics were woven by Weisbrod-Zürrer for their autumn 2000 range, for customers that include Lanvin, Nina Ricci, Cerruti, Charvet, and Tommy Hilfiger. Typical of the dense composition of tie silk, or surah, these contain a warp of unweighted organzine arranged at 120 ends per centimeter (approximately 300 per inch).

below, right Between 1990 and 1992 a number of fashion fabrics were produced by Norma Starszakowna for Issey Miyake Design, Tokyo, and subsequently used in Miyake collections. Shown here is a detail of one of these, "White Voids," 1991, composed of white printed silk, overprinted with heat-reactive and patinating media.

opposite In 1998 Yoshiko Wada collaborated with Masao and Mayumi Koshizuka, of Koshimitsu Textile Mill in Kiryu, Gumma Prefecture, to create a collection of Gumma-silk fabrics in western widths, to be distributed through Wada's "Project Metamorphosis" to an international array of artists and designers. Here, her own work displays the use of organza with a highly twisted weft yarn, the pleats arising from later degumming and the designs from *shibori* techniques.

and more complex cloth constructions, and special finishes. Creating a bonanza for designers of all types, this focus has brought forth, for those involved in knitwear, a visual feast of yarns. During the past decade the range of yarns—of benefit to weavers, too—has been extended to include a wide variety of crêpe silk yarns, which provide wrinkle resistance, and silk blends, spun with other natural fibers, including cashmere. Many such yarns are designed to be combined with elastane (spandex) and have been developed by Italian spinners. During the same period, one of the notable new yarns from Japan was a development of the late 1990s: a blend of silk waste and polyester, spun into a yarn that has the crease resistance of polyester on the inside and the softness of a silk sheath on the outside.

Increasingly, such innovations take account of the environmental impact their manufacture and use might have. The most influential country in this regard is undoubtedly Germany, which is the most populous of all European nations (not including Russia). Its environmental policies, including a ban on any product carrying carcinogenic azo dyes (since 1996), have had a positive effect worldwide, since German converters

dominate the European market and operate on a global scale, taking in and redistributing from raw silks to finished goods. A consequent preference for natural fibers has helped make Germany second to the United States (which has four times the population) in the consumption of silk carpets, primarily from Turkey, India, and Iran. It has also supported the recent fashion for silk wall coverings, bedding, and cushion covers, made of both handwoven and power-woven silks from Thailand and India. In the latter country, as a result, ancient skills with natural dyes are being revisited; and the same trading relationship may well have prompted the introduction of yarns made from recycled saris. For a commodity as scarce as silk, recycling is common sense, but in the past few years it has gone beyond practicalities, with scraps and leftover production runs of silk being cut-and-sewn, shredded, laser-cut, and otherwise manipulated to produce stunning accessories. Silk waste, aside from being now more efficiently managed by spinners, has been transformed into silk nonwovens for clothing, medical uses, cleaning products, filters, and the like. Introduced in 1997 by Toyobo, Japan, this process has the additional

right This Japanese-style guest room employs silk upholstery, wall covering, and bedding to provide a setting that is luxurious, restful, and nonallergenic.

178 · Silk

advantage of allowing nonwovens (of which paper and felt are examples) to be cut into very fine strips and twisted to form yarns; this avoids the reeling process, saving energy.

Despite that fact that silk forms a tiny percentage of the global textile trade, it remains important for a number of reasons. These can be loosely grouped into its economic and social significance, its importance as an eco-friendly fiber, and the enormous contribution it makes to innovation, whether within fiber sciences, fashion, or the textile arts. Although silk accounts for less than 0.2 percent of fibers sold annually, this figure, as the International Trade Centre has noted, "is misleading, since the actual trading value of silk and silk products is much more impressive. This is a multibillion-dollar trade, with a unit price for raw silk roughly twenty times that of raw cotton." The same report notes the difficulty in putting a precise value on the global silk business, "since reliable data on finished silk products is lacking in most importing countries."[7] Nevertheless, the value of silk not only sustains its production and distribution, but has also rendered the global industry increasingly interdependent. Without silk farmers, whether in Asia or Brazil, the luxurious finished products of Europe would not exist. American consumers, in turn, would lose their supply of the fine scarves and other neckwear

that mainly account for the more than 10 percent of U.S. silk imports that arrive from Italy (and primarily from Como, which today has Europe's largest concentration of silk manufacturers and printers). So intertwined is the global industry that it is possible for Chinese mulberry silk to be woven up in Italy, sent to the Republic of Korea for printing, and then sent on to Mexico to be made into garments for American retailers.

Of course, top-end silks also emerge from manufacturers and converters in France, Germany, Switzerland, and the United Kingdom, but today both European and American consumers rely on China, Korea, India, and Thailand as the main suppliers of finished silk products. This relatively recent development represents a major change in the quality of products outsourced to developing countries: China has modernized its silk processing and weaving plants and "has established several joint ventures aimed at improving the quality and finish of fabrics and garments destined for export. Well-known European and United States fashion designers have some of their collections of silk garments produced in China under the supervision and quality control of foreign technicians."[8] Indeed, having been at it for a long time, the silk industry provides a model of mature outsourcing. A century ago, for example, the Swiss had subsidiaries in

below The pure silk fabric used for this bag resulted from a collaboration between Vanners Silks, in England, and the Japanese designer Akira Minagawa, founder of Mina Co., Ltd. The fabric features a multicolor section warp. Vanners, Jacquard weavers in Sudbury, is part of Silk Industries Limited, formed in 1988, which also encompasses the silk printers Adamley Textiles of Macclesfield, which incorporated David Evans & Co., the last of the "London" silk printers. Vanners itself was founded in the early 18th century by three Vanner brothers of Huguenot origin, and was originally based in London's Spitalfields.

Germany, Italy, France, and the U.S., with roughly the same number of looms (15,000) operating outside their borders as within. Schwarzenbach, which still exists as a trading company, thus became the largest silk enterprise in the world during the 1920s; and a one-time competitor, Stehli, became so well known in the U.S., where it had two mills, that few have since remembered it as a Swiss subsidiary. Outsourcing increased so that by 1930 two-thirds of Swiss silks were produced abroad; today, Weisbrod-Zürrer, one of two remaining Swiss weaving companies (the other being Gessner AG, which also owns a printing unit originally devoted to silk, Seidendruckerei Mitlödi), still produces half of its fabrics through partner companies all over the world. With such global interests, it is hardly surprising that in the past two decades the Swiss, with the World Bank, have helped the Bangladesh Sericulture Board and its attached research station to revive mulberry and eri silk cultivation, and provided assistance in the upgrading of infrastructure and technology to India. Swiss standards of excellence have also been shared. Its independent testing institute—founded in 1846 for silk and since 1970 called Textex and dealing with all fibers—opened a branch in Hong Kong in 1995, followed by others established between 1999 and 2005 in Shanghai, Seoul, Beijing, Taipei, Kuala Lumpur, and Djakarta.

There are many similar collaborations aimed at maintaining, improving, and extending silk production. The Japanese, who made a significant contribution to silk science and technology during the twentieth century, preserve this heritage today by funding projects in developing countries in Asia, undertaking technical cooperation with silk scientists in India, and controlling some 80 percent of sericulture and silk processing in Brazil, which has one of the world's largest silk reeling units and where sericulture dates back to before 1876.[9] Japanese scientists have developed artificial food for silkworms, and today are among those who produce transgenic silkworms. In India, the Central Sericulture Research Institute has begun training personnel from other developing countries.[10] An organization that binds together 26 nations through technology transfer, collaborative studies, scientific interaction, and appraisal of sericulture projects for funding by other agencies is the International Sericulture Commission, headquartered at Lyon. (The Lyon-based International Silk Association also disseminated information among its members during its lifetime, 1949–2004.) So significant are aspects of silk science and technology that these have provided paradigms, most notably via the understanding of the genetic structure, biology, and chemical nature of the silkworm: after the common housefly, it is the most understood of the millions of insects.[11] Such knowledge has underpinned spider silk research, which has been undertaken sporadically for more than 300 years—and has already provided crosshairs of telescopes and other optical instruments—but has only recently achieved genetically engineered synthetic fibroin.[12] The goal is less to copy spider silk than to find inspiration in it to design high-performance fibers, just as *Bombyx mori* inspired the inception of man-made and synthetic fibers in the past.

Although these aspects of silk science may appear esoteric to the average silk consumer, other advances will not. These include the creation of washable silks and all-around improvements in silk performance, which "have come from better handling and care of the silkworm itself, the cocoon it spins, the filaments and yarn produced and their dyeing and finishing, rather than from a topical finish on the fabric."[13] With regard to this last, the great strides made in the application of nano-finishes have resulted in breakthroughs such as stain-resistant silks; these ultra-thin coatings—a nanometer is one-billionth of a meter (close to 40 inches)—can also be applied only to one side, thus reducing waste. Since fibroin is highly resistant to bacteria and fungi, these beneficial qualities make silk cloth and, especially, bedding, a contribution to healthy living. Beauty, too, finds its champions among silk scientists, such as those at the Japanese cosmetics manufacturer Kanebo, who have used silk's similarity to human skin to produce an anti-aging cream.[14]

As for the established silk centers, the preservation of this vital industry is also being supported in other ways. When Japanese raw silk production contributed only about 4 percent of the yarns used by their own weavers, in the late 1990s, the Gumma Prefecture Society for Sericultural Promotion was formed to seek expertise from leading designers and textile artists, including Junichi Arai and California-based Yoshiko Wada.[15] Conscious of the importance of silk to the northeastern Isaan region of Thailand—as a tourist destination as well as a source of cloths—the Thai government, in 2002, asked civil servants to wear handwoven Thai silks on Fridays.[16] With an eye to the future, the British silk manufacturer Henry Bertrand offers special services to students via its website. Forging ahead does not mean neglect of the great heritage of silk, particularly since many of the most successful firms have been in the same families' hands since their foundation: the ancient skills of hand weaving intricate brocades and velvets is kept alive by a handful of enterprises, such as Antico Setificio Fiorentino and, in Lyon, Tassinari et Chatel and Prelle, while the glory of past manufacture is harbored in the archives of manufacturers across Europe, as an inspiration for the generations to come.

The Future of Silk

by *Bruno Marcandalli*

For more than 5,000 years, silk has been used by mankind. For the same period it has been a symbol of glamour and luxury—once the exclusive privilege of kings and aristocracy and now the fiber of choice for high fashion. In parallel, silk has also embodied the most advanced technological achievements and entailed a very complex industrial chain, supported by a social organization, from farmers to final consumers, the whole world over. Moreover, thanks to its extraordinary properties, it was the chosen material for the most advanced technical applications until the second half of the twentieth century. Then, as a result of the development of more and more high-performing synthetic fibers and of new industrial processes, silk lost this central role, as the complex traditional social organization that had been built around silk production in the industrialized countries almost disappeared.

Yet scientific and technological progress is proceeding at a very fast rate—probably faster than in any other period of history. In the next few decades, the advances in materials science, chemistry, information technology, and robotics are going to completely transform the textile/clothing industry. The very way we have traditionally looked at textiles is going to change dramatically. Smart textiles with properties now unimaginable will be available; new revolutionary manufacturing processes will be introduced; mass customization will develop; and textiles will be used in entirely new sectors. This revolution is not bypassing silk. On the contrary, silk is arousing greater interest among researchers than other materials and is revealing extraordinary potentialities in a wide range of fields. All the stages of silk production, from sericulture to the final products, will be affected by this research. It is not easy to predict which lines of research will be successful. Here, only a short survey of the most promising and interesting fields can be attempted.

Proceeding along the silk production chain, we can start with the silkworm. The silkworm, together with the bee, is the only example of successful domestication of insects. This small and delicate creature is an extremely efficient protein production unit, being the animal that supplies the largest quantity of a single protein (fibroin) relative to

PREVIOUS SPREAD "Beach," painted silk between glass, by Carole Waller, 2006.

ABOVE This screen from www.baldoria.com illustrates just one way in which e-commerce is changing the way silks are made and marketed. An interactive assistant guides the shopper, who can add a personalized message to any tie or scarf, using an undisclosed method exclusive to Studio Pianezza, of Como, where third- and fourth-generation family members oversee production and a team of 25 designers.

its weight. This characteristic has attracted the attention of biotechnologists. Using genetic engineering, they can induce silkworms to synthesize new proteins, different from fibroin. Silk structure could be modified at will by careful gene selection, so obtaining fibers endowed with improved properties or completely new fibers—such as colored, fluorescent, or ultrafine. Or, following the same technological approach, the silkworm could produce completely different proteins for medical and pharmaceutical applications. This small insect could play, in the future, a primary role for the benefit of mankind.

Silkworm rearing, however, is a very labor-intensive activity, employing many men and women at all stages of production. It has hardly changed for thousands of years; only improvements introduced during the last two centuries, mainly connected to disease control and selection of more efficient hybrids, have altered the methods used in ancient China. Inevitably, in places where industrialization in general gathers momentum, claiming ever more land and labor, traditional sericulture will decline. Yet it is not a simple matter of transferring this industry to those developing countries where a silkworm-rearing tradition does not exist. On the other hand, thanks to robotics and computer science, today a totally automated silkworm-rearing process is possible, and actual examples of such silks have already been produced by some research groups. Also, the dependence of the silkworm on mulberry leaves could be avoided by genetic selection or modification or by providing the animal with artificial food. Silkworm rearing could thus play a vital role in industrial economies, even if the ancient farming traditions should be lost forever. This prospect is certainly bound to become a reality if some of the biotechnological projects described above are successful.

Silk could also be produced by methods not requiring silkworms. Plants (including

fungi), other animals, even bacteria could be induced to produce silk fibroin through the use of genetic engineering technology. Naturally, the fibroin so produced would need to be spun in an artificial way, from a solution, exactly as is done for rayon fibers from cellulose solutions. But then why limit such exploration to mimicking fibroin from *Bombyx mori*? There are thousands of insect and arachnid species that produce silk, and some of these substances have properties far superior to those of traditional silk. For example, spider silk is an amazing material—or, more precisely, a group of amazing materials. In fact, many species of spider produce up to seven kinds of silk, with different degrees of strength, flexibility, stickiness, and translucence. Dragline silk, which is used to sustain spider webs, can withstand greater stress, in proportion to its density, than any other material—and under the most adverse conditions. It is stronger than steel and more elastic than Kevlar. A very wide range of applications would be possible for this material, from wear-resistant clothes and shoes to strong ropes, nets, bulletproof jackets, parachutes, artificial tendons and ligaments, frameworks for reconstruction of body tissues, and many others. Unfortunately, spiders are almost impossible to domesticate. Here again, our good and patient silkworm could return to the scene—this time being

induced to create spider silk. Recently, scientists of a biotechnological company have succeeded in inducing genetically modified goats to produce spider fibroin in their milk. From such milk silk, threads could be spun artificially; however, intensive research efforts are still needed to develop a method that can produce, from aqueous solutions, fibers with characteristics comparable to those secreted by spider or silkworm glands.

Starting from here, we can come back to something less remote from our normal experience. The possibility of artificial spinning of silk fibers from fibroin solutions, obtained by using special solvents, could be exploited very soon. Thus silk wastes could be used to obtain artificial silk, and the recycling of processed silk could be possible. Moreover, by dissolving fibroin and other polymers—cellulose, for example—in the same solvent, one can obtain polymer blend fibers, possessing completely new properties. Laboratory prototypes are already available, and several processes have been patented.

Following the silk production chain, biotechnologies can also play an important role in the subsequent processes. Enzymes are already used, for example, in degumming; but careful selection and development of new enzymes could expand considerably their employment in a wide variety of processes, today carried out by using

RIGHT **Biochemist Thomas Scheibel of Munich's technical university holds a frame laced with artificial spider's thread, made in 2005 with the aid of genetically modified bacteria. Its tensile strength is one-fifth that of real silk.**

chemicals. This would represent considerable progress from many points of view. Enzymes are environmentally friendly substances and work at neutral pH and at low temperatures, reducing energy costs and risks of fiber damage.

While biotechnologies are so promising, chemistry is not lagging behind. New technologies can modify silk fibroin chemically, imparting new characteristics to the fiber and removing some of its traditional drawbacks, yet leaving unaltered its typical and much loved properties, such as handle, lustre, and dyeability. Plasma technologies, in particular, have aroused great interest. The definition (in physics) of plasma, or glow-discharge, is an ionized gas with an essentially equal density of positive and negative charges. It can exist over an extremely wide range of temperature and pressure. Examples of plasma include the solar corona, a lightening bolt, a flame, and a neon sign.

In textile modification, low-pressure (0.01 to 1 millibar) plasma, such as is found in the neon sign or fluorescent lightbulb, is used. However, other plasma treatments, working at normal pressure, such as corona and dielectric barrier discharge, are currently attracting strong interest. Plasma can modify chemically and physically the surface of any textile material, silk included. The chemical reactions brought about by plasma are dependent on the type of gas used and take place only at a very thin surface layer of the material (less than 50 nanometers). So even if some characteristics are altered dramatically, the general properties of the fiber do not change in any way. Moreover, the process is environmentally friendly, does not use water, and requires very small amounts of chemicals and energy.

Plasma techniques can give silk water-repellent, crease-resistant, flame-retardant, stain-proof, and antimicrobial properties;

can increase its dyeability; and can improve its wash-and-wear characteristics. Without losing its beauty, silk could acquire performance features at least equal to those of the most advanced synthetic fibers. Analogous results may be obtained by chemical grafting of special monomers on fibroin. This technology is not particularly new, but new grafting methods and new specific monomers have been developed that look very promising. Sericin can be fixed permanently to fibroin, so that weighting is no longer necessary, and new applications can be found.

Much more could be said about the various scenarios that science is opening to silk, but from the short survey given above, it is clear that the story of silk is far from over. For coming generations, silk not only may endure as a luxury linked to antiquity but may well also act as a leading example of futuristic concepts, through which science, technology, and artistry are combined.

OPPOSITE With the youngest generation at Weisbrod-Zürrer being the biologists Sabine and Oliver Weisbrod-Steiner, it is logical that their latest development should be a stain-resistant nano-coating (a mere 250–400 nanometers thick). Launched in 2006, after two years of experimentation with fluorocarbons and other molecules, this treatment was developed with the EMPA (Swiss Federal Laboratories for Material Testing and Research).

RIGHT, TOP AND BOTTOM With over fifteen years of success in hand printing, painting, and stenciling silks for interiors and accessories, Neil Bottle's workshop, based in Ramsgate, England, remains a small, specialist concern. Producing both unique designs and limited editions—here, two designs developed on a computer in 2005—he typifies the advantage of e-commerce for individuals, with his services being offered through www.patrickmcmurray.com.

Silk in Action

*Why Do I use silk? Despite all the advances in manmade and synthetic material **nothing** can compare to the combined characteristic performance, visual aesthetic and utter desirability of silk, **absolutely nothing.***

JANET STOYEL, *THE CLOTH CLINIC*, DECEMBER 2006

opposite Janet Stoyel's recent experiments with ultrasound and laser include this silk, treated by both methods, then sandwiched in glass and kilned. Stoyel's pioneering work with these techniques is undertaken for clients worldwide; her studio, The Cloth Clinic, is based in rural southwest England.

The unique characteristics of silk, discussed individually in preceding chapters, come together in practice to provide a large and varied vocabulary of behavioral and visual qualities. These, in turn, interact with the rich metaphorical language of silk, much of it revolving around the concept of metamorphosis. Just as silk emerges from its worm to become a thing of beauty, we too, by association with silk, can transform our everyday selves, or experiences, into something noble, lasting, and resonant with wonder. Equally, the allusions may lead elsewhere: to the daring or delicate, the seasonal or sensational.

This transformation of cocoon into cloth, and beyond that, into objects ranging from accessories to art, depends on a series of stages unlike those involved in processing any other fiber. Only silk is thrown; it alone absorbs dye with such ease and shows it with such intensity; its strength enables it to withstand great stress once converted into its final form. Each stage entails design decisions that can vastly alter the end result. This final chapter takes a look at contemporary fashion and textiles with these silk-related decisions in mind, focusing on how and why silk plays such a prominent role in these artistic fields.

Throughout, a few themes are dominant. All are related to two fundamental characteristics of silk: it is a natural fiber, and it is the lightest among such fibers. The origins of mulberry silk account for the imperceptible variation in its diameter, and thus for a subtle irregularity—something not shared by synthetics. Movement, translucence, and manipulated surfaces accentuate this barely visible attribute, highlighting the organic nature of silk; and its fineness allows for the ease of motion, sheerness, or malleability that make silk so graceful. Yet its ability to hold a form is also celebrated; Canada's Yvonne Wakabayashi sums up this trait in a description of her recent "Sea Anemone Series," in which "found objects, shells, and pebbles wrapped with unscoured sericin gummed silk or heavily starched organza have retained the three-dimensional textures and shapes in the memory of the fabric."[1] So too is its tolerance of heat, which allows for the sandwiching of silk between sheets of glass, then kilned into a composite whole, as is Stoyel's "Silkglas Series," one of which is shown in detail opposite.

Whether manipulated entirely by hand, as are Uehara's silks, or by machine, here represented by Mieli, the variety that exists naturally within silk strands—whether mulberry, wild, or spun—also offers a plethora of possibilities, as this survey of contemporary silks shows. The following pages also illustrate that, despite their small or non-existent silk industries, Japan, North America, and Northern Europe remain important contributors to the story of avant-garde silks.

right Using the thinnest possible hand-thrown silks and natural dyes, many produced in her own garden in Okinawa, Japan, Michiko Uehara creates what she calls *abezuba ori*, or dragonfly-wing weave. The example on the left, "Rising Steam 2005," is dyed with gromwell and cochineal, and "Rising Steam 2004," right, with gardenia, logwood, and getto.

opposite This vivid silk plaid is a recent product of Walter Mieli, Milan, which also operates a joint venture silk company, Jia Xing Idea Silk, in Zhejiang, China.

Color

In the realm of color, silk has no peer. As the images on this and surrounding pages prove, colors in silk range from the most subtle and delicate to the deepest and most vivid. The most brilliant tones can be made even richer by the juxtaposition of different-colored threads; in shot silk, the warp is one color and the weft another. Appropriately, this construction is called *changeant* in French, since the perceived color fluctuates from one shade to the other, and then to a mixture of the two, according to the angle of viewing. The fineness of silk strands permits this thorough blending of two colors to make a third, and by this means a silk plaid appears to contain more than twice the number of hues actually interwoven within it. All such effects—and single color damasks, too—are enhanced by the prismatic structure of mulberry silk: pure color seems to radiate from the surface.

Because silk absorbs dye so readily, printed silks account for most of those that are patterned, and these methods of patterning vary greatly. Individuals often explore techniques that are not viable for commercial production, using stencils, hand painting, and resist dyeing—here represented by Neil Bottle's ties and Judith Content's kimono-shaped panel, a *tour de force* of *arashi shibori*. Both use color to suggest depth, capitalizing on our instinctive "reading" of landscapes, in which muted tones are perceived to be more distant than intense ones. Light dancing over the surface further augments the allusions to atmospheric or natural phenomena that we understand through color: the time of day, the age of bronze, the maturity of wine.

Colors also elicit psychological responses, which is why the necktie is so often seen as a statement of personal identity. Denoting far deeper meanings than the obvious, color alone can alter the mood, recall distant memories, and even "warm" a cold room, the latter epitomized by the Designers Guild silks on page 195. But perhaps its most powerful impact is as a symbol of organizations, teams, and nations. For its radiant color, as seen overleaf in some Weisbrod-Zürrer damasks, silk is still used today for fine flags.

below A selection of limited edition ties by Neil Bottle, colored using a combination of screens and stencils, as well as hand painting. His clients have ranged from the Guggenheim Museum in New York to, most recently, the British Museum in London.

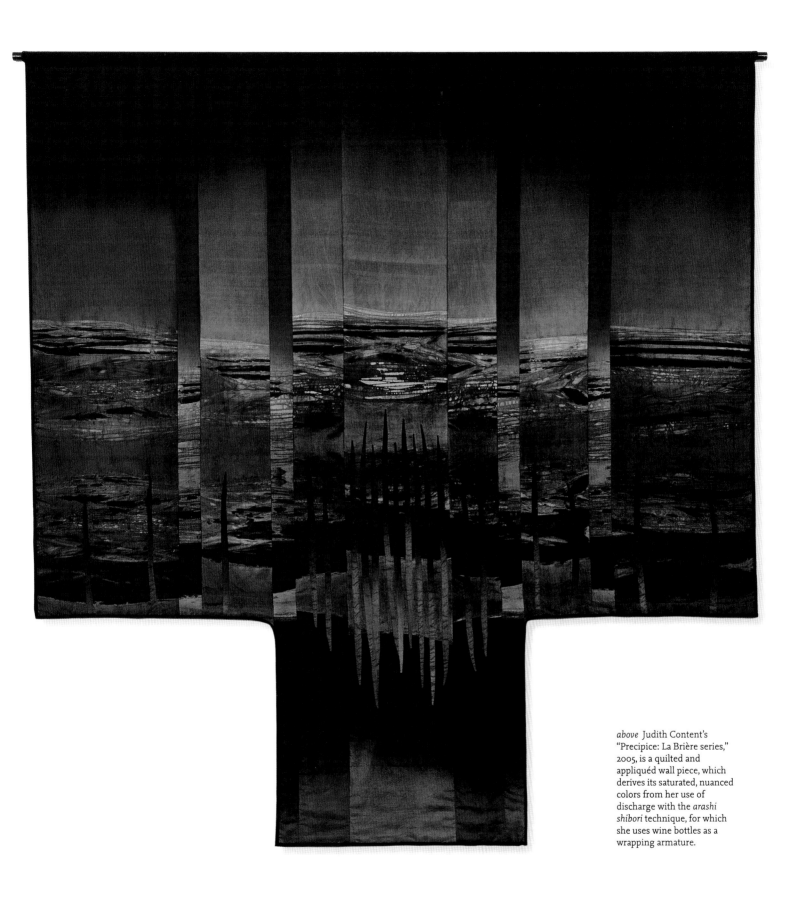

above Judith Content's "Precipice: La Brière series," 2005, is a quilted and appliquéd wall piece, which derives its saturated, nuanced colors from her use of discharge with the *arashi shibori* technique, for which she uses wine bottles as a wrapping armature.

opposite This selection of brilliantly toned weighty silk damasks were Jacquard woven by Weisbrod-Zürrer especially for flags and banners, most of which will be completed with embroidered and appliquéd motifs.

above and right From the autumn 2006 Designers Guild range comes this vivid embroidered furnishing silk, called "Valeriya." It epitomizes the daring use of color for which Tricia Guild has become known.

Metallics

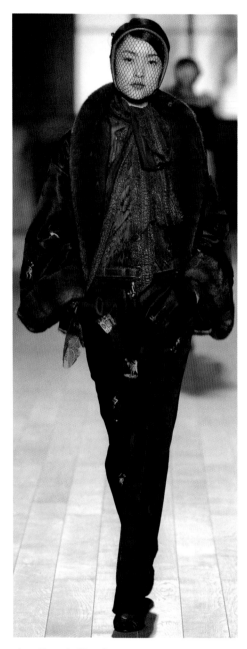

Because silk can never be mundane—due in part to its scarcity and relatively high cost—it elicits a high degree of expectation among the patrons of designers and artists who use this fiber. Add to this the ancient association between royalty and those silken cloths made even more resplendent with gold threads, and it is easy to comprehend why, as luxury and elegance returned with the post-millennium aesthetic, the combination of silk and metallics has also come to the fore. Nevertheless, this trend is no mere revival of old ideas, but the result of innovations with metallic materials.

Today, metallic yarns, generally called "filament," are seldom made from precious metals. Instead, they are mostly made from fine bands cut from a sheet of polyester foil, coated with a metallic film, which are then wound around a core. This composition makes filament lighter and more flexible than traditional metal threads, an asset that complements the fluidity of silk, as the recent ready-to-wear collections of Hermès and Roberto Cavalli demonstrate. Left flat, this filament percolates across a surface, which might also be printed. The latter technique is exemplified by a Mantero printed silk lamé, while the shimmer of a Schlaepfer sheer filament and silk cloth is enhanced with their signature printing style, which creates meandering patterns in unlimited colors. Unique to Stoyel is her development of laser techniques, which can produce patination, as seen overleaf.

Metallics can now also be laminated directly onto silk, which is more receptive to glued and bonded substances than are synthetics. Thus the quest for extraordinary effects has great scope, as Mantero's lavish use of gold laminate proves. For some artists, patination is a key element, as exemplified by Starszakowna's screen-printed visualizations of intense emotional landscapes, in which silver and metal leaf are added to various print media and heat-reactive pigments. The resulting rugged surfaces evoke the appearance of metals as found in nature, and this more rustic emphasis distinguishes contemporary metallics from their predecessors, as does the use of filaments mimicking base metals such as copper and pewter.

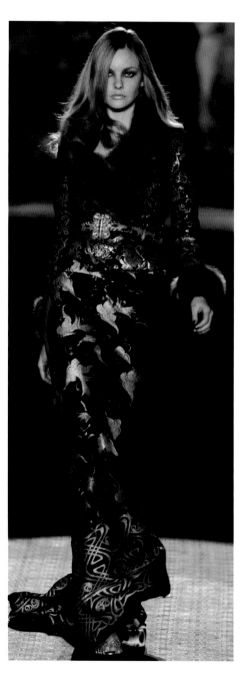

above Jacob Schlaepfer's 2003 filament and silk chiffon is shaded with their "Marvel-print" technique, which allows unlimited colors in meandering patterns. The filament is so fine that it is apparent only where layers of cloth overlap.

right Designed at Mantero for autumn/winter 2006–07, this self-pleated silk crêpe is laminated with gold pigments.

above This silk lamé by
Mantero, for autumn/winter
2006–07, incorporates flat
metallic strips, or lamella,
and is overprinted for
additional richness.

opposite In her 2006 "Silkglas"
series, Janet Stoyel employed
silk cloths woven with metal
threads in the weft; giving
them an invisible finish,
she encased them in glass,
employing different firing
temperatures to create
different effects, one of which
is shown here in "Silkglas4."

above These silks, Jacquard woven with metallic yarns, are among the recent designs created at Weisbrod-Zürrer for third-party brands.

opposite Norma Starszakowna introduces metallic sheens in her work both through the use of metal leaf and with patinating fluids, as seen in this detail of "Exposed Wall, Trieste" of 2002. The layered imagery is built up by digital printing on silk organza, followed by screen printing with various print media and latex, prior to patination.

Controlled contours

Aside from its ability to produce a sleek, smooth cloth, silk is also capable of taking on an exceptional range of contours. This is the result of its fineness: just as more dots on a screen give greater definition, more threads in a plane offer greater possibilities for manipulation. This analogy is especially apt when the silk is woven on a Jacquard loom. Capable of controlling each warp thread independently, this loom not only can weave a photographic likeness, but also can create complex multi-layered patterns. Here, this capacity is illustrated by a silk with floral motifs, given an added dimension by contrasting bound-down and floating threads.

In addition, the degree of twist and the diameter of silk yarns contribute to the possibilities. For the range of effects their incorporation can create, crêpe yarns, with their extra-tight twist, are especially interesting. Examples here are the work of Yoshiko Wada and Ana Lisa Hedstrom. Both employ Gumma *ecru* (or un-degummed silk) organza with an S-twist crêpe weft, developed in 1998 by Wada with Koshimitsu Textile Mill, in Kiryu, Japan. In both cases, the cloth is scoured, or cooked in a soda-ash solution, which removes the gum and creates pleats, permanent even to hand washing in cold water with a neutral soap. For the surface details, Wada employed *orini* shibori, a folded and edge-stitched resist that alters the surface texture, while Hedstrom chose a resist technique to both scour and dye the dress, and silk organza stitched to Gumma crêpe, which when shrunk creates *cloqué* areas in her coat.

A differential rate of shrinkage, in this case between a silk top and cotton backing, also produces the furrowlike contours in Diana Harrison's "Back and Forth," overleaf. Her work begins with silk noil, selected for its slubbed, matte surface, as well as for its density. Dyed black, it is layered and stitched, and then discharge printed; only the front is bleached, while the reverse remains black. The controlled contours urge the cloth to "barrel," or curve. This effect can also be seen in Vidushree Joshi's edge-stitched convolutions.

opposite Gumma silks inspired Yoshiko Wada to address the ambiguous relationship between body and clothing, or skin and silk, both of which are proteins. Her personal expressions cannot be conveyed with any other materials, here ecru organza with a bas relief of words created in *orini shibori* (a folded and edge-stitched resist), then scoured, or crêped.

above Textures, colors, and contours can all be incorporated in a Jacquard weave, as seen in the recent Weisbrod-Zürrer silk on the right; the silk on the left derives its "channels" from a weft-faced reversible weave.

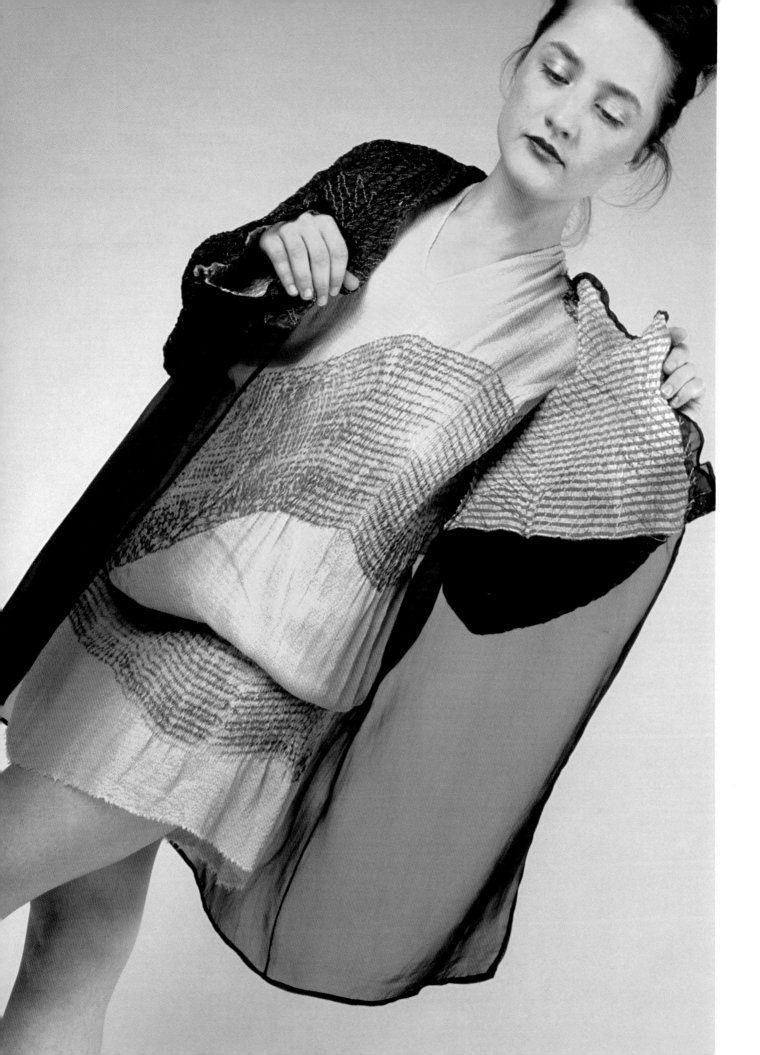

left and above Diana Harrison's long banner, "Back and Forth," 2006, is made from black-dyed silk noil layered over cotton, stitched, and discharged printed; when washed, the different rates of shrinkage create the contours. The difference this last procedure makes is evident by comparison with "Drawings in Cloth," one of a series of seven pieces made in the same way, but not washed.

opposite Ana Lisa Hedstrom uses resist scouring and dyeing in this dress and coat ensemble, not only to create controlled contours and subtle patterns but also to explore the "content" of clothing—that is, the language of cloth and its meaning. Here, using *shibori* techniques, she recalls parallels in Western dressmaking: smocking, shirring, and ruching.

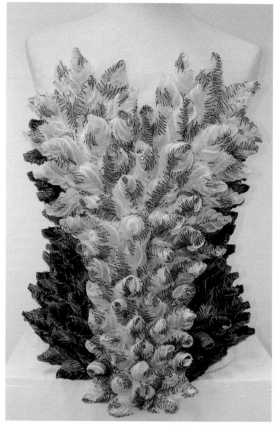

left and above From Vidushree Joshi's award-winning 2005 "Constructed Tucks" series comes this bodice of silk organza, the designer's choice for its ease of manipulation, ready absorption of dyes, and luxurious aesthetic. It formed part of a collection that won acclaim at the New Designers exhibition, the annual graduate design event held annually at the Business Design Centre, London.

opposite Also by Joshi is this detail of a different bodice, made of hand-dyed silk organza, machine-stitched with viscose thread and then manipulated into vault-like forms inspired by architecture. Joshi is an MA student of textile design at Chelsea College of Art, part of the University of the Arts, London.

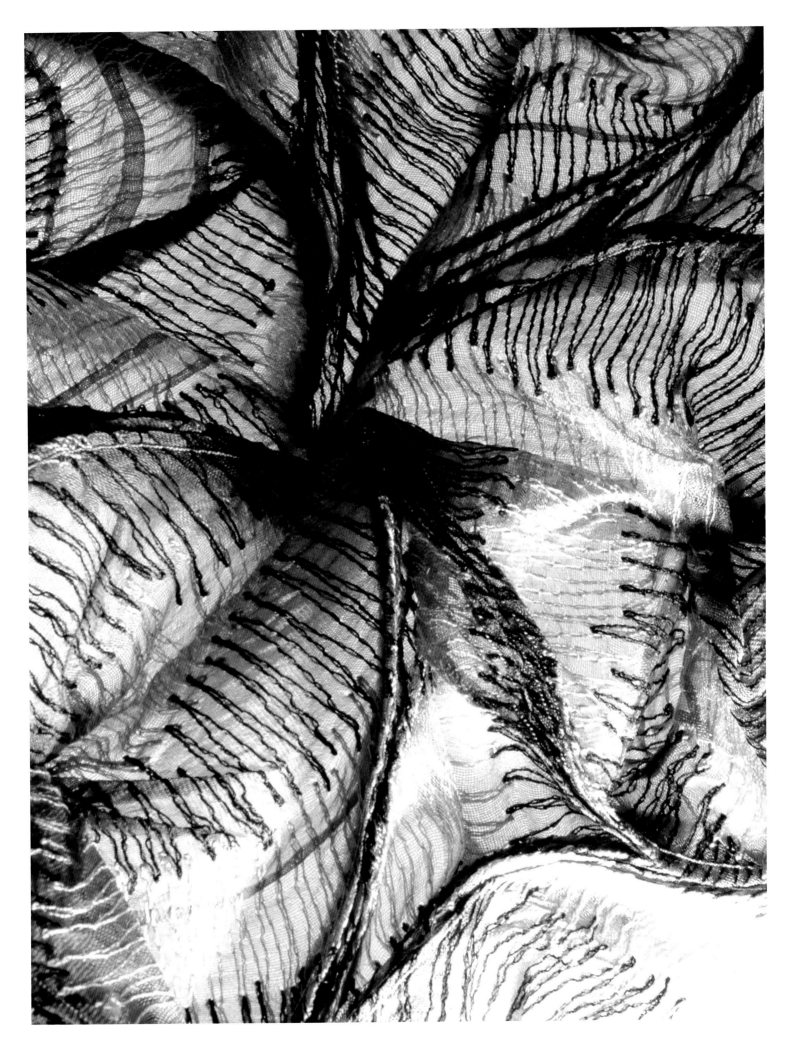

Distortions

Many of the same techniques that produce controlled contours can be used to create more pronounced distortions, generally by increasing the pressure or heat applied to a cloth, or by combining ever more disparate yarns. These techniques can be exploited by both hand and machine processes, as the following two pairs of images indicate. The results are often given the general term cloqué, meaning "blistered," because heat of some kind is essential, either to fix a distortion in place or to induce shrinkage in a cloth containing different yarns such as silk and a high-shrink synthetic. To satisfy the current desire for visual complexity, distorted silks today are often elaborated upon through rich colorations and even hand embroidery. In the hands of a master couturier such as Valentino (overleaf), these techniques may be combined in one ensemble.

Over the past decade seemingly random effects have provided new directions in silk finishes, and for "crush" prints, Norma Starszakowna has led the way. Her rust series, in which iron oxide-based pigment is combined with patination fluid to produce different rust effects, draws upon more than two decades of research into the creative potential of silk. Some of these effects were put into production for Shirin Guild, while those illustrated here were too complex to be replicated by commercial printers. Such studio production represents the way experimental work makes a significant impact on global trends. In this case, the combination of pigment printing and a shibori silk substrate had great influence, via Japan, and this helped a shibori revival outside its shores. By about 1990, there were only two native proponents of *arashi*, or "storm" shibori (a pole-wrapping resist technique developed in 1880 by Kanezo Suzuki), but far more elsewhere—among them, the American fiber artist Karren K. Brito, whose arashi shibori scarf with heat-set pleats, is shown overleaf. Other Japanese skills are preserved and disseminated by Akihiko Izukura, a hand-weaver and -dyer from a family that for centuries produced obi and kimono silks for the imperial court, who has lately collaborated with the label Donna Karan.

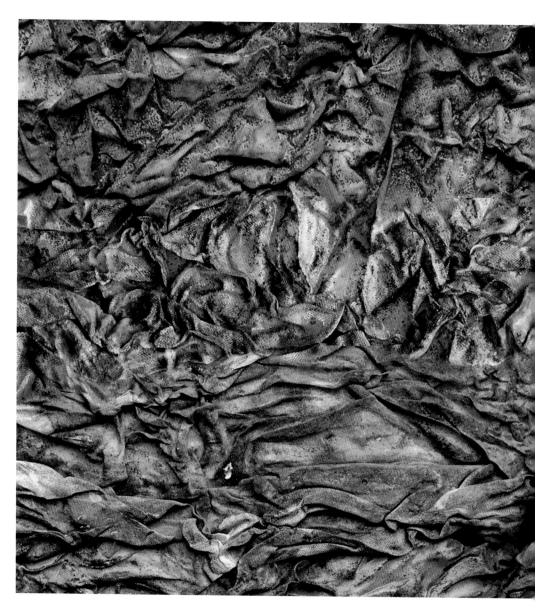

above and opposite Norma Starszakowna pioneered crush-printed lengths of silk, and these two examples indicate the range of effects she produces. Above is "Rust Crush," a closely crushed white silk overprinted with a dilute iron oxide-based pigment, then sprayed on the reverse with a patination fluid. Right is "Rust Oval," a habutai silk printed with heat-reactive pigment and overprinted with black iron oxide-based pigment, randomly heat embossed from both sides before being coated with the patination fluid, which produces the rust effect. Both were part of an extensive collection produced in 2003 for Shirin Guild's 2004 spring/summer collection.

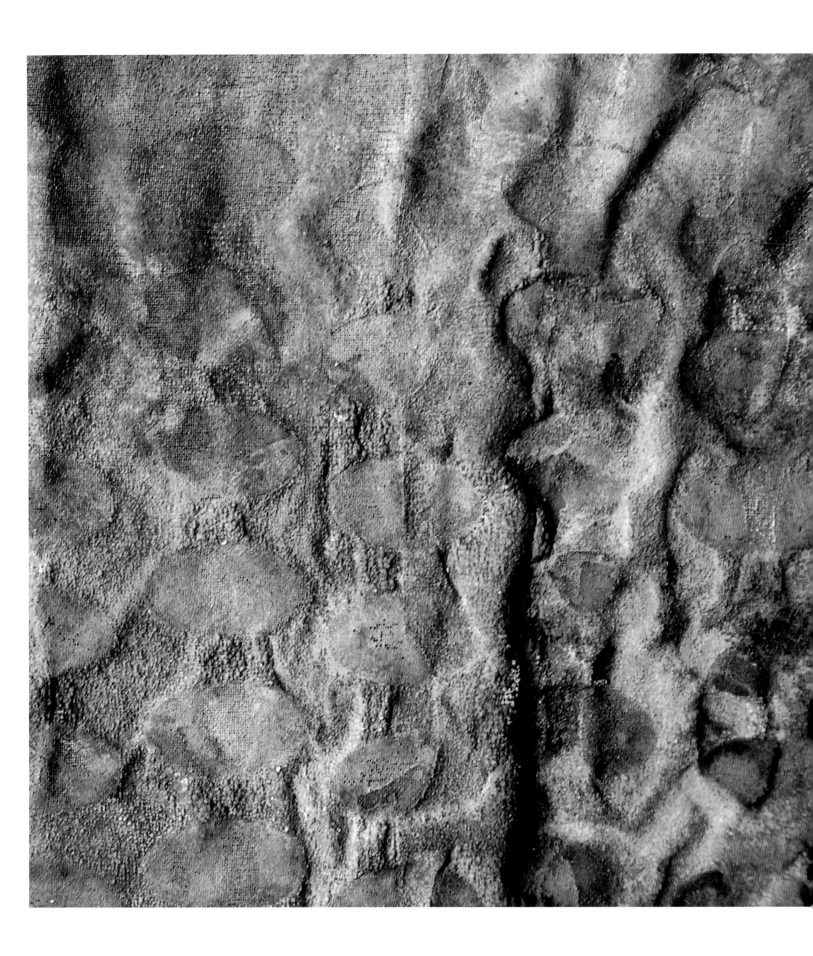

left A detail from Valentino's autumn 2006 couture collection highlights the subtle richness of cloquéd silks, with surfaces undulating in both tone and texture.

opposite Shibori can produce extreme layers of distortions, as seen in this detail of a 2004 silk scarf by Karren K. Brito. With a doctorate in chemistry, Brito is experimental as she dyes, pleats, and ties, frequently discharging the original color and overlaying many others.

above and opposite With the exception of the *karakumi*, or hand-braided silks, in the foreground among those by Akihiko Izukura (opposite), all of the distortions here have been created by using silk threads with others of fibers more prone to shrinkage. In 2006, those seen above were designed for power weaving by Weisbrod-Zürrer; Izukura's silks are handwoven.

Manipulations

Aside from the textural and visual effects that arise from weaving and the application of dyes or heat, there are many other ways to manipulate silk to creative ends. As this section illustrates, it can be braided, plaited, tucked, and tacked, bearing the stresses and strains of these processes with ease. But in addition, the examples included here are intended to highlight the extent to which form and sensory qualities act together to make a sculptural statement. Izukura, for example, in his signature *karakumi* (hand-braided) silks, aims to express the flow of water and air; the twisting threads represent the life force of nature. The American sculptor Carolyn Kallenborn is drawn to materials such as silk and metal for their transformative potential, creating another kind of "flow"—between materials and also the space occupied by her pieces, which make random movements in response to air currents.

As different as these examples are, they share a conscious manipulation of light and shadow. So, too, does the work of Katri Haahti, who in her Helsinki studio uses insect-mounting needles to fasten thousands of resin-hardened silk shards to a balsa-wood base. She describes the results as islands, stars, moons, and heavenly bodies, a scenery of reflections in a dark water or shadows on a white wall. Her sculptures, then, are images, "recorded by senses and instincts. . . . Illusion is strong: small and large change their places easily. Silk is light, but with lighting it casts strong shadows."[1]

These dichotomies—lightweight yet suggestive of concrete forms, fixed in place yet brought to life with movement (of the wearer, the piece itself, or the position of the viewer)—apply equally to Gaultier's plaited silk "spinal cord" gown. The same can be said of McQueen's cascades of ruched organdy, redefining the model's silhouette with each stride she takes. Historically, sculpture has often taken the human body as its subject; in such garments as these, which are both around and literally about the body, sculptural concepts are more than incidentally present. Instead, they champion couture's significance as a contemporary art.

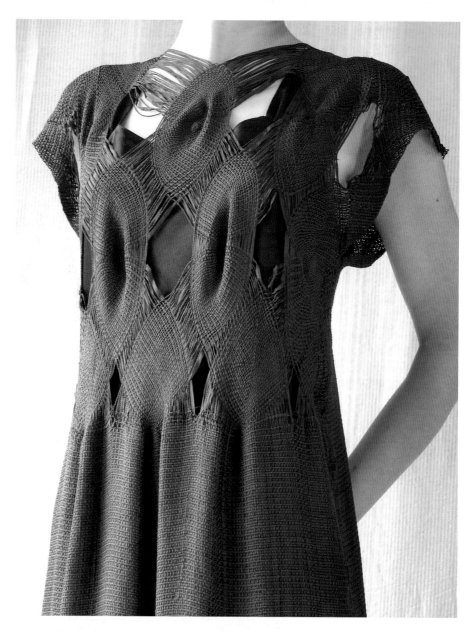

above and left Akihiko Izukura is now the only maker of *karakumi* silk garments (above), hand-braided into a characteristic design of symmetrical diamond patterns, which can be manipulated to create voids and depressions, or interlaced flat, as seen on the previous page. He uses spun cocoon waste, with its subtle texture enhanced by natural dyes (as seen left) and is dedicated to a philosophy of wasting nothing, recycling dyes and silks into ceramic glazes and handmade paper.

opposite A detail of Carolyn Kallenborn's 2005 silk and metallic installation, "Reduction."

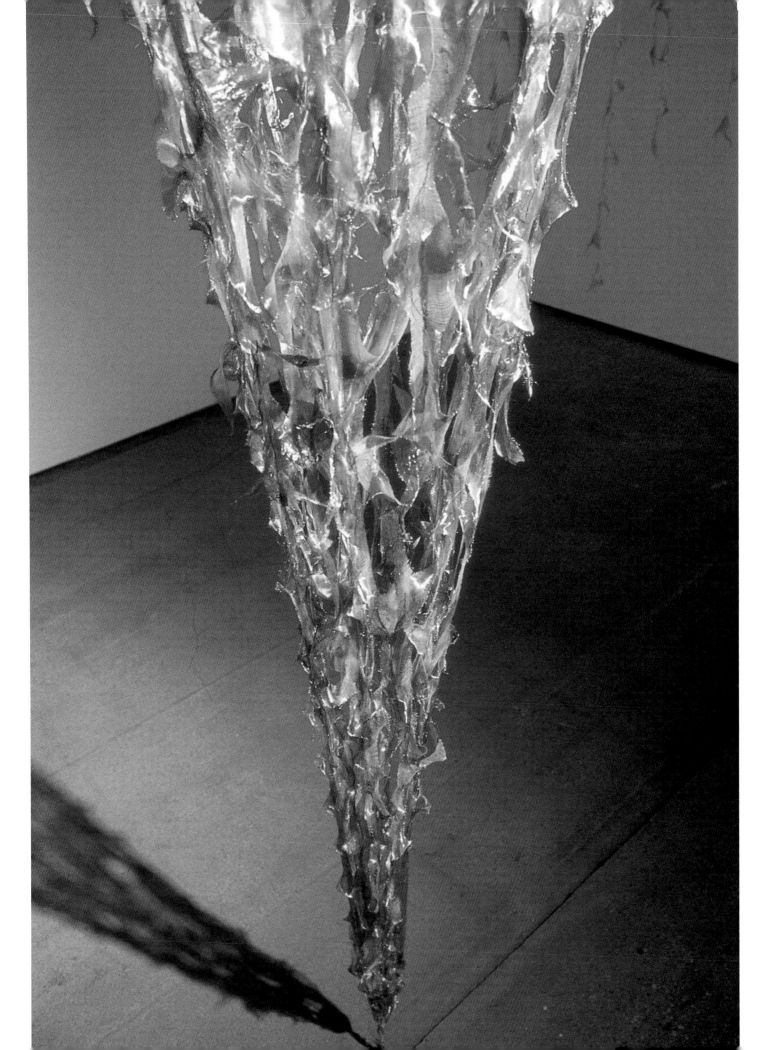

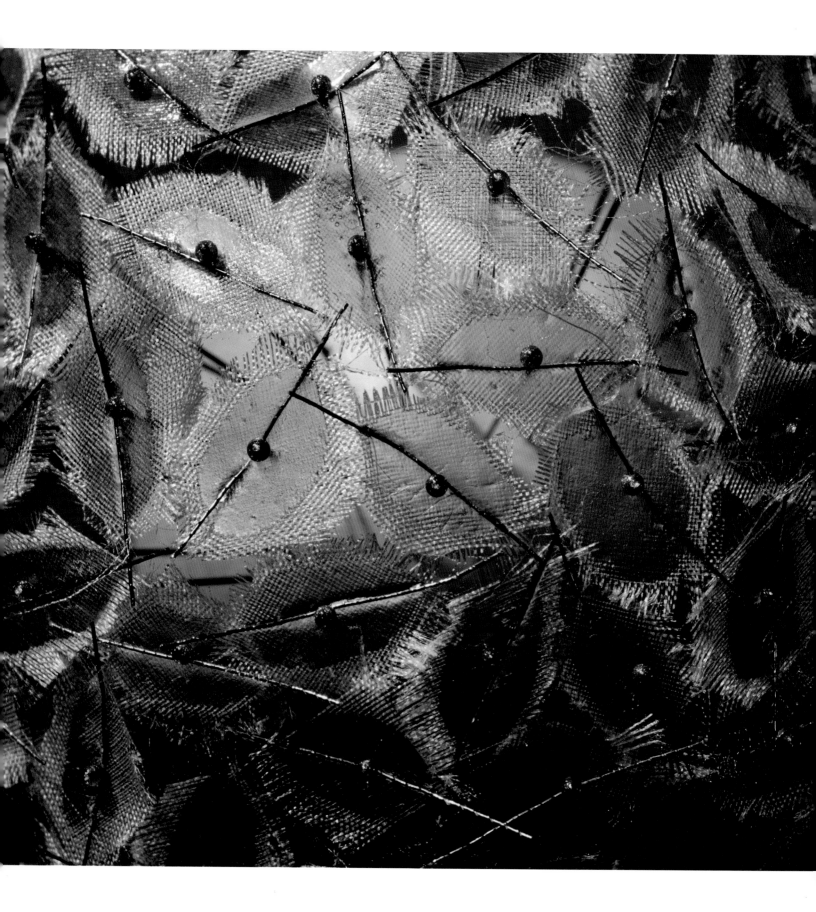

216 · Silk

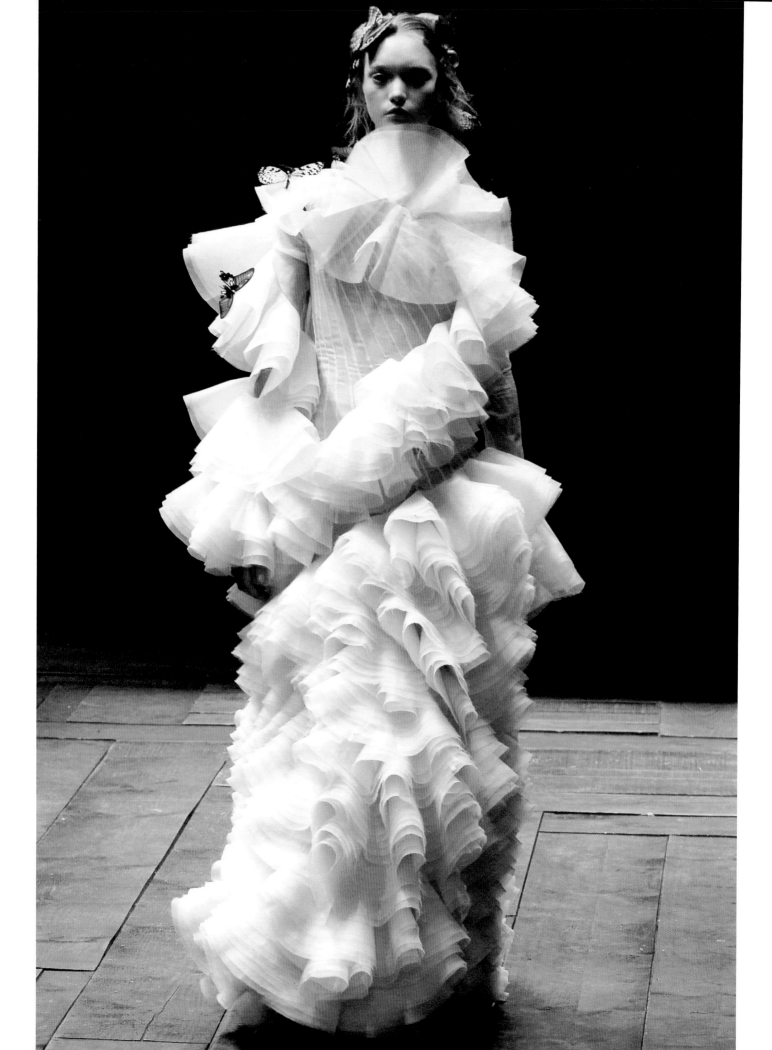

previous spread Both made by Finland's Katri Haahti in 2005, the detail of "Starlet IV" (left), shows her manner of securing resin-coated silk shards to balsa wood, using insect needles, while "Whitemoon" (right), illustrates the overall shimmering effect of her technique. The latter is 60 cm. (23 ⅝ in.) in diameter.

opposite In his autumn 2006 ready-to-wear collection, Alexander McQueen presented this gown of silk organza, its cascading ruffles creating a billowing form controlled with multiple diagonal tucks, which shape the garment to the body.

right Overlaid on a flesh-colored garment is an armature of purple chiffon, artfully manipulated to resemble a human spine and ribcage. This tour de force of mimicry made its debut in Jean Paul Gaultier's autumn 2006 couture collection.

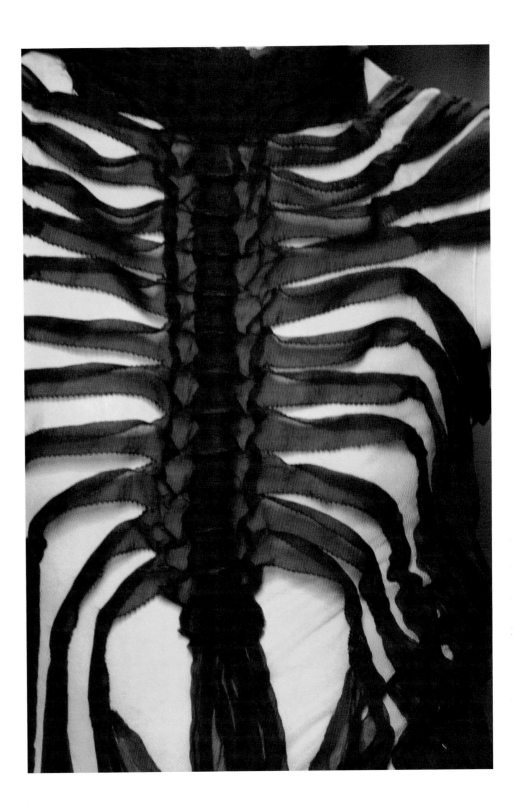

Sheer
and shaped

In the visual arts, the interest in deconstruction—that is, the emphasis on the parts that make up the whole—has been a driving force for over a decade. Recently, however, this trend has matured, becoming less forceful in its approach, moderated by the renewed interest in natural materials and in nature itself. Silk has proved to be an ideal medium for the exploration of this aesthetic, for several reasons. Lacking the deadening consistency of man-made and synthetic yarns, silk fibers, with their minute irregularities, introduce a flicker of life to any cloth. This characteristic is particularly evident in sheers. These, when inset with a denser structure, suggest the fragile skeletal evanescence of a dragonfly wing. Whether used for interiors or fashion, silk sheers have a moderating effect, creating an ever-changing sequence of delicate shadows, which perform an artful interplay of concealment and exposure.

To this end, designers have several means. Supplementary wefts, clipped away where they are not engaged with the ground cloth, can, depending on their appearance, create textured areas ranging from rugged to delicate, as the Rochas, Mantero and Ratti examples demonstrate. Warp effects, on the other hand, allow for the creation of ribbonlike streamers, which emphasize the architecture of the weave when the fabric is hung straight down, and produces contours when it is swagged, draped, or otherwise manipulated. When the cloth is woven of ecru, as seen overleaf, these tendencies are enhanced by the stiffening effect of the gum left in this type of silk. The juxtaposition of varying degrees of transparency can also be achieved by cutting, pleating and folding, or gluing opaque elements in place, as a selection from Jakob Schlaepfer illustrates. And just like a butterfly net, the stability of a sheer silk, derived from the strength of the fiber, allows it to "entrap" motifs in an envelope of fluidity. In the two examples from Nuno, it is recycled silk weaves and warps that are captured, while the Broadwick confection, opposite, incorporates tufts of printed silk tulle.

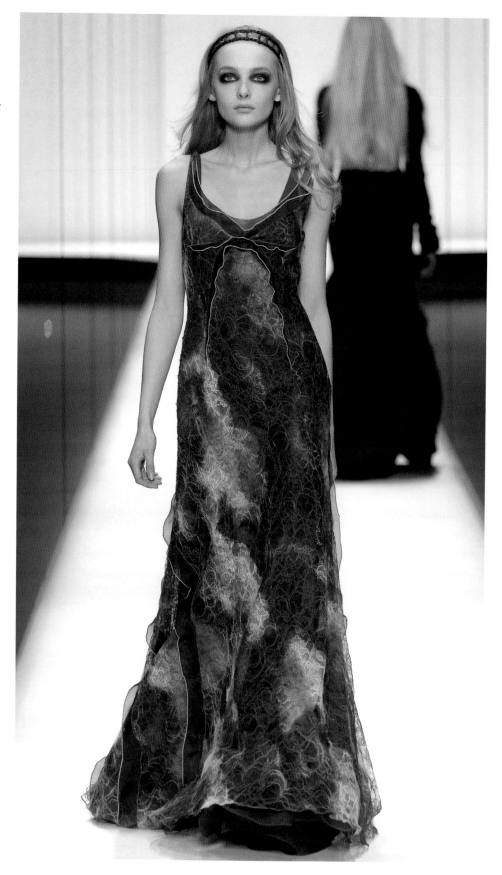

opposite Olivier Theysken at Rochas created this smoky gown for the Parisian house's autumn 2006 ready-to-wear collection, layering tulle and silk in reserved yet sensuous tones and textures to evoke a cloud-covered landscape.

above, top A 2006 Mantero printed silk chiffon inserted with cut wefts of lamella.

above, bottom Based near Como, which leads western silk production, the Ratti Group produces some 4.5 million m. (4.9 million yd.) of fabric annually; its focus on creativity and technical excellence is evident in this silk with a cut supplementary cotton weft, from the 2006 dyed-yarn Jacquard collection of Ratti Braghenti.

right "Found" feathers and recycled printed tulle are captured on silk georgette; the hand embroidery was worked in India exclusively for Broadwick Silks, London, who began to stock it in 2006.

above The transparent
sections in this 2006
Wesibrod- Zürrer curtaining
sheer are made with ecru,
also called silk grège, while
the vertical bands are
composed of a thick silk
and viscose chenille yarn,
giving it a velvetlike touch.

above Created in-house at
Jacob Schlaepfer in 2004 and
(second from right) 2003,
these four silks illustrate
the possibilities that three-
dimensional manipulations
afford in creating contrasting
sheer and opaque areas,
including cutting, pleating,
and (center) smocked pleating
evoked with ribbons secured
by silver studs.

overleaf, page 224 Under
the leadership of Reiko Sudo,
Nuno's design team developed
"Nuno Tsunagi" in 2004.
Ironed leftover fabric scraps
were cut to size, hand basted
onto silk organdy, and then
machine stitched in place.
No two lengths are identical.

overleaf, page 225 Using
leftover warps from the hand
looms on the Japanese island
Amani Oshima—famous for
its mud- resist ikat kimono
fabric—Nuno, in 2003,
re-milled bouclé threads,
urethane-core stretch threads,
and loop threads for use as
supplementary wefts in this
ecru-ground silk, called "Re-
text Oshima Mado."

A better canvas

Every follower of present-day art knows that the traditional assumption—that painters invariably use oils or acrylics on canvas—no longer holds true. What may be more surprising to many, however, is the antiquity of silk's role as "canvas," as well as its significance in that same capacity today. What silk offers, and canvas does not, is a truly flexible surface. Its fluidity is the obvious element of this flexibility, but equally important is the way silk cloths afford a range of options. These can be transparent, translucent, or opaque; light or heavy; textured or smooth. This last duality alone amends the painter's mark; in Waller's crushed organza dress, overleaf, the brush stroke is grounded, earthly, but flies swiftly over the sleek dupion of her quilted coat. In the Mantero example, right, three kinds of texture combined in a single cloth now interrupt and then enhance the printed brush-stroke-like lines.

It is in pushing the possibilities toward their creative limits that designers of limited-edition and couture fabrics function as artists, urging us to see, through cloth, with new eyes. This applies to every textile technique, but here the focus is on applications of gestural marks, which highlights a final difference between silk and canvas—namely the way color is integral to the one and merely sits on the other. An opaque silk, as Bottle's panel shows, preserves the nuances of hand-painted dilute dyes and their contrast to vibrant hand-screened and stenciled full-strength dyes and metallics, while Hedstrom's translucent silk habutai perfectly partners digital printing, which produces less intense colorations.

In different ways, Starszakowna and Waller paint with both color and degrees of opacity. The former builds layers of dyes and other print media on an organza ground, emphasizing the strength behind the apparent fragility of a sheer silk, as a metaphor for life itself. By contrast, Waller, in her glass-encased work, uses a silk-viscose cloth, etching away areas of viscose to reveal the thinnest possible silk membrane. The more opaque areas render colors stronger; the results are seemingly weightless images, hovering like memories in space.

left In this printed Mantero silk, designed for the 2007 spring season, the ground has a Jacquard-woven pattern surrounded by "fringes" of cut wefts, leaving semi-sheer areas exposed. This century-old firm, one of Como's premier silk manufacturers, maintains a large design team specializing in creating combined effects such as these.

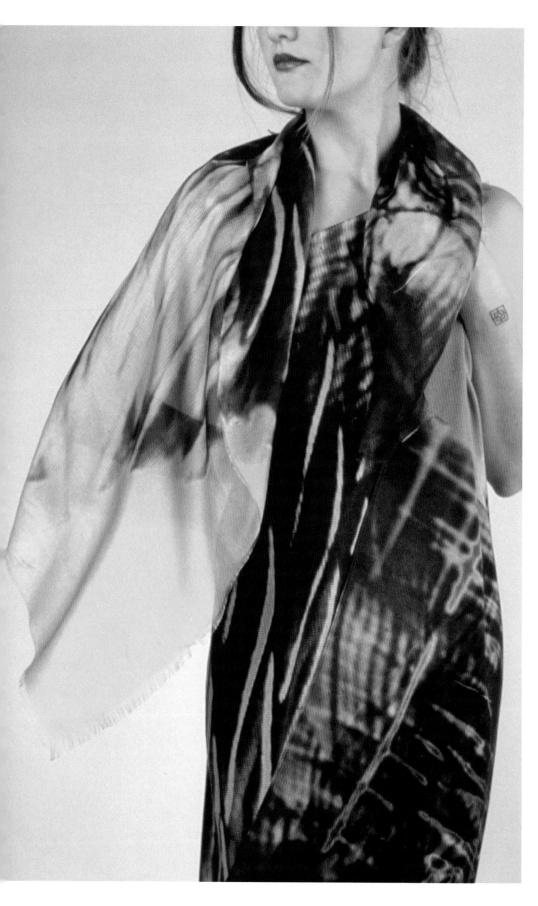

left With the imagery derived from scanned scraps of her own hand-dyed *shibori*, Ana Lisa Hedstrom's silk habutai dress and scarf are digitally printed with fiber-reactive dyes; she describes this recent departure, after thirty years of exhaustive explorations of labor-intensive techniques, as "liberating."

above Neil Bottle's screen-, stencil-, and hand-painted silk panel illustrates his approach to his work, which aims to create the illusion of depth and richness both in terms of the decorative use of pattern and color and in the range of subtle textures produced by overprinting.

opposite One of Carole Waller's ways of communicating as an artist is through painted clothing, which itself becomes part of her exploration of the human figure, and its absence and presence, appearance and disappearance. Illustrated here is a silk dupion quilted coat and crushed organza dress of 2003.

left Four of eighteen
double-sided sections
from "Hinterland," Norma
Starszakowna's 2004
permanent installation in
the Scottish Parliament
building, Edinburgh (see
also page 10), showing (from
left to right) two as seen
from the front and two from
the reverse. These intensely
textured panels are of
digitally printed silk organza,
then screen printed both
sides with various print
media, transparent glazes,
and heat reactive pastes,
with additional patinating
substances, and silver
and gold leaf.

opposite "Colonnade" was
created by Carole Waller
for the 2005 Chelsea Flower
Show, London, using glass-
encased paintings to project
human images into the
atmosphere. Her choice
of silk-viscose devoré as
the substrate renders
her paintings even more
ambiguous, as the sheer
and dense areas of cloth
moderate the intensity
of her brush-stroked dyes.

The Science
of Silk

Bombyx mori proteins and properties

The raw silk thread obtained from the cocoon has a "sheath-around-two-cores" composite structure consisting of two fibroin filaments, triangular in section and with an average diameter of 10–14 μm, embedded in a protein gum called sericin. Both fibroin and sericin are proteins. The former accounts for about 70–80 w% (percentage by weight) of the raw silk thread, depending on origin and culture conditions. Other minor components are waxes and fats (c. 1.5 w%), carotenoid pigments and mineral components (c. 1 w%), which occur exclusively in the sericin layer. Small amounts of polysaccharides have also been detected (glycosylated sericin fractions). The silk proteins, i.e. fibroin and sericin, are secreted by different specialized parts of the silk gland: fibroin in the posterior part, sericin in the middle part of the gland.

FIBROIN

Fibroin constitutes the core of the silk fiber. However, the term "fibroin" does not identify a single protein. Early biochemical studies have shown that two main components can be separated by reductive cleavage of the fibroin protein, one very large and another very small (Shimura et al., 1976; Gamo et al., 1977). They were called Heavy chain fibroin (H-fibroin) and Light chain fibroin (L-fibroin). Further, more sophisticated biochemical analyses, including gene sequencing and immunological studies, made it possible to confirm the presence of the above two distinct components, as well as to identify an additional fibroin component called P25 (Coublé et al., 1983). The gene sequence of H-fibroin (Suzuki and Brown, 1972; Zhou et al., 2000), L-fibroin (Kimura et al., 1985; Yamaguchi et al., 1989) and *P25* (Coublé et al., 1983; Chevillard et al., 1986a, 1986b) are known. These genes are present in single copies per genome and each generates a single polypeptide.

H-fibroin is the major protein component of the silk fiber. The H-fibroin gene presents a highly repetitive core flanked by nonrepetitive ends (Zhou et al., 2000). The repetitive core is composed of alternate arrays of 12 repetitive and 11 nonrepetitive domains. Repetitive domains differ from each other in length by a variety of tandem repeats of sub-domains, while the nonrepetitive domains are more evolutionarily conserved. A typical composition of a sub-domain is a cluster of repetitive units Ua (an 18 base sequence encoding the well-known fibroin repeat peptide GlyAlaGlyAlaGlySer), followed by a cluster of units Ub (75% of Ub units encode peptides of GlyAla repeats), with a Ua:Ub ratio of 2:1, flanked by conserved boundary elements. The deduced primary structure of H-fibroin is 5,263 residues long, with a molecular weight of 391 kDa, an isoelectric point of 4.22, and an amino acid composition comprising 45.9% Gly, 30.3% Ala, 12.1% Ser, 5.3% Tyr, 1.8% Val, and only 4.7% of the other 15 amino acid residues (Zhou et al., 2001). The sequence is made by a low complexity region (4,754 residues, corresponding to c. 94% of the sequence) bordered by short N- (151 residues) and C-terminal (58 residues) segments of more standard amino acid composition. The bulk of the low complexity region is made of repeats of the Gly-X dipeptide motif where X is Ala in 65%, Ser in 23%, and Tyr in 9% of cases. Val and Thr also occur as X, but to a lower extent (ca. 2%). The Gly-X repeats are distributed in 12 "crystalline" domains, designated Gly-X domains, whose length is highly variable (from 39 to 612 amino acid residues), separated by 11 nearly identical copies of boundary "amorphous" sequences (42–43 residues) containing most of the amino acid residues, including acidic and basic, that are absent in the Gly-X domains. The chemical structure of the amorphous spacer sequence, which is highly conserved, breaks the Gly-X alternance and terminates the crystalline regions. Gly-X dipeptide units are present mainly as part of the two hexa-peptides GlyAlaGlyAlaGlySer (433 copies) and GlyAlaGlyAlaGlyTyr (120 copies) which together account for 70% of the low complexity region. Each crystalline domain is composed of sub-domains containing reiterations of the GlyAlaGlyAlaGlySer motif and terminated with GlyAlaAlaSer. Within the sub-domains the Gly-X alternation is strict, which strongly supports the classic pleated b-sheet model of secondary structure (Marsh et al., 1955) in which b-sheets pack on each other in alternating layers of Gly/Gly and X/X contacts.

L-fibroin mRNA was first cloned by Kimura et al. (1985) and used as a probe to investigate relative concentrations of L-fibroin gene and mRNA in the posterior silk gland at different stages of the larval development of the *Bombyx mori* silkworm. The L-fibroin encoding gene was isolated and its nucleotide sequence was determined (Yamaguchi et al., 1989; Kikuchi et al., 1992). The deduced amino acid sequence of L-fibroin includes 262 amino acids. After cleavage of a signal peptide, the mature L-fibroin polypeptide comprising 244 amino acids is obtained. The N terminus of the mature form of L-fibroin was found to be an N-acetyl Ser. The molecular weight of mature L-fibroin was calculated to be 25.8 kDa, including the N-acetyl group. L-fibroin polypeptide contains three Cys residues. Two of them form an intramolecular disulfide bridge, while the Cys residue in position 172 binds with Cys-c20 (20 residues from the C terminus) of H-fibroin to form the intermolecular disulfide bridge which connects the two main fibroin polypeptides (Tanaka et al., 1999). Immunological identification of L-fibroin as the major light component that is disulfide linked to H-fibroin was performed by Tanaka et al. (1993). Assembly of H- and L-fibroin by a single disulfide bridge seems to be crucial for the intracellular transport and efficient secretion of native silk proteins into the lumen of the posterior silk gland (Takei et al., 1987). Analysis of secretion-deficient "naked-pupae" silkworms (Nd-s mutation) revealed that homozygous Nd-s mutants secrete less than 0.3% of fibroin into the lumen of the posterior silk gland, compared with wild types. The small amount of fibroin secreted consists of H-fibroin only and lacks L-fibroin, although the mRNA and the protein are present in the posterior silk gland cells. These findings strongly suggest that H-L subunit combination of fibroin polypeptides is essential for their efficient secretion.

Coublé et al. (1983, 1985) and Chevillard et al. (1986a) first purified and characterized a novel silk protein mRNA from the posterior silk gland. It yields a 25 kDa polypeptide, called P25, which is exclusively synthesized in the posterior silk gland, accumulates in the

middle silk gland lumen, and is spun out in the same way as the other silk proteins. The primary amino acid sequence was deduced from the gene by Chevillard et al. (1986b), and the regulation of gene transcription in the posterior silk gland during larval molts and intermolts was investigated by Nony et al. (1995). P25 is unique among the fibroin polypeptides in that it contains three N-glycosylation sites that bind oligosaccharides of the mannose type (Tanaka et al., 1999). N-glycosylated P25, which has a molecular mass of c. 30 kDa, is able to associate with the H-L disulfide-linked fibroin dimer by non-covalent (largely hydrophobic) interactions. The biological function of P25 had long been unknown until Inoue et al. (2000) proposed a model of assembly, intracellular transport, and secretion of fibroin polypeptides. In this model, a nascent H-fibroin chain forms a disulfide linkage with an L-fibroin chain. Then, six H-L dimers and one N-glycosylated P25 assemble into an $H_6L_6P25_1$ complex through hydrophobic interactions between P25 and H-fibroin and by hydrogen bonding between N-linked oligosaccharide chains and H-fibroin. N-glycosylated P25 exhibits molecular chaperone-like behavior and facilitates the formation of a stable complex, i.e. the elementary unit of fibroin, which is transported inside the cell and then secreted into the lumen of the posterior silk gland. The formation of the elementary unit ensures solubility of fibroin during the process of transport through the silk gland until the time of spinning from the tip of the anterior silk gland.

SERICIN

Sericin is the glue protein that binds the two fibroin filaments as they are spun by the silkworm to form the cocoon. The term "sericin" identifies a family of at least six proteins whose molecular mass ranges from 65 to 400 kDa. Some of them are glycosylated (Shinohara, 1979). Sericins are secreted in the middle silk gland, where they account for c. 50% of the proteins synthesized during the last larval instar, and represent 20–30% of cocoon proteins. Sericins are characterized by an unusually high content of serine, which accounts for about 38 mol% (Takasu et al., 2002), as well as other hydrophilic amino acids. The hydrogen bonding ability of hydroxyl amino acids is considered responsible for the gluelike properties of sericin, while a possible hypothesis for the heterogeneity of this group of proteins is related to the need of modulating viscosity and adhesiveness of the protein mixture as the cocoon is spun. Another important biological function that sericin is thought to perform is to lower the shear stress and to absorb the water squeezed from the stretched fibroin mass during cocoon spinning. The sericin layer is usually removed from silk textiles before dyeing and finishing by a process called degumming, which takes advantage of the solubility of sericin in boiling aqueous solutions containing various degumming agents, such as soap, alkali, organic acids, or synthetic detergents, including proteolytic enzymes (Freddi et al., 2003). Sericins are encoded by two genes, *Ser1* and *Ser2*, whose expression in the middle silk gland is topologically and temporally regulated, providing for sequential layering of different sericins around the silk thread (Coublé et al., 1987). The different molecular weight sericins result from alternative splicing events occurring at the transcript level in the middle silk gland cells (Michaille et al., 1986; Tripoulas and Samols, 1986; Coublé et al., 1987; Garel et al., 1997). The *Ser1* gene produces four different mature mRNAs by alternative splicing of a unique transcript (Michaille et al., 1986; Coublé et al., 1987). The gene structure was elucidated by Garel et al. (1997), who could also infer the most probable amino acid sequence and composition of four sericin proteins. The Ser content ranges from c. 31% to 40%, and the molecular mass is between 76 and 284 kDa. Interestingly, a peptide sequence highly enriched in charged amino acid residues and containing potential N-glycosylation sites able to confer water solubility to sericin proteins was identified. Moreover, the presence of two other peptide sequences comprising repeated units of a 40% Ser-rich motif was observed. These sequences are probably responsible for the ß-sheet structure detected in some regions of sericin proteins. These findings illustrate how assembling of different peptides can confer specific chemical and structural properties on the different sericins. The *Ser2* gene produces two mRNAs, one small and one large, by differential splicing (Michaille et al., 1990). The gene is characterized by a remarkable polymorphism. While the size of the small mRNA is constant, that of the large one is subject to length variations. Accordingly, variations in length were observed for the sericin polypeptides encoded by the *Ser2* gene and accumulated in the anterior sub-part of the middle silk gland. These polypeptides show a molecular mass from 164 to 226 kDa (Gamo et al 1982).
Giuliano Freddi

Bombyx mori silk properties

Silk is a highly oriented and crystalline fiber. The remarkable properties of silk originate from the chemical structure of the main fibrous component, i.e. H-fibroin. L-fibroin, and P25, which have a more standard amino acid composition and nonrepetitive sequences, play only a marginal role in determining fiber properties. The block-copolypeptide structure of H-fibroin consists of 12 crystalline domains made of Gly-X repeats separated by 11 amorphous spacer sequences. In the Gly-X repeats, X is Ala in 65%, Ser in 23%, and Tyr in 9% of cases. Each crystalline domain contains subdomains of c. 70 amino acid residues, which in most cases begin with the GlyAlaGlyAlaGlySer hexapeptide motif and terminate with the GlyAlaAlaSer tetrapeptide. The long stretches of Gly-X repeats are the building blocks of the pleated b-sheet model of structure (also known as Silk II) assigned to the whole fiber by Marsh et al. (1955). On the basis of X-ray diffraction measurements they proposed that the fiber is made of antiparallel ß-sheets packed on top of each other. The b-strands extend along the fiber axis, giving an axial repeat of c. 7 Å. The fibroin chains run antiparallel and are held together in the sheets by hydrogen bonds roughly perpendicular to the chain axis formed between the carbonyl and amine groups of adjacent peptide bonds (interchain distance of c. 9.2 Å). The sheets are assembled through hydrophobic interactions and are oriented in such a way that in any one sheet all the Gly side chains (-H) project from the same side, and the Ala ($-CH_3$) and Ser ($-CH_2OH$) side chains from the other side of the sheet. Sheets then stack with the Gly faces together and the Ala/Ser faces together, leading

to an alternation in intersheet spacing of c. 3.5 Å and 5.7 Å, respectively, corresponding to a repeating intersheet distance of c. 9.3 Å. X-ray diffraction and infrared measurements indicate a degree of crystallinity of the silk fiber of 62–66% (Warwicker, 1960; Nadiger and Halliyal, 1984). Based on X-ray diffraction data, the crystallite size varies from 1.5 to 2 nm perpendicular to the plane on the sheets.

The above model of structure with pleated ß-sheet molecules arranged in an antiparallel manner and polar projections of the side chains has been widely accepted. However, Takahashi et al. (1999) reconsidered this model in the light of newly observed X-ray reflection intensities and proposed a new way of assembling ß-strands and packing ß-sheets. The model of Marsh et al. (1955) perfectly fits a poly(GlyAla) sequence. However, Ser residues may introduce a certain extent of disorder in chain and sheet packing. By comparing measured and calculated diffraction patterns for different chain arrangements, Takahashi concluded that the most probable model of silk structure is an antipolar-antiparallel one, in which the methyl groups of Ala alternatively point to both sides of the sheet structure along the hydrogen bonding direction. The crystalline region of silk fibroin is therefore composed of stacking of two antipolar-antiparallel sheet structures with different orientations. More recently, Zhou et al. (2001) tried to fit the ß-sheet structure models to the actual sequence of crystalline domains and sub-domains and suggested that the ß-sheets may be parallel instead of antiparallel, because the model of Marsh et al. (1953) cannot fit the additional level of repetition discovered above the Gly-X units, i.e. the sub-domains. In conclusion, it appears that far more experimental evidence is needed to build up a widely accepted model for the crystalline structure of silk fiber.

Asakura et al. (2002a, 2002b) used different solid-state NMR techniques to investigate the intrinsically heterogeneous structure of natural silk fibers in the Silk II form. They were able to determine the relative proportions of the various structural and conformational components: for the 56% crystalline fraction, they found 18% distorted b-turns, 13% ß-sheets (parallel Ala residues), and 25% ß-sheets (alternating Ala residues); for the remaining 44% amorphous fraction they

found 22% of both distorted ß-turns and distorted ß-sheets.

Silk fibroin shows a typical crystalline dimorphism. If the silk gland content is slowly dried at room temperature or a concentrated silk fibroin solution is cast to prepare a film, fibroin takes a crystalline structure known as Silk I. The Silk I crystalline form is metastable, i.e. it can easily be converted into the more stable Silk II form by mechanical and thermal treatments. The assignment of a structural model to the Silk I form has been a controversial subject, which has involved a great deal of study (Asakura et al., 2001, and references cited herein) until Asakura, on the basis of NMR spectroscopy data, proposed a repeated b-turn type II-like structure, which was then confirmed by Raman spectroscopy (Monti et al., 2003).

MECHANICAL PROPERTIES

Primary and higher order structures of silk fibroin result in a fiber that exhibits outstanding mechanical properties. The mechanical properties of silk are a direct outcome of the chemical structure, the size and orientation of the crystalline domains, and the connectivity of these domains to the less crystalline and amorphous regions. Silk is unique in terms of strength and toughness among all the natural and synthetic fibers. Typical values of mechanical parameters are as follows: stress 710±130 MPa, strain 26±5 %, modulus 9.5±1.6 GPa (determined on single degummed silk fibroin filaments obtained from cross-breed cocoons; filament size: 12.9±1.4 ßm). Interestingly, an increase in the rate of loading causes increased elongation and thus greater resistance to rupturing. This is a typical feature of all natural silks, including silkworm silk, which represent an exception to most fibrous materials. In general, silk has an excellent ability to absorb energy at high rates of loading.

THERMAL PROPERTIES

Silk is virtually unaffected by temperature up to 140° C (284° F). Based on differential scanning calorimetry, thermomechanical, and thermogravimetric analyses, with increasing temperature up to about 200° C (392° F) silk displays an exceptional thermal stability (Tsukada et al, 1992). At higher temperatures, small molecular weight gas molecules, i.e.

CO, CO_2, NH_3, etc., start evolving due to thermal degradation of side chain groups of amino acid residues. If the temperature is increased further, degradation proceeds faster, leading to main chain fission and, at above 300° C (572° F), to complete burning. The glass transition temperature (Tg) is located at c. 175°C (347° F) (Magoshi and Magoshi, 1977). Along with other protein fibers, such as wool, silk is considered to have low flammability.

CHEMICAL PROPERTIES

Silk is hygroscopic in nature. Under standard environmental conditions (20° C [68° F], 65% R.H.) silk absorbs about 10 w% of water. Water absorption causes fiber swelling, which has been reported to be about 1.6% in the longitudinal direction and 18.7% crosswise. In the isoionic range (pH 4-5), swelling and reactivity are at their lowest.

As a protein fiber, silk is amphoteric because it possesses cationic and anionic groups on the side chain of various amino acid residues whose dissociation state depends on the surrounding pH conditions. This characteristic makes silk able to absorb and bind strong alkalis and mineral acids with the formation of salts. Moderately strong and weak acids undergo binding to silk via hydrogen bonds. Compared to wool, silk is more sensitive to acid and more resistant to alkali, due to the absence of acid-stable and alkali-unstable cystine bridges. This allows processing of silk under alkaline conditions (degumming) while dyeing should be better carried out at a weakly acidic or neutral pH.

Silk is able to absorb considerable amounts of salts. This property has been exploited in the traditional mineral weighting process with tin-phosphate-silicate, a method used for decades to increase silk weight in order to compensate for the loss resulting from degumming.

Silk is also characterized by a good chemical reactivity. Side chain groups of various amino acid residues (carboxyl, amine, aliphatic, and aromatic hydroxyl) can be exploited as reactive sites to bind selected chemical agents in order to obtain an effective and specific modification of the fibrous substrate (Tsukada and Freddi, 1996). As an example of a chemical process exploited at the industrial level, grafting with vinyl monomers, i.e. methacrylamide, has been regarded as an effective treatment to increase

silk weight as a substitute for the traditional mineral weighting, and also as a powerful method to improve the textile performances of silk, such as crease recovery, dimensional stability, rub resistance, photoyellowing, oil and water repellency, color fastness, etc. (Freddi and Tsukada, 1996).

Silk fibers are soluble in a limited number of solvents. Since fibers consist of highly ordered arrangements of fibroin chains linked together by intermolecular hydrogen bonds, in order for a dissolution process to be effective, swelling of the compact fibrous structure and breaking of the hydrogen bond network, leading to complete dispersion of the individual fibroin molecules, are required. An ideal solvent should be capable of penetrating into the fiber and dissolving it without inducing adverse reactions, such as depolymerization, derivatization, etc. The most common solvents used for silk are concentrated aqueous solutions of lithium salts (LiBr, LiSCN). LiBr is used as a solvent for the determination of the degree of polymerization of silk by intrinsic viscosity measurements (SNV 195595 standard method). As a solvent, LiSCN is usually preferred, because its solution is neutral, it is active at room temperature, and it is unlikely to cause peptide bond hydrolysis. Other concentrated salt solutions, such as NaSCN and $ZnCl_2$, can be used as solvents for silk. $CaCl_2/H_2O/EtOH$, $Ca(NO_3)_2/MeOH$, the Cuoxam metal complex system ($[Cu(NH_3)_4(OH)_2]$), LiCl/N,N-DMAc, hexafluoroisopropanol (DuPont patent), and N-methyl morpholine N-oxide (MMNO; Marsano et al., 2005), have also proved to be effective in dissolving silk and preparing spinnable silk fibroin solutions for the production of regenerated silk fibers.

Finally, silk fibers display outstanding physiological properties. In fact, silk by itself is thermo-insulating, well tolerated by the skin, and capable of maintaining an optimally moisturized environment. Biological properties are attractive as well. Biocompatibility of silk fibroin fibers, from which sericin has been removed, has been proved both *in vitro* and *in vivo* by a wide range of experimental results, which strongly recommend its use as a means to develop innovative biomaterials intended for clinical applications, with a focus on tissue engineering devices (Dal Pra et al., 2005). In terms of matrices for tissue engineering, silk

provides an important clinical repair option for many applications, thanks to its mechanical properties and to its ability to effectively support cell adhesion, growth, and differentiation and to undergo slow degradation rate *in vivo*.
Giuliano Freddi

The production cycle of drawn silk

The production of drawn silk consists of a cycle including three main operations:
1 operations before the thread is formed (drying, sorting, and peeling the cocoons)
2 operations forming the thread (cooking and brushing, reeling and re-reeling, folding and packaging)
3 operations following the formation of the thread that will make it usable for subsequent textile transformations (throwing, and steaming and drying)

DRYING AND SORTING
These form part of sericulture, described on pages 60–65.

PEELING
This operation can be done by hand or by machine and consists of removing the hard outer layer of the cocoon's cortex.

COOKING AND BRUSHING
There are various types of machine cooking processes. The most commonly used consists of an integrated system, subdivided into various compartments, in which the cocoons are treated in succession, so that when they emerge they have absorbed nearly 97 percent of their weight in water.

Roughly speaking, the process follows the scheme shown below.
• 1st chamber: soaking for 30–50 seconds in water at about 40° C (104° F).
• 2nd chamber: vaporization with saturated steam at 90–95° C (194–203° F).
• 3rd chamber: impregnation. The chamber contains water at 40–60° C (104–140° F), and because of the relatively low temperature of the water and partial condensation of the steam, the cocoons fill up with water. The water absorbed moistens the internal layers uniformly. Treatment time: 30 seconds.
• 4th chamber: the cocoons exiting from the third chamber are treated for about 120 seconds

with pressurized steam and brought to a temperature of 95–98° C (203–208° F). The sericin in the various layers is softened by this treatment, and the cocoon is filled with steam once again.
• 5th chamber: cooling of the water from 98° C (208° F) to 60° C (140° F). This must be done gradually, as excessively rapid cooling tends to make the cocoons collapse and become deformed. The cooling gradient should be established according to how compact the cocoon's skin is: the less compact it is, the slower cooling should be, and vice versa.
• 6th chamber: contains water at 50–60° C (122–140° F). This helps to fill the cocoon with water to 97 percent: the operation takes 10 to 11 minutes.

From the last chamber, the cocoons move automatically into vats containing water at 40–50° C (104–122° F), to be transferred to brushing.

Brushing is performed mechanically in hot water. The mechanical brusher consists of a shallow vat of water at about 65° C (149° F), to which five or more rice straw brushes are affixed. The brushes turn in the water with an alternating rotational movement, three-quarters of a turn forward and back, rubbing the sides of the macerated cocoons; the pressure is gentle, but sufficient to cause the end of the silk filament to emerge. After a pre-set number of turns, the brushes are lifted and the cocoons that remain attached are drawn toward a filament collector.

REELING AND RE-REELING
Basically, the reeling process entails placing the cooked cocoons in a basin containing either hot or cold water, depending on whether the system being used involves floating (hot) or submerged (cold) cocoons, in a sufficient number to form silk thread of the desired denier, or thickness. Whatever the system of drawing used to obtain raw silk thread, there are two basic rules that must be followed. First, the raw silk must have a uniform denier and, therefore, has to be composed of a number of filaments, since it is known that the diameter of the filament drawn from a cocoon varies, diminishing from the outer to the inner layers. It is evident, therefore that to produce a raw silk thread of 15 dtex (or 15 g per 1,000 m),

one can use four, five, or even six cocoons. The composition and number of cocoons with which a raw silk thread is made is known as the drawing "rose." Therefore the second, critical, rule is that for a batch of raw silk, the same rose must always be used, or defects will appear after dyeing.

Raw silk must also have good cohesion—meaning that its strands must hold together—in order to weave well. The cohesion and attachment of the strands depend partly on the breed of silkworm used, and partly on the breeding and maceration conditions, but they are most strongly influenced by the reeling conditions, particularly by the *croisure*, a process of twining and untwining the thread, effected in its passage from the threader to the reeler. It has various purposes, but it serves mainly to eliminate water from the thread, to increase cohesion, and to clean the thread. There are two kinds of croisure:
• Chambon, or French, method—today used only in the drawing of double cocoons;
• Tavella, or Italian, method—which is now generally used.

It should be emphasized that the croisure does not actually twist the thread, but only makes the filaments bind together better. Even after croisure, the raw thread still contains a considerable quantity of water; under these conditions, the thread may not flow smoothly.

An automatic denier regulator is usually located between the croisure and the reeler; there are several mechanical and electronic types, and if need be, they effect the arrival of a new cocoon and the inclusion of a new filament in the thread. A fixed denier by itself is not enough, however; as underscored previously, the filament's diameter changes from the outside to the inner layers of the cocoon; so it is also indispensable to maintain the same drawing rose. Automatic feeding facilitates this task for the workers, who must nevertheless always be ready to intervene if necessary. The automatic recall of the cocoon when the silk filament becomes too fine is controlled by a magnetic device.

Re-reeling is indispensable for making standard-size hanks, for commercial purposes. Skeins, to be sold easily, should have a perimeter of 150 centimeters (59 inches) and weigh about 200 grams (7 ounces) each. Re-reeling also serves to eliminate impurities and thinner areas, to retie broken threads, and to remove other defects. Before re-reeling, the skeins are moistened with softening solutions. In the trade there are two kinds of machines used to unwind skeins: *défilé* and *déroulé*. In agreement with international standards, to prevent tangling of the skeins, usually four strings (generally of cotton) are passed across the skein at predetermined distances in such a way as to divide it into five (usually equal) bunches tied together. This operation is known as lacing.

FOLDING AND PACKAGING

The laced skeins are then folded in a standard way. The folded skeins, about 25 in number, are collected in bunches, which are then packaged in paper sheets. Twelve packages, generally weighing 5 kilograms (11 pounds) each, are packed together in bales of 60 kilograms (132 pounds) each, covered with waterproof paper, and enclosed in an outer covering of raffia fiber. A batch is generally composed of five bales, making a total of about 300 kilograms (660 pounds) of silk.

Today the trend is to import raw silk on cones. Producing the cones requires skilled workers; it is crucial to achieve and maintain the right tension as the thread is wound around the cone. The finished cones, which weigh about 500 grams (a little over 17 ounces), are packed in cardboard boxes with separators.

THROWING

The process of silk throwing can be divided into three main stages:
1 *preparation*
2 *the throwing itself (twisting)*
3 *finishing (steaming and drying)*

1 *Preparation for throwing* Raw silk usually arrives at the throwing plants in bales and wound in skeins, although nowadays more and more raw silk is sold already wound on cones. The silk skeins must be properly prepared for throwing; they must be moistened, because they are usually too dry to withstand the mechanical wear and tear of throwing, and then wound on cones. The moistening operation usually includes dyeing with a fugitive dye and sizing. Different colors, established by international standards, are used to distinguish threads that have undergone different methods of twisting; this color is eliminated during the subsequent degumming process. Sizing solutions are mixtures of soaps, hydrocarbons, fats, and/or vegetable oils and their amidized or ethoxilated derivatives. All these substances must be easily removed during degumming. Recently, a machine has become available that can size silk in a vacuum. This reduces moistening time dramatically: in only three minutes, it uniformly moistens 20 kilograms (44 pounds) of silk. It also produces savings on materials, because the machine can choose and control the temperature of the bath and use preset amounts of solution and size. The vacuum, created by suction around the skeins before the liquid is added, facilitates uniform distribution.

The next procedure is winding. This consists of transferring the raw silk from skeins to bobbins, adapted to the various processes of throwing. Winding should be done in a fairly humid environment (80–85 percent relative humidity), with a certain tension and at a fairly low speed (about 250 meters [273 yards] per minute). When necessary, a rewinding process is carried out for the complete elimination of anything that could affect the cleanness of the thread.

Doubling consists of coupling two or more threads from as many bobbins and winding them together in a single thread on another bobbin. In the case of weft, crepe, and other yarns, it is done after the threads are rewound, while for organzine (used for fine warp threads) it is done after a first twisting. Like rewinding, doubling is done in a dry environment, to prevent parallel threads from having different tensions. It is important that the threads be maintained perfectly parallel during doubling, in order to obtain a thread that is free of defects.

2 *Throwing* The throwing, or twisting, process consists of winding the thread around itself. In the most common method, the rotation is impressed to the spindles for the bobbins from which the twisting threads are drawn, on a vertical axis, and the take-up bobbin rotates on the horizontal axis. In the ring system, which is used for some embroidery threads, the unwinding bobbin is on the horizontal axis and the uptake bobbin on the vertical; a ring guides the twisted thread around the winding bobbin.

The number of twists can be calculated as the ratio between the rotation speed of the take-up bobbins and the speed of rotation of the spindle and can be varied by modifying the speed of either.

Obviously, there is a limit to how many times the thread can be twisted around itself, based on the limitations of the machines, so when a yarn, such as crepe, requires strong torsion—or degree of twisting—it is thrown in two stages: the first passage at about 600 rpm, and the second at about 3,000 rpm, to bring it up to the desired torsion.

In the past few decades, double torsion throwing machines have been introduced for yarns requiring extra twisting. Before being wound onto a bobbin, the thread passes through the inside of the spindle, and two twistings are applied to it for each turn of the spindle, instead of one, as in normal throwing machines. Double torsion throwing machines save a good deal of production time, but they produce silk of somewhat inferior quality.

3 *Steaming and drying* The twisted thread tends to unwind itself and return to its original state, forming eyelets. To prevent this from happening, the torsion is fixed with steam. This steaming operation consists of exposing the twisted thread to the action of damp heat, which reduces the elastic forces present in the thread after throwing and also causes partial softening of the sericin, so that after drying, the twisted filaments stick together. The steaming chambers may be brick or stone rooms, which have holes in their walls to allow the steam to escape, or real autoclaves. The carts holding the bobbins from throwing are placed inside these rooms, and steam is added at about 70° C (158° F). This temperature is maintained from 20 minutes or so to several hours, depending on the denier of the thread, the number of torsions, and the thickness of the skeins. In order to distribute the moisture more evenly throughout the skeins, vacuum is applied. Subsequently, the carts holding the skeins are brought to the drying rooms, generally heated to 60° C (140° F).

After steaming, thrown silk bobbins must be carefully dried. For each type of yarn, conditions such as the tension of the thread and the duration and temperature of steaming and drying are carefully studied. Many weaving

defects are due to improperly made steaming or drying processes. The twisted thread is used directly for weaving or is sent for dyeing.

TYPES OF THROWN THREAD
The variety of thrown silk threads is very large. They are divided into five general categories, being threads for embroidery, knitting, sewing, wefts, and warps, and, in that order, require increasing strength to withstand the tension placed on the silk as it performs its task. Aside from floss (untwisted strands used primarily for embroidery and electrical insulation, and sometimes for wefts), within these large groupings, threads can be classified according to the twisting procedure to which they have been subjected.

Thrown singles are individual raw silk threads twisted in one direction.

Tram is made by twisting two or more raw silk threads together in only one direction; often these are only lightly twisted, merely to hold them together. Two-strand silk threads are suitable for embroidery and knitting; when tightly twisted for sewing, are referred to as "twist." Three-stranded threads are often distinguished as "machine twist," having been first made shortly after 1850 for use in sewing machines; to guarantee a smooth, even thread, these are stretched before finishing. The strong sewing silk used by tailors, saddlers, bookbinders, and the like is often referred to as "buttonhole twist," which is about three times the diameter of ordinary sewing silk. Often, weft threads are trams.

Organzine is made by giving the raw silk a preliminary twist in one direction and then twisting two or more of these threads together in the opposite direction. In general, organzine requires the best quality of raw silk and is used for warps, which bear the tension of the loom.

Crêpe is thrown in a way similar to organzine, but is twisted to a much greater extent, resulting in a "crinkle" effect.

In each class a very high number of different yarns can be obtained by changing the number of turns, the number of threads, and the direction of twisting. The combination of

different types of silk yarns of different denier and torsion can give rise to an extraordinarily large number of types of special yarns.
Bruno Marcandalli

The production cycle of spun silk

Thrown silk is certainly the most valuable silk product, but it represents no more than 30 percent of the total weight of the dry cocoons used for its production. The remaining part, which cannot be used for the production of continuous silk thread, constitutes the raw material of the spun silk industry. The process consists of collecting short filaments taken from waste silk, combing it, and spinning it together as silk thread in a manner similar to that used for cotton or linen. The yield of this process is low, and, on average, spun silk thread represents 20–25 percent of the weight of the corresponding thrown silk produced. The first known industrial plant for the production of spun silk was the Golgate Mill at Lancaster, England, in 1792. In 1824 a plant was established in France and another in Switzerland; in 1854 one was established in Italy. Later, the spun silk industry spread to all the nations where a silk industry was already present; today, however, it is restricted almost exclusively to China and India.

The various kinds of threads spun from waste silk are generically known as *schappe*, and they find wide application in pile fabrics, dress trimmings and linings, shantung, knitwear, silk garments, shirts, and sewing thread; they are also sometimes blended with other fibers. The waste derived from the processing of spun silk is also used, and this "second phase" waste is known as *bourrette*, *noil* silk, or silk *noil*. Silk noil may be reprocessed into spun yarn and woven into fabrics for draperies, upholstery, or sportswear. Spun silk is less expensive than reeled silk. It has lower strength and elasticity, as a consequence of the shorter staple used, but it possesses all the general characteristics of reeled silk.

TYPES OF WASTE SILK
Waste from cocoons This includes three types. It may come from pierced cocoons, from which the moth has emerged; from defective cocoons (black or stained, malformed, double [or dupion], undersized, and fragile cocoons, etc.); or from reeling waste, which can be

either the first part of the *bave* (French for "spittle") emitted by the worm for the framework of the cocoon or fibers produced by the brushing of the reeling machine (floss silk, or knubs).

Waste from unreelable cocoons and the remains of cocoons after reeling (basin waste).

Waste from subsequent processes, such as winding, rewinding, throwing, spinning, etc.

THE PRODUCTION OF SPUN SILK

The process used for the production of spun silk varies considerably from country to country and from mill to mill; however, a general scheme includes the following stages:

Maceration or *degumming* This operation has the purpose of eliminating sericin. In the traditional method, still in use especially in China, waste silk is put in large underground tanks filled with warm water, to which some soap and sodium carbonate have been added, and left there for 24–36 hours at a temperature of 30–40° C (86–104° F). Sericin begins to ferment and loosen. Successively, the material is transferred to smaller containers, boiled in a soap solution for 20–30 minutes, and washed. Usually about 2–3 percent of sericin, which is actually beneficial for subsequent mechanical handling, is left on the silk. The method is gentle and leaves the silk fine and lustrous, but the smell caused by fermentation is so offensive that it raises serious concern among workers and authorities. Moreover, the choice of the right moment for arresting fermentation requires great attention and experience.

Today the most-used method is similar to that for the degumming of thrown silk. The starting material is introduced into large steel tubular rotating containers, which maintain silk half submerged in the degumming solution all the time. Soap and sodium carbonate are normally used as degumming agents, and the temperature is raised and kept at the boiling point for 1–3 hours, as required. In many cases a bleaching process is carried out before maceration. This is particularly necessary when silk waste is strongly polluted by hairs or other fibrous contaminants, which could cause serious problems in dyeing operations. When the waste contains a large percentage of chrysalides, a preliminary operation, known

as beating, is performed. There are several means of doing this. The traditional beater has a large revolving disk on which the material is held by metal arms; as the disk slowly revolves, the silk waste is beaten by leather whips. Chrysalides are separated and removed.

Washing, dehydration, carbonization, neutralization, and drying After maceration, the material must be washed very carefully in order to remove all the residues of soap and chemicals. This is a very important step for obtaining a final product of good quality and requires large amounts of water. After washing, most of the water is eliminated by centrifugation. A carbonization step is often performed in order to eliminate all cellulosic residues that could be present in the macerated material. In fact, straw, twigs, leaves, and/or cotton or jute thread, used to bind the waste silk bales, may be present in remarkable quantities and have to be taken out. This operation is performed by immersing the material in a diluted sulfuric acid solution for 1–2 hours. By this treatment cellulosic materials are strongly degraded and will easily be removed in the subsequent combing processes. The next step is neutralization, usually carried out by means of gaseous ammonia, in which the tendency of silk to acquire electro-static charges is markedly reduced, thanks to small amounts of hygroscopic salts deposited on the fibers as a result of the treatment. The material is then thoroughly dried.

Opening, filling, and dressing Before combing, traditionally a process called opening is carried out in order to transform the macerated material from a tangled mass into a ribbon in which the single fibers begin to be aligned. The opener has a series of rollers of small diameter with rows of projecting steel pins and a large receiving drum similarly armed with fine steel teeth. The material is fed to the rollers on a belt and passed by them to the teeth of the swiftly rotating drum on which it forms a blanket of more or less straight and parallel fibers. When the blanket reaches a certain weight, the machine is stopped and the silk is removed from the drum, forming a sheet technically known as "lap." The lap is transferred to a second machine, known as a filling machine. This is similar to the opener as

far as the feeding arrangements are concerned, but the drum is covered not with fine steel teeth but with rows of combs, parallel to the axle of the drum and spaced at predetermined intervals. The two operations of opening and filling can be combined. Here again, when a sufficient weight is on the drum, the filling machine is stopped and the tangle of fibers is cut into untwisted strands, called slivers, corresponding to each comb. The slivers are removed, quickly rolled around small pegs, and taken to the subsequent process of combing.

The combing process is carried out by means of a "dressing machine." This machine consists of a large drum made up of separable wooden boards, between which the pegs bearing the slivers obtained from the filling machine can be clamped by a system of levers. The drum revolves slowly and brings the silk material in contact with two smaller rollers, placed one at each side of the lower part of the drum and turning in opposite directions, so that the material is combed first in one direction, then in the other. The pegs are then removed, collected for the following processes, and replaced by other pegs coming from the filling machine. The material collected on the rollers, consisting of shorter fibers, is taken off and sent back to a second filling machine with reduced space between combs in order to obtain a material composed of shorter staple. The same process can be repeated with a third or fourth machine.

The drafts (hanks of combed fiber) from dressing are classified in accordance with the length of the fibers, the longest being known as first draft and then second, third, etc., drafts, or as A, B, C, etc., "shorts." Each draft may be worked separately, thus keeping like with like; but occasionally one or more classes of draft can be mixed together. The noil coming from the last filling machine is added to the material used for making bourrette yarns.

Before combing, separate lots, from the various types of waste used, are usually mixed together in different ratios in order to obtain a more uniform material. This is a very important step if a final product of high quality is desired. In fact, many parameters have to be considered carefully—among them, the length of the fibers, the amount of residual sericin or oil, and the presence and quantity of different kinds of contaminants.

The process described above is essentially the traditional process, still widely used. It is a very labor-intensive procedure, and hence, many variations have been attempted and adopted. The opening and filling steps can be replaced by a carding process, using a machine adapted from that used for wool processing. The material deriving from the carding machine is relatively irregular and has to be fed into machines called drawers, which produce a regular sliver, which can be used for the subsequent combing stage and, if necessary, to a re-breaker, which reduces the length of excessively long fibers. In this procedure, combing is then performed using a machine substantially identical to that used for wool with some minor modifications.

Spinning Before spinning, various operations gradually reduce the slivers into a single ribbon of increasingly parallel fibers and reduce its size to make it ready for the final step of spinning.

First of all, the slivers coming from the dressing machine are carefully inspected on an illuminated glass panel, which puts them into silhouette, and any foreign matter, such as polypropylene or polyethylene thread fragments, metallic pins, etc., is removed by hand. Then the slivers are grouped into little bundles and transferred to a machine called a spreader, consisting of some smaller rollers and a large drum rotating at a faster speed. The spreader joins the slivers in a continuous ribbon, gradually draws out the ribbon until it is of regular size, and makes the fibers increasingly parallel. Drawing is repeated several times. The degree of stretching ranges from 1:6 to 1:12, in increasing degrees of fineness. At the end of this process a ribbon of uniform weight is gathered on the surface of a large wooden drum. From there, the sliver is taken to the roving frame, which is a drawing machine fitted with fallers, through which the sliver is drawn and given a final extension of about 1:8 and a slight twist. The completed yarn, or roving, is wound onto a bobbin and is ready for the spinning frame.

The spinning uses the same methods as for cotton or worsted. It is generally followed by doubling, which is carried out as with thrown silk. Two or three threads are wound together and afterward conveyed to the twisting frame

The final processes in the preparation of schappe thread are gassing and cleaning. The first consists of passing the thread rapidly over a gas flame to burn off the hairy and fibrous matter. Then the singed thread passes between rotating steel rollers, which remove the adherent burnt particles from the thread. The yarn is now finally ready for reeling into skeins.
Bruno Marcandalli

Silk dyeing, printing, and finishing

Before silk can be dyed, printed, or finished, it must undergo various preliminary treatments.

PRETREATMENT
Degumming of silk, usually carried out by the dyer, is the industrial process through which sericin (gum) is removed from fibroin and silk threads are made brighter and softer. In the case of *Bombyx mori* silk the gum content is about 20–30 percent. Generally, the process is performed using Marseilles soap or synthetic detergent solutions at a temperature of 95–98° C (203–210° F). Nowadays, enzymes at 50–60° C (122–140° F) or simply water at about 130° C (266° F) under high pressure are also used.

All degumming methods are based on the slight differences of chemical reactivity and/or solubility between sericin and fibroin. Therefore, great care must be exerted in order to eliminate sericin without damaging fibroin. During the degumming process, fats, oils, and other substances that may be present are also removed.

Degumming has a great influence on the results of dyeing. Several defects that can be found in the final product are due to inadequate degumming. In fact, dyeing defects may be the consequence of the presence of sericin residues or of fiber damage produced by overly harsh degumming conditions.

Boiled-off, or degummed, silk is raw silk from which sericin has been completely removed. In some cases, partial degumming may be desired; souple and crude (ecru) silk are obtained in this way. In the former case the reduction in weight is about 8–12 percent, whereas in the latter the loss is lower than 6 percent. Although degummed silk has a degree of whiteness sufficient for many applications, it may be necessary to bleach, in order to obtain a pure white—for instance, for wedding dresses—or to prevent yellowing caused by exposure to light.

Silk bleaching can be effected by reduction or by oxidation processes. Hydrosulfites are used as reducing agents; and hydrogen peroxide, at 40–60° C (104–140° F) and pH 9 in the presence of stabilizers, as the oxidizing agent. The two methods can also be used in combination for special effects. Fluorescent brighteners are also sometimes employed.

Loading, or weighting, permanently fixes various substances onto the fiber to form a stable union. These substances may be organic or mineral or both, according to the loading required. The weight increase is generally high. If the loading precisely compensates for the weight lost in degumming, it is said to be "at par," whereas if it does not compensate for this, it is said to be "below par." In special cases, "above par" weighting, up to 300 percent of the original weight, may be desired. The loading process increases the volume of the thread and gives the silk a characteristic heavy, supple handle, very suitable for certain fabrics (necktie silk, for instance). It may also give the cloth better flame retardant properties or better wash-and-wear behavior (crease resistance, for example). Originally, loading was devised with the idea of compensating for the economic loss due to the decrease of weight brought about by degumming; later the positive effects described here became the major reason to perform the process.

Traditional mineral loading originally used substances such as lead and bismuth salts. Later, tin salts began to be used. The process entails several stages, which can be repeated several times, with stannic chloride (pink salt), sodium phosphate, and silicate. Although tin loading became the most commonly used treatment, the complexity of mineral loading and the high degree of experience required, as well as problems related to chemical pollution, have recently rendered mineral loading almost obsolete. Today weighting is performed almost exclusively by grafting acrylic monomers (usually methacrylic amide) using ammonium persulfate as initiator.

When weighting is performed before dyeing, it can have a remarkable effect on the dye affinity of the fiber. For example, salts have traditionally been used as a mordant, so one effect is to increase the fibers' affinity for the dye. Organic or polymer weighting (see Finishing, below) can be performed either before or after dyeing.

DYEING

The capacity of silk to be dyed in a very wide range of intense colors has always been a major reason for the special position that this fiber occupies in fashion.

Being a protein fiber, silk possesses dyeing properties similar to those of wool or synthetic polyamide fibers. Due to the presence on the fibroin molecular chain of both acid and basic groups, as well as accessible hydroxyl groups, and to its supermolecular structure, silk can be successfully dyed with a large variety of dyes belonging to several tinctorial classes, such as acid, basic, direct, metal complex, vat, and reactive dyes. In comparison with wool, silk requires about twice as much dye in order to obtain the same color depth, as a consequence of its different fibrillar structure. Wild silks require even more. As a natural product, silk may show great variability in its molecular, supermolecular, and crystalline structure, resulting in marked differences in dyeing affinity. Therefore, it is important to avoid mixing batches of fibers of different origin in the same dye.

Basic dyes These natural substances are used at neutral pH. Thanks to their positive electrostatic charge, they interact with the acid groups of fibroin and provide bright colors, but their lightfastness is low. Today they are rarely used—mainly for very brilliant shades of green and turquoise.

Acid dyes, by contrast, are anionic substances and bind to acid functional groups of fibroin. Hydrogen bonding and van der Waals forces also contribute to the binding of the dye. Acid dyes are used in acid or neutral baths.

Direct dyes are used primarily for discharge grounds and are applied, in dyeing, under the same conditions as those usual for acid dyes.

Reactive dyes, which were perfected during the twentieth century, form covalent bonds with silk macromolecules, giving very good washing fastness. Dyeing is carried out in a slightly alkaline bath and a temperature no higher than 60° C (140° F), adding sodium sulfate in various amounts, up to 80 grams per liter (approximately 2¾ ounces per U.S. quart) for dark shades. At the end, soaping at 80-90° C

(176–194° F) is necessary in order to remove the unfixed dye molecules.

Silk can be dyed in the form of yarn, woven goods, or knitted goods. Traditionally yarn dyeing has been carried out on hanks, but today circulating dyeing machines, working on cones, or "cheeses," are more common. Piece dyeing is performed with a great variety of machines. Depending on the type of woven or knitted goods being dyed, winch becks, stars, jiggers, beam, jet, and overflow circulation machines are used. Star machines are particularly suitable for delicate, high-quality fabrics, but costs are higher due to the high liquid ratios that must be used and the lower productivity. Winch becks are employed especially for silk crêpe and heavy fabrics. Jiggers are preferred for smooth fabrics such as silk twill and satin. The use of jet and over-flow machines is steadily increasing, thanks to technical advances that have greatly improved their capacity of dealing with delicate fibers.

PRINTING

Printing is a form of localized dyeing and is the most versatile and important method used for introducing design to textiles. Printed fabrics constitute a greater proportion of silk than they do of any other textile fiber. The printing of textiles is carried out by the deposition, in pre-fixed positions on the fabrics, of pastes containing all the substances necessary to produce color, followed by one or more steps aimed at fixing the coloration and eliminating all the other auxiliaries used in the process.

Textile printing can be classified either according to the method used to develop color on the fabrics or according to the processing technologies:

Direct printing consists of depositing and fixing color directly on the fabric.

Discharge printing involves removing color from a previously dyed fabric by means of a discharge paste containing a substance able to destroy the dyes used and cause the white ground to reappear. If discharge-resistant dyes are added to the discharge paste, effects of different colors can be achieved.

Resist printing is effected by depositing on the

undyed fabrics a printing paste containing substances that prevent dye from fixing in a subsequent dyeing process. Resisting agents function either mechanically or chemically or, sometimes, in both ways. Batik is a form of resist printing that uses wax applied in the molten state as resisting agent.

As far as printing technology is concerned, at the end of the nineteenth century hand printing was still being performed, using wooden blocks or hand-etched copper rollers. Today, flat screens and rotary screens are the most commonly used techniques, although ink jet printing is also rapidly gaining favor.

Modern flat screens are metal frames, of various sizes, on which a fine mesh net is fixed. Polyester is normally used for the screen fabric. Rotary screens are nickel cylinders, which have uniformly spaced holes arranged in lines parallel to the axis of rotation. The design is created by coating the screens with a photosensitive resin so that the printing paste cannot get through the mesh in some places. For multi-colored design, one screen for each color is required. Today, fully automatic, high-speed printing is generally used. However, flat screen printing, which is not suited to truly continuous processes, is still employed, in a semi-automatic form, primarily for high-quality fabrics where more screens are required than would be possible with rotary printing.

FINISHING

Because of its natural beauty, silk requires minimal finishing treatments, generally limited to enhancing the soft hand, lustre, and draping quality of the fabric, essential and inherent characteristics to which silk owes its renown as the most precious fabric in the world. Although the finishing operations vary considerably, depending on the qualities desired in the final silk article, they must all take into account the chemical/physical properties of silk fiber, so as to eliminate eventual alterations produced by the previous processing (bleaching, dyeing, printing, drying) and recover the specified qualities.

To this end we distinguish between three types of finishing that can be applied to silk fabrics:

1. TRADITIONAL FINISHING
The fundamental purpose of these processes

is to restore natural brilliance, softness, and handle, eliminating the "papery" effect of previous treatments. In this context, the most important operations are the following:

Calendering, which may be performed on plain fabric or on fabric that has been sized. The rotary presses, or calenders, are made of a steel cylinder and two rollers sheathed in more elastic material, which press the fabric as it passes between them. By varying the speed of rotation, the heat, or the pressure, or by changing the traction, various degrees of glossiness and softness can be attained; in most cases silk is calendered in the cold state, which produces a soft handle. Higher lustre is obtained with hot calenders, but such a process requires great care to avoid negative effects.

Chemical finishing The thermal and mechanical treatments we have briefly mentioned above are often preceded by the application of specific substances that give silk cloth a fuller, or lighter, or softer handle—whatever properties one desires the cloth to have. In the past, these substances were typically animal or vegetable oils or gums, but today these have been almost completely replaced by various chemical products, including fat acids, amides or alcohols, oxyethylated alcohols, and polyvinyl acetate. The choice, method of application, and dosage depend on the specific handle desired.

Breaking The breaking machine, or breaker, is used to confer a particularly soft handle and a brilliant surface. Two types of machines are used: button and knife. On the first type, the piece is passed several times rapidly back and forth over small rollers with brass buttons, whereas with the second the fabric is drawn over the edges of slanted knives.

Tamponing Silk is very sensitive to mechanical friction. Despite the greatest precautions, in many cases, pieces may have been chafed in earlier processing operations. In former days, faulty portions of fabric were treated by hand with a tamponing cushion carrying a very small quantity of vegetable oil. Today this is done by tamponing machines, which apply a very fine, even film of oil to the fabric, smoothing out irregularities and improving its general appearance.

2. MODERN CHEMICAL FINISHING

Although traditional finishing improves the look and feel of silk fabric, today's market needs require it to be given additional properties, such as easy care and use, while not compromising its intrinsic qualities. As with synthetic fibers and cotton, the following are also important for silk: crease resistance, antistatic properties, and oil/grease resistance. In achieving these aims, it is vital to keep in mind the chemical-physical properties and the sensitivity and reactivity of the silk fibroin, in order to avoid possibly damaging the fiber molecules and/or altering the surface lustre and softness.

Crease resistance The aim is to provide better washing, drying, and ironing characteristics, making the fabric more convenient to care for. By using the appropriate aminoplastic or polyurethane resins, for example, we can obtain crease-resistant cloth; however, the handle is not acceptable. If a methylolueric resin is used in the presence of an acrylate-based emulsion and a silicon-based emulsion, this unfortunate effect is reduced. Nevertheless, the silk fiber still appears slightly altered, since these resins bond stably with the amino and hydroxyl groups found in the lateral chains of the silk protein, changing its basic fibrous structure and therefore also its properties.

Antistatic properties There are no substances designed especially to reduce static in silk. Products developed for water-repellent and insulating synthetic fibers (where the problem is greater) are normally used on natural fibers as well. Unfortunately, these finishes (polyethylenenglycols, sorbitol esters, amides, and oxyethylene derivatives) do not give satisfactory results on silk, in part because they are not efficient—above all, not long lasting—or because they alter the fabric's handle.

Stainproofing For this effect, used mostly for scarves, some fluorocarbons and fluoro-alcohol esters are especially effective, lowering the surface tension to the point that it is impossible to form physical or chemical bonds with any type of molecule.

3. SPECIAL FINISHES

These are treatments used solely for finishing silk fabric.

Scroopy handle A scroopy, or crisply rustling, handle characteristic of many silks (also called *craquant*) is highly prized. For this purpose, after bleaching and dyeing, the silk is treated with an acid solution, composed of either 10–20 percent of 85-percent formic acid or 40 percent of 30-percent acetic acid or 30–40 percent of 50-percent lactic acid, after which it is allowed to dry without rinsing.

Polymer loading processes The weighting process, already introduced above, has long been the object of research and experimentation, previously aimed at perfecting the technology used for traditional mineral weighting. Recently this research has been focused on the development of new polymer-loading processes. Organic weighting, by grafting vinyl monomers on silk fibroin, has become the general rule. The most commonly used industrial application is a reaction with methacrylamide, which results in a weight increase of about 20 percent, used especially in the production of silk yarns for ties.

Research in this field is very active. It has been shown that mono- and bi-functional reagents can react and form stable covalent bonds with the reactive hydroxyl, amine, and carboxyl groups present in the fibroin's polypeptide chains. This results in an increase in the weight of the fiber and in the modification of many properties.

Peach-skin or sandwashed finish In the last few years, the market and the fashion industry have made much use of special silk fabrics with a dense and velvety texture and a very soft handle. This effect, known as a "peach-skin" or "sandwashed" finish, is obtained either by dyeing on overflow machines under higher temperature or higher than usual fabric speed conditions or by using the right combination of chemicals, which cause the formation of fibrils, along with softeners and the opportune mechanical action, or by treatment in a wash tumbler to which pumice stones have been added. The process in any case involves a controlled degradation of silk.
Gian Maria Colonna and Maria Rosaria Massafra

The Science of Silk bibliography

Properties of *Bombyx mori* silk

ASAKURA, T., ASHIDA, J., YAMANE, T., KAMEDA, T., NAKAZAWA, Y., OHGO, K., KOMATSU, K., 2001.
A repeated beta-turn structure in poly (Ala-Gly) as a model for Silk I of *Bombyx mori* silk fibroin studied with two-dimensional spin-diffusion NMR under off magic angle spinning and rotational echo double resonance.
Journal of Molecular Biology, 306, 291–305

ASAKURA, T., YAO, J., YAMANE, T., UMEMURA, K., ULRICH, A. S., 2002.
Heterogeneous structure of silk fibers from *Bombyx mori* resolved by 13C solid-state NMR spectroscopy.
Journal of the American Chemical Society 124, 8794–8795

ASAKURA, T., YAO, J., 2002.
13C CP/MAS NMR study on structural heterogeneity in *Bombyx mori* silk fiber and their generation by stretching.
Protein Science, 11, 2706–2713

DAL PRA, I., FREDDI, G., MINIC, J., CHIARINI, A., ARMATO, U., 2005.
De novo engineering of reticular connective tissue *in vivo* by silk fibroin nonwoven materials.
Biomaterials 26, 1987–1999

FREDDI, G., TSUKADA, M., 1996.
Silk Fibers—Grafting.
Polymeric Materials Encyclopedia, J. C. Salamone Ed. CRC Press. Boca Raton, Vol. 10, 7734–7744

MAGOSHI, J., MAGOSHI, Y., NAKAMURA, S., KASAI, N., KAKUDO, M., 1977.
Physical properties and structure of silk. V. Thermal behaviour of silk fibroin in the random coil conformation.
Journal of Polymer Science: Polymer Physics Edition, 15, 1675–1683

MARSANO, E., CORSINI, P., AROSIO, C., BOSCHI, A., MORMINO, M., FREDDI, G., 2005.
Wet spinning of *Bombyx mori* silk fibroin dissolved in N-methyl morpholine N-oxide and properties of regenerated fibres.
International Journal of Biological Macromolecules, 37, 179–188

MARSH, R. E., COREY, R. B., PAULING, L., 1955.
An investigation of the structure of silk fibroin.
Biochimica et Biophysica Acta, 16, 1–34

MONTI, P., TADDEI, P., FREDDI, G., OHGO, K., ASAKURA, T., 2003.
Vibrational 13C-Cross-Polarization/Magic Angle Spinning NMR spectroscopic and thermal characterization of poly(alanine-glycine) as model for Silk I *Bombyx mori* fibroin.
Biopolymers (Biospectroscopy), 72, 329–338

NADIGER, G. S., HALLIYAL, V. G., 1984.
Relation between structure and properties of natural silk.
Colourage, 31, 23–32

TAKAHASHI, Y., GEHOH, M., YUZURIHA, K., 1999.
Structure refinement and diffuse streak scattering of silk (*Bombyx mori*).
International Journal of Biological Macromolecules, 24, 127–138

TSUKADA, M., FREDDI, G., NAGURA, M., ISHIKAWA, H., KASAI, N., 1992.
Structural changes of silk fibers induced by heat treatment.
Journal of Applied Polymer Science, 46, 1945–1953

TSUKADA, M., FREDDI, G., 1996.
Silk Fibers—Chemical Modification.
Polymeric Materials Encyclopedia, J. C. Salamone Ed. CRC Press, Boca Raton, Vol. 10, 7728–7734

WARWICKER, JO., 1960.
Comparative studies of fibroins. II. The crystal structures of various fibroins.
Journal of Molecular Biology, 2, 350–2,362

ZHOU, C. Z., CONFALONIERI, F., JACQUET, M., PERASSO, R., LI, A. G., JANIN, J., 2001.
Silk fibroin: structural implications of a remarkable amino acid sequence.
Proteins: Structure, Function, and Genetics, 448, 119–122

Bombyx mori proteins

CHEVILLARD, M., COUBLE, P., PRUDHOMME, J. C., 1986.
Complete nucleotide sequence of the gene encoding the *Bombyx mori* silk protein P25 and predicted amino acid sequence of the protein.
Nucleic Acids Research, 14, 6341–6342

CHEVILLARD, M., DELEAGE, G., COUBLE, P., 1986.
Amino acid sequence and putative conformational characteristics of the 25 kD silk protein of *Bombyx mori*.
Sericologia, 26, 435–449

COUBLE, P., MOINE, A., GAREL, A., PRUDHOMME, J. C., 1983.
Developmental variations of a non-fibroin mRNA of *Bombyx mori* silk gland encoding for a low molecular weight silk protein.
Developmental Biology, 97, 398–407

COUBLE, P., CHEVILLARD, M., MOINE, A., RAVEL-CHAPUIS, P., PRUDHOMME, J. C., 1985.
Structural organization of the P25 gene of *Bombyx mori* and comparative analysis of 'uits 5' flanking DNA with that of the fibroin gene.
Nucleic Acids Research, 13, 1801–1814

COUBLE, P., MICHAILLE, J. J., GAREL, A., COUBLE, M. L., PRUDHOMME, J. C., 1987.
Developmental switches of sericin mRNA splicing in individual cells of *Bombyx mori* silk gland.
Developmental Biology 124, 431–440

FREDDI, G., MOSSOTTI, R., INNOCENTI, R., 2003.
Degumming of silk fabric with several proteases.
Journal of Biotechnology, 106, 101–112

GAMO, T., INOKUCHI, T., LAUFER, H., 1977.
Polypeptides of fibroin and sericin secreted
from the different sections of the silk gland
in *Bombyx mori*.
Insect Biochemistry, 7, 285–295

GAMO, T., 1982.
Genetic variants of the *Bombyx mori* silkworm
encoding sericin proteins of different lengths.
Biochemical Genetics, 20, 165–177

GAREL, A., DELEAGE, G.,
PRUDHOMME, J. C., 1997.
Structure and organization of the *Bombyx mori*
sericin 1 gene and of the sericins 1 deduced
from the sequence of the Ser 1B cDNA.
Insect Biochemistry and Molecular Biology,
27, 469–477

INOUE, S., TANAKA, K., ARISAKA, F., KIMURA, S.,
OHTOMO, K., MIZUNO, S., 2000.
Silk fibroin of *Bombyx mori* is secreted,
assembling a high molecular mass elementary
unit consisting of H-chain, L-chain, and P25,
with a 6:6:1 molar ratio.
Journal of Biological Chemistry, 275,
40517–40528

KIKUCHI, Y., MORI, K., SUZUKI, S.,
YAMAGUCHI, K., MIZUNO, S., 1992.
Structure of the *Bombyx mori* fibroin light chain
encoding gene: upstream sequence elements
common to the light and heavy chain.
Gene, 110, 151–158

KIMURA, K., OYAMA, F., UEDA, H., MIZUNO, S.,
SHIMURA, K., 1985.
Molecular cloning of the fibroin light chain
complementary DNA and its use in the study
of the expression of the light chain gene in
the posterior silk gland of *Bombyx mori*.
Experientia, 41, 1167–1171

MARSH, R. E., COREY, R. B., PAULING, L., 1955.
An investigation of the structure of silk fibroin.
Biochimica et Biophysica Acta, 16, 1–34

MICHAILLE, J. J., COUBLE, P.,
PRUDHOMME, J. C., GAREL, A., 1986.
A single gene produces multiple sericin
messenger RNAs in the silk gland of
Bombyx mori.
Biochimie, 68, 1165–1173

MICHAILLE, J. J., GAREL, A.,
PRUDHOMME, J. C., 1990.
Cloning and characterization of the highly
polymorphic Ser 2 gene of *Bombyx mori*.
Gene, 86, 177–184

NONY, P., PRUDHOMME, J. C.,
COUBLE, P., 1995.
Regulation of the P25 gene transcription
in the silk gland of *Bombyx mori*.
Biology of the Cell, 84, 43–52

SHIMURA, K., KIKUCHI, A., OHTOMO, K.,
KATAGATA, Y., HYODO, A., 1976.
Studies on silk fibroin of *Bombyx mori*.
I. Fractionation of fibroin prepared from
the posterior silk gland.
Journal of Biochemistry, 80, 693–702

SHINOHARA, H., 1979.
Glycopeptides isolated from sericin of
the silkworm, *Bombyx mori*.
Comparative Biochemistry and Physiology,
63B, 87–91

SUZUKI, Y., BROWN, D. D., 1972.
Isolation and identification of the messenger
RNA for silk fibroin from *Bombyx mori*.
Journal of Molecular Biology, 63, 409–429

TAKASU, Y., YAMADA, H., TSUBOUCHI, K., 2002.
Isolation of three main sericin components
from the cocoon of the silkworm, *Bombyx mori*.
**Bioscience, Biotechnology, and
Biochemistry**, 66, 2715–2718

TAKEI, F., KIKUCHI, Y., KIKUCHI, A.,
MIZUNO, S., SHIMURA, K., 1987.
Further evidence for importance of the
subunit combination of silk fibroin in its
efficient secretion from the posterior silk
gland cells.
Journal of Cell Biology, 105, 175–180

TANAKA, K., MORI, K., MIZUNO, S., 1993.
Immunological identification of the major
disulfide-linked light component of silk fibroin.
Journal of Biochemistry, 114, 1–4

TANAKA, K., KAJIYAMA, N., ISHIKURA, K.,
WAGA, S., KIKUCHI, A., OHTOMO, K.,
TAKAGI, T., MIZUNO, S., 1999.
Determination of the site of disulfide linkage
between heavy and light chains of silk fibroin
produced by *Bombyx mori*.
Biochimica et Biophysica Acta, 1432, 92–103

TRIPOULAS, N. A., SAMOLS, D., 1986.
Developmental and hormonal regulation of
sericin mRNA in the silkworm, *Bombyx mori*.
Developmental Biology, 116, 328–336

YAMAGUCHI, K., KIKICHI, Y., TAKAGI, T.,
KIKUCHI, A., OYAMA, F., SHIMURA, K., 1989.
Primary structure of the silk fibroin light
chain determined by cDNA sequencing
and peptide analysis.
Journal of Molecular Biology, 210, 127–139

ZHOU, C. Z., CONFALONIERI, F., MEDINA, N.,
ZIVANOVIC, Y., ESNAULT, C., YANG, T.,
JACQUET, M., JANIN, J., DUGUET, M.,
PERASSO, R., 2000.
Fine organization of *Bombyx mori* fibroin
heavy chain gene.
Nucleic Acid Research, 28, 2413–2419

ZHOU, C. Z., CONFALONIERI, F., JACQUET, M.,
PERASSO, R., LI, A. G., JANIN, J., 2001.
Silk fibroin: structural implications of
a remarkable amino acid sequence.
Proteins: Structure, Function, and Genetics,
448, 119–122

Notes

Silk in History
Ancient silks

1 Shelagh Vainker, *Chinese Silk: a Cultural History* (London: British Museum Press, 2004), p. 24. The following three paragraphs are also indebted to this volume.

2 See Dieter Kuhn, "Silk Weaving in Ancient China: from geometric figures to patterns of pictorial likeness," in *Chinese Science* 12 (1995), pp. 77–114.

3 J. P. Hardiman, *Silk in Burma* (Burma: Rangoon Government Printing, 1901), p. 1.

4 B. and R. Allchin, *The Rise of Civilization in India and Pakistan* (Cambridge: Cambridge University Press, 1982), pp. 273–6.

5 Dating by comparison of textual references to astronomical events places the *Mahabharata* much earlier in the Vedic period, at 1478 B.C.

6 See, for example, Ron Cherry, "Sericulture," *Bulletin of the Entomological Society of America* 35 (1989), pp. 83–4, and Xinru Liu, *Silk and Religion: An Exploration of Material Life and the Thought of People, AD 600–1200* (New Delhi: Oxford University Press, 1999), p. 50.

7 Such papers, dating from the reign of Emperor Wu (140–86 B.C.) to the Western Jin dynasty (A.D. 265–420), have been found among the Xuanquanzhi ruins of Dunhuang in northwest China's Gansu Province.

8 See Elizabeth Barber, *Prehistoric Textiles* (Princeton: Princeton University Press, 1991), pp. 203–05.

9 Irene Good, "On the Question of Silk in Pre-Han Eurasia," *Antiquity*, December 1, 1995 (Internet resource).

10 "General Notes on Maritime Commerce and Shipping in the Early Centuries CE," http://depts.washington.edu/uwch/silkroad/texts/weilue/appendices.html, p. 2.

11 See Lionel Casson, *The Periplus Maris Erythraei: Text with Introduction, Translation and Commentary* (Princeton: Princeton University Press, 1989) for an anonymous mid-1st century A.D. account written by a Greek-speaking Egyptian merchant.

12 See "From the Wei-lio (written before 429 C.E.), for 220–264 C.E.," in J. S. Arkenberg's modification from F. Hirth, *China and the Roman Orient: Researches into their Ancient and Mediaeval Relations as Represented in Old Chinese Records* (Shanghai and Hong Kong, 1885), pp. 35–96 (http://depts.washington.edu/uwch/silkroad/texts/romchin1.html, 2000), p. 10.

13 The Chinese brocade-like cloths of this period (*jin*) were made with two or more different-colored warps (a warp-faced compound tabby in the Han period, with twill introduced under the Tang); these have continuous wefts, unlike the later brocades of Europe, made with discontinuous wefts inserted only where extra colors were wanted.

14 See, for example, Rattan C. Rawlley, *Economics of the Silk Industry: A Study in Industrial Organizations* (London: P. S. King, 1919), p. 16.

15 Xinru Liu, *op. cit.*, p. 74, note 1. This story is based on the legend that the Khotanese smuggled eggs of silkworms from their eastern neighbor, China, and the Nestorian monks smuggled the eggs of silkworms from Serindia, as recorded by the Roman historian Procopius (VIII, xvii, 1–14).

16 It also overlooks the provision of Chinese silks by Egyptian (and thus Byzantine) mariners, whose cessation of this trade in about 440 may be accounted for by an increase in supplies nearer to hand. (It may also be because by then much of the Middle East and Mediterranean was in political disarray, as was Asia until China was reunited under the Tang dynasty in 618.) In addition, mulberry silk rearing is thought to have evolved from wild silk processing in Greek and Aegean islands during this period; see F. Michel, *Recherches sur le commerce, l'usage, et la fabrication des étoffes de soie* (Paris, 1852).

Diffusion

1 Liu, *op. cit.*, p. 162.

2 A useful summary of studies in Sogdian silks is found in Anne E. Wardell and James Watt, *When Silk was Gold: Central Asian and Chinese Textiles in The Cleveland and Metropolitan Museums of Art* (New York: Harry N. Abrams, Inc., 1997), pp. 21–28.

3 Dale Gluckman in *Pratapaditya Pal, Art of Tibet: A Catalogue of the Los Angeles County Museum of Art Collection; with an Appendix on Inscriptions by H. E. Richardson; and Additional Entries on Textiles by Dale Carolyn Gluckman* (New York: Harry N. Abrams, 1990, expanded ed.), p. 24.

4 Matteo Compareti, "Sogdiana: Iranian Culture in Central Asia," *The Iranian*, July 24, 2001.

5 Anne E. Wardell & James Watt, *op. cit.*, p. 24.

6 Cloths increased from an average of 56 centimeters (22 inches) across to more than twice that during the Tang period.

7 The Liao dynasty, who were Khitan people, ruled lands adjacent to the Northern Song (960–1127); other ethnic groups included the Jurchen, who forced the Song southward—thus distinguished as Southern Song (1127–1279)—and founded the Jin dynasty in former Song territories.

8 Wardell and Watt, *op. cit.*, pp. 24–27.

9 C. Mackerras, *The "New Táng History"(Hsin Táng-shu) on the History of the Uighurs* edited by D. C. Waugh for the Internet: http://depts.washington.edu/uwch/silkroad/texts/tangshu/tangshu.html, pp. 18–21.

10 Anna Muthesius, "Byzantine silks," in *5,000 Years of Textiles* (London: British Museum Press, 1993), p. 75.

11 Robert B. Serjeant, *Islamic Textiles: Material for a History Up to the Mongol Invasions* (Beirut: Librairie du Liban, 1972), p. 27, citing the *Kitāb al-Boldān*. Qi-damasks are single-color (or self-patterned) designs using interrupted tabby or twill weaves; at Birka was found a Chinese self-patterned tabby-woven silk.

12 Chris Spring and Julie Hudson, *Silk in Africa* (London: British Museum Press; Seattle: University of Washington Press, 2002), p. 9.

13 Genoese merchants also had a trading quarter in Constantinople, with other Italian merchants from Amalfi, Venice, and Pisa.

14 For weave plans and a straightforward explanation, *see* Agnes Geijer, *A History of Textile Art* (London: Sotheby Parke Bernet Publications, 1979), pp. 57–62.

Expansion

1 See Geoffrey Marks, *The Medieval Plague: The Black Death of the Middle Ages* (New York: Doubleday, 1971), pp. 1–5, 29, 45–49; George Deaux, *The Black Death 1347* (New York: Weybright and Talley, 1969), pp. 1, 2, 43–49; and Robert S. Gottfried, *The Black Death* (New York: The Free Press: 1983). p. 35.

2 Suwati Kartiwa, *Songlet Weaving in Indonesia* (Djakarta: Penerbit Djambatam, 1986), pp. 4–6, dates the trade in Chinese and Indian gold-thread woven goods from the 7th century; see also Victoria Rivers, *The Shining Cloth: Dress and Adornment that Glitters* (London: Thames & Hudson, 1999), pp. 50–55, for the use of gold platelets and thread around the world.

3 Mary Schoeser, *World Textiles: a Concise History* (London and New York: Thames & Hudson, 2003), p. 76; see also Wardell and Watt, *op. cit.*, p. 14.

4 Janet Harvey, *Traditional Textiles of Central Asia* (London: Thames & Hudson, 1997), p. 57.

5 This contributed to the replacement of agents residing in Champagne with those in Paris or, starting in 1250, in London; *see* Douglas R. White, *Civilizations as Dynamic Networks: from Medieval to Modern* (eclectic.ss.

uci.edu/~drwhite/Civ/papers/cities WWWnet.pdf, 2005), pp. 16–19; *see also* Peter Spufford, *Power and Profit: the Merchant in Medieval Europe* (London: Thames & Hudson, 2002).
6 Girolamo Gargiolli (ed.), *L'Arte della seta in Firenze: Trattato del secolo XV* (Florence: 1868), pp. 102–8, cited in Luca Mola, *The Silk Industry of Renaissance Venice* (Baltimore and London: Johns Hopkins University Press, 2000), p. 56.
7 Mola, *op. cit.*, p. 4. Several Italian states nevertheless maintained commercial relationships with silk-producing regions to the east, importing both fabrics and dye stuffs.
8 Bernard Ceysson, *Rubans Français: au Musée d'Art et d'Industrie de Saint-Etienne* (Tokyo: Gakken, 1981), p. 212. Bologna was soon to be overtaken by Piedmont as the leader in sericulture and silk production, retaining its position as the foremost exporter in the western world until the early 19th century, when leadership in this arena passed to France. Some of the techniques developed in Piedmont are still in use today.
9 Italian mechanisms for silk thread production had been published in 1607 in Padua, by V. Zonca (*Novo teatro di machine*), but despite further editions in 1620 and 1686, diffusion of this technology remained dependent on firsthand experience. Silk throwing ceased at Lombe's mill in 1908. For Lombe and a good related bibliography, see www.derwentvalleymills.org/04_his/his_001k.htm
10 For Sabatier, *see Oxford Dictionary of National Biography* (Oxford: Oxford University Press, 2004; hereafter ODNB); for Leman and Garthwaite, see Natalie Rothstein, *Silk Designs of the Eighteenth Century* (Boston, Toronto, London: Bullfinch Press, 1990); for Revel, see Leslie E. Miller, "Jean Revel: Silk Designer, Fine Artist or Entrepreneur?" in *Journal of Design History* 8, no. 2 (1995), pp. 79–96; for Lasalle, *see* Lesley E. Miller, "The Marriage of Art and Commerce: Philippe de Lasalle's Success in Silk," *Art History* 28, no. 2, (April 2005), pp. 200–26; and for summaries of the European industry, see Mola *op. cit.* and Geijer *op. cit.*
11 See Woodrow Borah, *Silk Raising in Colonial Mexico* (Berkeley: University of California, 1943), pp. 32–38.
12 See L. P. Brockett, *The Silk Industry in America: A History Prepared for the Centennial Exposition* (Washington, D. C.: The Silk Association of America, 1876); R. D. Margrave, *The Emigration of Silk Workers from England to the United States of America in the Nineteenth Century, with Specific Reference to Coventry, Macclesfield and Patterson, New Jersey, and* South Manchester, Connecticut (New York and London: Garland Publishing, Inc., 1986); and P. B. Scranton (ed.), *Silk City* (Newark, N. J.: New Jersey Historical Society, 1985). In 1910, there were close to 1,300 silk mills in the US.
13 Natalie Rothstein, "Silk: The Industrial Revolution and After," in *The Cambridge History of Western Textiles*, ed. David Jenkins (Cambridge: Cambridge University Press, 2002), p. 793.

Silk in Use

Setting the stage

1 Liu, *op. cit.*, pp. 75 and 3.
2 Tom Witmer, *Silk and Religion: An Exploration of Material Life and the Thought of People, AD 600–1200: a review* by Tom Witmer, http://www.globaled.org/nyworld/xinru.html, sourced Feb. 26, 2006.
3 Xinru Liu, "Silks and Religions in Eurasia, c. A.D. 600–1200," http://www.learner.org/channel/courses/worldhistory/support/reading_7_2.pdf., 2004, pp. 7–9. These hypothetical silk ropes form a parallel to the western *Jack and the Beanstalk* tale.
4 Liu, *op. cit*, pp. 51–52.
5 Nitya G. Mukerji, *A Monograph on the Silk Fabrics of Bengal* (Calcutta: Bengal Secretariat Press, 1903), introduction.
6 Kay Staniland, "Basing, Adam of (d.1262x6)," in *ODNB, op. cit.* Basing was Mayor of London in 1251–52.
7 See Yedida K. Stillman, "Textiles and Patterns Come to Life Through the Cairo Geniza," in *Islamiche Textilkunst des Mittelalters: Aktuelle Probleme*, ed. Berichte Riggisberger, (Riggesberg, Switzerland: Abegg-Stiftung, 1997), pp. 36–52.
8 For a survey of Jewish dress, see Alfred Rubens, *A History of Jewish Costume*, 2nd ed. (New York: Crown Publishers, Inc., 1973); for Moroccan bridal costumes, see pp. 73–74.
9 Nasreen Askari and Liz Arthur, *Uncut Cloth* (London: Merrell Holberton, 1993), p. 21.
10 International Trade Centre UNCTAD/WTO, *Silk Review 1997: A Survey of International Trends in Production and Trade*, 5th ed., pp. 6 and 10.
11 Vainker, *op. cit.*, p. 54. "After the Wang Mang interregnum (AD 9–23) however silk became an explicit form of currency along with cotton, gold and grain according to the *Hou Hanshu* (History of the Later Han) which elsewhere defines brocade as gold, with the equivalent value being provided by the intensity of the labour put into the textile. The use of silk as currency in a barter economy was to characterize periods of political plurality or unrest in China's subsequent history, and certainly it took hold in the period following the Han dynasty."
12 All ODNB, *op. cit.* The last Vanner associated with England's Vanner Silks company (J. E. Vanner, 1834–1906), was also a banker and oversaw the merger of the Midland and City banks in 1900. A possible reason for the close connection was the high capital required to finance silk manufacturing. This information courtesy of David Tooth.
13 François de Capitani, "Zwischen Wohlstand, Extravanganz und Arbeitseifer: Die Zürcher Seidenfamilien," in *Seide: Stoff für Zürcher Geschichte und Geschichten* (Zurich: Zürcher Kantonalbank, 1999), p. 35; translation courtesy of Mirjana Matovic. For Trudel, see this volume, p. 104, and conversation with the author, March 2006.

Art and interiors

1 Vainker, *op. cit.*, p. 135.
2 Wardell and Watt, *op. cit.*, p. 61. It was not until the 19th century, with the development of the Jacquard loom, that woven silk portraits, landscapes, and other subjects could be produced with greater speed. Jacquard himself created the first example, a self-portrait, and it was not long before it became customary for politicians and royalty to be commemorated thus; woven postcards and limited editions were also made—the latter even to today.
3 See Thomas P. Campbell, *Tapestry in the Renaissance: Art and Magnificence* (New Haven: Yale University Press, 2002), p. 416.
4 ODNB, *op. cit.*
5 *Ibid.*
6 Wardell and Watt, *op. cit.*, pp. 134 and 139.
7 Ariana Turpin, "Baroque Upholstery and Beds," in N. Riley (ed.), *The Elements of Design* (London: Mitchell Beazley, 2003), p. 61.
8 See Mary Schoeser, "Baroque Textiles and Wallpaper" and "Rococo Textiles and Wallpaper," in Riley, *op. cit.*, pp. 76–79 and 122–25.
9 Sanjay Sinha, *A Wealth of Opportunities* (New Delhi: Oxford and IBH Publishing Company PVT Ltd., 1990), p. 5.
10 Vainker, *op. cit.*, p. 169.
11 The majority of orders until 1810 were given to Pernon and to his successor, Grand (from 1808). See Jean Coural and Chantal Gastinel-Coural, *Soieries de Lyon: commandes royales au XVIIIe s. (1730–1800)* (Lyon: Musée Historique des Tissus, 1988), and the same authors with Muriel Muntz de Raissac, *Inventaire des collections publiques français: Paris, Mobilier National, Soieries Empire* (Paris: Réunion des Musées Nationaux, 1980).
12 The queen's order for 92 meters (100 yards) in the color *ponceau* was placed by a Mr.

Hutchinson (Tassinari et Chatel order no. 2096); the Walters brocatelle was in brilliant blue (Prelle pattern 4576). For Tassinari et Chatel, see Marie Bouzard-Tricou, "Analyse et catalogue raisonné de la production des Frères Grand, fabricants de soierie à Lyon, de 1808 à 1871, d'après les archives de la Maison Tassinari et Chatel, leurs successeurs, 11 place Croix Paquet." *Mémoire de maîtrise* [master's thesis], Université de Lyon, Nov. 1985. Prelle, founded in 1749, was run as Lamy et Giraud by A. Lamy and his son Édouard from 1866 to 1914. For the context of these orders, see Mary Schoeser, *French Textiles from 1760 to the Present Day* (London: Laurence King, and Paris: Flammarion, 1991), pp. 97–112.
13 Most important among these was *Le Garde-Meuble, ancien et moderne, journal d'ameublement*, appearing first in 1839 and surviving until 1935.
14 However, lengths of high-quality silks were still imported: $50m of French silks in 1874 alone. Only by 1880 was a decline more apparent; in that year $32m of silk cloths were purchased by Americans, and more of these (a quarter) were German and Swiss in origin. See Schoeser, *French Textiles, op. cit.*, p. 138.

Fashion
1 Irene Turnau, "Knitting," in *The Illustrated History of Textiles*, ed. Madeleine Ginsburg, (London: Studio Editions, 1991), p. 153.
2 Joan Thirsk, "Knitting and Knitware, c. 1500–1780," in Jenkins, *op. cit.*, p. 564.
3 Santina Levey, "Lace in the Early Modern Period, c. 1500–1780," in Jenkins, *op. cit.*, p. 585.
4 Natalie Rothstein, "Silk in the Early Modern Period, c. 1500–1780," in Jenkins, *op. cit.*, p. 528.
5 For an account of this evolution, see Yuniya Kawamura, *The Japanese Revolution in Paris Fashion* (Oxford and New York: Berg, 2004).
6 Ceysson, *op. cit.*, p. 212.
7 See Rothstein, *op. cit.* for a detailed account of these fashions.
8 Archives Nationales, Paris, illustrated in Aileen Ribeiro, *Fashion in the French Revolution* (London: B. T. Batsford Ltd., 1988), pp. 30–31.
9 See Vyvyan Holland, *Hand Coloured Fashion Plates 1770–1899* (London: B. T. Batsford Ltd.), who lists 52 fashion periodicals first published between 1770 and 1820 (with only 12 lasting for more than a few years and beyond 1820), 71 for the period 1821–42, and 72 for 1843–70 (plus 15 surviving from earlier periods).
10 Ceysson, *op. cit.*, p. 213.
11 For a full account of these developments, see Alfredo Redaelli, "The Evolution of the Velvet Loom," in Fabrizio de' Marinis (ed.), *Velvet: History, Techniques, Fashions* (Milan and

New York: Idea Books, 1993 and 1994).
12 de Capitani, *op. cit.*, p. 40
13 About three-quarters of the broad silk industry was located in Pennsylvania and New Jersey. See *United States Tariff Commission, Broad Silk Manufacture and the Tariff* (Washington, D. C.: Government Printing Office, 1926), pp. 3–7.

Silk in Detail
1 Mahesh Nanavaty, *Silk Production, Processing and Marketing* (Columbia, Missouri: South Asia Books, 1990), p. 131.

Color and texture
2 However, Florence was also known as a center of expertise for dyeing with the red plant dye madder, so much so that the family of merchants dealing with this dyestuff came to be known as della Robbia (derived from the Latin name for madder, *Rubia tinctorum*).
3 Ken Ponting, *A Dictionary of Dyes and Dyeing* (London: Bell and Hyman, 1981), pp. 122–23.
4 "Fenwick family," *ODNB, op. cit.* Logwood added weight to silk cloths, much to the benefit of merchants and manufacturers.
5 See Ponting, *op. cit.*, pp. 70–72, for a list of dye developments between 1856 and 1956; the first dye to rival cochineal was Biebrich scarlet, developed in 1878 by Nietzki.
6 Wardle, an authority on Indian silks, was also instrumental during the 1890s in reviving sericulture in Kashmir; see Brenda King, *Silk and Empire* (Manchester and New York: Manchester University Press, 2005), pp. 93–97.
7 For Mairet, see Margot Coatts, *A Weaver's Life: Ethel Mairet 1872–1952* (London: Crafts Council, 1983); for Rodier, see Paul Rodier, *The Romance of French Weaving* (New York: Tudor Publishing Co., 1936). This trend was also supported by the illustrations chosen for the most influential journal of its day, *The Studio: an Illustrated Magazine of Fine and Applied Arts*, founded in 1893 by George Holme, the son of a silk manufacturer and a buyer for Liberty's from c. 1880 to 1892; he was also a founder member of the Japan Society, founded in Britain in the year he retired from Liberty's.
8 William Warren, *Jim Thompson: The Unsolved Mystery* (Singapore: Archipelago Press, 1998), pp. 73–112.

Printed and dyed patterning
1 For an introduction to these techniques, see John Gillow and Bryan Sentence, *World Textiles: A Visual Guide to Traditional Techniques* (London: Thames & Hudson, 1999), and Schoeser, *World Textiles, op. cit.*, pp. 134–55.

2 For more information on related techniques, see E. Noteboom, "Screen Printing: Where Did It All Begin?" *Screenprinting: The Journal of Technology and Management* 82, no. 10 (1992).
3 Rayon had made little impact on the use of silks until the 1930s. For the development of this and other man-made and synthetic fibers, see Susannah Handley, *Nylon: The Manmade Fashion Revolution* (London: Bloomsbury, 1999).

Sculptural silks
1 Hilary Alexander, "Paris Haute Couture Round-up," *Fashion Telegraph*, January 26, 2004.
2 Florence Charpigny, "L'étoffe de la mode: Soierie lyonnaise et haute couture, l'exemple de la maison Ducharne," in Danielle Allérès (ed.), *Mode: des parures aux marques de luxe* (Paris: Economica, 2005), p. 29, and, quoting Pierre Ducharne, p. 30. I am indebted to Lesley Miller for drawing my attention to this essay. Maison Ducharne wove and printed silks in Lyon and dealt with wholesalers to obtain the wool cloths, which it did not make; it also had a showroom in New York, opened in the early 1920s.
3 Christian Dior, *Dior by Dior: The Autobiography of Christian Dior*, trans. Antonia Fraser (London: Weidenfeld and Nicholson, 1957), p. 95; originally published as *Christian Dior et moi* (Paris: Dumont, 1956).
4 A converter is a company, usually wholesale, that designs but does not manufacture; instead, it commissions production from a range of other companies. Abraham, which existed until very recently, was based in Zurich and is also remembered for working closely with Yves Saint Laurent.
5 Lesley Miller, *Cristóbal Balenciaga* (London: B. T. Batsford Ltd., 1993), p. 55.
6 J. Mendel's recent New York fashion shows can be seen on http://www.newyorkmetro.com/fashion/fashionshows.
7 Catherine McDermott, *Made in Britain: Trend and Style in Contemporary British Fashion* (London: Mitchell Beazley, 2002), p. 121. Macdonald was appointed head knitwear designer for Chanel and Karl Lagerfeld in 1996, launched his first own-label collection in 1997, and was Creative Director of Givenchy from 2001 to 2004.
8 Chalayan's interest in the behavior of silk dates back to his graduation collection at St Martin's (now Central St Martins) College of Art & Design, London, in 1993, when he buried silk clothes in the earth to see how they would decompose. See www.we-make-money-not-art.com for a summary of his career.
9 Edward George Earle Bulwer-Lytton, *The*

Last of the Barons (London: Saunders and Otley, 1843), I, p. iii.

10 See, for example, www.worldofquotes.com and www.theotherpages.org.

11 The International Trade Centre estimates that there were 300,000 haute-couture clients in the 1930s and that there are some 1,000–2,000 today.

Strength and warmth

1 See Eliza B. Thompson, *Silk* (New York: The Ronald Press Company, 1922), p. 83, a department-store merchandise manual first published in 1918 as *The Silk Department* (same publisher).

2 See, for example, http://phoenixlines.com.

3 The hydrogen balloon was invented by J. A. C. Charles, and the rubberized silk was essential to contain the hydrogen. See http://www.allstar.fiu.edu/aero/balloon2.htm.

4 A replica of the Silver Dart is on display at the Canada Aviation Museum in Ottawa.

5 *ODNB, op. cit.*

6 For example, the inflatable resuscitation device with an inflatable air spring of rubberized silk, United States Patent 5388576, filed August 13, 1993.

7 Amy M. Spindler, "A Versace Looks Ahead, through Tears," *The New York Times*, October 10, 1997.

8 See "The Mystery of the Printed Hankie," in Mary Schoeser and Christine Boydell, *Disentangling Textiles* (London: Middlesex University Press, 2002).

9 The long-sleeved knitted silk undershirt worn by King Charles I on the scaffold is preserved in the Museum of London.

10 The 1850s' campaign for "bloomers" (named after the American reformer Amelia Bloomer) had met with most of its resistance on the grounds that women were dressing like men, even though this was not based on fact.

11 See *Harper's Bazaar*, February 1920; Parisian couturiers are recorded as making their most daring ensembles for rich Americans.

12 See Louanne Collins and Moira Stevenson, *Silk: Sarsenets, Satins, Steels and Stripes* (Macclesfield: Macclesfield Museums Trust, 1994), pp. 60–63, regarding the spun silk crêpe made colorfast when washed by having been boiled in olive oil soap for six hours during the finishing process, and "Day and Night Dress of Filmy Wash Silks," *The American Silk Journal* 37, no. 8 (August 1918), p. 54a.

13 Lastex was invented by Percy Adamson and developed by his brother James between 1925 and 1932 at Dunlop; it consists of an elastic core wound around with silk or other threads.

14 The main swimsuit manufacturers were initially jersey knitters, since this cloth construction had the requisite elasticity prior to the incorporation of latex threads. Catalina swimwear was produced by Bentz Knitting Mills, later to rename themselves Pacific Knitting. Cole of California was the swimwear brand of West Coast Knitting, and Jantzen was previously known as Portland Knitting Mills.

The Potential of Silk

1 He looked forward to a point when the United States would export silk goods rather than importing them, when American manufacturers would weave cloths that surpassed in quality those of European looms, and when "the moderate-priced but durable spun silks will claim their place as the most economical of dresses for our American women while engaged in their every-day duties." L. P. Brockett, *op. cit.*, pp. 131–32.

2 Typescript, "Report on Silk Production and Manufacturing in California" (Sacramento: The Silk Industry Project Committee of the California State Reconstruction and Reemployment Commission, June 1946), p. 18, citing Robert L. Gulick, Jr., "Imports—the Gain from Trade," a report for The Committee on International Economic Policy in cooperation with The Carnegie Endowment for International Peace.

Storm and sunshine

3 Stan Gellers, "Washed Silks Will Ride Popularity into Fall," *New York Daily News Record*, October 22, 1990, paragraph 6. Shamash & Sons was founded in the 1870s as an exporter of teas, spices, and silks to the Middle East and relocated to New York in 1946. Its partner in Germany in 1987 was Kress, then the oldest silk dyer in Europe, founded in 1874. See also *Silk Review 1997: A Survey of International Trends in Production and Trade*, 5th ed. (Geneva: International Trade Centre UNCTAD/WTO), 1997.

4 *Silk in World Markets*, International Trade Forum report, January 1, 1999, paragraphs 5–12.

5 See Rajat K. Datta and Mahesh Nanavaty, *Global Silk Industry: A Complete Source Book* (Boca Raton, Florida: Universal Publishers, 2005), pp. 35–82.

6 Marja Kurki, "Advice to New Silk Exporters," *International Trade Forum*, July 1, 1990, p. 4.

7 "Silk in World Markets" (ITC website: http://www.intracen.org/textilesandclothing/silk_in_world_markets.htm) 2002, sourced July 17, 2006.

8 *Silk Review 2001: A Survey of International Trends in Production and Trade*, 6th ed. (Geneva: International Trade Centre UNCTAD/WTO, 2001), p. 16.

9 Brockett, *op. cit.*, p. 49, discusses a display mounted at the Centennial Exposition, 1876, by Luis de Resende, whose mulberry plantation consisted of 100,000 trees. Some authorities date Brazilian sericulture from the arrival of Italian settlers in the 1920s; in either case its rise to commercial scale occurred in the hands of the Japanese during and after WWII.

10 In cooperation with the International Centre for Training and Research in Tropical Sericulture (ICTRETS). The Centre, located in Mysore, was established in 1980 under the auspices of the Indo-Swiss Technical and Scientific Cooperation.

11 For information on the Japanese silkworm gene bank, see E. Kosegawa, "Conservation Status of Sericulture Germplasm Resources in Japan" (Rome: Food and Agriculture Organization of the United Nations), http://www.fao.org/docrep/005/AD108E/ad108eoi.htm.

12 See Paul Yager, "Silk Protein Project," http://faculty.washington.edu/yagerp/silkproject home.html, and Manuel Elices, José Pérez-Rigueiro, Gustavo R. Plaza, and Gustavo V. Guinea, "Finding Inspiration in Spider Silk Fibers," *JOM* (Journal of The Minerals, Metals & Materials Society), http://www.tms.org/pubs/journals/JOM/-5-2/Elices-0502.html. As an example of earlier research, see Hubert Jacob, *Les Soies dans l'extrême orient et dans les colonies français* (Paris: Augustin Challamel, 1902), pp. 72–78, regarding the early-eighteenth-century work with silk from Madagascar spiders.

13 Marvin Klapper, "Washable: Silk's Newest Wrinkle," *Women's Wear Daily*, Internet resource, September 9, 1987.

14 "Kanebo Is as Smooth as Silk," *Cosmetics International*, Internet resource, 27 Jan. 2006.

15 For some of the resulting "Gumma silks," see Yoshiko Iwamoto Wada, *Memory on Cloth: Shibori Now* (Tokyo: Kodansha International Ltd., 2002), p. 177 and passim. Gumma silk processing was modernized with Italian technology in 1872.

16 Somporn Thapanachai, "Thailand's Silk Garments Catch On. . . . ," *Bangkok Post* (via Knight-Ridder/tribune Business News).

Silk in Action

1 Yvonne Wakabayashi, "Sea Anemone Series", *Surface Design Gallery Issue*, September 2006, p. 62.

2 Katri Haahti in Martina Margetts et al., *Interface: an exhibition of international contemporary art textiles* (Edinburgh: The Scottish Gallery, and Ruthin: The Gallery Ruthin Craft Centre, 2005), p. 34.

Glossary

bast formerly the inner bark of the linden (lime) tree, now any flexible fibrous bark, including mulberry, and similar woody plant fibres.

brocading originally, the process by which additional colors are added by hand-held bobbins, inserting the threads in the weft-ways direction only where these are required; 'brocade' refers to cloths made in this way and, today, those that have the same appearance, however made.

brocatelle a cloth with a raised pattern created by using two sets of warps, too many to lie in one plane.

chain-stitch a linked, looped stitch, done with a needle or hook.

chiffon a light, plain-woven transparent silk, usually woven with a crepe yarn.

chiné the French term for a cloth with patterns resist-dyed on the yarn prior to weaving (also called ikat) and from the 1830s onward often also meaning a cloth with a pre-printed warp.

cloqué a cloth with a blistered effect, produced by gauffering or the juxtaposition of yarns or finishes that shrink at varying rates.

cochineal a carminic acid dye from the dried bodies of the females of the *Coccus* cacti insect, introduced from the Americas to Europe early in the 16th century; alone it produces a purple, with various mineral salts, reds, and with tin salts, a brilliant scarlet.

compound weave a general term for a cloth construction using more than one set of warp or weft threads, or both, and generally modified by a description of the dominant thread on the surface and the binding weave, as in a weft-faced compound twill, historically known as *samitum*; see also "lampas."

crêpe highly twisted yarn, or cloth made with it, which has a matt, crinkled surface and great suppleness.

damask a single-colored cloth with a pattern made apparent by the use of two different weave structures, usually satin and twill. Early Chinese variants are distinguished as *qi-*damasks and juxtapose plain and twill weaves.

denier the number of milligrams per 9 meters (a unit of weight equal to about 8 troy grains), used to indicate the weight and fineness of silk since the 1830s.

diasper historic term for a lampas, generally of the tissue type.

dye patterning the localized application of dye or a dye-attracting substance on either yarn or cloth, to create a pattern.

ecru silk thrown or woven with its natural gum intact.

fibroin protein fibers in silk; see "*Bombyx mori* proteins," page 232.

filature A reel for drawing off silk from cocoons and thus also an establishment where reeling takes place.

filé a smooth metallic thread with a silk core, wrapped around with lamella, which see.

filoselle silk thread spun from the coarser waste of the *Bombyx mori* and similar to schappe except for the latter's de-gumming by fermentation; often used in embroidery instead of the glossier thread, floss.

floss a soft silk yarn without twist, used for embroidery and electrical insulation of wires; also, the very small amount of low-grade silk from the outer part of a cocoon.

frame knitting the production of a knitted fabric through the use of a frame mounted with a series of hooks and latches; developed in the 17th century, frame knitting allowed the first mechanization of knitwear production; initially powered by hand, it makes a flat cloth (hence the "stocking frame" as it was often called, made pieces needing to be sewn together)—a later development is a related machine for circular knitting.

frisé a crinkled metallic thread made so by wrapping lamella around a spiral core.

gauffering the process of embossing or stamping with hot metal blocks or engraved cylinders to create a raised design; on velvet resulting in "Utrecht velvet."

gauze a light, open cloth in which some warps are diverted to the right or left of another warp and fixed in this "crossed" position by the passage of a weft.

georgette a very light crêpe.

habutai a light, closely woven Japanese fabric woven from raw silk given very little twist.

half-silk a cloth composed partly of silk and another fiber, frequently a fine worsted.

ikat an Indonesian term now generally used to describe all patterns created by resist-dyeing the warp or weft, or both, the latter being called a "double ikat."

Jacquard a hand- or machine-powered automatic patterning device fitted to a loom or knitting frame, to make complex patterns; originally employing punched cards, it provided the basis for data-input in first-generation computers and was thus readily computerized itself.

kermes a kermesic acid dye from the dried bodies of the female *Kermes vermilio*, an insect that lives on the kermes oak native to the eastern Mediterranean and Middle East, and giving bright scarlet and reds.

kesi a Chinese term for the slit-tapestry weave in silk, or silk and metal.

knub silk waste brushed from the outer layers of the cocoon before reeling; also known as *Flockseide* or *Frison* in German, *frison* and *moresque* in French, and *strusa* and *moresca* in Italian.

lamé a general term for textiles containing a weft of metallic thread.

lamella a flat metallic strip used alone or wound around a core thread; traditionally

of precious or base metal, gilt or silvered leather or membrane, or gilt or silvered paper, it is today composed of a synthetic material such as polyester and often called "filament" or "metallic filament."

lampas a general term for a cloth construction employing supplementary warps or wefts, although some authorities limit this term's meaning to supplementary wefts only. The English term for additional multiple coloring wefts running from selvedge to selvedge is "tissue"; the French term for a pattern formed by floating wefts is *liseré*.

leno a type of gauze with a pronounced square-shaped network.

metallic filament see lamella.

moiré a rippled or watered effect made on a ribbed fabric by folding and applying high pressure, which causes some ribs to flatten and thus become more light-reflective.

mulberry silk silk from the *Bombyx mori*, so-called because it feeds on mulberry leaves.

nasij a cloth of gold made in the Mongolian empire from at least the 10th century A.D., but especially associated with the period of the "Great Khans," 1206–1388 and the Mongolian Yuan Chinese dynasty, 1279–1368.

noil the short-length residue from the preparatory stages of silk spinning.

organza a sheer silk woven with ecru, having a mesh-like appearance and stiff handle.

organzine a strong thread produced by giving raw silk a preliminary twist in one direction and then twisting two or more of these threads together in the opposite direction.

patola the Indian term for a double ikat.

pibrine an epidemic disease of the silkworm, characterized by the presence of minute vibratory corpuscles in the blood, which in the 1860s and 1870s decimated French, Italian, and Indian sericulture; Pasteur's research on pibrine in Italy (1869–70) led to its control.

plain weave the simplest form of weaving, in which the weft crosses over and under every other warp; also called "tabby."

qi-damask see damask

raw silk silk as reeled from the cocoon, containing its original sericin.

samitum see compound weave.

satin a smooth densely-woven cloth with its surface predominantly the warp, bound down in units of five or more so that the binding weft is hardly apparent; a weft-faced satin is made on the same principle, but with a prominent weft rather than warp.

sericin a glue protein in silk; see "*Bombyx mori* properties," in The Science of Silk.

schappe a yarn or cloth made from waste silk degummed through fermentation (schapping) and then spun; about 10 percent of the gum remains in the finished silk.

shantung originally a Chinese hand-woven fabric using the undomesticated *Bombyx croesi*, which produces a rich yellow silk and an uneven texture in the plain cloth; retaining its characteristic slub, later made from silk waste and unthrown tussah, power woven in Shanghai and Japan during the interwar period, and now typically made of schappe.

shibori Japanese term for all resist-dyed patterns, including tie-and-dye, ikat, and clamp resists.

shot silk an iridescent cloth, often taffeta, woven with different-colored warp and weft.

small wares narrow-loom products such as ribbons and loom-woven braids.

surah in the United States, a term synonymous with tie silk; printed surah is called "foulard."

tabby see plain weave.

taffeta a plain and closely woven silk with a warp and weft of equal sizes.

tapestry a hand-weaving technique in which the warp is covered with wefts of different colors, worked only where they are needed; slit-tapestry creates no contact between areas of color, while interlocked tapestry links adjacent colors by interlocking wefts.

tartar cloths a European term for Mongolian silks of, especially, the 13th and 14th centuries, characterized by the asymmetrical semi-naturalistic depiction of imagery in silks usually incorporating gold threads.

throwing the main process in the formation of silk threads without spinning; see "The production cycle of drawn silk," page 235.

tissue see lampas

trapunto a means of producing a raised design by quilting a pattern on a "sandwich" of two layers of cloth and then slitting the back open to insert a wadding.

tussah silk from wild moths, especially *Antheraea pernyi* and *Antheraea mylitta*, used in India and China for thrown silk but produces a high proportion of waste silk, which is spun.

twill a weave in which warp threads float over two or more weft threads in a diagonal formation; in a weft-faced twill it is the weft that floats.

velvet a pile weave made with an additional warp that is looped during weaving and then cut to form the pile; pile in two or more heights is *alto e basso* and when areas are left without pile the velvet is called "voided"; *ciselé* velvet has a pattern, often voided, of cut and uncut loops.

warp the threads placed in a loom under tension, running parallel to the selvedge of the finished cloth; any cloth described as warp-faced has the greater proportion of these threads on the surface.

weft the threads interwoven crosswise with the warp to bind it into cloth; any cloth described as weft-faced has the greater proportion of these threads on the surface.

wild silk silk from wild and now somewhat-domesticated silkworms, such as tussah.

Bibliography

ALLSEN, THOMAS T.
Commodity and Exchange in the Mongol Empire: A cultural history of Islamic textiles (Cambridge: Cambridge University Press) 1997

ASKARI, NASREEN AND ARTHUR, LIZ.
Uncut Cloth (London: Merrell Holberton) 1993

BARBER, ELIZABETH.
Prehistoric Textiles (Princeton University Press) 1991

BIANCHI, ETTORE.
Dizionario Internazionale dei Tessuti (Como: Tessile de Como) 1997

BLOOM ET AL.
Islamische Textilkunst des Mittelalters: Aktuelle Probleme (Riggesberg: Abegg-Stiftung, Riggisberger Berichte, Vol.5) 1997

BORAH, WOODROW.
Silk Raising in Colonial Mexico (Berkeley: University of California) 1943

BRITO, KAREN K.
Shibori: creating color and texture on silk (New York: Watson-Guptill Publications)

BROCKETT, L. P.
The Silk Industry in America: a history prepared for the Centennial Exposition (Washington DC: The Silk Association of America) 1876

BLAZY, GUY ET AL.
Les grandes heures de la soierie lyonnaise (Dijon: Editions Faton, Dossier de l'Art no.92) 2002

CEYSSON, BERNARD.
Rubans Français au Musée d'Art et d'Industrie de Saint-Etienne (Tokyo: Gakken) 1981

CHUNG, YOUNG YANG.
Silken Threads: a history of embroidery in China, Korea, Japan and Vietnam (New York: Abrams) 2005

CLERGET, PIERRE.
Les industries de la soie en France (Paris: A. Colin) 1925

COLLINS, LOUANNE AND STEVENSON, MOIRA.
Silk: sarsenets, satins, steels & stripes (Macclesfield: Macclesfield Museums Trust) 1994

COURAL, JEAN AND GASTINEL-COURAL, CHANTAL.
Soieries de Lyon: commandes royales au XVIIIe s. (1730–1800) (Lyon: Musée Historique des Tissus) 1988

COURAL, JEAN; GASTINEL-COURAL, CHANTAL; AND DE RAISSAC, MURIEL MUNTZ.
Inventaire des collections publiques français: Paris, Mobilier National, Soieries Empire (Paris: Réunion des Musées Nationaux) 1980

DELANOË, GUIREC.
Etude sur l'evolution de la concentration dans l'industrie du textile en France (Commission des Communautés Européennes) November 1975.

LA FORCE, JAMES CLAYBURN.
The Development of the Spanish Textile Industry, 1750–1800 (Berkeley and Los Angeles: University of California Press) 1965

GAVIN, TRAUDE.
Iban Ritual Textiles (Leiden: KITLV Press) 2003

GEIJER, AGNES.
A History of Textile Art (London: Sotheby Parke Bernet Publications) 1979

HAMILTON, ROY W. (ED.)
From the Rainbow's Varied Hue: Textiles of the southern Philippines (Los Angeles: UCLA Fowler Museum of Cultural History, Textile Series No.1) 1998

HARDIMAN, J P.
Silk in Burma (Burma: Rangoon Government Printing) 1901

HARVEY, JANET.
Traditional Textiles of Central Asia (London: Thames & Hudson) 1997

HENDON, ZOE. (ED.),
Woven Splendour (London: Middlesex University Press) 2004

HYDE, NINA.
"The Queen of Textiles" in **National Geographic** Vol.165, No.1, January 1984

JENKINS, DAVID. (ED.).
The Cambridge History of Western Textiles (Cambridge: Cambridge University Press) 2002

DE JONGHE, DANIEL ET AL.
The Ottoman Silk Textiles of the Royal Museum of Art and History in Brussels (Turnhout: Brepols) 2004

KARTIWA, SUWATI.
Songlet Weaving in Indonesia (Jakarta, Penerbit Djambatam) 1986

KING, BRENDA.
Silk and Empire (Manchester and New York: Manchester University Press) 2005

KOLBE, CHRISTIAN. (ED.)
Seide: Stoff für Zürcher Geschichte und Geschichten (Zurich: Zürcher Kantonalbank) 1999

KUHN, DIETER.
'Silk Weaving in Ancient China: from geometric figures to patterns of pictorial likeness' in **Chinese Science** 12, 1995

LI, L. M.
China's Silk Trade: Traditional industry in the modern world, 1842–1937 (Cambridge MA: Harvard University Press, Council on East Asian Studies) 1981

LIU, XINRU.
Silk and Religion: An Exploration of Material Life and the Thought of People, AD 600–1200 (New Delhi: Oxford University Press) 1999

LIEU, D. K. (LIU TA-CHUN).
The Silk Industry of China (Shanghai, Kelly & Walsh Ltd) 1940

DE'MARINIS, FABRIZIO (ED.).
Velvet: History, Techniques, Fashions (Milan and New York: Idea Books) 1993 and 1994

MATTHEE, RUDOLPH.
The Politics of Trade in Safavid Iran: Silk for Silver, 1600–1730 (Cambridge and New York: Cambridge University Press) 1999

MAY, FLORENCE LEWIS.
Silk Textiles of Spain Eighth to Fifteenth Century (New York: Hispanic Society of America) 1957

MICHEL, F.
Recherches sur le commerce, l'usage, et la fabrication des étoffes de soie (Paris) 1852

MOLA, LUCA.
The Silk Industry of Renaissance Venice (Baltimore and London: Johns Hopkins University Press) 2000

MUTHESIUS, ANNA.
Byzantine Silk Weaving AD 400–AD 1200 (Vienna: Verlag Fassbaender) 1997

NANAVATY, MAHESH.
Silk Production, Processing and Marketing (Columbia, Missouri: South Asia Books) 1990

PONTING, KEN.
A Dictionary of Dyes and Dyeing (London: Bell & Hyman Ltd) 1981

RAWLLEY, RATAN C.
Economics of the Silk Industry (London: P. S. King & Son Ltd) 1919

RAWLLEY, RATAN C.
The Silk Industry and Trade (London: P. S. King & Son Ltd) 1919

REUT, MARGUERITE.
La Soie en Afghanistan: L'élevage du ver à soie en Afghanistan et l'artisanat de la soie à Herat (Wiesbadin: L. Reichert) 1983

ROTHSTEIN, NATALIE.
Silk Designs of the Eighteenth Century (Boston, Toronto, London: Bullfinch Press) 1990

SCHOESER, MARY.
French Textiles from 1760 to the Present Day (London: Laurence King, and Paris: Flammarion) 1991

SCHOESER, MARY.
World Textiles: a concise history (London and New York: Thames & Hudson) 2003

SCRANTON, P. B. (ED.)
Silk City (New Jersey Historical Society) 1985

SERJEANT, ROBERT B.
Islamic Textiles: Material for a History Up to the Mongol Invasions (Beirut: Librairie du Liban) 1972

SHOWEB, M.
Silk handloom industry of Varanasi: a study of socio-economic problems of weavers (Varanasi: Ganga Kaveri Publishing House) 1994

Silk Review 2001: a survey of international trends in production and trade 6th ed. (Geneva: International Trade Centre UNCTAD/WTO) 2001

SINHA, SANJAY.
A Wealth of Opportunities (New Delhi: Oxford and IBH Publishing Company PVT Ltd.) 1990

SPRING, CHRIS AND HUDSON, JULIE.
Silk in Africa (London: British Museum Press and Seattle: University of Washington Press) 2002

TILDEN, JILL.
Silk and Stone: The Art of Asia (London: Hali Publications Ltd.) 1996

VAINKER, SHELAGH.
Chinese Silk: a cultural history (London: British Museum Press) 2004

VAN ASSHE, ANNE.
Fashioning Kimono: Dress and modernity in twentieth-century Japan; the Montgomery Collection (Milan: 5 Continents Editions) 2005

WADA, YOSHIKO IWAMOTO.
Memory on Cloth: shibori now (Tokyo: Kodansha International Ltd) 2002

WATT ET AL.
When Silk was Gold: Central Asian and Chinese Textiles in The Cleveland and Metropolitan Museums of Art (New York: Abrahms) 1997

WARREN, WILLIAM.
Jim Thompson: The Unsolved Mystery (Singapore: Archipelago Press) 1998

WESCHER, H. AND ZELLER, R.
"The Silk and Velvet Industries of Crefeld" in **Ciba Review** 83, December 1950

ZANIER, CLAUDIO.
Where the Roads Met: East and West in silk production processes (Kyoto: Italian School of East Asian Studies, Occasional Papers 5) 1994

ZHAO, FENG.
Treasures in Silk (Hong Kong: ISAT/Costume Squad) 1999

Industry contacts

Ufficio Italiano Seta
Unione Industriali de Como
Via Raimondi, I-22100 Como
Tel: +39 031 234 280
mail: serica@unindustria.co.it

SSS Stazione Sperimentale per la Seta
Via Giuseppe Colombo, 83, I-20133 Milano
Tel: +39 02 70 63 50 47
mail: mizzau@ssiseta.it

Unité séricicole:
INRA, Unité National Séricicole
25, quai Jean Jacques Rousseau
69350, La Mulatière
M. le Professeur Chavancy
Tel: +33 478 504 198
mail: info@inserco.org

Intersoie, c/o Unitex
Villa Créatis, 2, rue des Mûriers, CP 601
69258, Lyon Cedex 09
Tel: +33 472 537 200
mail: contact@intersoie.org

Unitex:
see Intersoie for address and phone number.
M. Claude Szternberg
mail: unitex@textile.fr

Index

Numbers in italics refer to illustrations

Acknowledgments

The creation of this book would not have been possible without the generous assistance of Jacqueline Atkins, Dilys Blum, Neil Bottle, Chiara Buss, Michele Canepa, Linda Eaton, Maureen Fallon, Lynn Felsher, Michael Francis, Herbert C. Frei, Francesca Galloway, Patrick Genoud, Ester Geraci, John Gillow, Titi Halli, Diana Harrison, Ana Lisa Hedstrom, Philip Hughes, Gladys Johnson, Martin Leuthold, Laura Lewis-Paul, Patricia Malarcher, Adrian Meili, Lesley E. Miller, Adrian Pratt, Rachael Preece, Doni Ratti, Martin Simcock, Urs Spuler, Jo Ann Stabb, Norma Starszakowna, Janet Stoyel, Sharon Takeda, David Tooth, Anna Della Torre, Bernhard Trudel, Yoshiko Wada, Carole Waller, and Annabel Westman. For her superb copy-editing skills, it is a pleasure to acknowledge the contribution of Eleanor van Zandt, and, for design and the complex editorial co-ordination, Terry Jeavons and Catherine Hooper respectively. I would also like to thank Professor Bruno Marcandalli for orchestrating the scientific texts, and—for enabling my research while in Como—Dr. Gian Maria Colonna, his colleague in that city's Stazione Sperimentale per la Seta. Ronald Weisbrod deserves credit for not only doing the same in Switzerland, but also for acting as a facilitator on behalf of several silk associations. Finally, special thanks go to Sue Kerry, who gave generously of her time and expertise.

The publisher acknowledges the kind contribution by Julien Macdonald for his foreword.

Picture credits

The publishers would like to thank the following sources for their kind permission to reproduce the photographs and illustrations in this book.

KEY

BM = British Museum
BAL = Bridgeman Art Library
FG = Francesca Galloway
NTPL = National Trust Photo Library
V&A = V&A Images/Victoria and Albert Museum

l = left r = right
t = top b = bottom